War Beyond Words

What we know of war is always mediated knowledge and feeling. We need lenses to filter out some of its blinding, terrifying light. These lenses are not fixed; they change over time, and Jay Winter's panoramic history of war and memory offers an unprecedented study of transformations in our imaginings of war, from 1914 to the present. He reveals the ways in which different creative arts have framed our meditations on war, from painting and sculpture to photography, film, and poetry, and ultimately to silence, as a language of memory in its own right. He shows how these highly mediated images of war, in turn, circulate through language to constitute our "cultural memory" of war. This is a major contribution to our understanding of the diverse ways in which men and women have wrestled with the intractable task of conveying what twentieth-century wars meant to them and mean to us.

Jay Winter is Charles J. Stille Professor of History Emeritus at Yale University and Distinguished Visiting Professor at Monash University. He won an Emmy award as coproducer of the BBC/PBS television series *The Great War and the Shaping of the 20th Century* (1996) and is a founder of the Historial de la grande guerre, an international museum of the Great War inaugurated in 1992. He is the author of *Sites of Memory, Sites of Mourning: The Great War in European Cultural History* (1995), editor of *America and the Armenian Genocide* (2008), and editor-in-chief of the three-volume *Cambridge History of the First World War* (2014).

War Beyond Words

Languages of Remembrance from the Great War to the Present

Jay Winter

Yale University
Monash University

CAMBRIDGE
UNIVERSITY PRESS

CAMBRIDGE
UNIVERSITY PRESS

University Printing House, Cambridge CB2 8BS, United Kingdom

One Liberty Plaza, 20th Floor, New York, NY 10006, USA

477 Williamstown Road, Port Melbourne, VIC 3207, Australia

4843/24, 2nd Floor, Ansari Road, Daryaganj, Delhi – 110002, India

79 Anson Road, #06–04/06, Singapore 079906

Cambridge University Press is part of the University of Cambridge.

It furthers the University's mission by disseminating knowledge in the pursuit of education, learning, and research at the highest international levels of excellence.

www.cambridge.org
Information on this title: www.cambridge.org/9780521873239
DOI: 10.1017/9781139033978

First published 2017

Printed in the United Kingdom by TJ International Ltd. Padstow, Cornwall

A catalogue record for this publication is available from the British Library.

ISBN 978-0-521-87323-9 Hardback

For Petra

And who will remember the rememberers?

. . .

How does a monument come into being?

. . .

And what is the best time for remembering? At noon
when shadows are hidden beneath our feet, or at twilight
when shadows lengthen like longings
that have no beginning, no end, like God?

Yehuda Amichai, "And who will remember the
rememberers?" [1]

[1] Yehuda Amichai, *Open closed open,* trans, by Chana Block (New York: Mariner Books, 2006)

Contents

Color plates are to be found between pp. 74 and 75 and pp. 170 and 171

Illustrations

Figures and Tables

Figures

Tables

Acknowledgments

In my academic life, I have been very fortunate to work with many colleagues who share my commitment to collective history, that form of scholarship written by individuals working and writing in groups, and benefiting from a kind of subtle inspiration unknown to many scholars working in peaceful isolation alone in their studies. The importance of public history – that directed to the public outside universities – and the tempestuousness of the world of cultural history are discoveries directly due to my work with colleagues in the Research Centre of the Historial de la grande guerre, Péronne, Somme, from the moment it was conceived in 1986, through its design until its inauguration in 1992, and in the decades which have followed. Listening to, disputing with, and reading the work of my partners in the Comité directeur of the Research Centre has been an education all of its own. The thinking of the founding generation of Stéphane Audoin-Rouzeau, Annette Becker, Jean-Jacques Becker, and Gerd Krumeich is writ large on every page of this book. When John Horne fortified the Comité directeur by his presence, he added his name to the unacknowledged authors of a kind of cultural history of war of which the present book is but one example. Working with Caroline Fontaine in the Research Centre over two decades has been similarly fruitful. Understanding that objects have narratives imbedded in them has made my history different, and I hope deeper, than it would have been had I stayed outside the orbit of the museum and its Research Centre. A big thank you is due to you all.

In France, my closest interlocutor, coauthor and friend has been Antoine Prost. Our friendship, and the hospitality he and Paulette Prost

have offered me, dates from before I started to work on the Historial. His lapidary prose and immense knowledge have inspired me for more than thirty years. Further east, Helmut Konrad has welcomed me to his center for the study of contemporary history at the University of Graz. There I have benefited from inspiration and wonderful forays into the Slovenian vineyards. Colleagues in Jewish history there, in particular, the late Petra Ernst, helped make Graz a haven and a home for this peripatetic scholar.

The Master and Fellows of Pembroke College, Cambridge, provided me with a congenial home and wonderful students over more than two decades. The same is true with respect to my colleagues and students at Yale, where I have spent the last fifteen years. It is a simple fact that teaching the cultural history of war in these wonderful institutions has enabled me to write about it. Teaching with gifted colleagues such as David Blight, Ute Frevert, Jonathan Spence, and Bruno Cabanes was a privilege. Jim and Ilana Ponet were my students and teachers in ways they almost certainly do not acknowledge. My initial attempt to draw my thinking together on languages of memory came from an invitation to give the Humanitas Lectures at Cambridge in 2012. A delightful stay in 2012 at Aleida Assmann's Centre for the study of history and memory at the University of Konstanz brought me into fruitful contact with many scholars in this field. But the sheer intellectual authority and originality of Aleida and Jan Assmann are something to behold. Their generosity and openness of mind and spirit are unique. Walking into their home in Konstanz and hearing Jan and their daughter Carina playing a duet enchanted me; their family has continued to do so until this day.

The coincidence that the centenary of the outbreak of the Great War occurred while I was writing this book enabled me to speak about it and receive thoughtful responses to various parts of it not only in Europe and North America, but in venues spanning from Ecuador and Chile to Singapore, Hong Kong, China, and Japan. In particular, two separate stays for a month at the University of Hong Kong in 2014 and at the National University of Singapore in 2015 gave me the time to complete the text of this book.

The centenary of the outbreak of war contributed to the drafting of this book in yet another way. I was commissioned by Cambridge University Press to edit the three-volume *Cambridge History of the Great War*, and with the Comité directeur of the Research Centre

of the Historial de la grande guerre as my editorial committee, we managed to complete and publish these massive volumes both in French and English in 2014. A Chinese translation is en route. Yet another instance of the value of collective history, these volumes not only present state-of-the-art interpretations of every facet of the war, but also offered me the chance to think hard about the cultural history of the Great War from a transnational and global perspective. I am grateful too to Queens' University, Belfast, for inviting me to give the Wiles lectures in 2016, which enabled me to try out some of these ideas in extremely congenial company.

Archivists and librarians have made this book possible in ways of which most are unaware. Aside from finding a home away from home in both the Archives nationales in Pierrefitte-sur-Seine and at the Bibliothèque nationale de France in Paris, I also must thank in particular Benjamin Gilles of the Bibliothèque de documentation internationale contemporaine for his generosity and advice. The staff of both Yale University Library and the Yale Center for British Art were more than helpful in the fifteen years I taught there; they followed in the footsteps of staff of the Cambridge University Library and Pembroke College library, who made my two decades and more there so agreeable. William Spencer of the National Archives, in Kew, went out of his way to help; what a model he is for his profession.

My appointment as a recurrent visiting professor at Monash University in Melbourne was of great importance in the development of my thinking about the cultural history of the Great War. I owe much to Rae Frances and Bruce Scates, who have made Monash a center for cultural history in general and for the cultural history of the Great War in particular. Corrie McKee found ways to make things happen with astonishing efficiency. Rebecca Wheatley was a constant help and a loyal friend. My debt to Ken Inglis is of an entirely different order. He has taught me more about the English language than anyone else, and serves still as a guide to civility. When I am puzzled about how to respond to a colleague or student, I think, what would Ken do in this situation? Rai and Yael Gaita provided hospitality and a kind of peace that only they know how to create. Al Thomson, Seumas Spark, and Mark Baker welcomed me to Melbourne in different ways, but with the same congeniality. Australian archives are superbly organized and very rich in their coverage not only of the war but of its long aftermath. The National Archives of Australia and the archives of the Australian

War Memorial are treasure troves, and their staff courteous and unfailingly helpful. In sum, Melbourne is an oasis in the academic world, and I am very grateful for the opportunity to enjoy it. Not far are the Adelaide Hills, where Robert Dare time and again dispensed his unique brand of generous hospitality and shrewd advice. In the vicinity, Robin Prior, savant and wit, offered sage advice on demand.

And then there are the unsung heroes I need to thank – the friends who could not say no when I asked them to read the whole thing: Rebecca Wheatley, Rae Frances, Bruce Scates, Antoine Prost, Kolleen Guy, Jennifer Wellington, John Horne, Harvey Mendelsohn, Astrid Erll, Sasha Etkind, Robert Dare, Helmut Konrad, and Petra Ernst. For help with individual chapters, I want to thank in particular Santanu Das, Alice Kelly, Alan Trachtenberg, Martin Jay, David Kennedy, Giacomo Lichtner, Sarah Cole, Marzena Sokolowska-Paryz, Marc Saperstein, William Spencer, Robin Prior, Paul Lancaster, and Sandy McFarlane.

As to the list of colleagues who read preliminary drafts, or responded in seminars or in academic meetings I addressed, it is sufficiently long to enable me to hide under the cover of age, and to ask you to accept as a senior moment your being placed anonymously in the collective category of my benefactors. I offer heartfelt thanks to each and every one of you.

Michael Watson and his colleagues at Cambridge University Press have been wonderful in the work they have done to steer this project to its destination. I have worked with Cambridge for more than two decades, as editor of their series in the social and cultural history of modern war, and can only express my delight in the professionalism and care they have shown in every facet of their work. Bravo.

There are other acknowledgments which are important to register at this point. I have been the fortunate beneficiary of a grant from the Hilles Fund of Yale University, which has helped defray production costs. I am grateful for permissions to reproduce material previously published in the following works: For material in Chapter 1: "Beyond glory: First World War poetry and cultural memory," in Santanu Das (ed.), *The Cambridge companion to the poetry of the First World War* (Cambridge University Press, 2013), pp. 242–56; for material in Chapter 2: "Faces, voices, and the shadow of catastrophe," in Estela Schindler and Pamela Colombo (eds.), *Spaces and the memories of violence* (Basingstoke: Palgrave Macmillan, 2014), pp. 77–90; for material in Chapter 3: "Filming war," in David M. Kennedy (ed.),

The modern American military (Oxford University Press, 2013), pp. 153–76; for material in Chapter 5: "War and martyrdom in the twentieth century and after," in Uilleam Blacker and Julie Fedor (ed.), *Journal of Soviet and Post-Soviet Politics and Society*, special issue on martyrdom and memory (2015), pp. 217–55; and for material in Chapter 7: "Shell shock, Gallipoli and the generation of silence," in Alexandre Dessingué and Jay Winter (eds.), *Beyond memory: Silence and the aesthetics of remembrance* (London: Routledge, 2015), pp. 190–206.

INTRODUCTION

What we know of war is always mediated knowledge and feeling. The event itself, what Walt Whitman called the "red business,"[1] the actual killing, is beyond us. We need lenses to filter out some of its blinding, terrifying light in order to see it at all. I want to draw attention to these lenses as the elements which make understanding war possible at the same time as they limit what we see. These lenses are not fixed; they change over time, and following such transformations in the ways we have imagined war since 1914 is one of the aims of this book.

Some of these lenses are furnished by the languages we speak. Here too I claim that each language carries its own lexicon about war, in which are imprinted traces of the experience of armed conflict. Thus the way the French speak of war is not at all identical to the way the British or the Germans speak of it; within anglophone culture, distinctions persist too. The Irish vocabulary of war in the early twentieth century was very different from the English one.

Other lenses come with the nature of the creative arts – sculpture, painting, photography and film. All present highly mediated images of war which in turn circulate through language to constitute in part what Jan and Aleida Assmann term the "cultural memory" of war.[2]

[1] Walt Whitman, "Drum-taps," the Walt Whitman archive, published works, www.whitmanarchive.org/published/LG/1867/poems/159. This and all the other Internet citations listed in what follows were used between 2009 and 2016.

[2] For an introduction to the Assmanns' approach, see: Jan Assmann's seminal article, written with Aleida Assmann and translated by John Czaplicka, "Collective memory and cultural identity," *New German Critique*, 65 (Spring–Summer 1995), pp. 125–33;

My central premise, therefore, is that language frames memory. Here I use the term "language" to describe the ways different creative arts, including the art of speech, have framed our meditations on war. In the first part of this book, we start with configuring war, including painting and sculpture, before turning to photographing war, to filming war, and then to writing war. Each of these vast fields of creative activity has a history, and I try to describe thematic, spatial, and temporal variations in these mediated images of war produced in the century which has passed since 1914.

In the second part of the book, I examine what I term frameworks of memory, through which what Samuel Hynes termed our "war in the head,"[3] our imaginings of war, are set. The first chapter turns to memory and the sacred, and explores different patterns of recourse to images of martyrs and martyrdom as a way of understanding mass death in the twentieth century. The second is spatial in character, and refers to choices artists, designers, and architects have made when using the horizontal axis and/or the vertical axis to organize a site of memory or other kinds of monuments and commemorative works. Finally, I turn to silence, defined as a socially constructed space in which everyone knows what no one says. Silence, I believe, is a language of memory in its own right. Here the argument is based on a study of shell shock, occluded, ignored, and underestimated radically by officials and physicians, but present nonetheless in the lives of former soldiers. As in all the previous chapters, this story of silence, the suppression of troubling images and events, starts in 1914 and continues to our own times.

This study is perforce incomplete. There are other important fields – for instance, music – which require detailed examination by

and Jan Assmann, "Communicative and cultural memory," in A. Erll and A. Niinning (eds.), in collaboration with S. B. Young, *Cultural memory studies: An international and interdisciplinary handbook* (Berlin: de Gruyter, 2008), pp. 109–18. For the full range of reference in the Assmanns' work, see Aleida Assmann, *Der lange Schatten der Vergangenheit. Erinnerungskultur und Geschichtspolitik* (Munich: C. H. Beck, 2006); her *Erinnerungsräume. Formen und Wandlungen des kulturellen Gedächtnisses* (Munich: C. H. Beck, 1999; 4th edn. 2009); her *Geschichte im Gedächtnis. Von der individuellen Erfahrung zur öffentlichen Inszenierung* (Munich: C. H. Beck, 2007), and Jan Assmann's classic, *Moses the Egyptian. The memory of Egypt in western monotheism* (Cambridge, Mass.: Harvard University Press, 1998). Their scholarship is the gold standard in this field.

[3] Samuel Hynes, *A war imagined: The First World War in English culture* (London: Bodley Head, 1990) and *The soldiers' tale. Bearing witness to modern war* (New York: Allen Lane, 1997).

those qualified to do so. This book is more a series of reflections in cultural history than an authoritative and exhaustive study of any one of its branches.

In another important respect, this is a personal book. It is based on archival research, and substantial secondary sources, but given the fact that much of the material on which this book is based is visual and that many of these images are in the public domain, the choices I have made remain, to a degree, arbitrary. I believe this is unavoidable, and that other researchers addressing the questions I have posed would come to roughly similar solutions using other sources.

Still it is in the interests of full disclosure to admit that, using the experience of forty years as an historian, I have tried to understand, with whatever compassion I could register, the horrors of industrial war and mass death and to survey the diverse ways men and women have wrestled with the intractable task of conveying what twentieth-century wars meant to them and mean to us. I have reflected on a partial and limited selection of representations of war I have seen or read or traversed. Having made this journey over my academic career, I have concluded that there are a number of findings I can convey which may be of interest to scholars and laymen alike.

The first is that there was a shift from 1914 to the end of the twentieth century and after from representing war to representing warriors. Focusing on soldiers rather than on the larger framework of armed conflict opened up the possibility that soldiers themselves were victims of war, whether they were on the winning or the losing side. And this change coincided with a second significant development. Over the same period, representing war came to mean representing civilian victims of war and genocide. Taken together, these two trends in representation helped undermine the legitimacy of war as an instrument of political life. If war is inevitably a Pandora's box, which once opened, yields horrors no one had anticipated in full, then the resort to war is a resort to an unacceptable state of affairs.

This conclusion applies, as I state openly in several chapters, in some parts of the world and not in others. And yet, even if limited, this is a significant matter for us all. For the delegitimation of war is, to a degree, the delegitimation of the powers of the state, defined by Weber as that institution which has a monopoly on the legitimate use of physical force. In 1914, war was a "normal" part of the political

landscape; I claim that in some places this is no longer the case, and that what I term the arts of memory show that this is so.

In large parts of the world – Eastern Europe, Russia, the Middle East, Asia, and parts of the United States – what Judith Butler terms the "frames of war," the discursive and visual fields in which armed conflict makes "sense," are alive and well, and continue to justify, legitimate and at times glorify war and warriors. This is both true and at the heart of a real divide in which conversations about war take place today[4] in different locations. It is hardly surprising that those countries which still bear the marks and memories of the slaughter of the First World War have developed different "frames of war" than those whose memories were either occluded, as in Russia, or of less significance than those following the "good war" of 1941–45 in the United States.

My argument that language frames memory applies to many other phenomena than war. The same assertion would hold with respect to memories of love or childhood or politics.[5] Memories of war in the twentieth century are different, though, in that they deal with exceptional and extreme experiences of massive, industrialized, violence and mass death. As Primo Levi put it, the only people fully qualified to speak about these matters are the dead themselves. That does not justify silence among the survivors, but it does require us to admit that all attempts to configure war in our time, to transmit its terrifying meaning in full, are bound to fail. And yet, as this book shows, so many people have tried to do so over the last century, and I am one of those who still goes on trying.

Taken together, these chapters are intended to contribute to three separate fields. The first is the cultural history of modern warfare.[6] The second is what we now term "memory studies,"[7] a growing field

[4] Judith Butler, *Frames of war: When is life grievable?* (London: Verso, 2016), pp. xii in the introduction to the paperback edition.

[5] I owe much to Antoine Prost for his comments on this point.

[6] I define cultural history as the study of signifying practices in the past. The literature on this subject is so vast that it would be invidious to cite one or two individuals as leading players in the field. One way to gain an introduction is to read volume III, on civil society, of the *Cambridge history of the First World War*, edited by Jay Winter (3 vols.; Cambridge University Press, 2014). Each chapter has a bibliographical essay which refers the reader to the wealth of research available in this field. Many of these approaches have been applied to later twentieth-century wars and their cultural consequences.

[7] See the journals *Memory Studies* and *History and Memory*, based in Britain and Israel, respectively. See also, Jeffrey K. Olick, "Between chaos and diversity: is social memory

on its own, but one which offers much to students of war. The third is the study of the history of concepts, or *Begriffsgeschichte*, pioneered by Reinhart Koselleck.[8] By exploring the words and images we have used over time to talk about war, we disclose some surprising trajectories of what I term languages of memory, and thereby deepen our understanding of how we have tried to make sense of armed conflict since the first fully industrialized war broke out in 1914.

Let me reiterate one central point. Languages, in the sense I am using the term, are as protean as war itself. We are dealing with two unstable, even dynamic and at times volatile, variables – war and language. A high degree of selection is inevitable, both in subject matter and in geographical reach. But even if the book were twice as large and if it were to take twice as long to write, the problem of the representativeness of the material I present here would still remain. In no sense could this book be comprehensive or exhaustive.

Still, it goes beyond the solely British, French, and German focus of *Sites of Memory, Sites of Mourning*, which I published twenty years ago. It refers time and again to the Shoah, a subject I have not had the courage to treat until now, fifty years after starting my work as an historian. It deals with matters of perennial concern in our own turbulent times.

Leon Trotsky is said to have noted to those uninterested in the history of armed conflict that you may not be interested in war, but war is very interested in you. The cruelties of today's wars span the globe, and seem immune to containment by law, by force, or by persuasion. Anyone who thinks that I write here of a subject with purely academic interest, should think again. In sum, this book offers a pathway into the deep shadows twentieth-century war has cast on our imaginations, a pathway that I hope younger scholars will follow in the coming years.

studies a field?," *International Journal of Politics, Culture, and Society*, 22, 2 (2009), pp. 249–52; Jeffrey K. Olick and Joyce Robbins, "Social memory studies: From 'collective memory' to the historical sociology of mnemonic practices," *Annual Review of Sociology*, 24 (1998), pp. 105–40; and Anna Green, "Individual remembering and 'collective memory': Theoretical presuppositions and contemporary debates," *Oral History*, 32, 2 (2004), pp. 35–44.

[8] For an introduction to Koselleck and his school, see Sandro Chignola and João Feres Júnior, "In honor of Reinhart Koselleck," *Contributions to the History of Concepts*, 2, 1 (March 2006), pp. 3–6; Kari Palonen, "The politics of conceptual history," *Contributions to the History of Concepts*, 1, 1 (March 2005), pp. 37–50; and Reinhart Koselleck, Javiér Fernández Sebastián, and Juan Francisco Fuentes, "Conceptual history, memory, and identity: An interview with Reinhart Koselleck," *Contributions to the History of Concepts*, 2, 1 (March 2006), pp. 99–127.

PART I

VECTORS OF MEMORY

1 CONFIGURING WAR: THE CHANGING FACE OF ARMED CONFLICT

Configuring war is as old as the drawings on the walls at Lascaux. No one who enters this field can do more than add a small note to the vast literature on the subject. Aside from a strong dose of modesty, what is required is a theme which can throw light on aspects of the history of responses to war in painting and sculpture over the last century.

That theme can be stated simply. I want to explore some well-known and widely disseminated works of art to suggest that the way contemporary artists today (2017) see war is very different from the way they saw it a century ago. The key difference is that in many kinds of artistic work, war is no longer con-figured, if I can decompose this term, primarily or centrally through the human face. In part this is a reflection of internal changes in the arts, but in part it is a reflection of the changing nature of war. In 1914, war had a human face – the face of the generation of soldiers who fought and died on the battlefields of the Great War. But over time, the faces of those who have fought war and at times of those who have become its victims have faded slowly from the artistic gaze. I want to trace the nature and consequences of this flight from "figuration," understood as a progressive occlusion of the human face and form, in representations of war in the twentieth century and beyond.

The ugliness of war is hardly a twentieth-century invention. Goya's *Disasters of War* left hardly anything about human cruelty to the imagination; and as we shall see in the next chapter, the art of photography accompanied both the bloody battles of the American

Civil War and the brutal suppression of the Boxer rebellion in China at the turn of the twentieth century.

What many visual artists focused on in their work after 1914 were shifts in the targets of war and in its killing-power. The terror in what we term "total war"[1] rests both on the industrialization of violence, and on the fact that the reach of the state and its agents was greater than ever before; consequently, in wartime, no one was safe. After 1914, a new kind of assembly-line destruction appeared, mixing high-explosive shells, poison gas, and by the 1930s air power as well as toxic forms of ideology in different deadly amalgams. As a result, war and mass terror, arising from what Judith Butler terms the "precarity" of ordinary life beyond the field of battle, became virtually synonymous.[2] And this use of the term "terror" in international war developed new and even darker meanings when it referred to the war Stalin waged against his own people in the 1930s and after.

What I term the degeneration of war is a change both in the weapons systems deployed and in the rules of engagement for using them. Gas warfare is one such change; the distribution of gas masks among civilians, children among them, announced a new landscape of battle, in which the boundary between legitimate and illegitimate targets of military action first blurred and then faded away.

In the interwar years, the bombing of civilian targets became for the first time a centerpiece of armed conflict; after 1941, genocide became an integral part – some would say the defining part – of the war the Nazis waged. In each case, though in different ways, terror became the unavoidable face of war, and artists were there to con-figure it, to give terror a face, a name, and a place. This chapter sketches some of the ways artists created enduring representations of the twentieth-century degeneration of warfare into inescapable terror both on and beyond the battlefield. The three individuals whose work I focus on particularly are Otto Dix, Pablo Picasso, and Anselm Kiefer, though I will refer to other individuals and forms of configuration of the victims of organized violence and war as well.

[1] On the notion of total war, see J. M. Winter, "Under cover of war: The Armenian genocide in the context of total war," in Robert Gellately and Ben Kiernan (eds.), *The specter of genocide. Mass murder in historical perspective* (Cambridge University Press, 2003), pp. 189–214.
[2] Butler, *Frames of war*, p. xxx.

All three artists are well known, but putting them together may help us see more clearly both the changing link between history and terror and changing strategies of configuring war over the past century. The evolution of visual representations of war shows us how images change when targets – or if you will, victims – change. In the Great War, terror had a face, and it was that of the front-line soldier. There were tens of millions of victims, but the ones to receive iconic status both during the conflict and in its immediate aftermath were the men at the front. There were other icons. As we shall see in Chapter 5, the victims of the Armenian genocide were there too; but the political conflict over their treatment went on and on, occluding their genocidal fate. But no one doubted at the time that the enduring images of industrial killing in the 1914–18 war were the men in the trenches, the men we still call the "lost generation."

My first point is a simple one: As war has changed, so has its artistic configuration. The second point I want to make is more formal. That is, when we move from the Great War to the interwar years, and then to the Second World War, we can see that the partial occlusion of the human face is one of the most striking features of changing European representations of war. There are exceptions, to be sure, but on balance, the move I try to document in this chapter is one away from a naturalistic representation of the human face and figure. Thus the images in Otto Dix's Great War paintings, done from 1914 to 1940, are still life-size and identifiably human, though the soldiers so represented faced monumental horror on the field of battle. The terror of the victims of the destruction of Guernica in Picasso's painting is inscribed in part in facial features, and in part in the cruciform and symbolic elements of the ensemble. In contrast, there is a more complex set of choices in artistic representations of the Second World War in general and of the Shoah in particular. There have been many nonfigurative images used metonymically to stand for the monstrous whole. Many representations of the Kristallnacht, organized destruction of synagogues in Germany in November 1938, are void of figures; this was true of much, though not all, photography of this event at the time. It remains true in later representations of this iconic act, and of so many other acts which followed it, as in the case of Kiefer's *The Breaking of the Vessels*, to which I will return, and his more recent *Language of the Birds*.

A different set of problems emerged when artists approached the task of representing the emptying of a whole discrete world, the

Jewish world of central and Eastern Europe, an entire population, its language, its culture, its presence, now almost entirely gone. The dimensions of this, the essential victory registered by Hitler, are, in their magnitude, overwhelming. And yet this terror has been made visceral first in art by portraiture, in prose, in poetry, and then later, in some but by no means all cases, by the effacement of figuration itself.

Consider first the face of Anne Frank on her published diary, or her conventional, and at times, sanitized, representation on the stage and in film as one end of the spectrum. Then consider the configuration of the cover of the now iconic account of Primo Levi's time at Monowitz-Buna, part of the Auschwitz complex. In years of visiting libraries, I have found scores of editions of both writers. In my experience, Anne Frank's book always has her face on it. With one exception to my knowledge, Primo Levi's book entitled either *If this be a Man* (in Europe) or *Survival in Auschwitz* in North America, time and again has a cover without the face of its author.[3] Anne Frank lived through the antechamber of the Shoah; her diary stops before she reaches the camps. Primo Levi's *If this be a Man* is both in and at the heart of what David Rousset termed *l'univers concentrationnaire*.[4]

Putting a human face on the Shoah may be an impossibility, not because the crime is indescribable, but because its enormity seems to have undermined certain currents of humanistic thinking which return to the face as the source of our knowledge of ourself and others. Look at a Rembrandt self-portrait and you will see what I mean. Here is Emmanuel Lévinas's phrasing of the issue. "The face," he writes, "a thing among other things," pierces the frailty of our existence. "The face speaks to me and thereby invites me into a relationship with another, a relationship without parallel, leading either to fulfillment or to recognition."[5] The Shoah erased or blotted out that face, that relationship, that recognition. In that sense, it had no face, and thus no meaning. Facelessness is a language of post-Shoah art.

[3] The one exception I have found is a British publication in one volume of two of Primo Levi's books, *If this be a Man* and *The Truce*. There is also *Moments of Reprieve*, a Penguin edition of Levi's writing, with his face on the cover. As in every facet of cultural history, there are always exceptions to any blanket assertion.

[4] David Rousset, *L'Univers concentrationnaire* (Paris: Éditions de Pavois, 1946).

[5] Emmanuel Levinas, *Totalité et infini* (Paris: Martinus Nijhoff, 1961), p. 172. I owe this reference to Paul Gradvohl.

And yet the human face, that profile about which Primo Levi asked us to consider "if this be a man," did not vanish completely. If conventional figuration seemed inadequate to the task at hand, many jurists, survivors, artists, and healers turned to a different kind of portraiture, to a different field of force, this time one with voices attached. Conjuring up the Shoah has turned to the human voice more and more, in an effort to capture the shape and sentiment of the 6 million who vanished during the Shoah, and of the men and women who survived the slaughter. Voices convey speech acts to which we attach faces, as any radio listener can attest.

To be sure, this contrast between figuration or portraiture before Auschwitz and alternative auditory configurations after Auschwitz needs to be qualified. Firstly, the challenge to figuration in cubism antedated the First World War, though the war stimulated both experiments in abstract art and a return to what Kenneth Silver terms "order."[6] Secondly, as we shall see in Chapter 6, some sculptors continued to use the human form and face as part of their work well after 1918. War memorial art took many forms, but sculpture was a prominent element in such commissions around the world.[7] Furthermore, the images of grotesquely joined piles of corpses being shifted into mass graves by bulldozers were captured by British and American troops almost immediately after the liberation of the camps in 1944–45.[8] Thereafter, the faces of skeletal prisoners in striped uniforms were seared into our minds, and alongside other images, for instance of children surrendering from the ruins of the Warsaw ghetto, these portraits *in extremis* informed and still inform our sense of the terror of the Shoah.

Perhaps the safest statement to make is this. The Shoah made ambiguous a return to the human form as a metonym for mass suffering, as occurred in art dedicated to capturing some sense of the terror of war in 1914–18 or of warfare in the interwar years. Instead, representations

[6] Kenneth Silver, *Esprit de corps: The art of the Parisian avant-garde and the First World War, 1914–25* (Princeton University Press, 1989).

[7] Aside from Käthe Kollwitz's work, discussed in Chapter 6, one of the most striking instances of sculptural figuration is Charles Jagger and Lionel Pearson's design for the memorial for the Royal Regiment of Artillery at Hyde Park Corner in London. See Nicholas Penny, "English sculpture and the First World War," *Oxford Art Journal*, 4, 2 (1981), pp. 36–42.

[8] Angi Buettner, *Holocaust images and picturing catastrophe: The cultural politics of seeing* (Farnham: Ashgate, 2011).

of the terror of the Shoah describe a house of many mansions, most of them ruined or totally destroyed. Some employed figuration – for example in Resnais' 1955 masterpice *Nuit et brouillard*, in the close-up photography and voices of Claude Lanzmann's *Shoah*,[9] and in the video portraits, preserved in Shoah survivor archives around the world, to recapture the face of terror in the faces of those who survived it. At the same time, other artists have used more abstract metonyms, or gestures toward the terror in the art of ruins – here Kiefer is a central figure – or of what James Young has termed "antimonuments," those which fall apart or disappear.[10] We shall return to these projects in Chapter 6, on the geometry of memory. Here I want to discuss this shifting landscape of the representation of the terror of the Shoah primarily through the installation art of Anselm Kiefer.

Kiefer was born, as I was, in 1945, and his work is filtered through later German history as much as it bears witness to the terror of the Shoah.[11] But one of the features of the representational universe surrounding the Shoah is its slow transformation over the second half of the twentieth century and beyond. We need to go well beyond 1945 to see this phenomenon clearly. After what may be termed a latency period, when the faces and voices of the survivors were occluded, for instance in the Nuremberg trials, they returned into our auditory and visual fields after the Eichmann trial, and in the 1970s and after.

Voices now had listeners, and writers had new readers; indeed, both found in time an audience that has grown exponentially. Primo Levi's masterpiece *If this be a Man*, was written in 1947; it sold 1,500 copies and then faded into obscurity. It was reprinted in 1957, and later captured an exponentially growing reading public. Since the 1970s, it has appeared in thirty-eight translations and is an international best-seller.[12] I wonder why many more people wanted to find out what he had to say at one moment, and not before?

[9] Stuart Liebman (ed.), *Claude Lanzmann's Shoah: Key essays* (Oxford University Press, 2007).

[10] James Young, *The texture of memory* (New Haven, Conn.: Yale University Press, 2000).

[11] The literature on Kiefer is vast. A good place to start is Andreas Huyssen, "Anselm Kiefer: The terror of history, the temptation of myth," *October*, 48 (Spring 1989), pp. 25–45.

[12] Primo Levi, *Survival in Auschwitz: The Nazi assault on humanity*, trans. Stuart Woolf (New York: Simon & Schuster, 1996).

One answer is that, over time, memory became tied up in law, and both became performative. The witness has a voice, and the witness demands to be heard.[13] She testifies. Another answer is that the emergence of the Shoah witness coincided with the rebirth of human rights as the signature of the European experiment. It was a coincidence, to be sure, but through the Helsinki accords, international agreements guaranteeing the western borders of the Soviet Union in the mid 1970s, Human Rights Watch and other groups earned the right to survey, hear, and defend the voices of Soviet dissidents, the voices of Charter 77 in Prague, and other voices around the world. Which is cause and which is effect is hard to say; both Shoah testimony and human rights activism were powerful acts of witnessing.[14]

Technical change made a difference, though of a facilitating rather than a fundamental kind. Over the same years, audio cassettes were complemented by cheap video cassettes and recording technology, and both were amplified by the Internet in their ability to preserve the voices (and faces) of witnesses of all kinds. The impulse was there; the audience was there; the new technology of the 1970s and 1980s brought them together and there they remain to this day.

Here I offer four caveats. First, the distinction I make between privileging the voice and privileging the face in representations of terror and its victims is a heuristic one. Both have had their place in the representation of war and terror. Still, I believe that there has been a change, in the sense that voices matter more now after the end of the twentieth century than at its beginning. The sound of the drum beat of German guns at Verdun or the cry of wounded men on the Somme are things we can never hear; the drone of the bombers or the voices of those under the Condor legion's attack in Guernica are not available to us; but the voices of those who survived the camps are there and we have preserved them. Auditory commemoration is now a pillar of remembrance; it has developed in museums, in archives, in film, on the Internet, and in the courtroom, as a complex complement to the earlier facial and

[13] On performativity, see Shoshana Felman, "Theaters of justice: Arendt in Jerusalem, the Eichmann trial, and the redefinition of legal meaning in the wake of the Holocaust," *Critical Inquiry*, 27, 2 (Winter 2001), pp. 201–38.

[14] Jan Eckel and Samuel Moyn (eds.), *Breakthrough: Human rights in the 1970s* (Philadelphia: University of Pennsylvania Press, 2014); see also Annette Wieviorka, *L'ère des témoins* (Paris: Plon, 1998).

figurative representation of terror in wartime.[15] We now hear what war and terror did to people, and perhaps through hearing this, in a way we can "see" them or imagine them more profoundly as well.

What we hear, after all, when affect is attached to a voice, configures visual images in powerful ways. I am reminded of the remark of the great British journalist Alistair Cooke, whose *Letter from America* was broadcast on BBC radio every Sunday morning for forty years. He was asked one day why he preferred to work in radio. His answer was the pictures are better.

The second caveat is that we must resist a form of contextual reductionism in understanding the visual arts. They have their own rules and rhythms, and their autonomous unfolding can never be reduced to a mechanical process in which superstructure follows base as night follows day. Still, we should not reify the arts either, as if those who produce them live in a cocoon, until that moment when they emerge as beautiful creatures and fly their own way. They are among us.

The third caveat is this. I can only refer in the most cursory fashion to a field much, much larger than my capacity to analyze it. All I want to suggest in a preliminary manner is that capturing the voices of the survivors has become one essential way of making present in our lives the encounter of war, terror, and the imagination, on which we reflect throughout this book.

Fourthly, I believe the distinction to which I point here is one most clearly visible in Europe west of the Elbe. Heroic histories and images, fully visible and figurative, dominated the Soviet empire until its collapse in 1991. The figuration of war and the victims of war has not faded in Poland, Russia, the Ukraine and elsewhere in the intervening decades,[16] nor has it diminished in parts of the United States or Australia where the face of the soldier past and present is a common point of reference.[17] The purchase of my argument is strongest, I believe, in Western and central Europe, where the European Union has grown precisely at a time when the presence and political and

[15] On the court room, see Thomas Keenan and Eyal Weizman, *Mengele's skull: The advent of forensic aesthetics* (Berlin: Sternberg Press, 2012).

[16] See Alexander Etkind, Uilleam Blacker, and Julie Fedor (eds.), *Memory and theory in Eastern Europe* (Basingstoke: Palgrave Macmillan, 2013).

[17] See Bruce Scates, Rebecca Wheatley, and Laura James, *World War I: A history in 100 stories* (Melbourne: Penguin, 2015), and Marilyn Lake et al., *What's wrong with Anzac? The militarization of Australian history* (Melbourne University Press, 2008).

cultural significance of the military has diminished radically. When historian James Sheehan asked in the title of a history of twentieth-century Europe "where have all the soldiers gone?,"[18] he was making a statement of great significance for the cultural history of modern warfare.

Mediations: Otto Dix and the Great War

All art is a form of mediation, and the notion that experience is captured in some pristine form by the artist is a conceit long since repudiated by producers and consumers alike.[19] Images of horror are mediated images, and to show the differences in such mediation is to do much to unfold some of the differences of early and later twentieth-century images of terror in war.

Otto Dix's etchings of the war and the Western Front are a case in point. He served on the Somme in 1916, in Champagne in 1917, where he was wounded three times, and on the Russian front. As a noncommissioned officer, and machine gunner, he saw some of the worst fighting of the war. When in 1924 he sought to return to this landscape, he did so through photography. Why? In part, it was the heaviness of his personal memory of the war.[20]

Like many other veterans, Dix was haunted by images of trench warfare. He experienced recurrent nightmares, in which he crawled through destroyed houses forever. He never lost sight of the fact that living in the front lines was like living in a noisy, filthy maze. He had volunteered in 1914, but quickly lost his youthful illusions about military service. He painted the face of war in 1914 (Illus. 1.1), before he found out how mistaken he was about it.

Already inclined to mythical and decadent themes prior to the war, he found on the Western Front a diabolical landscape beyond his worst imaginings. He summed up his experiences of trench life in these words, recorded in his war diary in 1916: "Lice, rats, barbed wire, fleas,

[18] James Sheehan, *Where have all the soldiers gone? The transformation of Europe* (New York: Alfred A. Knopf, 2008).
[19] Martin Jay, *Songs of experience. Modern American and European variations on a universal theme* (Berkeley: University of California Press, 2005).
[20] Jörg Martin Merz, "Otto Dix' Kriegsbilder. Motivationen – Intentionen – Rezeptionen," *Marburger Jahrbuch für Kunstwissenschaft*, 26 (1999), pp. 189–226.

shells, bombs, underground caves, corpses, blood, liquor, mice, cats, artillery, filth, bullets, mortars, fire, steel: that is what war is. It is the work of the devil."[21]

The work of the devil was visible in the faces of the men who killed and who faced the risk of mutilation and death every day they were in the trenches. The range of horrors was evident. They lived with the dead and began to resemble the dead. Descending a slope with machine gun equipment meant negotiating what appears to be a landslide of corpses. In his lithographs, the living rest alongside and are braided together with the entrails of men and the roots of trees. Illustrations 1.2 and 1.3 tell us about the terror of combat, through the gas-mask covered faces of storm troopers, and the unmasked and unhinged face of a trench soldier. In another lithograph, a blackened boyish figure grins in front of a scene of total devastation. Other images return to the theme of the monstrous deformation of the bodies of dead men and dead horses. One image of terror removed from the battlefield is that of a mutilated soldier; his face is gone, but surgeons have made an effort to replace it. This lithograph is entitled "Transplantation." Here again, the notion of the human face as the measure of terror extends from the dead to the living, from the mad to the mutilated. If we do not look at the face of the warrior, Dix tells us, we do not know anything about war, nor do we know about the terror it spread among the millions of men who endured it.

Death Descends from the Skies

Dix's series on war included one on civilians under aerial bombardment in the Great War (Illus. 1.4). This image points to the argument of the second part of this chapter. It is that war and terror were redefined by technology; that is, the emergence of bombers capable of reaching any city in Europe with a load of explosives enabled the terror of war to move from rural trenches to cities.[22] Stanley Baldwin, the British prime minister, famously asserted that the bomber will always get through. From 1936 on, the notion circulated widely that the outbreak of war in

[21] Otto Dix, *War diaries, 1915–1916* (Albstadt: Stätische Galerie, 1985), p. 25, as cited in Eva Karcher, *Otto Dix* (New York: Crown Publishers, 1987), p. 14.

[22] Susan Grayzel, *At home and under fire: Air raids and culture in Britain from the Great War to the Blitz* (Cambridge University Press: 2012).

Europe was bound to mean civilian deaths on a hitherto unknown scale. Even though this catastrophe did not happen in September 1939 when war broke out, its contours were already well known.

That shift of the image of terror from trenches to cities was one function of newsreels. But while newsreels brought the facts of war to millions virtually at the same moment the violence happened, it was art mediated by newsreels which provided us with iconic images of terror. I refer to Pablo Picasso's *Guernica,* painted in a fever in the four weeks following the Condor Legion's attack on the Basque city on April 26, 1937. Here was what contemporaries termed "terror bombing," the purpose of which was not to move the line to the advantage of one side in the war, but to destroy the lives of noncombatants behind the lines.

This obliteration of the distinction between civilian and military targets had begun in 1914, when Belgian and French civilians were targeted or executed by advancing German troops. This degeneration of the rules of warfare was evident in the case of Russian atrocities in Galicia in 1915, and in the expulsion and murder of nearly one million Armenians from eastern Turkey, begun in the same year. Civil wars throughout Eastern Europe and what was termed euphemistically by diplomats "population exchange" in Greece and Turkey after the war made everyone the target of military or paramilitary violence.[23] But it was air power which transformed the face of war and began to change the way the human face itself was represented in the visual arts.

Picasso's *Guernica* (Illus. 1.5) is probably the most celebrated and the most circulated image of war in our times or at any time. Attention to its configuration can tell us much about configurations of terror in the time when death came from the skies. The composition is marked, even framed, by newsprint, and by the black and white of newsreels. There are two clusters of faces. Three on the right, terrified faces of people, are moving to the center of the scene; three on the left are victims: one man, probably a soldier, broken sword in hand, is prostrate, indeed cruciform in shape, with a frozen cry on his face; his eyes still see, but not those of the child to his left. His dead body is cradled by his mother. In the center are two animals: an immutable *toro,* and a terrified horse, above which an electric light shimmers.

[23] John Horne, "Atrocities and war crimes," in Winter, *Cambridge history of the First World War,* vol. I, pp. 561–84.

I have puzzled over this light bulb, and determined, using Ockham's razor, that it is precisely that – a light bulb, drawing ironic attention to the power of electricity, driving the engines, wiring, and instruments of bombers delivering terror from the air. Why ironic? Because Picasso painted the *Guernica* canvas to be displayed in the Spanish pavilion within the Exposition international des arts et métiers de la vie moderne, opened in May 1937. And that expo was a celebration of science, and in particular, of electricity, which turned Paris into the city of lights, of illumination promising a cornucopia of benefits to mankind. Raoul Dufy, an artist whom Picasso detested, painted for the expo the biggest mural ever made. It was entitled *La fée electricité*, and expressed this bold and naive view of science as entirely beneficent. It was in gazing at this fair that Walter Benjamin began the meditations which arrived in his celebrated aphorism that there is no document of civilization which is not at one and the same time a document of barbarism. Picasso, casting a jaundiced eye at Dufy's mural, painted that document of barbarism. He saw electricity as embodying technical progress combining the innocent and the lethal. In *Guernica*, terror had a human face, but it was one detached not only from platitudes about science, but also from prior representations of warfare. Picasso was the artist of angular planes, of body parts decomposed, or rather recomposed to express something figurative art could no longer embody.[24]

I see Picasso as a liminal figure in whose work configurations of terror are visible, but not in the kind of composition Otto Dix and his contemporaries knew. Both Dix and Picasso constructed images of terror mediated by prior visual images;[25] photos in the case of Dix, newsreels in the case of Picasso. The question I want to pose in the third part of this chapter is this: How were the horrors of the Second World War and the Shoah configured? My response is a mixed one. There were conventional and figurative images of war and genocide available at the time. But what we see in the art of terror which followed the Shoah is a set of images in which the human figure is either absent or marginal.

[24] Jay Winter, *Dreams of peace and freedom: Utopian moments in the twentieth century* (New Haven, Conn.: Yale University Press, 2006), ch. 3.

[25] On mediation, see Astrid Erll, "Media and the dynamics of memory: From cultural paradigms to transcultural premediation," in Brady Wagoner (ed.), *Oxford handbook of cultural memory* (Oxford University Press, 2017).

Empty Spaces

I want to clarify this problem not in the spirit of definitive scholarship, but as a *piste*, as the French put it, or a tentative step toward framing an argument that cannot be definitive. Why not? Because the more we look at the Shoah, the less we tend to see. This is a claim made by Inga Clendinnen,[26] and it is one I share. I do not mean that we miss the traces, or cannot identify sites of remembrance; they are not hard to find. My claim is rather that when we see the topography of terror, we see elements of a story the full contours of which tend to escape us. Metaphors seem to lack their conventional power, as to a degree did photographs.[27]

Human faces and bodies predominated in photos immediately after the war. Most of these photographs were of concentration camps liberated in the west and not of the death camps in the east. There were faces to see in Buchenwald and Belsen, but nothing remained of Treblinka or Sobibor. Auschwitz-Birkenau was a gigantic complex, and though many inmates were forced to move west when the Red army approached, there were many people still there when liberation came. The Shoah was not a unity, and differences between camps account in part for differences in the representation of victims of Nazi terror. Soviet writers, including Jewish ones, conveyed different messages from those of their Western allies. Jews were not only victims, but also soldiers whose revenge was taken through the destruction of the Nazi regime.[28]

There are photographs of Mauthausen liberated, with prisoners, almost certainly staged, saluting welcoming American troops. The liberators were so shocked at what they found that they turned these images into documentary newsreels, and in some cases, forced German civilians to see them.[29] In Western Europe, this phenomenon is

[26] Inga Clendinnen, *Reading the Holocaust* (Cambridge University Press, 1998).

[27] See a similar argument about metaphors and the Gulag, in Alexander Etkind, *Warped mourning: Stories of the undead in the land of the unburied* (Stanford University Press, 2013).

[28] Harriet Murav, *Music from a speeding train: Jewish literature in post-revolution Russia* (Stanford University Press, 2011). On Soviet cinema, also earlier in confronting the Shoah than many Western filmmakers, see Olga Gershenson, *The phantom of the Holocaust. Soviet cinema and Jewish catastrophe* (New Brunswick, NJ: Rutgers University Press, 2013).

[29] David Wingeate Pike, "Les photographes de Mauthausen: Aspects nouveaux d'une affaire célèbre," *Guerres mondiales et conflits contemporains*, 218 (April 2005), pp. 85–99.

well documented, and so was the use of documentary images in Alain Resnais' *Nuit et brouillard*, released a decade after the end of the war, in 1955. Resnais worked with two survivors, Jean Cayrol, who wrote the script, and Hans Eisler, who composed the music. Resnais aimed at a kind of desolate tranquillity in his presentation of the landscape of terror, but he ran into censorship problems when he showed the faces of French policemen who guarded Jewish deportees on their way to Drancy, and then Auschwitz. In order to get the film shown commercially, Resnais had to efface the policemen so that no one in the audience could see the French *kepi*. Thus French responsibility for the Shoah literally would be blotted out.[30]

I want to use this instance of effacement to raise a more general point about the representation of war and terror after the Shoah. My view is *not* that the Shoah is beyond representation; it is rather that the focus on the single human face, so striking in both Dix and in different and liminal ways in Picasso, is missing in what we now term "Holocaust art." Yes, this reflects movements toward abstraction or toward conceptual art, already under way. But it may also be a statement of puzzlement on the part of artists themselves as to how to represent something as vast, as complex, and as disturbing as the Shoah.

I want to explore this point primarily with respect to the work of Anselm Kiefer.[31] The reason for doing so is both his standing in the world of contemporary art, as well as what I would like to term his strategy of effacement in representing the Shoah.

Consider for a moment what Kiefer left behind in terms of strategies of representation. Perhaps 10 million men died on active military service during the First World War, but no one to my knowledge tried to represent this immense absence through what I have termed effacement, or perhaps more simply stated, through making us aware of this vast disappearing act called war by making the human face disappear from their canvasses. There were indeed monuments to unknown soldiers built after the war, but they were there to represent those not without a face but without a name. I develop this point in Chapter 6.

[30] Sylvie Lindeperg, *"Nuit et brouillard," un film dans l'histoire* (Paris: Odile Jacob, 2007).

[31] See Lisa Saltzman, *Anselm Kiefer and art after Auschwitz* (Cambridge University Press, 1999).

During the Spanish Civil War and its aftermath, millions of men and women died; one estimate has it that over 1 million Republicans died after the formal end of the fighting in March 1939.[32] And yet our images of that war are still figurative, visual, and – what I would term for the purposes of argument – facial. The development of photojournalism insured that that would be so. But even before then, Dix's art of disfigurement draws us back to the human face.

For a host of reasons, many artists came separately to the conclusion that what happened thereafter in Germany and throughout Europe was not possible to con-figure, if I may decompose the word. Instead, and with its own dynamics, abstraction and symbolic art took the place of the human form. Let me show you how this operates in the work of Anselm Kiefer and others of his generation.

Born in 1945 in southwestern Germany, Kiefer's early schooling in Rastatt between the French border and the Black Forest was filled with silences on the war and on what we now call the Holocaust. As did so many other young men and women in the years leading up to the student revolt of 1968, Kiefer made it his business to break those silences.[33] To do so, he turned away from an initial commitment to the study of law and languages at the University of Freiburg in order to study art first in Freiburg and then in Düsseldorf.

It was in Düsseldorf that he encountered Joseph Beuys. Beuys's trajectory was all too familiar.[34] Born in 1921, he joined the Hitler Youth, attended the Nuremberg rally – his face could have been one of those delirious young admirers of the Führer lining the route of the Führer's arrival. He volunteered for the Luftwaffe, and fought as a rear gunner in a Stuka detachment. His plane was shot down over the Crimea in March 1944. He attributed his survival after severe burns to care by Tatar tribesmen who covered him in animal fat and felt. Whether or not this actually happened is neither here nor there. Beuys recovered, and he was redeployed as a paratrooper on the Western Front, where he was wounded a further five times. If ever there was an

[32] Helen Graham, *A short introduction to the Spanish Civil War* (Oxford University Press, 2006).

[33] Winter, *Dreams of peace and freedom*, ch. 5.

[34] Claudia Mesch and Viola Michely (eds.), *Joseph Beuys: The reader*, with a foreword by Arthur C. Danto; additional translation by Nickolas Decarlo, Kayvan Rouhani and Heidi Zimmerman (London: I. B. Tauris, 2007).

artist who knew the face of war and the terror it conveyed, it was Joseph Beuys.[35]

Beuys later constructed an abstract design for a Shoah memorial at Auschwitz, but his project was not accepted. In 1961 he became Professor of Monumental Sculpture at Düsseldorf; he lasted for eleven years, during which time he accepted anyone who wanted to study with him. One such student was Anselm Kiefer.

In the late 1960s and early 1970s, Kiefer used art to accuse his parents' generation of refusing to face the horrors of the Nazi regime. Photography and collage were the forms in which he initially fashioned this accusation, in his 1969 collection of images *Occupations*, made up of photographs of Kiefer himself giving the Nazi salute in offices and in other unlikely sites.

It is easy to see the influence of Beuys's approaches to the use of natural materials – trees, glass, straw, wood – in Kiefer's early work. He also followed Beuys in much later experiments with cabinets of curiosities.[36] But unlike Beuys, he was never accused of avoiding the Shoah or his own past. These critiques – mostly without any foundation – surrounded Beuys in his later years, and it is important not to draw too direct a line between Beuys and Kiefer. Here there are clear affinities, but dissimilarities too. Both have mystical elements in their work, but in the case of Kiefer, it is Jewish mysticism, as well as numerous texts, poetic, hermetic, cabbalistic and biblical, both Old and New Testament in origin, which have been at the center of his art in recent years.

Kiefer has addressed the Jewish-German embrace in a host of ways, but to my knowledge, rarely through the human face. He uses some figurative elements in his work, but most of the time the face is hidden or nonexistent. There are notable exceptions. In his early years, he used photography to attack the smugness of Germany after the economic miracle brought it back to the center of European life and world affairs. He famously photographed himself giving the Nazi salute in front of a military sculpture or other sites. In addition, on some rare occasions, he used portraits for ironic purposes. *The Ways of Worldly Wisdom. Arminius's Battle* is an oil on woodcut mounted on paper. It is a collage of German romanticism, using the faces of notables in German

[35] *Joseph Beuys: In memoriam. Joseph Beuys, obituaries, essays, speeches*, trans. Timothy Nevill (Bonn: Inter Nationes, 1986).

[36] Jean-Michel Bouhours, "Les alchimistes montent au ciel," in Jean-Michel Bouhours (ed.), *Anselm Kiefer* (Paris: Éditions du Centre Pompidou, 2015), p. 170.

cultural life to question the still present danger of the national idea and the myths of Germanness surrounding it.

In his youth, when Kiefer photographed or painted the face and figure, it was in a savagely ironic manner. In his early *Occupations* series, he made it clear that the face of recent German history was the face of those giving the Nazi salute (Illus. 1.6). It was for this reason, I believe, that Kiefer felt that it was no longer possible to configure the human face, debased through worship of the Führer or through images of the Führer himself. The question he has posed ever since is how to go beyond the figurative and the facial in artistic meditations on the upheavals of the recent past.

In Kiefer's later work, and with some exceptions relating to German myths and Eastern religions, the human figure is by and large absent. Could it be, I wonder, that this choice is part of Kiefer's exploration of Jewish tradition in general and Jewish mysticism in particular? He may have had in mind the Jewish precept that we must never reproduce the human face, because that puts us at risk of reproducing the face of God, something entirely forbidden in orthodox Jewish tradition. This may be indirectly evident in a theme Kiefer has returned to time and again over decades: the cabbalistic story of the breaking of the vessels.

In short, the cabbalistic answer to the question posed by theodicy – how can evil exist in a world created by an omnipotent and benevolent God? – is that when God created the universe, he withdrew in space in order to create the void in which the universe was born. The creative material out of which the world came was contained in vessels, which broke into shards through the force of the "big bang" of divine creation itself. Those shards fell to earth, and jagged and dangerous, they remain here, as evil in the world.

Have a look at Kiefer's installation in the St. Louis Museum of Art, entitled *The Breaking of the Vessels* (Illus. 1.7). This theme recurs in many other installations Kiefer has created. What we see is the Kristallnacht, the shards of glass, the burnt library of a destroyed synagogue, framed by the cabbalistic signs of the zodiac as a kind of rainbow after the flood.[37]

[37] For an informative approach to Kiefer's exploration of the cabbalah, see Mark-Alain Quaknin, "La Kabbale et l'art de la bicyclette," in Bouhours, *Anselm Kiefer*, pp. 28–43. On his approach to other Jewish themes, see Lisa Salzmann, "L'année prochaine à Jérusalem, cette année à Paris: À propos d'Anselm Kiefer, der impératifs iconographiques et des juifs," in Bouhours, *Anselm Kiefer*, pp. 50–59.

Now I ask you to have a look at a photograph of a London library after the Blitz (Illus. 1.8). The iconic images of destruction or of the ruins of libraries and the piles of burned or damaged books clearly emerge from events other than the Shoah. But such images take on a metonymical function when the Shoah is located centrally within the destruction wrought by the Second World War.

When I started work in the field of the cultural history of war, the Shoah was not at the heart of narratives of the Second World War. Now it is, and that development is not simply an historiographical matter; public institutions have elided the two. There is now a powerful Shoah exhibition permanently placed on top of the large displays on the Second World War in London's Imperial War Museum. The same elision is evident in other war museums, including the Auckland War Memorial Museum in New Zealand. This instauration of the Shoah within war narratives is now a global phenomenon.

Consequently, it is hardly surprising that a photograph from the London Blitz was one source for another important visualization of the Shoah which has dispensed entirely with the human figure. I speak of the design of the Jewish Museum in Berlin by Daniel Libeskind, a Polish-born child of Holocaust survivors, who at the age of 13 moved from Poland to the United States.[38]

To be sure, a comparison of installation art and architecture is both necessary and difficult. What interests me in Libeskind's work is the transformation of photography into architecture. Have a look at the internal design of the museum (Illus. 1.9). It presents visitors with the crossing lines of the broken and burnt beams of a synagogue destroyed seventy years ago in the Kristallnacht. And it has a sense of an absence, a never to be filled void, which is both uncanny and troubling. Each time I have visited the museum, I have felt ill. Partly it is due to the lack of straight lines; partly to the incline of all planes. In part, it is due to the absence of the human face.

In recent years, the curators of the museum have filled it with faces. It contains a rich and varied collection of the history of German Jewry over one thousand years. I must admit that this collection, admirable though it is, leaves me cold. This is not because of its design or its

[38] *Daniel Libeskind and the Jewish Museum of Berlin/Remarks by W. Michael Blumenthal* (New York: Leo Baeck Institute, 2000).

meticulous presentation of a world which has vanished. It is because the building overwhelms its contents. The void sucks into it whatever objects come to fill it. It is its lack of representational elements which gives the building its force to act as a work of art.

Blurred Faces: Gerhard Richter

My aim in this chapter is a modest one: it is to explore some of the ways the use of figuration in general and of the human face in particular has become problematic in some artistic quarters after the Holocaust. Consider several works of the German artist Gerhard Richter. A master in many fields of contemporary art, Richter lived through both the Nazi and the East German dictatorships. So did his family. His masterpiece *Uncle Rudi* (1965) (Illus. 1.10), is a painting based on a small family photograph of his uncle, who died in France while fighting after the Normandy landings in 1944. Just as in Dix's work, painting followed photography, as mediators of the past. In 1965, when Richter produced this work, the Frankfurt Auschwitz trials were under way, and so was the exposure of the complicity of so many ordinary people in the Nazi war effort. In addition, Richter's aunt was murdered by the Nazis, making his family history – and that of millions of others – truly blurred.

His reflection on the violent past of his native Germany went beyond the Second World War to focus on the urban terrorism which emerged after the upheavals of 1968. His cycle of paintings *October 18, 1977* (1988) dwells on the deaths in prison of the leaders of the Baader-Meinhof Gang.[39] To choose but one image, he presents Ulrike Meinhof horizontally, with the marks of her hanging still visible (Illus. 1.11). We shall return in Chapter 6 to the use of the horizontal axis as the language of mourning. But what sense of loss is Richter trying to convey?

[39] For a range of comment on Richter's multiple points of view, see Benjamin H. D. Buchloh, "A note on Gerhard Richter's 'October 18, 1977,'" *October*, 48 (Spring 1989), pp. 88–109; Buchloh, "Divided memory and post-traditional identity: Gerhard Richter's work of mourning," *October*, 75 (Winter 1996), pp. 60–82; Thura E. Knapp, "Gerhard Richter and the ambiguous aesthetics of morality," *Colloquia Germanica*, 45, 1 (2012), pp. 95–112; and Robert Storr, "October 18, 1977," *MoMA*, 4 (January 2001), pp. 31–33.

His signature use of blurred images can be interpreted in many ways.[40] One is that it enabled him to express distance.[41] Another sees in this practice a language of sympathy, ambivalence, and revulsion at this complex and violent strand in Germany's recent history, which was, to Richter and others, an outcome of the earlier violence of the Third Reich. The student revolt of the late 1960s had pointed out the extent to which the postwar rebuilding of Germany, east and west, had blurred recognition that so many killers had escaped judgment for their crimes. When student revolt faded away in the early 1970s, a group of radicals spun off from mass movements into small clusters of urban terrorists who apparently chose suicide over continued incarceration.[42] Blurring was a brilliant artist's technique for introducing doubt, distance, irony, into any judgment of these people and their beliefs. It was a mixture of the meditative and the melancholic,[43] in the spirit of Roland Barthes, whose reflections on photography we will discuss in the next chapter.

For our purposes, we can see the link between Richter's demolition of the discrete practices of painting and photography, and Kiefer's move from polemical photography, of himself giving the Nazi salute, towards more complex reflections on the Shoah. Kiefer's use of Jewish symbols and myths enabled him to take Richter's innovation one step further, in his ongoing reflection on the braiding together of the Jewish and the German past. Having moved to Paris, Kiefer can be said to place that embrace in a fully European context, which is the only way to make sense of it. The Shoah was a European crime, disfiguring the shape of European history and its artistic representations in complicated and enduring ways.

The first tentative conclusion we can draw from this brief and incomplete discussion is that terror has a history. It is a history filtered through images which change over time. In the Great War, terror took on the

[40] Gertrud Koch, "The Richter-scale of blur," *October*, 62 (Autumn 1992), pp. 133–42.

[41] Achim Borchardt-Hume, "'Dreh dich nicht um': Don't turn around. Richter's paintings of the late 1980s," in Mark Godfrey and Nicholas Serota, with Dorothée Brill and Camille Morineau (eds.), *Gerhard Richter. Panorama* (London: Tate Publishing, 2011), pp. 163–200, esp. p. 167.

[42] Jay Winter, *Dreams*, ch. 5, "Liberation."

[43] Alex Danchev, "The artist and the terrorist, or the paintable and the unpaintable: Gerhard Richter and the Baader-Meinhof Group," *Alternatives: Global, Local, Political*, 35, 2 (April–June 2010), pp. 93–112; and Lisa Saltzman, "Gerhard Richter's Stations of the Cross: On martyrdom and memory in postwar German art," *Oxford Art Journal*, 28, 1 (2005), pp. 27–44.

face of the *Frontsoldaten*, the *poilu*, Tommy Atkins, those unfortunate men who lived and died in a trench system stretching with various intervals across Europe, from Calais to Caporetto and beyond. Those who withstood the terror, who stood their moral ground and remained recognizable human beings, these men could indeed be seen as heroes. And yet over time, when war lost its human face, so too did the hero. The cult of the military hero is one of the casualties of the changing face of warfare over the past century. This is not to diminish the extraordinary bravery of men and women in the Resistance or in later conflicts; it is simply to register a change in both the way war has been waged and how it has been represented.

In the interwar years, the killing power of the bomber transformed the space of violence from the battlefield to the city. Slaughter in China after the Japanese invasion of 1931 and the murderous campaigns of 1937 and after took on older forms. But the bomber changed perceptions of war and broadened the pool of victims trapped by the new technology of destruction.

In the Second World War, the face of victimhood changed again. This time there were millions of foot soldiers who died in combat, and millions more civilians who died either under aerial bombardment or in extermination camps. Those who vanished in the Shoah, those who were fed into the machines of assembly-line murder, were the victims of a technology of killing if not new, then one refined and perfected by a kind of demonic Taylorism, to an end that still stretches our imagination. When the liberators of the camps disclosed the remains of those trapped in the terror we now call the Shoah, there were photographs and newsreels to record the moment. But over time, the visual record of what Primo Levi termed the actual injury, the insult to humanity, began to fade.

There followed a period when the victims of the camps went into the shadows. As Pieter Lagrou has shown, their face was occluded by the face of the Resistance, whose bravery was undoubted, but whose story of active defiance and struggle contrasted with and superseded that of the survivors of the Shoah. Only by the late 1960s and early 1970s, when the political reconstruction of Europe was complete, was it possible for there to emerge an audience to hear and to see the survivors of the camps.[44]

[44] Pieter Lagrou, *The legacy of Nazi occupation: Patriotic memory and national recovery in Western Europe, 1945–1965* (Cambridge University Press, 1999).

In all three cases – after the Great War, at the time of the Spanish Civil War, and in the aftermath of the Second World War – the image of the victim engraved by very different artists was mediated by the visual technology of the day. Photographs provided Otto Dix with the face of war he then transformed into his own vision. Newsreels gave Picasso what he needed to fire his imagination in such a way as to produce the painting of the century in four short weeks. Those meditating on the Shoah initially had the film shot by liberators of the camps and the human wreckage left in them. There were photographs too, of the kind ordinary soldiers take; we shall return to this point in Chapter 2.

Over time, though, the face of the victim of the Shoah receded from the headlines and the newsreels. It took twenty-five years for them to reemerge, but by the 1970s and after, there unfolded a different problem. When many of those who visited the camps, and the killing fields of occupied Europe, they saw the buildings and the material traces of the Shoah. But the event was so vast and so hard to grasp that there remained a sense of puzzlement; where do you look in Auschwitz when you try to see the Shoah?

Artists like Anselm Kiefer and architects like Daniel Libeskind reflected a more general tendency to focus less on the faces of the survivors than on the void left by those who did not survive the Shoah. Here again, there were parallels with the destruction of the Armenian world in Anatolia. And yet there was a short-lived Armenian republic, transformed into a Soviet republic by 1923. And further separating the two cases was the emphatic and perverse denial by successive Turkish governments that the genocide had taken place at all.[45]

Clearly there are multiple explanations for the shift within the work of artists and architects from one set of signifiers, focusing on the human face, to another, focusing on ruins and voids. Art has its own rhythms and its own tensions. Clement Greenberg offered an internal explanation for the movement of art toward abstraction in the twentieth century.[46] A sense that the figurative realm had been exhausted did move many artists to experiment with abstraction in the same way that twelve-tone or atonal music emerged with the recognition that it was pointless to try to write Beethoven's Tenth Symphony.

[45] See Chapter 5.

[46] John O'Brian (ed.), *Clement Greenberg: The collected essays and criticism* (5 vols.; University of Chicago Press, 1986–93).

In this chapter, I have tried to establish three claims. My first claim is essentially a simple one: As war changed, so did artistic configurations of terror and the victims of terror in wartime. The second point is more formal in character. When we move from the Great War to the interwar years, and then to the Second World War and beyond, we can see that the partial occlusion of the human face is one of the most striking features of changing Western representations of war and terror. There are major exceptions, but on balance, the move I have tried to document here is one turning away from a naturalistic or expressionistic representation of the human face and figure in a number of important artistic meditations on war and terror.

I have acknowledged that this turn is not uniform or universal. In the history of the Vietnam War, there are many iconic images of a figurative kind, especially in photography or documentary film. These are not the same as installation art or painting of the kind done by Kiefer and Richter, but their presence needs to be acknowledged. And in recent years, as I have already noted, Kiefer has added bodies to his installation art, for instance as cadavers under the weight of the pyramid.[47] In the span of an artist as fertile as Kiefer, no one approach or interpretation will do.

My third claim is more speculative. It is not only abstraction which frames this shift; it is also a change in the stance of artists on how to represent the victims of terror. From the 1970s on, the voices as well as the faces of the victims became central to their representation. This was both due to the judicialization of memory and to the appearance of forms of cheap and reliable technology enabling the capturing and preservation of both the voice and the face of the witness. We may not be able "to see" the Shoah, but we can hear the stories of those who saw it from within.

Thus we come full circle. The construction of dozens of Holocaust archives, starting with the first in 1982 at my university, Yale, has made a difference in the human cartography of terror. The face of suffering in times of terror, to a degree, has faded from artistic representations in the century since 1914. But in recent times, the voices recording terror, and where possible the faces of the men and women who recall it decades later, have been preserved. These voices penetrate the void, people it, and give us some elements of the story and

[47] Bouhours, *Anselm Kiefer*, pp. 120, 213 and *passim*.

some ways to tell it. Perhaps we can hear what we cannot see; perhaps spoken words or voices convey images unavailable to us in other ways.

I want to close by emphasizing again the incomplete and tentative nature of this framework of analysis. So much is left out. One element in particular requires separate treatment. Why have I not, critics have asked, incorporated material on the spiritualization of art, and the return to sacred forms in the Second World War, in particular in the work of Henry Moore in Britain? Fair enough; this subject tends to reinforce my view that the Second World War was a moment of crisis, when older modes of representation flared up, as Benjamin put it, just before their disappearance in a secularized culture.

Why have I not, other critics ask, incorporated the very substantial figurative work done by Shoah survivors themselves, whose art is full of the faces of those who went through the catastrophe? Fair enough as well; but here, too, there is a problem which needs to be elaborated further.

The art created by survivors is moving and enduring testimony to the astonishing tenacity of men and women to cling on to their dignity and their vision of humanity even or especially at a moment when humanity was obliterated. Their work must be included in any account of this subject. The problem arises from the fact that a substantial part of the population murdered in the Shoah were Jews from the great centers of Jewish life in Poland and Eastern Europe. Their sense of time was mythical rather than historical, and many of them completely rejected as blasphemy images of the human face or form. These were created in the image of God and therefore were not for us to conjure up as documentation, nostalgia or entertainment. It is no accident that great artists – Chagall or Zadkine, for instance – emerged from this world, but the key point is that they rejected it. To use the art of Shoah survivors (or any art) to "speak for" the victims is deeply problematic in many ways. Legends, not images, captured the mentality of much of the Jewish world of the cities and towns of Eastern Europe which vanished in the Shoah, though here too the sheer diversity of Jewish life swept away in the 1940s precludes any single approach to characterize it.

In short, the choices I have made in this chapter are in no sense arbitrary. In all memory cultures, many forms of art coexist, and the artists who created them started from many different perspectives. As we shall see in the discussion of war poetry in Chapter 4, though, dissemination and reception matter in the study of cultural history.

The works of Dix, Picasso, and Kiefer have circulated very widely. Indeed, a number of them have reached iconic status in our memory cultures. Their works have come to arrest our collective attention, in a transnational arena, through their appearance in exhibitions, reproductions, scholarly works, and commemorative sites and events relating to the horrors of war and genocide in the twentieth century and beyond.[48]

Let me return finally to a set of images which capture my interpretation about change over time. They are two works of art: one painted by Paul Klee in 1919; a second sculpted by Anselm Kiefer nearly a century later. The first is entitled *Angelus Novus*, and was given by Klee to Walter Benjamin, who, reflecting on it, wrote his celebrated ninth thesis on the philosophy of history. Here is the angel of history, unable even to close his wings, facing the catastrophe of "progress," the detritus of which rises to the sky. He cannot stem the tide; he is no guardian angel, and cannot protect us. All he can do is look and bear witness.

Klee's angel of 1919 had a face; Kiefer's *Sprache der Vögel* or *Language of the Birds*, of 1989 and 2012 is faceless. Kiefer's winged creature is decapitated, with burnt books as its body. There are evident continuities between these two works. Seeing his *Sprache der Vögel*, or his *Breaking of the Vessels*, is to witness a silent dialogue between Kiefer and Klee. Klee's painting emerged in the immediate aftermath of the First World War. Kiefer's installation is a meditation on the warning Klee left us a century ago: in the century of total war, the angel of history is powerless.

Kiefer's art captures elements of the degeneration of warfare in the twentieth century and beyond. Who can miss his references to Heine's warning that first they burn books and then they burn people? And he uses Jewish legend, in part to acknowledge what the Nazis destroyed and in part to follow Klee's lead into a world where legends fade away. Kiefer's art of the destroyed book recalls the story of Hanina ben Teradion, burned at the stake by the Romans for teaching the Torah. When asked by his students, what do you see, Rebbi?, he answered, "the parchment is burning, but the letters are taking wing."[49] The redemptive thrust of this legend now, after a century of war and genocide, is well out of our reach, but its echoes are still

[48] I am grateful to Astrid Erll's comments on this point.

[49] André Schwarzbard, *The last of the just* (New York: Alfred A. Knopf, 1963), p. 253.

audible.[50] Ruins without redemption: here is one of the many faces of war a century after 1914.

The boundaries between the arts representing war over the past century are very porous, in particular those separating painting from photography. There are certain facets of the history of photography, though, in the context of war, which require separate attention. It is to this subject we now turn.

[50] Anselm Kiefer, *L'art surivra à ses ruines* (Paris: Collège de France–Fayard, 2011). On Kiefer's approach to the art of the book, see Marie Minnseux-Chamonar (ed.), *Anselm Kiefer. L'alchimie de livre* (Paris: BNF–Éditions du Regard, 2015).

2 PHOTOGRAPHING WAR: SOLDIERS' PHOTOGRAPHS AND THE REVOLUTION IN VIOLENCE SINCE 1914

Photographing war is an enduring phenomenon; cameras have followed armies ever since the first photographs were developed in 1839. In this respect, photography is simply another technology for capturing the face of war. It has its own rules and technical limitations, but it is no different from other media. Together, writing, figuring, filming, and photographing war are all signifying practices through which we have tried to make sense of those forms of collective violence we call war.

In the mid nineteenth century, there were two forms in which images of soldiers and battlefields emerged: daguerreotypes and stereoscopic images. The latter introduced the illusion of depth, and created what might be termed roughly three-dimensional images.[1] Less than a decade following the birth of photography in 1839, there were photographs of the Mexican-American war.[2] The Crimean War and the French-Austrian conflict of 1859 were photographed, as was, extensively, the American Civil War.

Matthew Brady was one of the first war photographers. He dedicated his private fortune to creating a visual archive of the War between the States. He was at Bull Run in 1861, at Fredericksburg in

[1] On stereotypes, see Oliver Wendell Holmes, "The stereoscope and the stereograph," *The Atlantic*, June 1, 1859, www.theatlantic.com/magazine/archive/1859/06/the-stereoscope-and-the-stereograph/303361/. I am grateful to Alan Trachtenberg for his thoughts on this subject.

[2] Mary Warner Marien, *Photography: A cultural history* (2nd edn.; Upper Saddle River, NJ: Pearson/Prentice Hall, 2006), pp. 46–47.

1862, at Gettysburg just after the battle in 1863, and at Petersburg in 1864. One admirer said: "He is to the campaign of the Republic what Vandermeulen was to the wars of Louis XIV. His pictures, though perhaps not as lasting as the battle pieces on the pyramids, will not the less immortalize those introduced in them."[3] And like others whose aim is to immortalize, Brady was not averse to arranging bodies into what might be taken to be more picturesque poses.[4]

To immortalize those no longer living: that was the photographers' aim in the long term. But in the short term, photography was a meditation on death and on the dead. Oliver Wendell Holmes rushed to the battlefield of Antietam to search for his wounded son. What he saw there was not war but the wreckage it left in its wake. As he wrote in the *Atlantic Monthly* in 1863:

> Let him who wishes to know what war is look at this series of illustrations. These wrecks of manhood thrown together in careless heaps or ranged in ghastly rows for burial were alive but yesterday. How dear to their little circles far away most of them! How little cared for here by the tired party whose office it is to consign them to earth! ... It was so nearly like visiting the battlefield to look over these views, that all the emotions excited by the actual sight of the stained and sordid scene, strewn with rags and wrecks, came back to us, and we buried them in the recesses of our cabinet as we would have buried the mutilated remains of the dead they too vividly represented.[5]

War photography, then, started as a meditation on death and has never left that preoccupation behind. But the nineteenth-century pioneers were hampered by the technology of the day. Action was beyond them, and given the complexity of arranging an image and exposing film, war photography became something almost hieratic, fixed in set poses, like the Egyptian kings.

Then came the Kodak revolution. Instead of encumbering photographers with tripods and cases and the impedimenta of the trade, the Eastman Kodak company provided at a modest price Kodak pocket

[3] Robert Taft, *Photography and the American scene: A social history 1839–1889* (New York: Macmillan, 1942), p. 228, citation from *Humphries' Journal*.

[4] Thanks are due to Martin Jay for comments on this and other points.

[5] Taft, *Photography*, pp. 235–36.

cameras, just in time for the First World War. A war which was fought on the principles of mass production was now captured by an instrument of mass consumption. The Vest Pocket Kodak camera initially sold at $1 a shot in the United States at best, and at £1 10 shillings in the United Kingdom.[6] In 1915 the more expensive Autographic camera, enabling you to identify particular shots, was introduced. For a modest price, including the cost of the development of a sequential roll of negatives into positives, virtually anyone could take and keep snapshots of war. In addition, one Vest Pocket Kodak per squad or platoon could serve a dozen soldiers. It is no exaggeration to claim that millions of soldiers made use of this light consumer-durable good (and products like it) in the Great War.

This chapter follows the consequences of this revolution in the technology of photography. First it shows how censorship became either a very leaky vessel or simply impossible in the face of the appearance of millions of cameras and cameramen on the battlefields of the First World War. Secondly, it shows how the democratization of photography renders incomplete and at times misleading the existing history of war photography as a reflection of three and only three populations: official photographers producing propaganda; commercial photographers producing marketable products; and what may be termed "avant-garde" photographers, looking at photographic images as works of art. There is a fourth dimension to the story of war photography. I call this missing link "soldiers' photography" to include the millions of pictures taken by soldiers in uniform not for profit or for propaganda but simply to record their experience of soldierly life – with whom they served, where they were, what they saw, and some of what they did during the Great War.

These distinctions should not be drawn too sharply. In France, some soldiers cashed in on their amateur photos and sold them to magazines at very good prices, even though they may have been taken

[6] Colin Harding, "The Vest Pocket Kodak was the soldier's camera," http://blog.nationalmediamuseum.org.uk/the-vest-pocket-kodak-was-the-soldiers-camera. This text accompanied a BBC television program on March 13, 2014. Compare the price for the simple Vest Pocket Kodak camera listed in the *British Journal Photographic Almanac*, cited by Harding, with the much higher prices of the Vest Pocket Autographic Kodak camera, cited by Joëlle Beurier, in her pioneering book, *Photographier la Grande Guerre. France–Allemagne: L'Héroïsme et la violence dans les magazines* (Presses Universitaires de Rennes, 2016), p. 65. Her source is the catalog of Paris dealer Photo-Plait of 1916, citing a price of 50 francs for a vest pocket camera. That is equivalent to 150 euros today, or roughly $175.00. Almost certainly the French price was for a much more elaborate camera than the original vest pocket camera.

simply to gratify the soldier photographer and his comrades. The French weekly *Le Miroir*, whose circulation reached between 500,000 and 1,000,000 readers during the war, announced on its cover of August 9, 1914 that it "would pay whatever price it took to obtain particularly interesting photographic documents relative to the war."[7] There is in the French case (though not in the German or British cases) a slippery slope linking soldiers' private photos and the images reproduced in illustrated magazines. While acknowledging the French exception, we can still claim that millions of soldiers' private photos, not earmarked for sale, placed in family albums or boxes, form a largely unexplored visual archive of what soldiers saw of war and what they tried to capture of their war experience through photography.

In addition, many of these soldier photographers were either officers or noncommissioned officers. This is the source of a contradiction, or more likely, of a double standard. These men took their own photos but were supposed to constrain other soldiers from doing so. When the erstwhile censor of unauthorized photography turned into a photographer himself, the impossibility of controlling war photography became apparent.[8]

I focus below on four kinds of photographs soldiers took in the war: images of the dead, images of the dying, images of civilians fleeing from the carnage of war, and images of the landscape of war. The first two bodies of evidence in particular tell us much, as Oliver Wendell Holmes suggested, about the carnage of war.

I have already referred to the transformation in the nature of war in the 1914–18 conflict. First, the second industrial revolution in metallurgy, chemistry, and light engineering created the means to fashion and deploy guns and shells in dimensions the world had never seen. The result was the destruction of millions of men by artillery, literally to nothing. Fully half of the 10 million men who died in the war have no known graves. Artillery reduced makeshift battlefield cemeteries to dust, and made the possibility of identifying the bodies of those who died in the war infinitely difficult.[9]

[7] Beurier, *Photographier la Grande Guerre*, citation on p. 84; on circulation, p. 17.

[8] Thanks are due to Benjamin Gilles and Joëlle Beurier for their thoughts on this subject.

[9] Jay Winter, "Vermisste Söhne. Der Krieg als Akt des Auschlöschung," in Uwe M. Schneede (ed.), *1914. Die Avantgarden im Kampf* (Cologne: Snoeck, 2013), pp. 326–31.

 The second facet of the revolution in violence was the obliteration in practice of the distinction between military and civilian targets in wartime. Articles 25–28 on the Law and Customs of War on Land of the Annex to the Hague Convention of 1899 specifically grant protection to civilians from military targeting, and state clearly that "The attack or bombardment of towns, villages, habitations or buildings which are not defended, is prohibited."[10] The 1907 Hague Convention reiterated these protections, but they had virtually no force when confronted by the initial German invasion of Belgium in August 1914.[11] German commanders were well aware of the extent to which their troops violated these standards, but saw military necessity as trumping international law. German atrocities in this campaign were no myth, and they stood as the first of a very long list of abuse of civilians not only on territory occupied by an invading army but by armies maltreating their own citizens in 1914–15 in Eastern and central Europe as well as in Ottoman Turkey.[12] This chapter follows the way soldiers themselves, either without command authorization or against orders, registered visually through photographs and occasionally through amateur film both of these radical developments in the arts of war between 1914 and 1918.[13]

Photographing the New Face of War

After 1914, a difference in degree became a difference in kind. Immediately after the onset of hostilities, 1 million men in uniform lost their lives in four months of combat. After the invasion of Belgium, 1 million civilians fled their native land to safety abroad. Perhaps

[10] http://avalon.law.yale.edu/19th_century/hague02.asp

[11] Isabel V. Hull, *A scrap of paper. Breaking and making of international law during the Great War* (Ithaca, NY: Cornell University Press, 2014).

[12] John Horne and Alan Kramer, *German atrocities, 1914: A history of denial* (New Haven, Conn.: Yale University Press, 2001). On Austrian atrocities, see Hannes Leidinger et al., *Habsburgs schmutziger Krieg – Ermittlungen zur österreichisch-ungarischen Kriegsführung 1914–1918* (St. Pölten/Salzburg/Vienna: Residenz Verlag, 2014). Thanks are due to Petra Ernst for drawing this work to my attention, and for her generous comments.

[13] On the issue of soldiers bearing witness, see Robin Wagner-Pacifici, "Witness to surrender," in John R. Hall, Blake Stimson, and Lisa Tamiris Becker (eds.), *Visual worlds* (London: Routledge, 2005).

500,000 fled combat in Galicia and Bukovina. In 1915, more than 1 million Armenians lost their homes and their lives after being forced into the Mesopotamian desert. Whatever the threshold is converting an experience from being worse to being different, these events passed it. Thinking in very large numbers, numbers which beggar the imagination, became a necessary way of thinking about war.

To some extent, photographs of the destruction caused by the Russo-Japanese war and the two Balkan wars in the international press had broken the taboo, where it existed, against showing the terrifying power of industrialized killing. But what pre-1914 wars lacked was an alternative archive of soldiers' photos of war, and that is precisely what mass mobilization in 1914 triggered.

Outside of the many sanitized state-sanctioned "official" visual archive, or that of most of the commercial and illustrated press, from 1914 on, there existed a set of photographic images which showed facets of these two revolutionary features of the conflict.[14] Officialdom tried to keep the lid on both these developments, and most official and commercial photographers toed the party line. The images I want to show were taken by amateurs, those not in the business of photography, and therefore not under the thumb of military and civilian propagandists.

These distinctions should not be drawn too sharply. Many amateurs earned money by responding to the offer published in popular magazines of cash for interesting photos, and particularly in the French case from early on in the war, illustrated magazines presented images of dead bodies of soldiers and civilians alike. But as Joëlle Beurier has shown, the French case is exceptional, in that the circulation of explicit photographs of dead French soldiers, alongside snapshots of the conditions the *poilus* were forced to endure, was evident. The aim was to solidify the bond between the front and the rear, a vital matter in France, since the war was fought on French soil from the beginning of the war until the Armistice.[15] The captions to such images in the illustrated press exhorted the population to honor and support come what may those who faced such horrors and stood defiant in the defense of their country. The German and the British illustrated press were more restrained, the first through official censorship, the second through self-censorship, in

[14] Annette Becker has recently drawn attention to this phenomenon in her wide-ranging study, *Voir la Grande Guerre. Un autre récit* (Paris: Armand Colin, 2014), ch. 1.

[15] Beurier, *Photographier la Grande Guerre*.

which the press aimed to do nothing to undermine voluntary recruitment in the first half of the war or conscription from 1916 on.

Beurier's research has established further that French soldiers' private photo albums describe all kinds of humdrum events, the stuff of life behind the lines, precisely because they point to the monumental effort these men made to retain their humanity under inhuman conditions and with a full sense of the precariousness of their lives.[16] In this respect, French soldiers were like the other 60 million men who served in the Great War. They were in a foreign world no one had ever seen before, and found in camaraderie an essential lifeline linking them to the world they had left behind. Many such photos show men doing trivial things in a nontrivial world, smiling or even laughing in the belly of the whale. Like Jonah, their chances of survival were beyond them. Beurier notes one taboo in their visual landscape. They didn't show men in physical or psychological pain. The hardship and suffering they knew viscerally were implicit in these images; every photographer was well aware that he was indirectly "regarding the pain of others," in Susan Sontag's phrase.[17] Most soldiers recognized limits to what they could or should photograph.

The collections Beurier has examined in French archives are simply the tip of the iceberg. There are thousands of collections which have recently come to light in the Grande Collecte in France, or appeal from public institutions to families, asking them to donate their private holdings of photos and other objects to archives.[18] Similar appeals have yielded a rich harvest all over the world. In this chapter, we see in four very different cases, based on individual photographic and filmic archives, what soldiers' photography revealed about the revolution in warfare.

1914: The Pocket Camera Arrives

From the early days of the First World War, the Eastman Kodak company (followed by others) made cheap vest pocket cameras available to millions

[16] Joëlle Beurier, *14–18 Insolite: Album-photos des soldats au repos* (Paris: Nouveau Monde Éditions et Ministère de la Défense, 2014), pp. 237–39.

[17] Susan Sontag, *Regarding the pain of others* (New York: Picador, 2003).

[18] http://centenaire.org/fr/la-grande-collecte. See also, "La Grande Collecte," *Chroniques*, 70 (April–June 2014), Chronique de la Bibliothèque nationale de France, p. 28.

of soldiers (Illus. 2.1). In the United States, the standard Kodak O model sold for $1 in 1917, and simply could not be kept out of the hands and the vest pockets of men who wanted to capture this extraordinary moment in their lives. Some soldiers came to photography for the first time during the war; others, perhaps better-off city dwellers, had tried their hands at it before 1914. But what lay behind the widespread cult of photography in wartime was the twofold effects of travel to distant and sometimes to exotic places, and the sheer scale of devastation, damage, and death which filled these sites with unusual, bizarre, or even spectacular images. Dark tourism took off in the Great War and has been with us ever since.

Family scrapbooks of all kinds are filled with such photos, frustrating the common effort among military authorities to censor what soldiers photographed or, as in the Canadian army, to forbid soldiers from having cameras in their kit.[19] It didn't work, since one illicit pocket camera could be used by many. This meant that there were two sources of photography during the war: those provided by official war photographers and cameramen, dominating the commercial market, and those captured by soldiers or others on their own.[20]

Except in France, official photographers controlled most of the market for images in newspapers and magazines, though occasionally, as we have already noted, editors would ask ordinary soldiers to send in their own photos. Most official photos were authentic, but some were fake. The Australian photographer Frank Hurley created composite photos of attacking Allied forces from shots taken during maneouvres, sold as a real account of combat.[21] Official photographers were supposed to sanitize war, so as not to shock the readers of the newspapers and magazines to which they sold images. Soldiers were under no such compulsion to clean up what they saw through the lens of their pocket cameras.

And yet, there were limits to what any soldiers' photographs show. It would be naive to assume that there are photographs which are truthful and others which lie.[22] There are some images which are

[19] Laura Brandon, "Words and pictures: Writing atrocity into Canada's First World War official photographs," *Journal of Canadian Art History/Annales d'histoire de l'art Canadien*, 31, 2 (2010), pp. 110–26.

[20] On which see Beurier, *Photographier la Grande Guerre*.

[21] Arndt Weinrich, "Visual essay," in Winter, *Cambridge History of the First World War*, vol. II, p. 664 and fig. 24.2.

[22] See Susan Sontag, *On photography* (New York: Farrar, Straus & Giroux, 1977); and Martin Jay, "Can photographs lie? Reflections on a perennial anxiety," unpublished paper (2015). I am grateful to Martin Jay for providing me with a text of this paper.

doctored and pretend to preserve what the photographer did not see. But more importantly, there is the limit of the photographic frame, providing a proscenium arch for action which frequently had no center. Not knowing what is outside the frame is a clear and unavoidable check on certitude in interpreting what photos show. A degree of caution is always a wise strategy to adopt in these treacherous analytical waters.

All photographs must be treated not as true statements of what once was, but as shifting fields of signification.[23] Photos mean different things to people who bring different assumptions to the act of viewing them. I follow Geoffrey Batchen's view that photographs are "dynamic modes of apprehension rather than ... static objects from the past that veridically represent it."[24] Soldier photographers provide us with the evidence we need to begin to understand shifting imaginings of war, rather than to take what the state or the military or the commercial press presented to us as either the unadorned truth or a set of bald-faced lies about war.

It is clear that the corpus of war photography has large and socially sanctioned omissions. Only rarely do photographs, whatever the source, show either dismembered bodies or photos of men dying. There was (and is) a kind of moral censorship which operates on the assumption that there are limits to what should be shown of the human body *in extremis*. My claim is that these grounds for turning away from some images are not legislated but generated by different groups over time. Photographic self-censorship of various kinds is the outcome, operating among ordinary soldiers in the First World War as in later conflicts.

That is precisely what makes photographs which break these rules so important. They show that cheap technology ended state control of what images both soldiers and civilians could produce and access about war. Yes, there were visual clichés about heroism and the glory of war alongside verbal and filmic ones, but there was another register entirely, which brought out, at times unintentionally, the new face of industrialized warfare, and thereby left a significant legacy to subsequent generations. Showing the ugliness of war is one way to salute the fortitude and determination of the men who endured it.

[23] Jay, "Can photographs lie?"

[24] Geoffrey Batchen, "Seeing and saying: A response to 'incongruous images,'" *History and Theory, Theme issue*, 48 (December 2009), pp. 26–33.

Cadavers

Sergeant Albert Gal-Ladevèze served in the French 268th Infantry Regiment at Le-Bois-le Prêtre sector in Meurthe-et-Moselle in 1915.[25] He was then 32 years old. A year later he was seconded to the Air Force and was killed in a training accident on May 18, 1916. During his service with the infantry, he was among the few soldiers who had access to a film camera. He used it for many purposes, but one was to show the way the French army stacked its corpses for removal from the front to burial in provisional gravesites (Illus. 2.2). It was only after the end of the war that formal cemeteries, with one cross and one grave for each soldier, were built. Before then, the army did the best it could to gather the bodies of the dead and to prepare them for proper burial in designated cemeteries, fit for the families of the dead to visit. There is no evidence that this film was ever shown at the time. What is astonishing is that it was ever made.

To the best of my knowledge, there is no other film of the time preserved in archives showing the stacking of corpses like firewood in the aftermath of battle.[26] The army had little choice but to proceed in this manner, since decomposing corpses posed sanitary dangers of which everyone was aware. Still, Gal-Ladevèze's filmic and accompanying still visual imagery of industrial warfare and of industrialized armies dealing with the "waste" products of industrial warfare is shocking. Armies frequently used the term "wastage" to refer to casualties, but that euphemism turns into something entirely different when we see that the term refers to dead men, who were evidently alive not long before.

French film historian Laurent Veray confirms that this film is unique. "This relatively long sequence shows what mass death looks like, and is unlike anything shown at the time."[27] It is improbable that Gal-Ladevèze was ordered to take this film for official purposes; more

[25] BDIC, PH ALB 081 (7). I am grateful to Benjamin Gilles for his help on this and other matters.
[26] *Après les combats de Bois-le-Prêtre*. The film can be seen on the website of the French Mission Centenaire 14–18, http://centenaire.org/fr/video-darchive/apres-les-combats-de-bois-le-pretre.
[27] Laurent Veray, cited in "Un film montrant la mort de masse pendant la Grande Guerre, exhumé un siècle après," *Le Monde*, January 23, 2014, Propos recueillis par Antoine Flandrin. www.lemonde.fr/societe/article/2014/01/23/un-film-montrant-la-mort-de-masse-pendant-la-grande-guerre-exhume-un-siecle-apres_4353424_3224.html#bi6tg3pFdwlyCyWU.99

likely, he was filming on his own initiative, capturing daily life among the soldiers of his unit, and took the opportunity to show what happened after combat. This explanation is reinforced by the fact that he took many still photographs, both of images of the destruction of the landscape and of single corpses in existing trenches, alongside those of soldiers – some drunk – in various places in the trenches. The personal, unofficial nature of this set of photos is reinforced by some of the captions. Consider Illustration 2.3, boasting that "mine is bigger than his," using shells to make a time-honored adolescent joke. It is possible that an official army cinematic unit was passing by, and Gal-Ladevèze simply picked up their camera, but that is unlikely. The link between the film and the still photos suggests that he was engaged in his own effort to capture what saw at Bois-le-Prêtre.

The still photographs of corpse removal capture the mechanics of the gathering, identification where possible of intact bodies, followed by remains being loaded, bound in what appear to be tents, to hold bodies which were probably not in one piece. What follows are images of men loading more remains, their securing the wagons, before the mortuary vehicle goes on its way.

From film to still photos to caption involves multiple perspectives on these scenes. We are watching Gal-Ladevèze watching his comrades engaged in transporting soldiers' corpses towards burial sites. The photographer's captions help us grasp what sense he made of what he saw. This is individual notation, not for the army, but for buddies, families, later observers, and for himself.[28]

What to do with the bodies was, of course, a concern of all armies during the war, and had been a major question in the American Civil War as well.[29] It is not the logistics of removing the dead from the field of battle which is striking here; it is the treatment of dead soldiers like the effluent from a vast factory of death. What we see is a microcosm of that immense killing machine early in the war. From 1916 on, the temporary grave sites behind the lines in which these men's remains were placed were likely to have been blown to pieces, making the later identification and reburial of the dead very difficult, if not impossible.

[28] Thanks are due to Petra Ernst for useful comments on this point.

[29] Drew Gilpin Faust, *This republic of suffering: Death and the American Civil War* (New York: Alfred A. Knopf, 2008).

Sergeant Albert Gal-Ladevèze captured the beginning of the process in which half of those who died in the Great War simply vanished.[30] He also, through breaking the rules about showing anyone what happened to the "glorious dead" after they "fell" in combat, made mass death visible.

Anyone who thinks that the Nazis created the first stacks of corpses piled up like matchsticks and later photographed by camp liberators should attend to these photos and this unscripted film, taken by a common soldier who vanished in the course of the Great War. The man making sure that bodies are tidily stacked had his counterparts in later battles and later wars. The assembly line for the removal of human bodies followed the assembly line production of the weapons which killed them.

There were many other photographic records of the treatment of the dying and the dead which escaped the control of the censor. Another instance is also French. It concerns a certain Dr. Beurier, who served with French forces on the isle of Vido near Corfu. He left his photo album, of which he was evidently proud, to the Bibliothèque du documentation internationale contemporaine (BDIC) in Paris.[31] Illustration 2.4 shows the cover of the album, apparently put together after the war for his family.

Most of the images Beurier himself shot, or staged when he was the subject of the photo. We see him being benevolent, throwing coins to children on the island; we see him on horseback, with a rifle, and treating an African patient: all the stuff of war as tourism in exotic locations. But then we enter another realm; that in which Dr. Beurier's training as a physician enabled him to see, to frame, and to photograph the dying and the dead.

The isle of Vido was part of a network of Allied hospitals which treated Serbs and other soldiers who were either wounded or suffering from infectious diseases. The two photographs which are the most striking in Dr. Beurier's photo album probably are those of a Serb soldier in the last moments of his life (Illus. 2.5) and shortly after his death (Illus. 2.6 and 2.7, a close-up of 2.6). That he felt that it was right and proper to photograph this man is in itself worth pondering. There seems to be no medical treatment or care involved, simply the gaze of a man used to seeing the dying become the dead. The second and third

[30] Winter, "Vermisste Söhne," pp. 326–31. [31] BDIC, PH ALB 075 (2), 1916.

photos show the same man (followed by a close-up of his body among the dead), now identified not by name but by the classical reference to Caron's barque, the classical carrier of those en route to the land of the dead.

What do we make of Dr. Beurier's gaze in these photos? It is possible to see him using the form of a photo album of his military service in the Mediterranean to distance himself from the subject of these images. It is also possible to retain a degree of discomfort in his very act of capturing a man in his last living moments. Is this the physician's gaze, looking not at a person but at an object, or rather at a subject about to become an object? Does not the dying man deserve more dignity than to be objectified in this way? The close-up of the dead man, eyes open, ribs exposed, brings me to the view that, in this photograph, we have arrived at a kind of voyeurism, a use of a human body, no longer living, as a visual effect.

This photo can be seen as a violation of what Ariella Azoulay calls "the social contract of photography," the requirement that we recognize the common humanity we share with the person photographed, in this case, in the moment of his death. For Azoulay, sympathy or shame or pity are not enough; the respect of two equals, one photographing and the other being photographed, is what we need.[32] In this photograph included in his family album, did Beurier strip away from this man some of the dignity of the living, even, or perhaps especially, in the act of dying?

There is no simple answer to the question of his intent, but some clues lie in what follows in Beurier's photo album, a collection in which he ordered his wartime memories in later years. Beurier followed the dead man as he joined a substantial number of corpses, transported away from Lido for sanitary reasons. Illustration 2.8 is Beurier's image of the arrival ship, ironically named the *St. Francis of Assisi*, which had come to remove the corpses from Lido. It is unclear if they would be dumped at sea, or treated in some other manner to prevent the spread of infectious diseases.

And yet there is an alternative reading of these images. What if Beurier took the photo and wrote the caption to sacralize the moment of this man's passing? By writing "Caron's barque" and juxtaposing

[32] Ariella Azoulay, *The social contract of photography* (New York: Zone Books, 2008), p. 17.

images of death and the dead body receding from our view, was he not entering the realm of myth, classical as well as Christian? I wonder.

It is possible, too, that Beurier was trying to aestheticize this corpse. He may have seen some reproduction or the original of Géricault's studies of the heads of the guillotined, with their mouths still open, enabling him to frame his photograph in a way which suggested, if only to him, that even in death, the human body was an object of a kind of terrifying fascination. The similarity between his photo of a dead man in Vido and Géricault's 1819 studies for *The Raft of the Medusa* is sufficiently striking to make me wonder if his photograph was intended as a work of art.[33] His handwritten legend "Barque de Caron" places his reading of these images in both the classical and the romantic traditions.

Like Sergeant Gal-Ladevèze, Beurier used photography to present the material realities of mass death as part of his visual memory of his military service. He took it for granted that the presence of the dead among the living was an intrinsic part of war. Not seeing the dead is not seeing the war for what it was: the source of killing on a scale the world had never seen before. Both during and after the war, many soldiers, either intentionally or accidentally, went beyond the military rules of the day, and insured that the censors failed to keep the lid on the official secret that war destroyed human bodies by the millions. It would not do if too much of this kind of photography got back to the home front; hence most official photographers shied away from this reality. Soldiers' photographers went their own way.

Susan Sontag was not the only critic of photography to remind us that to look at these images is always to regard the suffering of others.[34] I wonder if the medical gaze is different because doctors are trained over years to take a healing distance from those they treat? Medical journals of the time show photographs of appalling wounds presented coolly and clinically as essential for the training of those who had the task of healing them. There are films as well which gave doctors-in-training an idea of what they would face when treating men with unusual wounds or conditions like shell shock.[35] When does distance

[33] Nina Athanassoglou-Kallmyer, "Géricault's severed heads and limbs: The politics and aesthetics of the scaffold," *Art Bulletin*, 74, 4 (December 1992), pp. 599–618.

[34] Sontag, *Regarding the pain of others*. See also Susie Linfield, *The cruel radiance. Photography and political violence* (University of Chicago Press, 2010).

[35] Jay Winter, "Shell shock," in Winter, *Cambridge History of the First World War*, vol. III, pp. 310–33.

become disinterest or a numbing of all fellow feeling? This is a question which refers not only to physicians and their photographs, but to all those who took out their Kodak pocket cameras and pointed them in the direction of the dead, the dying, and the wounded.

Another physician on another front told a different story through his personal photographic album. This was a story both of military life and of the refugees who were dislodged from their homes on the Eastern Front. The variety of images in this photographic collection brings into focus the second major catastrophe of the Great War. Not only was it a vast killing machine and vanishing act, but it also generated that emblem of the twentieth century, the home-less and hopeless refugee. By placing civilian victims of war alongside the military, Bernard Bardach, a Viennese physician serving in the Austrian army on the Eastern Front, contributed to a second essential achievement of soldiers' photography, one found in the visual archive of later conflicts as well. The camera of soldiers like Bardach captured the erosion and progressive erasure of the distinction between military and civilian targets in modern war. Civilians were no longer out of place in the photographic record of war; they were not "collateral" but lived at the heart of the story of what war had become. Modern war reduced tens of millions of ordinary people to what the Italian philo-sopher Giorgio Agamben termed "bare life," those without a roof over their heads, without protection, without law, without a future.[36] Bardach's photographs and diaries show us, in a way of which he was unaware, the beginning of the end of an entire world, that of Eastern European Jewry.

Bernard Bardach served in Poland and in Volhynia, now in western Ukraine, on a front which was indeed all quiet for long periods of time. We should not forget that boredom was an essential facet of military life, and for physicians, there were long periods of inaction, followed by intense times of feverish activity. In those *longeurs*, Bardach indulged his flair for painting and for photography.

For his family, he preserved the photos he took and the paint-ings he made in a war scrapbook. It is a remarkable document, with some of the power of Roman Vishniak's elegiac portraits of Polish

[36] Giorgio Agamben, *Homo sacer: Sovereign power and bare life*, trans. Daniel Heller-Roazen (Stanford University Press, 1998). See Anthony Downey, "Zones of indistinc-tion: Giorgio Agamben's "Bare Life" and the politics of aesthetics," *Third Text*, 23, 2 (March 2009), pp. 109–25.

Jewish life in later years on the edge of total destruction.[37] Bardach intended no such thing, and we must try to look at these photos without seeing the photographer's own prefigurations of the Shoah in them.

The best way to understand these images[38] is to see them as anthropological in character. Bardach was a sophisticated and talented man, sent to a very remote and isolated corner of the Eastern Front. He had a great deal of time on his hands, and used that time to record what he saw, including his confrontation with a distinct Jewish population, people who had some surface resemblance to him as Jews, but who were (in his view) at an entirely different level of development and culture.

At roughly the same time, the French Jewish banker Albert Kahn financed a photographic and filmic effort to go to the remote parts of the world to photograph indigenous people before their contact with "the West" transformed them or even made their world disappear.[39] Bardach did something similar, and thereby left a photographic profile of civilian life in disarray, for both Jews and non-Jews alike. Illustration 2.9 reproduces the front page of his album, with a collage of photographs he took of peasants, churches, soldiers, townspeople, and refugees. This was an exotic world, treated both as entirely remote from the photographers', and as a vast space full of local color and character he attempted to capture.

Bardach was an assimilated Jew, but did welcome the chance to observe Yom Kippur, even in Volhynia. Here is his description of the day, October 7, 1916:

> Day of Atonement – Yom Kippur – Due to the invitation of the field chaplain Levi, I already drove to Wladimir Wolynski at 9.30 a.m., by car that the General himself was offering me ... I spent the whole day in Temple in a place of honor next to Levi, with exception of the afternoon break from 2 till 4 ... I returned to the Temple and stayed until 5.30 p.m. whereon I drove back and reached the commando at 7.00 p.m. The car was supplied for me the whole day. I fasted until that point, actually very easy, and I didn't feel hungry at all. The sermon this time was so much better

[37] Marion Wiesel (ed.), *To give them light: The legacy of Roman Vishniac* (New York: Simon & Schuster, 1993).

[38] Available on the Leo Baeck Institute website: see www.lbi.org/digibaeck/results/?term=bardach&qtype=basic&dtype=any&filter=All&paging=25

[39] Paula Amad, *Counter-archive: Film, the everyday, and Albert Kahn's Archives de la Planète* (New York: Columbia University Press, 2010).

> than the one for New Years. The praying itself was sincere and in
> Hebrew. – an excellent cantor – just the company was pretty lowly,
> a bunch of ordinary soldiers and Russian Jews.[40]

Note the snobbery – ordinary German soldiers and Russian Jews were grouped together as "lowly" or of low social status. It is this "low life" and the landscape in which it lived that he documented with his paintbrush and his camera over the following year.

In his photographic scrapbook, we see many facets of life in occupied Volhynia. He presented general images of towns and churches, alongside portraits of individual Jews and their environment. Like many contemporary observers, he thought in terms of social and cultural "types," or representatives of collectives.[41] There is one portrait which we could see in this way, that of the wandering Jew, a symbol of the centrifugal forces of war, and of the vulnerability of civilians during war, impelling this old man God knows where (Illus. 2.10).

Bardach, as a physician, took note of the dangers of unsanitary conditions affecting occupied and occupier alike: he took photos of the tombs of Jewish doctors who died of cholera; Bardach himself was inoculated against it. He insured his colleagues' Jewish identities were honored on their graves. His interest in Jewish life extended to photographing the synagogue in Wladimir Wolinski, where he had prayed on Yom Kippur, and its adjacent Jewish cemetery. A photo of an old Jewish man crossing a street could have been taken anywhere in the east, but the Ukrainian flag of allies of the Austrian and German occupation forces locates it more particularly here in Western Volhynia.

Bardach saw other sides of the war too. He was charged with examining prostitutes – probably Jewish prostitutes – living near his encampment. Their services were used regularly by the men stationed there, and his job was to control the spread of venereal disease. Note the effort of the women to cover their identities from the photographer (Illus. 2.11). Another form of entertainment was the local soldier's cinema (Illus. 2.12), a splendid illustration of global warfare.

Fighting Russian and irregular troops led German soldiers in his sector to burn down houses and destroy villages, to execute criminals –

[40] Sections of Bardach's diary taken from the Leo Baeck Institute website: www.lbi.org
/digibaeck/results/?term=bardach&qtype=basic&dtype=any&filter=All&paging=25
[41] On Jewish typologies of other Jews in Eastern Europe, see Petra Ernst's work on uses of the term "Ostjuden."

in one case, someone who was hanged for defiling corpses (Illus. 2.13) – and to engage in infantry and cavalry operations in the old style. He photographed Austrian soldiers still using lances on horseback in 1917. The mix of the old and the new in the Great War is captured well in Bardach's photograph of a military airplane being towed to its base by horses, which were everywhere on the Eastern Front, and without which the war would have ground to an immediate halt (Illus. 2.14).

There is little indication in Bardach's diary or his photographic collection that he saw the Ostjuden around him as brothers or kindred spirits. They were men from another world, one of extreme poverty, one filled with long columns of Jewish refugees, and one which he would leave to its fate in 1918, when his unit was called home to a very uncertain future.

From his diary, we can see more of Bardach's outlook as a conservative patriot. He was distressed at the breakup of the old empire, and on October 21, 1918 blamed both domestic politicians and Woodrow Wilson for the disaster:

> The long-desired answer of Wilson to our Monarchy finally came and destroyed all of our hopes. Many were of the opinion that Wilson would treat us mercifully in order to turn us away from Germany – all of them were mistaken, the answer exceeds all baseness ever, he is not negotiating with Austria at all just with the Czechoslovakians!!
>
> As a reaction to the imminent collapse of Austria into federal states, Hungary answers with separation from Austria and the foundation of a personal union.
>
> Our people seem to have lost their head. From the bottom of my heart, I wish revenge on these brawlers. Truly everyone should be convinced that our people prefer to live together further in peace and Harmony in a peaceful Austria, but these brawlers and betrayers of the fatherland envision something else.

In this one archive, we find evidence of the cracks in the Austrian war effort, as well as, further east, the outlines of a civilian world unbalanced, in movement, and in crisis. What Bardach saw was a very small part of a human flood, desperately trying to move out of the line of fire, away from the fighting which destroyed homes and people alike. One historian has estimated that in 1917, one in five of all inhabitants of the

western provinces of the Russian empire were on the move.[42] What was happening in Volhynia was happening in Lithuania, in Belarus, in western Russia, in Galicia, the heartland of the old Pale of Settlement. This century-old domain was being dislocated by its roots, a casualty of the centrifugal tendencies of global war. Bernard Bardach's portrait of one Jewish family on the road, stopping in a field near Lublin, for Shaharith, the morning prayer, gives us a glimpse of this unanchored world on the move (Illus. 2.15).

Borrowing from Carl Schmitt,[43] we now see that the Great War was the generalization of a permanent "state of exception," that extended moment when those without weapons (and millions in uniform too) became nothing other than pawns in the biopolitics of total war. Bardach's achievement in creating a photographic record of victimhood in wartime was both unintentional and unavoidable. The region Bardach photographed arrested his attention through its strangeness, its remoteness from his own. But what he left behind for his family and for us was also a record of a change in the destructive power of war for both those in uniform and those who never dreamed of taking up arms.[44] As war changed, so did the photographic record of those whose lives were ruined by it.

These refugees were no longer solely those unfortunates in the path of marauding enemy troops. They were also attacked or forced from their homes by their "own" side.[45] Thanks to Bernard Bardach, we can see their plight. Whatever protection they had had in law or tradition vanished in the years of war which, unfortunately for them, continued well beyond the Armistice of 1918.

German soldiers and medical personnel serving in the Ottoman empire were photographers too. The Jerusalem physician Dr. Tawfiq

[42] Peter Gatrell, "Refugees," in Winter, *Cambridge History of the First World War*, vol. III, ch. 10.

[43] Carl Schmitt, *Political theology. Four chapters on the concept of sovereignty* (1922), trans. G. Schwab (University of Chicago Press, 2005), pp. 5, 10, 12–13; A. Norris, "Sovereignty, exception, and norm," *Journal of Law and Society*, 24, 1 (2007), pp. 31–45; Schmitt, *The concept of the political* (University of Chicago Press, 1927); Richard Wolin, "Carl Schmitt: The conservative revolutionary habitus and the aesthetics of horror," *Political Theory*, 20, 3 (August 1992), pp. 410–35.

[44] Jay Winter, "The Great War and Jewish Memory," in Petra Ernst (ed.), *European Jewish literatures and World War One. Yearbook for European Jewish Literature Studies no. 1* (Berlin: de Gruyter, 2014), pp. 13–40.

[45] Eric Lohr, "The Russian Army and the Jews: Mass deportation, hostages and violence during World War I," *Russian Review* (July 2001), pp. 404–19.

Canaan collected photos taken by German soldiers and included them and their German captions in an album produced during the war. It is unusual in being a hybrid, incorporating Canaan's own photos and those of his German and Turkish colleagues, many of whom were physicians. One recent scholar has noted that the album is part of a much larger photographic archive produced by those who served in the German army on the Palestine front. "Almost every German soldier," Norbert Schwake, custodian of the German war cemetery in Nazareth, writes, "had brought along his camera."[46] Even if this is a slight exaggeration, here is another instance of the widespread use of cameras by soldiers during the war. Most images in the album appear to have been taken in 1917–18.

One other German serving in the Ottoman empire produced images that certainly constituted unofficial photography. This time, it was not a doctor but a male nurse in the German army who wielded the camera, and he did so to provide graphic evidence of the extermination of the Armenian people by the Ottoman Turkish regime allied to Germany.[47]

This is a relatively well-known incident, but the major outlines bear repeating in this context. Armin T. Wegner was one of many German poets and intellectuals who felt a kind of spiritual renewal at the outbreak of war. As soon as they saw the brutal face of war, most sobered up and took their distance from the values they thought they had seen reflected in the first days of the conflict. Wegner took another step, and wound up as a pacifist at the end of the war.

He volunteered for nursing duty in Poland in the winter of 1914, served during the victorious Tannenberg campaign, and received the Iron Cross for his service in caring for the wounded. He was active in producing anti-Russian propaganda, which was not at all a problem for a man with his progressive political views.

Everything changed, though, when in the summer of 1915, he was sent to Ottoman Turkey and served in the German Sanitary Corps, incorporated in the 6th Ottoman Army under the command of General

[46] Norbert Schwake, "The Great War in Palestine: Dr. Tawfiq Canaan's photographic album," *Jerusalem Quarterly*, 56–7 (Winter 2013–Spring 2014), issue on Palestine in World War One, pp. 140–56.

[47] Sybil Milton, "Armin T. Wegner: Polemicist for Armenian and Jewish human rights," *Armenian Review*, 42, 4 (1989), pp. 17–40.

Colmar von der Goltz. Following up rumors he had heard about massacres in Anatolia, he traveled from Constantinople to Baghdad and back again in the second half of 1915 and in 1916, and took photographs surreptitiously of Armenian deportations and the miserable conditions in which the deportees were forced to live and die. He hid his camera under his Arab gown, and collected a substantial number of photos before the Turkish authorities asked the German army to send him home. Hiding the emulsions in his belt, Wegner took many of them back to Berlin. There he wrote an open letter to Woodrow Wilson, published in the *Berliner Tageblatt*, the largest daily in the city, on February 23, 1919, detailing what he had seen and making an urgent plea for American protection of the survivors of what we now term the Armenian genocide.[48] The images and his account of taking them were the subject of a public lecture he gave at the Urania science hall in Berlin in 1919,[49] and of other illustrated lectures, including one in Vienna in 1924, for which we have the full text and illustrations.[50]

The 1924 lecture was a full account of the long and rich history of Armenian life in Anatolia, and of the emergence of Pan-Turkish sentiment in the decade before the First World War. Here is the origin of what we now call genocide. "For Ottoman officials," this ideology "could only signify one thing: the pitiless extermination of everyone who was not a Turk."[51] The outbreak of war provided the conditions enabling the governing elite in Constantinople to carry out this policy.

Wegner understood that this policy had to be handled ruthlessly and without interference from any quarter, German or Turkish. Hence the ruling elite "forbade under penalty of death the taking of

[48] Armin T. Wegner, "Armenien ... Offener Brief an den Präsidenten der Vereinigten Staaten von Amerika, Herrn Woodrow Wilson, über die Austreibung des armenischen Volkes in die Wüste," *Berliner Tageblatt und Handels-Zeitung, Morgen-Ausgabe*, 85, February 23, 1919, 4. For more details on Wegner, see Martin Tamcke, *Armin T. Wegner und die Armenier. Anspruch und Wirklichkeit eines Augenzeugen* (Hamburg: Lit, 1996).

[49] Armin T. Wegner, *Der Weg ohne Heimkehr. Ein Martyrium in Briefen* (Berlin: Fleischel, 1919 and 1920; 2nd edn., Dresden: Sibyllen-Verlag, 1920). See also Wolf Gruner, "'Peregrinations into the void?': German Jews and their knowledge about the Armenian genocide during the Third Reich," *Central European History*, 45 (2012), pp. 1–26.

[50] Armin T. Wegner, *Die Austreibung des armenischen Volkes in die Wüste*, ed. Andreas Meier, with an essay by Wolfgang Gust (Göttingen: Wallstein Verlag, 2011).

[51] Ibid., pp. 24–25.

photographs of the unfolding of the expulsion of the Armenians."
Wegner went on:

> By taking the images that I will show you, I risked a court martial;
> consequently I smuggled them out under my belt among my
> newspapers. I hasten to underline that I did not take all the photos;
> some refer to earlier events going back to 1909, and I have added
> others since many of my pictures have been spoiled in the heat;
> I hope you believe the testimony of an eye witness that these
> additional images do not differ from what I saw, and that I took the
> large majority of the photographs.[52]

Nothing he heard or saw confirmed anything of the Turkish accusation
that the Armenians were deported because substantial numbers of them
were supporting, implicitly or directly, the Russian war effort. Here
Wegner was in line with the Protestant missionary Johannes Lepsius,
who tried in vain to persuade the German government to speak out
against the killings. The only way Wegner could comprehend these
events was by comparing Turkish hatred of the Armenians to the
"mad hostility" of some of our "compatriots" against Jews.[53] In sum,
there was no justification in military or political terms for the "diabo-
lical" plan to exterminate the Armenian people.

 His lecture is a visual presentation of hell. He leads the audience
on a via dolorosa of staggering cruelty, a true "martyrs" way,[54] vividly
documented by his photos. Wegner's purpose is not only to bring the
murder of a people to the attention of German and Austrian audiences;
it was also to accept himself the collective guilt which he felt for being
part of the war machine, while the killing was going on.

 In the 2011 edition of Wegner's Armenian lectures, two scholars
raise doubts as to the documentary authenticity of some of Wegner's
narrative. The literary scholar Andreas Meier traces Wegner's trajectory
through the camps of Maden, Tibini, Abu Herrera, and Rakka. He met
and was guided by two knowledgeable nuns, Anna Jenssen and Beatrice
Rohner at the orphanage of Aleppo. These women gave him letters which
he later took to the American ambassador in Constantinople. All this can
be established. But a number of the accounts in Wegner's 1924 lecture
were more a product of his imagination than his photographs. Meier
shows some of the weaknesses in Wegner's narrative, which he attributes

[52] Ibid., p. 26. [53] Ibid., p. 27. [54] Ibid., p. 86.

to the mind of a poet and not that of an historian. Wegner focused not on the "provenance of the photos" but on "the coherence of the narrative line."[55]

How much does this compromise the standing of Wegner as a self-professed eye witness? Certainly, his passion for the Armenian cause exceeded his ability to present unimpeachable images and narrative accounts of the murder of over 1 million Armenians. Within an account of soldiers' photography, if he had used images taken by civilians and called them his own, then the value of his photographic corpus in this book would have been compromised still further. And yet, it seems likely that he used other German soldiers' images when his faded away in the Anatolian sun. Adopting these photos as his own undermined to a degree his claim to be an eye witness. What he provided was a somewhat compromised, but still unique, archive of what we now know as the first genocide of the twentieth century.[56]

These photographs (Illus. 2.16–2.18) are graphic, to say the least.[57] Their shock value is impossible to miss, though the same issues about whether photography violates the dignity of the dead or the dying are posed here as they were in the case of Dr. Beurier's images of a dying Serb. Wegner's images tell a story with a political purpose missing in Beurier's, but in both cases, the faces of the dead of the Great War reach out to us, despite whatever efforts the authorities took to suppress them. Censorship foundered because there were simply too many cameras around and too many people determined to use them to record their own visual story of their time at war.

Here too, Wegner's captions turn the image from the general to the particular, while incorporating the anger of the onlooker, as Goya did in his captions to his series of etchings on the Disasters of War. And like Goya's unforgettable etchings, we confront the question as to whether exposure to such horrors turns the viewer numb.

[55] Andreas Meier, "Nachwort: Armin T. Wegners Armenienprojekt," in Wegner, *Austreibung*, pp. 157–60. For Meier, on pp. 157–60 of *Die Austreibung*, the images that are certain to be Wegner's are these: 19, 20, 22, 23, 24, 27, 32, 38, 45, 46, 48, 69, 72, 74, 75, 76, 77, 78, 79, 82, 86, 87, 88, 92, and 95. Others need to be treated with caution: 50, 51, 53, 54, 71, 73, 78, 85.

[56] See Hans-Lucas Kieser and Donald Bloxham, "Genocide," in Winter, *Cambridge History of the First World War*, vol. I, pp. 585–614.

[57] To see a fuller range of Wegner's photographs, see: www.armenian-genocide.org /photo_wegner.html

Susan Sontag was of two minds on this question, and I share her ambivalence. In her earlier work on photography, she sensed the tendency of some war images to stimulate voyeurism, and perhaps indifference to the subjects shown. Later, though, she changed her view to assert that whatever the risks, these images must be shown, or war itself would be sanitized.[58] That must be true, though we must retain a kind of vigilance at any signs of indifference whenever examining such visual records of war.

In Wegner's case, his photos were intended to inspire compassion, and continue to do so. He was intensely aware that what he showed were the traces of the aftermath of the suffering and murders which had already occurred. We therefore have no choice but to draw inferences from these terrifying photos as to what happened before. And it is there, not in what the photograph shows but in what it does not show, that the deepest terror may lie.

In later years, Wegner remained a champion of the Armenian cause, and even had the audacity to write to Hitler protesting against his anti-Jewish measures. He was an expressionist poet and a literary witness to mass murder, a man more dedicated to graphic denunciation than to photographic precision.[59]

Denunciation was the explicit aim of another photographic project, one with some similarities (and many dissimilarities) with the four examples examined here. In 1924, the German anarchist and pacifist Ernst Friedrich opened an antiwar museum in Berlin, and published a collection of captioned photographs dedicated to exposing the horrors of the Great War. The museum was closed down by the Nazis in 1933, but Friedrich managed not only to reopen it in exile, but to survive the Second World War. The book is still in print. What distinguishes this set of photographs is its unambiguous political purpose. The filth and detritus of war are highlighted time and again. But unlike our four war photographers, Friedrich never served. He lacked the moral authority of the participant, the man whose photographs showed undeniably that he was there. To a degree, the effect of Friedrich's work is to deaden responses to the cruelties of war. He was no Goya, and by his very

[58] Sontag, *Regarding the pain of others, passim.*

[59] Meier, "Nachwort," pp. 190–91. See also Tessa Hofmann and Gerayer Koutcharian, "'Images that horrify and indict': Pictorial documents on the persecution and extermination of the Armenians from 1877 to 1922," *Armenian Review,* 45, 1–2 (1992), pp. 53–184.

relentlessness, Friedrich tended to undermine the power of his message. Wegner, like Friedrich an expressionist poet, also set out to tell the yet unknowing world about the ugliness of war, in the particular case of the Armenian genocide, but his war service, his presence at the scene of the crime, gave his work a power Friedrich's chamber of horrors never achieved.[60]

War Photography after the Great War

War photography during the Great War was an unstable field, one in which official photographers tried to sanitize war and unofficial ones went their own way. Many unofficial photographers followed conventional lines too, but not having to answer to a bureaucrat or an editor gave some freethinkers and freelancers a degree of independence rarely available to their professional peers. Their photographs captured the arbitrariness of survival, what Robin Kelsey terms the "arts of chance," disclosing the face of war few statesmen wanted their people to see.[61]

In subsequent years, the same tension remained between the officially sanctioned and the maverick images of war. Commercial photography grew apace, and had a lot of work to do in the interwar years and after. War photographers became celebrities, and some created iconic views of war. There is a vast literature concerning photography and the Holocaust which includes references to amateur photos taken by perpetrators and bystanders.[62] Images of civil wars, surrogate wars, and international "police" operations show similar tendencies to move in many different directions serving different purposes.[63] Controlling photography in civil wars is at least as difficult as it is in conventional military conflicts.

[60] Ernst Friedrich, *War against war!*, with an introduction by Douglas Kellner (Seattle, Ill.: Real Comet Press, 1987); see also Dora Apel, "Cultural battlegrounds: Weimar photographic narratives of war," *New German Critique*, 76 (1999), pp. 49–84.

[61] Robin Kelsey, *Photography and the art of chance* (Cambridge, Mass.: Harvard University Press, 2015). I owe this reference, and much else, to Robert Dare.

[62] A good place to begin is Sybil Milton, "Photography as evidence of the Holocaust," *History of Photography*, 23, 4 (1999), pp. 303–12.

[63] For just two instances, see: Liam Kennedy, "Soldier photography: Visualising the war in Iraq," *Review of International Studies*, 35, 4 (October 2009), pp. 817–33; Patricia Hayes, "Vision and violence: Photographies of war in southern Angola and northern Namibia," *Kronos*, 27, *Visual History* (November 2001), pp. 133–57.

More recently, we have seen indelible evidence of the extent to which in this field, technology matters. Just as the Kodak pocket camera opened up the field for millions of men and women to become photographers, so has digital technology provided opportunities to preserve and to disseminate images of war that could not be controlled by those in authority for long. Witness the uploading of photographs of torture of Iraqi captives by American servicemen in 2003–4. Unofficial photography of the kind which emerged in the First World War marked the beginning of a century-long losing effort on the part of governments to hide elements of war from those whose support they needed and still need to wage them.

In the later twentieth century, when subversive images emerged, they tended to show two facets of war. The first is its destructive, killing power, from the mushroom cloud over Hiroshima to the ruins of Gaza in 2014. The second is the entrapment of civilians wounded and killed in modern war by the millions. The delineation of a social space off-limits to killing in wartime ended in practice if not in law in 1914. What has followed are variations on a theme which the soldier photographers whose work we survey in this chapter had already made their own.

And yet 1914–18 made a real difference. The Great War occasioned a transformation of warfare such that its killing power reached unprecedented levels, including very large civilian populations alongside those in uniform. The Second World War mirrored the same civilianization of war casualties. The Holocaust extended the logic of the Armenian genocide to the killing of all Jews the Nazis could get their hands on. In terms of genocidal ambition, they went a step further than the ruling triumvirate that ordered the genocide in Ottoman Turkey in 1915.

Since the Second World War, wars of decolonization have produced massive death lists as well, in which civilians have been prominent and frequently predominant. Post-1945 warfare has shifted the range of war photography in at least two ways. War photography – official as well as unofficial – has tended to show that the category of victims of war now includes soldiers as well.

Among them are images of mentally damaged soldiers, discussed below in Chapter 7. The category of posttraumatic stress disorder, legitimated as a medical syndrome in 1980 by the American Medical Association, is now widely accepted as a risk all soldiers face when they enter combat zones. The scholarship on their suffering and

their treatment is now very substantial.[64] So is that of their physically damaged brethren. The way such men are treated varies considerably, but mentally damaged veterans are no longer invisible either to other soldiers or to the societies they serve.

The second "new" category of war victims is that of child soldiers.[65] In Asia and in Africa, these children are forced to fight, and to kill, and we have abundant photographic evidence as to what these victims of war look like. The impressment of child soldiers is now a war crime, but it is a practice unlikely to disappear.

These developments have consequences for the way we see war. When the category of war victims includes everyone engaged in it or by accident trapped in its wake, then many of the myths that drew men and women to war begin to fray or even to fall apart completely. Now, in the twenty-first century, in some countries but not in others, war is no longer a political act through which a nation's leaders can lead its nation in order to defend its interests or its honor. War is an invitation to disaster for soldiers and civilians alike.

In 1914, war was not only an option, it was a desirable or at least an acceptable option in the eyes of many who later rued their naive utterances. What changed the minds of many (though not all) of them were the cruelties of war, captured in part by photographers, some of whom showed that the normal face of war was not benign and ennobling, but more likely than not, malignant, cruel, and degrading for civilians and soldiers alike. The implications of that facet of the cultural legacy of the Great War are still to be worked out today.

The *Studium* and the *Punctum*: Frameworks of Meaning

In this chapter, I have tried to expand the corpus of photographs which we use to access the soldiers' world in the 1914–18 conflict by including freelance, uncommercial, unauthorized photography taken by soldiers simply because they had the time, the instrument, and the inclination to go their own way. No one told them what to photograph, or more importantly, what not to photograph.

[64] A good place to start in this literature is *PTSD Research Quarterly*.

[65] For a start, see Leora Kahn (ed.), *Child soldiers* (New York: PowerHouse Books, 2008).

These amateurs shared something important with photographers employed by armies, governments, or news agencies to capture images of war. They all were aware of the tendency of war photographs to capture the mix of the ordinary and the uncanny in the landscape of war. The French critic Roland Barthes offered some important reflections about this facet of the power of photography, though his selection is largely taken from the work of photographers whose market is magazines and newspapers – what I have termed commercial photojournalism.[66] Here is Barthes:

> I was glancing through an illustrated magazine. A photograph made me pause. Nothing very extraordinary: the (photographic) banality of a rebellion in Nicaragua: a ruined street, two helmeted soldiers on patrol; behind them, two nuns. Did this photograph please me? Interest me? Intrigue me? Not even. Simply, it existed (for me). I understood at once that its existence (its "adventure") derived from the copresence of two discontinuous elements, heterogeneous in that they did not belong to the same world (no need to proceed to the point of contrast): the soldiers and the nuns. I foresaw a structural rule (conforming to my own observation), and I immediately tried to verify it by inspecting other photographs by the same reporter (the Dutchman Koen Wessing): many of them attracted me because they included this kind of duality which I had just become aware of.[67]

In elucidating "the co-presence of two discontinuous elements," Barthes suggested a way to understand the oddity of their juxtaposition. The first he termed "the *studium*," or ordinary knowledge, what we might term conventional images about war, or received wisdom. This visual library is what the literary critic Samuel Hynes referred to as our "war in the head."[68] Aside from photos of devastated landscapes, images of war almost always have soldiers in them; they usually carry

[66] On Barthes, see Geoffrey Batchen (ed.), *Photography degree zero: Reflections on Roland Barthes'* Camera Lucida (Cambridge, Mass.: MIT Press, 2009), and Martin Jay, "Photography and the event," in Olga Shevchenko (ed.), *Double exposure: Memory and photography* (New Brunswick, NJ: Transaction Books, 2014), ch. 5.

[67] Roland Barthes, *Camera Lucida*, trans. Richard Howard (London: Flamingo, 1984), p. 23.

[68] Hynes, *Soldiers' tale*, p. 8.

weapons, and most of the time, they operate in groups. Individual portraiture of soldiers is important, but the war in which they fight is always collective. The war photographers try to capture a set of engagements in which one side uses violence to impose its will on another group of men in uniform, until one of the two sides gives up or goes home or both. To be sure, soldier photographers like to portray themselves as Bardach and Beurier did, as artists or administrators. They saw themselves as men who can see the way the world works, even in exotic environments.

These conventional images come out of a field of knowledge commonly and widely shared. Here is how Barthes describes this kind of visual information:

> a field, which I perceive quite familiarly as a consequence of my knowledge, my culture; this field can be more or less stylized, more or less successful, depending on the photographer's skill or luck, but it always refers to a classical body of information: rebellion, Nicaragua, and all the signs of both . . . Thousands of photographs consist of this field, and in these photographs I can, of course, take a kind of general interest . . . What I feel about these photographs derives from an *average* effect, almost from a certain training. I did not know a French word which might account for this kind of human interest, but I believe this word exists in Latin: it is *studium*, which doesn't mean, at least not immediately, "study," but application to a thing, taste for someone, a kind of general, enthusiastic commitment, of course, but without special acuity. It is by *studium* that I am interested in so many photographs, whether I receive them as political testimony or enjoy them as good historical scenes: for it is culturally . . . that I participate in the figures, the faces, the gestures, the settings, the actions.[69]

We all share this kind of photographic library; just try to access Google images and you will see what Barthes had in mind. Most war photographs stop at the *studium*, that is, they provide visual confirmation of what we already know or think we know.

Some pictures, though, go beyond the conventional, and that makes them particularly useful for an understanding of changes in photographic representations of war in the twentieth century.

[69] Barthes, *Camera Lucida*, pp. 25–26.

Photography can probe contradictions, oddities, peculiar geometries produced by other elements which somehow sneak into the field of the *studium* and disrupt it. Due to its violence, war can deform or transform landscapes or things or human forms which we take for granted. Here is how Barthes puts it:

> The second element will break (or punctuate) the *studium*. This time it is not I who seek it out (as I invest the field of the *studium* with my sovereign consciousness), it is this element which rises from the scene, shoots out of it like an arrow, and pierces me. A Latin word exists to designate this wound, this prick, this mark made by a pointed instrument: the word suits me all the better in that it also refers to the notion of punctuation, and because the photographs I am speaking of are in effect punctuated, sometimes even speckled with these sensitive points; precisely, these marks, these wounds, are so many *points*. This second element which will disturb the *studium* I shall therefore call *punctum;* for *punctum* is also: sting, speck, cut, little hole – and also a cast of dice. A photograph's *punctum* is that accident which pricks me (but also bruises me, is poignant to me).[70]

In the particular photograph Barthes has in mind, the punctum is the odd presence of two nuns, walking right across the *studium*, the field of conventional imagery. One of the nuns looks at the soldiers, but does not engage them through eye contact or by words. Heaven knows what they are doing there, but whatever brought them there, their presence stops us in our conventional visual tracks. War is also about nuns walking across a fire zone; it is not only about soldiers on parole. War is about the uncanny juxtaposition of things that don't belong together, the encounter of the banal and the bizarre.

It is true that Barthes' essay is entirely a meditation on death, and on how photography captures what is no longer there. But on another level, I believe that Barthes captured something we have seen in the soldiers' photographs discussed in this chapter, something which illuminates the transformation of war photography, both in its uses and in its reception, in the twentieth century and beyond. The *studium* doesn't stand still; it is a product of countless conversations and controversies concerning war, and it reflects changes in the way war is

[70] Ibid., pp. 26–27.

waged and how it is understood. The social relations of photographic reproduction change over time, such that the balance or contrast between *studium* and *punctum* shifts. My reading of Barthes is consistent with Margaret Olin's critique of his position not as offering truth statements about what was in front of the camera, but about providing what she terms a "performative index" or "index of identification," enabling the viewer to express feelings and to make sense of what she sees.[71] We need what may be termed a dictionary of images to understand war photographs, but that dictionary is subject to change over time. Locating an image within a social context is hardly an objective matter. Once we openly and (I hope) creatively shift Barthes's approach from the domain of objectivity to that of subjectivity, from constituting memory itself to being a "theater of memory," in Walter Benjamin's terms, then we can talk fruitfully about the changing messages photographs provide as well as their composition and their implicit captions. Far from destroying the utility to the historian of Barthes' interpretation of photography, Olin has opened a door to our exploitation of his insights in helping us clarify how the meaning of war photography has changed over time.

From this standpoint, soldiers' photography in the 1914–18 war shows how the *studium* of war – conventional images of soldiers at war – changes when the *punctum* of war – unconventional images of landscapes and victims – changes. Soldiers fighting soldiers is a time-honored framework for war photography; but soldiers fighting or abusing or killing civilians or other innocents is another matter entirely. First, noncombatants constitute the *punctum* of war photography; like the nuns Barthes refers to, they shouldn't be there. Their presence tells us something is awry. War has moved out of the battlefield into the civilian realm; that is what civil war or civil insurrection entails. The refugees in Bardach's photographs were hit by a combination of war, civil war, and old-fashioned pogrom, and the violence they faced did not stop when

[71] Margaret Olin, "Touching photographs: Roland Bathes's 'mistaken' identification," *Representations*, 80 (Fall 2002), p. 114. For further criticisms of Barthes' position, see: Joel Snyder and Neil Walsh Allen, "Photography, vision, and representation," *Critical Inquiry*, 2 (1975), pp. 143–69; William J. Mitchell, *The reconfigured eye: Visual truth in the post-photographic era* (Cambridge, Mass.: MIT Press, 1992); Margaret Iversen, "What is a photograph?" *Art History*, 17 (1994), pp. 450–63; and Ralph Sarkonak, "Roland Barthes and the spectre of photography," *L'esprit createur*, 22 (1982), pp. 56–57.

the Peace Treaties were signed. It went on and on and on. After 1914, civilian refugees have moved from being the *punctum* to being the *studium* of war. The women defecating in a field in Armin Wegner's photograph were the frail survivors of genocide. Sebastian Salgado's terrifying images of genocide and war in Rwanda show other such victims; so does more recent photography of the civil war in Syria.[72] To be sure, there is still today a reluctance among soldiers in many armies to accept that civilians are and will continue to be military targets, but there are too many instances of the extent to which the "exceptional" and "unfortunate" killing of civilians recurs for us to ignore that a change in fact as well as in norms (admitted or not) has indeed occurred.

That is not the only significant change in the balance between *studium* and *punctum* in twentieth-century war photography. By the fourth quarter of the century, soldiers themselves were pictured increasingly as victims, a shift in perspective either partially or entirely subverting the distinction between the *studium* and the *punctum* of war photography. What pierces us now is that soldiers too are victims of war. War is a game in which people bleed and everyone loses. Such was not received wisdom before or during the 1914–18 war, but it has become so in the century which has followed.

One reason for this change is the transformation of what may be termed the social relations of war photography. What we bring to war photography today, the unstated captions we use, are not the same as those commonplace a century ago. This distinction should not be drawn too sharply, but it still remains the case that war photography has changed over time by going beyond the simple distinction between soldiers and civilian victims.

The historical experience of war in different parts of the world accounts for the way this recognition came at different times in different places. The Great War hit both Western and Eastern Europe with unprecedented force. The Spanish Civil War did the same in the Iberian Peninsula twenty years later,[73] as did the Chinese civil war and

[72] See *The Salt of the Earth*, the 2014 film about Sebastian Salgado by Juliano Ribeiro Salgado and Wim Wenders; on Syria, see Paul Salopek, "Fleeing terror, finding refuge," *National Geographic* (March 2015), http://ngm.nationalgeographic.com /2015/03/syrian-refugees/salopek-text

[73] On which see Caroline Brothers, *War and photography: A cultural history* (London: Routledge, 1997).

other conflicts preceding and following the Second World War. At some point, probably during and after the Vietnam War, soldiers joined the category of victims of war in a vast range of war photographs. When this occurred, I argue, the *studium* of war changed fundamentally. Then, our "war in the head" came to include soldiers as victims, and not only as armed actors, and thereby made war itself the source of all the misery such photographs display. I claim that this change is of importance, in that it both reflects and deepens a body of opinion in what we loosely term "the West" prepared to delegitimate war as a political option. This argument is not shared by a majority anywhere in the world, but the fact that it exists at all is a remarkable fact, one I believe reinforced by widely disseminated images of warfare in the twentieth century and after.

The massive circulation of images of civilian abuse in Abu Ghraib prison in Iraq in the early twenty-first century showed what happens when technology outstrips military censorship. Just as in the First World War, no one in authority could stop ordinary soldiers from using cameras for their own purposes. These images, the then Secretary of Defense, Donald Rumsfeld, said were "radioactive." Here we enter the domain of sadism and pornography, remote from the visual world of the four Great War photographers whose images are examined in this chapter. And yet the Kodak revolution of 1914–18 was the prelude to the camcorder generation which fought the Iraq War and which produced the Abu Ghraib images. When cameras become readily available, we can conclude that when there is a will to photograph, soldiers will find a way to do so.[74]

Captions

In conclusion, a word or two about captions are in order. I want to offer you a number of examples of what Jacques Rancière describes as "that speech which holds its tongue,"[75] the tendency of images to have unstated but powerful captions which become legible through social exchange and dissemination. If all images have captions, those which

[74] For a penetrating commentary on these images, see Errol Morris, *Believing is seeing (Observations on the mysteries of photography)* (New York: Penguin, 2011), pp. 75–114.

[75] Jacques Rancière, *The future of the image*, trans. Geoffrey Elliott (London: Verso, 2007), p. 11.

are arrested, challenged, interrupted by *puncta* have captions which matter, since they subvert our tendency to convert them into conventional *studia* images, confirming what we already know or what "people" take for granted. The "obviousness of the visible" which those in power use to naturalize their actions in the *studium*, suddenly turns unnatural when something visible and odd cuts right across it. Then the unsayable becomes both visible and sayable, turning the photograph's unstated but real caption into something disturbing, problematic, even at times transformational.

The four sets of First World War soldiers' photographs I present in this chapter help us understand this slow but steady transformation of what we "know" about war. Sergeant Albert Gal-Ladevèze, Doctors Beurier and Bardach, and Armin T. Wegner had only one thing in common: they were captivated by the camera and used it to show us something they found arresting about war. Wegner had a political objective – to document an atrocity committed by Germany's ally Ottoman Turkey – but the other three appear to have been unencumbered by military or commercial constraints; that is part of their essential interest to us today. I do not know if Gal-Ladevèze knew he was breaking the rules; Wegner certainly was aware he was doing so. But all four make us aware that the war in which they were engaged had created images of many different kinds – the conventional, the uncanny, the shocking, even the beautiful. Both Beurier and Bardach wrote captions, but these were probably afterthoughts, ways of introducing their families to the albums they produced, by suggesting an order of time and place, a kind of coherent narrative about the photographer's past. Their own captions are either too brief or too descriptive to capture the way the bizarre, the unexpected, the contradictory, creep into these photographs. They show that after 1914, war became something, to say the least, beyond contemporary expectations. That violent leap into the beyond is what we see in soldiers' photography, that vast archive we only have just begun to explore.[76]

[76] We have already cited the pioneering work of Joëlle Beurier on French soldiers' photo albums. Jane Carmichael, the noted historian of photography, has also drawn attention to private photos in the collection of the Imperial War Museum. Some of these photographs were taken by women. See Jane Carmichael, *First World War photographers* (London: Routledge, 1989).

3 FILMING WAR

The leitmotif of this book is the following claim: language frames memory. What most of us know of war is always mediated knowledge, shaped and refracted by the stories we are told. Film is one such story-teller, an exceptionally powerful one, reaching a public much larger than that comprising readers of memoirs, fiction, poetry, and viewers of the visual arts. This chapter focuses on the mediation of nondocumentary, commercial film in the formation and dissemination of popular representations of war.

Doing so enables us to see that imagining war has a history, in film as in the other visual arts, parallel to but not identical to that of waging war. The arts of the imagination reflect changes in the material conditions and forms of warfare, and thereby contribute to the evolution of armed conflict, by framing the ways contemporaries understand what war is. In the twenty-first century, the complexities of counterinsurgency warfare are both material and perceptual. Frameworks of thinking about war are not constructed out of documents alone; images matter. Policy makers always bring to the table what historian James Joll termed the "unspoken assumptions" of their generation, and many of them arise from images of war in photography, in the visual arts, and especially in film.

Film itself has developed dramatically over time, but some elements remain constant. In cinematic history, we must attend to the marketplace at all times. The portrayal of military conflict in film is a mainstay of the industry. Box office considerations are never absent in the framing and gestation of commercial film, and the perennial

popularity of films about combat – terrestrial or extraterrestrial – requires us to take measure of their power to represent war and men at war.

It was an accident that the film industry came of age as a centerpiece of mass entertainment at precisely the moment industrialized warfare arrived in 1914. That first global war helped globalize the film industry, which saw exponential growth in particular in American film marketing at the same time as the U.S. position in the war remained neutral.[1] It is impossible, however, to treat film in strictly national terms because the upheavals of the 1930s produced a massive hemorrhage of talent from Germany to Britain and elsewhere, and from continental Europe to London and Hollywood, among other destinations. European filmmakers such as Fritz Lang, Ernst Lubitsch, and Billy Wilder brought their art with them, and braided it together with American approaches to the medium. I examine representations of war from a transnational perspective, while recognizing the significance of national institutions and codes, many of which are explicitly political in character.

Phases of War Film History

In this effort, we may speak of roughly three periods in the cinematic history of war. The first is the silent epoch, from about 1900 to 1930. I extend this first period beyond 1926, when sound was initially introduced, because many directors schooled in silent film imported silence into the talkies. They framed sound by its absence, and did so in dramatically important ways. Consider the famous scene in Fritz Lang's classic film *M* (1931), in which a child murderer, played by Peter Lorre, faces a kangaroo court made up of hundreds of Berlin criminals. The faces of those criminals are scanned in a 45-second soundless tracking shot that seems to last for hours. Silence did not disappear with the talkies; it entered into and inflected the medium in a host of ways, even years after the introduction of sound.

We frequently lose sight of the artistic and affective power of silence. Suggestion is more hypnotic than instruction. I have already cited Alistair Cooke's response to the question as to why he preferred to

[1] Jay M. Winter, *The experience of World War I* (London: Macmillan, 1988), p. 238.

work in radio. His answer bears repetition. It was that in radio the pictures are better. And silent film arguably delivered better sound, by drawing on viewers' pulse and heartbeat and internal voices. It is best to treat silent film not as a simple precursor of the talkies, but as a powerful art form in its own right, one that launched the cinematic history of war.[2] Recently, we have been reminded of the power of silent film by the artistic and critical success of *The Artist*, directed by Michel Hazanavicius, which won the Oscar for best motion picture of the year in 2012.

The second phase of the filmic history of war takes place in the lead-up to the Second World War and its aftermath, from 1933 to 1970. I include pre-1939 films because fear of the return of total war is evident in 1930s cinema. War was both unthinkable and just around the corner. Images of war in the 1930s were seen by audiences that included millions of veterans, many of whom would take up arms again: first in Manchuria, then in Ethiopia, next in Spain, and finally throughout Europe and the Pacific. European filmmakers who later fled the Continent, such as Jean Renoir, did some of their greatest work in the later 1930s. This period also saw the production of some of the few pacifist classics in the history of the medium.

I have somewhat arbitrarily chosen 1970 as the end of this second phase of the cinematic history of war, but I base that dating on two interlaced developments. First, the Shoah assumed a central place in the history of the Second World War and increasingly itself became a subject of powerful cinematic treatment. Second, the Vietnam moment arrived, both repeating many of the heroic stereotypes of the Second World War era and, to a degree, subverting them. Films of Vietnam drew on Second World War tropes but went beyond them. Defeat mattered, yet so did dissent and disaffection, muting the unflinchingly patriotic posture of early Vietnam films, such as *The Green Berets* (1968), and producing in the next, the third period of war films, much darker and more ambiguous treatments of the conflict: for example, *The Deer Hunter* (1978), *Apocalypse Now* (1979), and *Full Metal Jacket* (1987). For these reasons, it makes sense to separate war films made between 1933 and 1970 from silent films before and from the films of what I term asymmetrical war that came after.

[2] Kevin Brownlow, *The war, the West, and the wilderness* (New York: Alfred A. Knopf, 1979).

The third phase of representations of war in film covers the period from the 1970s to our own times, when changes in the face of war itself have inflected the face of war in film. Historian Charles Maier has described what he terms the end of the age of territoriality at around 1960,[3] an insight which forces us to see war over the last forty years or so not in national terms alone, but in subnational and transnational terms as well. War is no longer primarily a classic military encounter between nation-states and armies, but rather a messy and chaotic array of violent clashes between national troops, say, American forces in Somalia, Iraq, or Afghanistan, and a wide variety of insurrectionary groups – not nations. Since the 1970s, war has often meant "dirty wars" waged by military elites against their own people, including in Central America, South America, Africa, and the Middle East. Not surprisingly, film has followed the tides of war into these destinations.

Asymmetrical war also means civilian casualties on a scale, and as a proportion of all losses, greater than ever before. In the Second World War, civilian casualties constituted more than half of all war-related deaths. By 2001, some analysts and the International Committee of the Red Cross put the ratio of civilian to military deaths in such conflicts as ten to one.[4] Some commentators are unpersuaded by this claim, and see substantial variation in the distribution of casualties in asymmetric wars. Even then, their estimates of civilians casualties to all casualties in many post-1960 conflicts are substantially above the Second World War levels of 50 percent.[5]

This distinction matters in the history of film because the shadow of the Shoah is also cast on the victims of wars remote from those of Nazi-occupied Europe. War as horror is not new, but the horror is no longer limited essentially to the battlefields; it is present in cities, in the country-side, indeed, everywhere. One reason the Shoah has become metonymical, standing for victims of war and violence elsewhere, is that no one of Jewish origin was safe anywhere within the Nazis' reach; they could be

[3] Charles Maier, "Consigning the twentieth century to history: Alternative narratives for the modern era," Forum Essay, *American Historical Review*, 105, 3 (June 2000), pp. 807–31.

[4] For the source and use of this statistic, see Sabrina Tavernise and Andrew W. Lehren, "A grim portrait of civilian deaths in Iraq," *New York Times*, October 22, 2010; Ruth Leger Sivard, *World military and social expenditures 1991* (Washington DC: World Priorities, 1991), p. 20.

[5] Adam Roberts, "Lives and statistics: Are 90% of war victims civilians?," *Survival*, 52, 3 (June–July 2010), pp. 115–36.

killed with impunity, all they had was bare life, in Giorgio Agamben's terms.[6] Wars of extermination are wars without limits; for that reason, among others, the war against the Jews was a transformational event.

Metonym or Metaphor

Let me add an additional analytical distinction. In each of these three phases of war film history, I believe, filmmakers have operated in one of two registers, or in combinations of two registers – that of spectacle or in other words a direct approach on the one hand, and of indirection, on the other. Another way of making the same point is to say that some films are *metonymical*, in that they claim to be true parts of a whole; others are *metaphorical*, in that they gesture toward another reality, beyond the scope of the medium.

Film has always flourished in the atmosphere of the spectacular drama of war.[7] But the power to convey the spectacle was limited in the first phase by the absence of sound, and in the third phase by the absence of the kind of moral transparency distinguishing "good" and "evil" in the war against the Axis powers. The Second World War was the cinematic "good war" par excellence in that its power to simplify and dramatize latched on to a cause that was clearly intelligible in precisely those terms: the war of good against evil. In the evolution of that moral calculus, the Shoah became more and more important as time went on. Here, the cinematic tools of indirection or metaphor, or a transverse rather than head-on collision with the destructive power of war, were necessary because the problem of representing the Shoah defies conventional protocols of representing warfare.

Emphasizing indirection or metaphor as a directorial choice also has the advantage of enabling us to see how many films which treat larger themes contain within them important comments on war and its enduring consequences. François Truffaut's *Jules et Jim* (1962) or Michael Hanneke's *The White Ribbon* (2009) are two such instances of films which deal with other themes, but which have powerful things to say indirectly about war.[8]

[6] Agamben, *Homo sacer*.
[7] James Chapman, *War and film* (London: Reaktion Books, 2008).
[8] Thanks are due to Giacomo Lichtner for comments on this and other points.

The third, post-1970 generation of war films did not leave the Second World War behind, but instead oscillated between morally simplifying war and recognizing unsanitized glimpses of its horrors and moral predicaments. These films are one important source of the moral ambiguity with which the public has come to view war in the last few decades. In the history of war cinema, as in the history of the military, the 1970s constituted a breaking point, when perceptions and practices changed in important ways.

The effects of this shift in perspective about war have been significant. As war has changed, it has been increasingly difficult to construct moral certainties about its meaning. Yet most films that show the ugliness of war in recent years stop short of pacifism. They suggest not that war is always immoral, but rather that it is always and already out of control and leaves men and women broken in its wake, whatever the outcome. If these films have anything positive to say, it is to visualize the camaraderie, courage, and sacrifice of warriors, affirming its power to bring out not only the worst but also the best in ordinary people. Over the course of a century, war films have developed from studies of conflict to studies of combatants, their loves, their hatreds, their inner lives.

Within this chronological framework, I note what may be termed a pendulum theory in the choices directors of war films make. Early filmmakers' first forays were perforce not realistic; they were indirect, allusive, suggestive, performative. They had to be so, because the texture and the roar of war – the sound of battle and of artillery and of airpower – were not reproducible. To be sure, early film audiences were awed by the visual power of film to convey battle or other historical scenes. In certain respects, they believed in film's indexicality, its power to bring you in your imagination to places you could never have reached. But in an important sense, silent films' technological weakness was their strength. They gestured toward images of battles rather than pretending to show war "as it really was." No one could, and I assert more generally, no one can, do that.

In the second generation of war films, the quest for cinematic "realism" dominated, to the great profit of the industry. Over and over, audiences saw combat, sacrifice, and killing and were led by filmmakers to believe they "were there," on Guadalcanal, in Iwo Jima, on Bataan. Technical effects and massive injections of cash produced this mighty canvas of war, but however hard they tried, filmmakers could as little

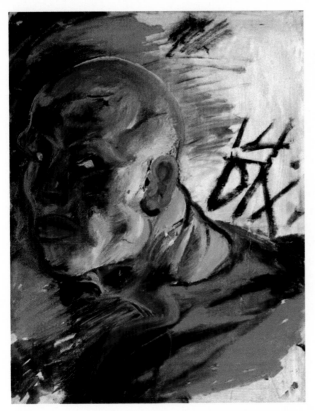

Illustration 1.1 Otto Dix, *Self-portrait*. Artepics / Alamy Stock Photo.

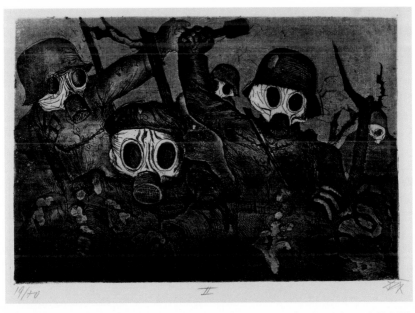

Illustration 1.2 Otto Dix, "Stormtroopers Advancing Under Gas" (1924). DACS 2016/Bridgeman Images.

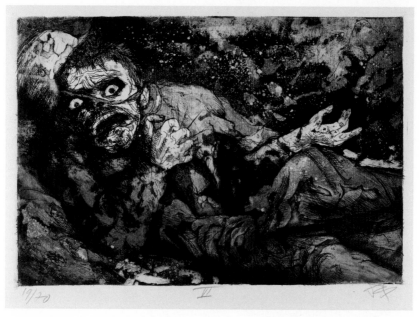

Illustration 1.3 Otto Dix, "Wounded Man" (1924). DACS 2016 / Bridgeman
Images.

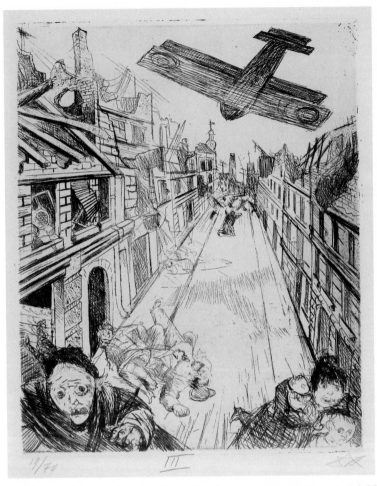

Illustration 1.4 Otto Dix, "Civilians Bombed in Bapaume" (1924). DACS 2016/
Bridgeman Images.

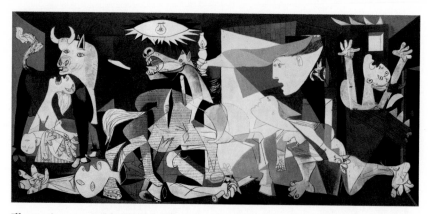

Illustration 1.5 Pablo Picasso, *Guernica* (1937). Museo Nacional Centro de Arte Reina Sofía.

Illustration 1.6 Anselm Kiefer, *Occupations* (1969). Published in Interfunktionen no. 12, Cologne, 1975. Collage, black and white photograph. Photo: Atelier Anselm Kiefer

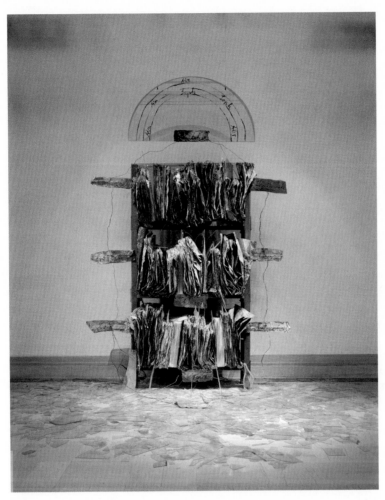

Illustration 1.7 Anselm Kiefer, *Bruch der Gefäbe* (1990). Lead, iron, glass, copper wire, and charcoal. Photo : The Saint Louis Art Museum, St Louis, MO.

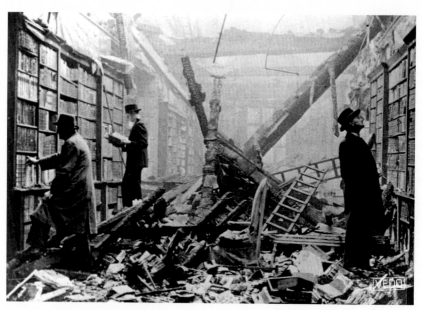

Illustration 1.8 A London library after the Blitz (1940). Black Star / Alamy.

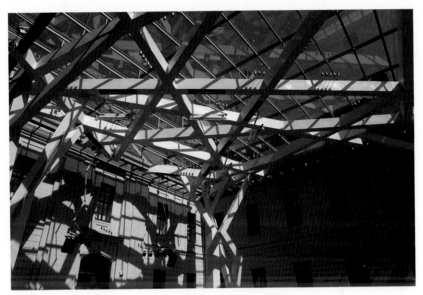

Illustration 1.9 Roof structure of the glass yard in the Jewish Museum (Architect: Daniel Libeskind). Photo: Bladt / ullstein bild via Getty Images.

Illustration 1.10 Gerhard Richter, *Uncle Rudi* (1965). © Gerhard Richter 2017 (0012).

Illustration 1.11 Gerhard Richter, *Tote* (1963). © Gerhard Richter 2017 (0012).

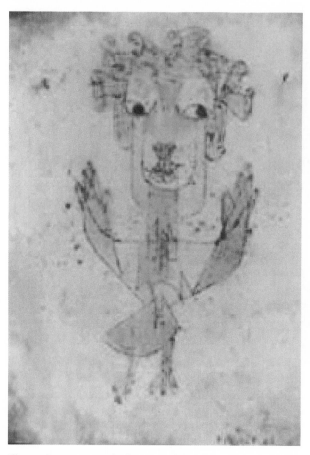

Illustration 1.12 Paul Klee, *Angelus Novus* (1920). photo (c) The Israel Museum, Jerusalem, by Elie Posner.

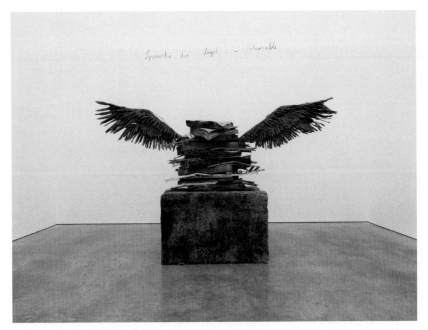

Illustration 1.13 Anselm Kiefer, *Sprache der Vögel* (Language of the Birds) (1989). Photo: White Cube Gallery, London.

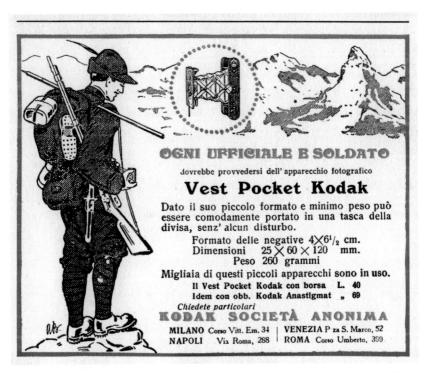

Illustration 2.1 Kodak vest pocket camera, advertisement for the Italian market (1915). Fototeca Storica Nazionale. / Getty Images.

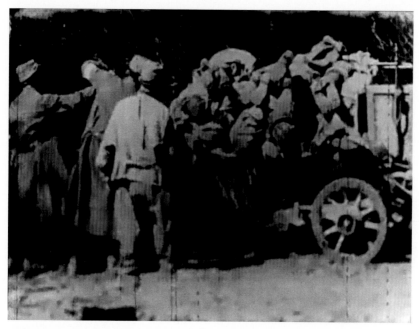

Illustration 2.2 Sgt. Albert Gal-Ladevèze, 268 RI, still image from a film of corpse disposal (1915). Collection: Bibliothèque de documentation internationale contemporaine, Nanterre.

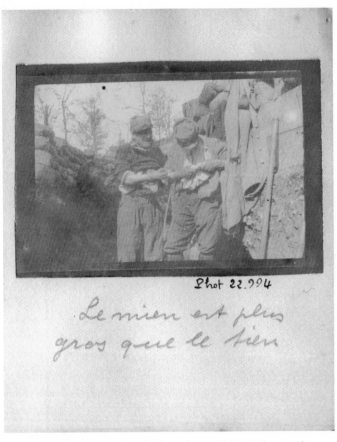

Illustration 2.3 Sgt. Gal-Ladevèze, photo, "Mine is bigger than yours" (1915). Collection: BDIC, Nanterre.

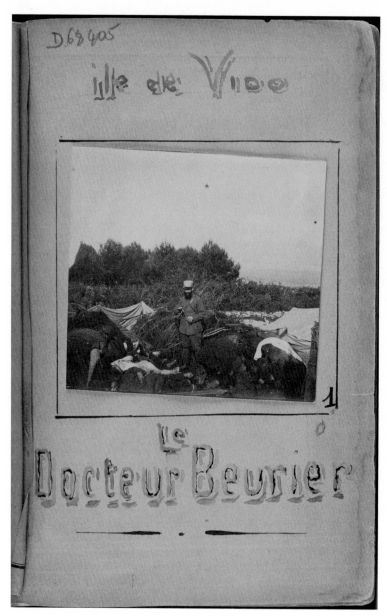

Illustration 2.4 Dr. Beurier, "Ile de Vido," photo album cover. Collection BDIC, Nanterre.

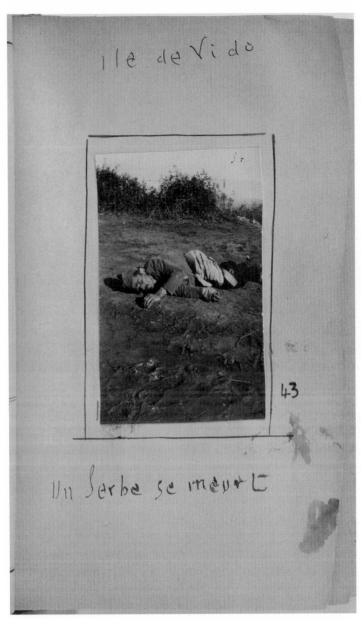

Illustration 2.5 Beurier album, "Un serbe mourant" (a dying Serbian). Collection: BDIC, Nanterre.

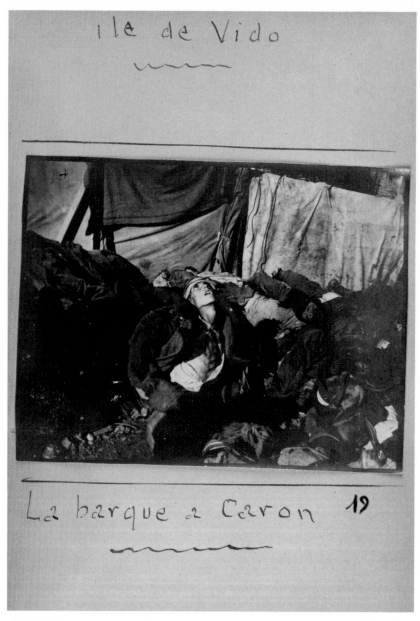

Illustration 2.6 Beurier album, "La barque a Caron." Collection: BDIC, Nanterre.

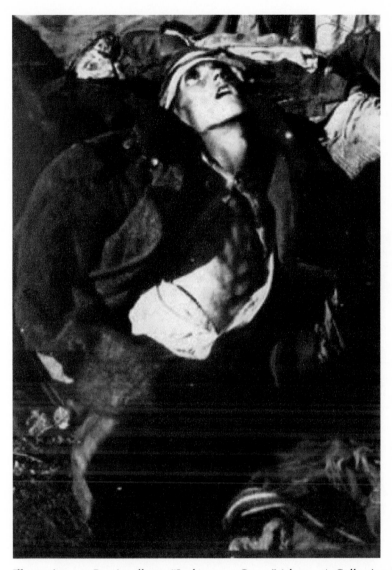

Illustration 2.7 Beurier album, "La barque a Caron" (close-up). Collection: BDIC, Nanterre.

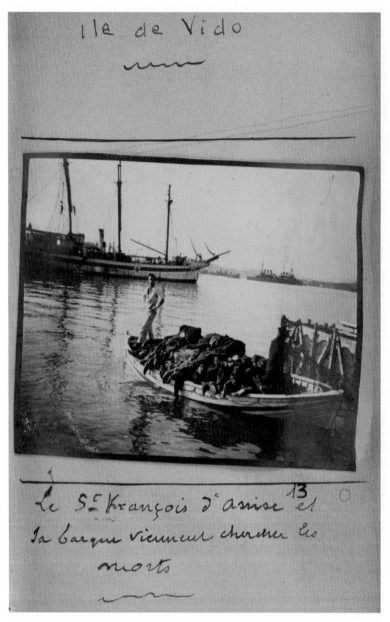

Illustration 2.8 Beurier album, "The St. Francis of Assisi coming to collect the dead." Collection: BDIC, Nanterre.

Illustration 2.9 Bardach album cover. Courtesy of the Leo Baeck Institute, New York.

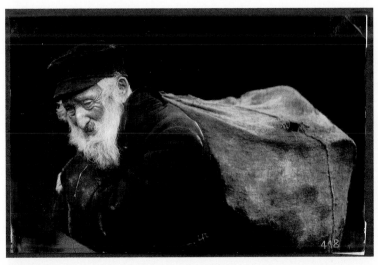

Illustration 2.10 Bardach album, old man with a sack. Courtesy of the Leo Baeck Institute, New York.

Illustration 2.11 Bardach album, prostitutes. Courtesy of the Leo Baeck Institute, New York.

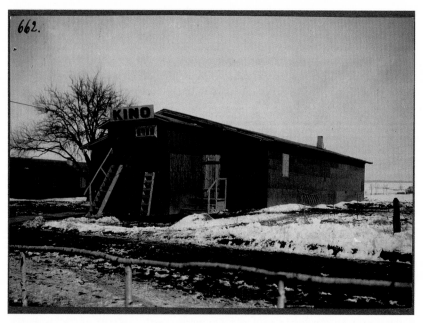

Illustration 2.12 Bardach album, field cinema. Courtesy of the Leo Baeck Institute, New York.

Illustration 2.13 Bardach album, "Corpse robber." Courtesy of the Leo Baeck Institute, New York.

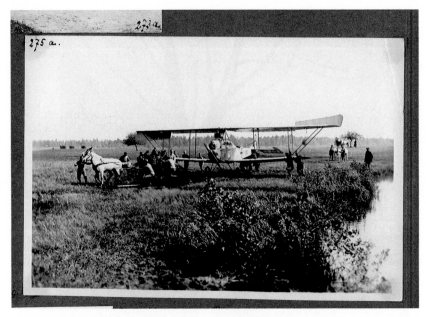

Illustration 2.14 Bardach album, airplane hauled by horses, Zwierow. Courtesy of the Leo Baeck Institute, New York.

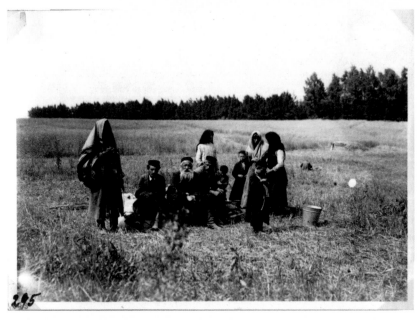

Illustration 2.15 Bardach album, morning prayers in a field near Lublin. Courtesy of the Leo Baeck Institute, New York.

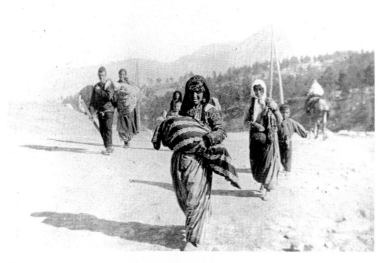

Illustration 2.16 "Armenian mother on the march." Armenian National Institute, Wegner Collection.

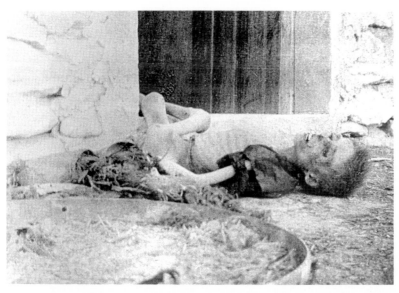

Illustration 2.17 "Starved boy." Armenian National Institute, Wegner Collection.

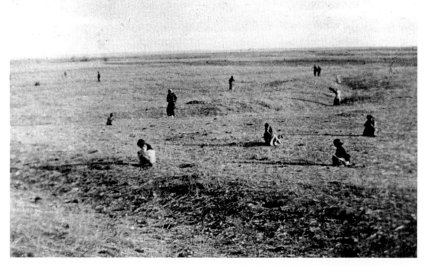

Illustration 2.18 "Foraging for grain" Armenian National Institute, Wegner Collection.

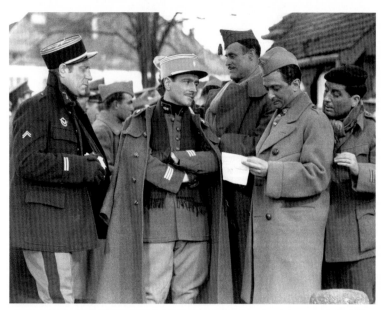

Illustration 3.1 Jean Renoir, *La Grande Illusion* (*Grand Illusion*) (1937), French actors Pierre Fresnay, Jean Gabin, Gaston Modot, Marcel Dalio and Julien Carette on set. (Photo by Sunset Boulevard/Corbis via Getty Images).

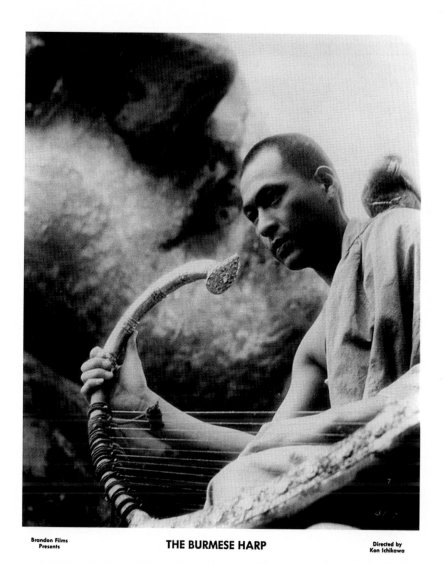

Brandon Films
Presents

THE BURMESE HARP

Directed by
Kon Ichikawa

Illustration 3.2 Kon Ichikawa, *The Burmese Harp* (1956), still of Mizushima (Shôji Yasui) with harp and parrots. (Photo by Brandon Films/Getty Images). Michael Ochs Archives / Stringer

Illustration 3.3 *The Longest Day* (1962), still of actors John Wayne, Stuart Whitman and Steve Forrest. (Photo by Stanley Bielecki Movie Collection/Getty Images).

Illustration 3.4 David Lean, *The Bridge on the River Kwai* (1957), promotional portrait of actor Alec Guinness. (Photo by Columbia Tristar/Getty Images).

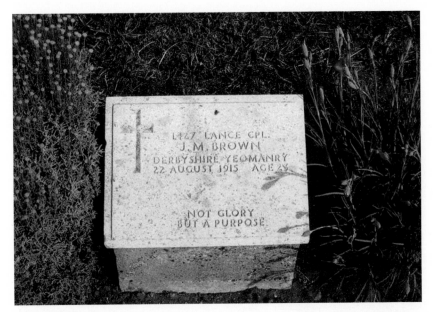

Illustration 4.1 Epigraph on tombstone of J. M. Browne, Suvla Bay, Gallipoli.
Photograph: the author.

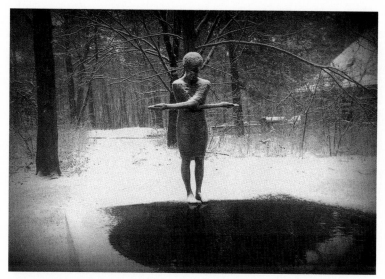

Illustration 5.1 Małgorzata Chodakowska, *Sea of Tears*, Dresden city cemetery (2010). Photograph: the author.

Illustration 5.2 Umschlagplatz memorial, Warsaw. Photograph: the author.

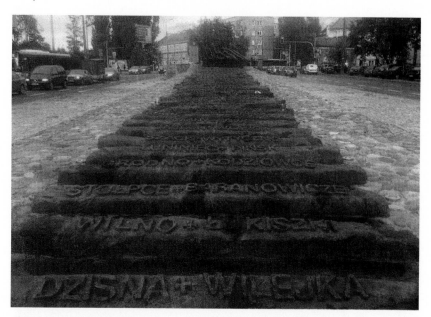

Illustration 5.3 Monument to the Murdered and Fallen in the East, Warsaw. Photograph: the author.

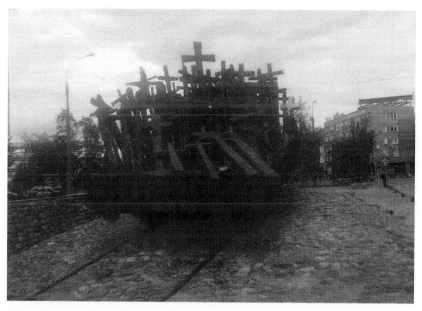

Illustration 5.4 Railway carriage with crosses, Monument to the Murdered and Fallen in the East, Warsaw. Photograph: the author.

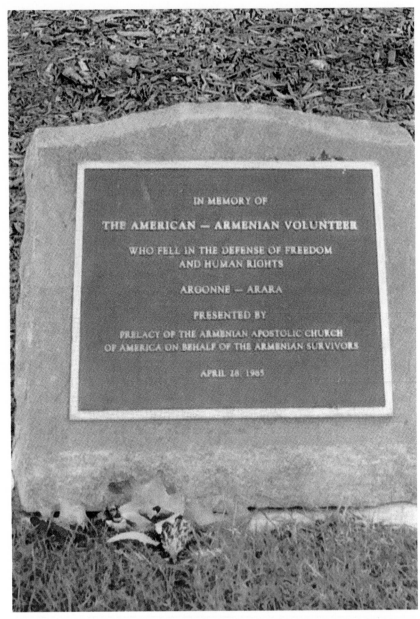

Illustration 5.5 "In memory of the Armenian-American volunteer," Arlington National Cemetery. Photograph: The author.

show the face of war realistically as they could show the dark side of the moon. In the Second World War period, the pendulum swung too far toward what was taken to be verisimilitude.

That urge to show the "real face of war" is still apparent, but it exists alongside another powerful impulse, one that moves away from realism and toward suggestions that war is not representable in film. The emergence of this new element reflects the literariness of cinematic culture. War literature, from Robert Graves's *Goodbye to All That*, to Ernest Hemingway's *A Farewell to Arms*, to Erich Maria Remarque's *All Quiet*, to Joseph Heller's *Catch 22*, has made the madness of war part of our cultural landscape. The literary witnessing of the victims of the Shoah has brought that madness into an even more haunting register that is increasingly at the heart of Second World War narratives. But the change in representations of war is also a consequence of the change in war itself: its civilianization, its transformation into the asymmetrical struggles which made the (misleadingly named) Cold War and its proxy wars bloody wars between men in uniform and ordinary people, brutalized, mutilated, killed by the millions since the 1970s. The Cold War was "cold" or bloodless only if we myopically interpet it as confined to the Soviet-American stand-off. Ask people in Indonesia, in Colombia, in Sri Lanka, in Vietnam, in Cambodia, in Rwanda what was "cold" about the "Cold War" and you are likely to get a different answer.[9]

In this period of new forms of warfare, war films introduce us to different kinds of landscapes of violence, doing so in new and indirect ways. There is little in the pre-1970 period to match the hallucinatory effects of the Israeli film *Waltz with Bashir* (2008), a cartoon exploration of shell shock. Innovative approaches have the power to move beyond realism to explore the face of war – at a tangent, at an angle, indirectly, and with great power. And that face is a soldier's face, not the face of war.

The arguments advanced in this chapter are these: first, that there is a shape to the history of war films, and second, that there is a set of choices filmmakers made, which we can see in all three periods. Those choices can be summarized very roughly in this way. There was one school of filmmaking, predominant in the years 1940–70, which I term that of "war cinema realism." War cinema realism is that style of filmmaking which, through sound, scenery, and special effects, enables

[9] Hoenik Kwon, *The other cold war* (New York: Columbia University Press, 2010).

a viewer to leave behind the knowledge that violence and destruction are staged and accept while watching it that the film is portraying war "as it actually is." In contrast, there was and is an alternative school, which I term "war cinema indirection," evident before 1930 and more so after 1970. It is that style of filmmaking which never lets the viewer leave behind the knowledge that the violence and destruction on screen are staged, and never lets the viewer accept the illusion while watching it that the film is portraying war "as it actually is." A few films of the Second World War adopted this indirect style, both before and after 1970, but by and large the bulk of films made about the war were "realistic" in the terms I use here, and frequently spectacular. Over time, the spectacle of war became less important in cinematography than the pathos of victimhood.

Silent Film

First, silent film. War stories were at the core of D. W. Griffith's *The Birth of a Nation* (1915), which wandered through the Civil War and Reconstruction with a romantic brush, memorably presenting heroism in battle, the assassination of President Lincoln, and the "chivalry" of the Ku Klux Klan. We should recognize the technical innovations Griffith brought to producing a war film: the use of montage, movement, swings between front and home front, extras and so on. These were facets of filming which later directors employed to great effect.

Silent filmmakers soon turned to the 1914–18 conflict, which formed the perfect setting for adventure stories, melodramas, romances, and the like. But aside from good box office entertainment, cinema contributed to popular narratives of the war by locating it within identifiable and mundane themes, thereby humanizing it. By suggesting the monumental scale of the conflict, in a way prose rarely could do, cinema mythologized the war as a vast earthquake against the backdrop of which the petty conflicts and hopes of ordinary mortals were played out. Here again, the superior power of images over words has had a greater impact on popular attitudes to war than most commentators have recognized. This is as true today as it was a century ago when war cinema was in its infancy.

The balance between what I call the *cinema of indirection or metaphor* and the *cinema of spectacle or metonym* differed in each

period of the history of war film. In the silent period, the realistic genre was per force indirect because sound was absent, and silence was either preserved or replaced by impromptu or arranged piano or organ music. Audiences brought their own sound effects with them, and thereby were drawn into the story in even more compelling ways. Consider the contrast after 1926, when the score, inscribed on a sound track, told us (and still tells us) how to react to what we see. With sound came emotional *dirigisme*, a kind of authorial instruction that we should feel suspense at one moment, relief later, and resolution at last. This was not universally true; witness the genius of the long tracking scene at the end of Fritz Lang's *M* in generating emotion visually. But in many other cases, the sound track was there to point the way to "appropriate" emotional responses to what was on the screen.

In 1916, the British government produced a film entitled *The Battle of the Somme*, which was distributed and shown while soldiers were still engaged in that six-month operation. Perhaps 19 million people saw it in six weeks, the equivalent in today's Britain of a majority of the civilian population going to the same film at roughly the same time. At the center of the film was an entirely false reconstruction of what it meant to "go over the top." A line of soldiers in a trench crawl up to its lip, then stand and proceed through smoke and fire to engage the enemy. One man is "hit" and slides down the trench. Entirely silent, without any musical accompaniment, the scene had a devastating effect on the audience, many of whom had relatives serving in the war at that very moment. Women fainted; others cried out and had to be escorted from the cinema. Accompanying piano music was suspended during the attack scene. Silence provided the visceral punch.[10] I shall return in Chapter 7 to investigate the power of silence to frame our understanding of war and the damage it causes.

Sound films framed audience reactions in ways that tended to reduce their own affective choices to the ones the cineaste or his composer provided. Silent films were more open-ended emotionally, and hence potentially more powerful. Yet whatever the sound or silence accompanying the scene, those screen images carried a kind of authenticity, a surface realism, with them. They appeared to be about real

[10] Roger Smither, "'A wonderful idea of the fighting': The question of fakes in *The Battle of the Somme*," *Historical Journal of Film, Radio and Television*, 13, 2 (1993), pp. 149–68.

people; a real man hit on the lip of a trench, who could have been the husband, brother, or son of someone in the audience. The power of film to lie about war was revealed at its inception, though the power of sound expanded this field of invention in significant ways. Indeed, the introduction of sound effects enabled viewers to believe that they could actually imagine war. What is thinkable is what is doable, and one ramification of the introduction of the talkies was that war films helped domesticate a set of violent events that, at their core, resist representation. To be sure, all films misrepresent war; but talkies do so with gusto and with even more powerful effect.

One reason for the unrepresentability of war in all film is its chaotic character. Battle has no vanishing point, no center of gravity, and the rubble of destruction accompanying industrialized warfare in 2017 – just as in 1916 – makes it difficult to see what is happening and why. Films have a proscenium arch, just like the theaters and music halls out of which they were born; they frame action and draw our eyes to some central point of action. Yet the strangeness of war and the weird, uncanny sights it presents to soldiers are frequently beyond even today's special effects.

If the physical landscape of battle is almost always trivialized or reduced to mundane proportions, the emotional landscape of battle also eludes cinematic portrayal. We cannot capture the smell of cordite or decaying bodies, or the stench of the detritus war brings in its wake. Fear can be suggested but very rarely tasted in film, and without that dimension, cinematic representations of war always remain stylized or worse. Thus, both the material and the affective framing of war in film tend to reduce it to formulae or clichés. Exceptions prove the rule.

Silence had another major advantage in the early interwar years. Silent film, which can be defined as a set of cinematic nonspeech acts,[11] framed the mourning process in ways rarely, if ever, matched by talkies. Music and banal dialogue frequently turn filmic treatments of this theme into kitsch and worse. By saying less, and leaving viewers to create the words and voices in their own minds, silent film had the power to portray the predicament of men and women alive in the aftermath of wars that took life, not by the scores but by the millions.

[11] Jay M. Winter, "Thinking about silence," in *Shadows of war: The social construction of silence*, ed. Efrat Ben-Ze'ev, Ruth Ginio, and Jay Winter (Cambridge University Press, 2010), pp. 1–30.

Spiritualism had wide appeal in both Europe and America both before and after the First World War, and it gave a mournful character to many war films. When viewers reached the end of Lewis Milestone's *All Quiet on the Western Front* (1930), they encountered the faces of the dead looking back at them before they marched off to eternity. This was a very American film, spoken with American accents and intentionally without inflection. Five years earlier, King Vidor's *The Big Parade* had also offered a downbeat version of war, including the hero's loss of a leg in combat and his rejection by his prewar sweetheart. His French *petite amie* managed to come to the rescue afterward. *The Big Parade* was the biggest box office hit of the silent era – more than *Birth of a Nation*.[12]

In the 1930s, a number of talking films presented the dread of war to a public more and more concerned with the menace of a new war. Frank Borzage's 1932 film *A Farewell to Arms* was downbeat, as was Sidney Franklin's *The Dark Angel* (1935). More elegiac, and marked by a deep sense of the futility of war, was Jean Renoir's masterpiece *La Grande Illusion* (1937). Sympathetic to German soldiers, filled with the fierce and defiant patriotism of French prisoners of war, Renoir's film humanized not war but the men trapped in it. I am not alone in considering it in a class of its own as a war film. It said so much about war without showing a single battle scene. That is indirection or metaphor as cinematic genius (Illus. 3.1).

<p style="text-align:center">***</p>

It is indeed arbitrary to choose to bracket films about the Second World War in the period from roughly 1933 to 1970, and to argue that most of them adopted a realist's pose in presenting war to cinematic audiences. Second World War films were certainly produced long after 1970,[13] and I return to this matter in a moment. In addition, there were nonrealistic, indirect, and unusual war films in this era. One such film, René Clément's *Jeux interdits* (*Forbidden Games*) from 1952, directs our attention away from the battlefield of 1940 and to the ways two children, aged 4 and 7, deal with war and death in the French countryside. They puzzle over how to bury a little girl's pet dog killed by strafing

[12] Michael T. Isenberg, *War on film: The American cinema and World War I, 1914–1941* (Rutherford, NJ: Fairleigh Dickinson University Press, 1981), pp. 118–22.
[13] Carl Boggs and Tom Pollard, *The Hollywood war machine: U.S. militarism and popular culture* (London: Paradigm, 2007).

in her family's escape from Paris in May 1940. The answer they come to is simple: they build a cemetery for animals, large and small, with room for people too, but get into terrible trouble by stealing all the crosses from the local church and cemetery to provide the crosses they need for their own. Brigitte Fossé aged 4, never played a better role.[14] Another is the Japanese masterpiece *Biruma no tategoto* (*The Burmese Harp*), first released in 1956 in black and white and rereleased in color in 1985. Kon Ichikawa's tale concerns a Japanese soldier who, at the end of the war, is sent by his Allied captors to persuade his comrades not to fight on after the Armistice. He fails in his mission and is nearly killed. In his effort to rejoin his comrades, he traverses old sites of combat and is horrified by the hundreds of unburied Japanese corpses he sees. He decides to put on the robes of a Buddhist monk and stays to tend the graves of his fellow soldiers. His lonely vigil transforms the landscape of war into an eternal landscape of mourning (Illus. 3.2).

Stanley Kubrick's *Paths of Glory* (1957) is a devastating portrait of evil or incompetent commanders saving their careers by executing soldiers for "cowardice" in the First World War. Charged with failing to succeed in a senseless and impossible operation, the three men shot are chosen at random; none was a coward. What constitutes courage or cowardice had already made American cinematic history in Borzage's *A Farewell to Arms*, starring Helen Hayes and Gary Cooper. Cooper, who plays an American volunteer ambulance driver in Italy in 1917, deserts from the chaos of the Italian defeat at Caporetto to find his lover, a British nurse. They are reunited, but Hayes's character dies in childbirth. Indirection or metaphor, indeed, plays out in the story of loss of a mother's life in wartime.

While death is ever-present in most films set in the Second World War, it is not the central element in this body of work. As historian John Bodnar has recently shown, the movie industry presented many different facets of the Second World War, but the primary focus was internal, in the sense that what mattered was what Americans had done in the war "and what type of people they were." This guiding theme left room for both national celebration and meditation on the rocky road many veterans faced in returning to civilian life.[15] Here, we

[14] www.avclub.com/articles/forbidden-games,63508/
[15] John Bodnar, *The "good war" in American memory* (Baltimore, Md.: Johns Hopkins University Press, 2010), p. 165.

see an important transition in film from a focus on war to a focus on men at war. Once again, this is a matter of emphasis, not precision, but it may be useful to bear in mind nonetheless.

However nuanced their positive view of the Second World War as "a good war," most filmmakers aimed at a kind of verisimilitude that made audiences believe they could actually know "what it had really been like." The most spectacular instance of this approach is *The Longest Day* (1962), directed by Ken Annakin and Andrew Martin. Filming in black and white to highlight the film's "authenticity," producer Darryl Zanuck managed to acquire substantial support and military hardware from Britain and France as well as from American authorities. Cameo performances by an array of stars helped make this film the biggest box office success before Steven Spielberg's *Schindler's List* (1993), a classic of the third generation of war films (Illus. 3.3). Similarly admiring of the swagger of military masculinity and the American way of waging war was George C. Scott's portrayal of Patton in Franklin Schaffner's eponymous film of 1970. Bringing viewers onto the battlefield meant bringing them into the minds of the men who imposed their will on it and on the enemy; no one did that with more panache than Patton.[16]

The presentation of the home front was another matter entirely, and in William Wyler's *The Best Years of Our Lives* (1946), the troubled return of veterans emerges without much sugar-coating. The film generated twice the box office earnings of *Sands of Iwo Jima* (1949), demonstrating that filmgoers were prepared to deal with the difficult aftermath of military service, though within certain conventional limits.[17] Indeed, the theme of return and recovery unites films spanning the silent era – *The Big Parade*, for instance – to later cinematic work such as Hal Ashby's 1978 film *Coming Home*.

What I term the *direct* or *realistic* approach to presenting war in film had plenty of room for nuance and contradiction. By no means were all Second World War films formulaic presentations of sadistic Japanese or snarling Nazis, subdued in turn by simple, small-town, honest GIs. Realism in war cinema was not exclusively the domain of American films. It marked British approaches to the ambiguities of war, too. In *Bridge on the River Kwai* (1957) (Illus. 3.4) and *In Which We Serve* (1942), both directed by David Lean, we find counterparts to the

[16] Ibid., pp. 144–45. [17] Ibid., p. 151.

American filmic presentation of "realistic" war scenes and "realistic" approaches to the home front. In one controversial film, which Winston Churchill tried to scrap, a vision of British decency as an obstacle to victory was presented in terms of getting rid of the old guard who were too old school and not nasty enough to win the war. Churchill took the message personally, but Michael Powell and Emeric Pressburger's *The Life and Death of Colonel Blimp* (1943) survived anyway.[18]

Other pre-1970s European film presentations of the war are similarly heroic and realistic in their account of combat. Jean-Pierre Melville's 1969 film *L'armée des ombres* (*Army of Shadows*) in effect summarized a gritty, harsh, unvarnished presentation of the impossible choices Resistance fighters had to face. Their war was indeed a dark one, and honoring it was the least the film industry could do while nations like France were recovering from defeat, humiliation, and collaboration.[19]

Trajectories

Indirection or metaphor was evidently not an invention of the post-1970 period, but it has carried different messages about war ever since. After 1970 or so filmic representations of the Second World War changed in important ways. The lid came off the story of collaboration and the Shoah, both on screen and in wider discussions of the war. The effect of Marcel Ophüls' 1969 film *Le chagrin et la pitié* (*The Sorrow and the Pity*) was palpable. The narrative of collaboration and resistance turned from one of black and white to many shades of gray.[20]

The rewriting of the Second World War narrative to include the Shoah in a central role coincided with American defeat in Vietnam. The combination opened up a new phase in the history of war films. The focus shifted from the war the soldiers waged to the victims of violence in the midst of a new kind of asymmetric warfare. This new

[18] Robert Murphy, *British cinema and the Second World War* (London: Continuum, 2000).

[19] Sylvie Lindeperg, *Les écrans de l'ombre: La Seconde Guerre mondiale dans le cinéma français (1944–1969)* (Paris: CNRS, 1997).

[20] Henry Rousso, *The Vichy syndrome. History and memory in France since 1944* (Cambridge, Mass.: Harvard University Press, 1994).

form of war ushered in a renewed and deepened concentration on the psychological and moral effects of war on combatants themselves.

In this way, the meaning of asymmetric war was inflected by its growing linkage to the Shoah, the only war the Nazis won. Asymmetric wars of a different kind emerged after the end of the Vietnam conflict, pitting Western forces, mostly American, against insurgents in many parts of the world.[21]

Film followed the flag, first into Vietnam and then into these transnational or subnational conflicts. I have already noted the transition from *The Green Berets* to the much more complex landscape of *The Deer Hunter*. At the end of the latter film, the group of young, working-class men and women at the heart of the story wind up singing "God Bless America." One is paraplegic, another is scarred mentally, and one of their circle, who lost his mind in Vietnam, has just been brought home and buried. The tone of the anthem is muted: are they still patriotic? Probably, but the message can be read another way. In a world of ugly choices, God had better bless America, for Americans cannot find answers in the old patriotic tags. War as madness takes over in *Apocalypse Now* and in *Full Metal Jacket*, both tales of disillusionment and savagery.

Oliver Stone's *Platoon* (1986) added a different dimension to the cinema's representation of the Vietnam War. Stone drew on his own service in Vietnam. His ambivalence about the war emerged in his treatment of two sergeants: one humane, the other a brute who commits war crimes with impunity. Open the Pandora's box of war, Stone says, and who knows how any of us will be transformed by it? Atrocities are built into war, he shows; no one is unscarred by it. Here, Stone echoes many literary accounts of the passage in wartime from innocence to savagery; the film is both reminiscent of First World War poetry and anticipates Tim O'Brien's *The Things They Carried*, published four years later, in 1990.

The link with the Shoah is especially evident in the work of Steven Spielberg. His masterpiece *Schindler's List* was followed five years later by *Saving Private Ryan*. The films both show the essential elements of the new cinema of war. The first is a powerful and realistic account of the morally ambiguous figure of Oskar Schindler, who lived

on the tightrope of Nazi bureaucracy surrounding the Shoah and managed to save hundreds of Jews thereby. The Second World War is only the backdrop of the story, but there are few portrayals more powerful of precisely what Hitler's war against the Jews meant than the *Aktion* (or murderous round-up) in Krakow. In *Saving Private Ryan,* war is the central subject. Spielberg starts with blood and guts, in a boldly realistic manner, in his portrayal of the Normandy landings, and then segues to a more conventional account of the rescue of a surviving soldier whose three brothers had died in combat. The film ends with the survivor asking his wife, in the cemetery where one of the men who rescued him is buried, if he is a good man – if the loss of life in his rescue had produced something good to ennoble it.

Once the wars in Iraq and Afghanistan began, moral ambiguity became dislocated from nostalgia, and films increasingly portrayed war as cruelty, bloodshed, and (at times) butchery without redemption. In Sam Mendes's *Jarhead* (2005), set in the first Gulf War, the brutality of Marine Corps training echoes Kubrick's *Full Metal Jacket*; but this time, the men itching to get into the action "only" manage to mutilate corpses and do not even shoot at the enemy. The Air Force gets in first, and the frustrated Marines fire off a fusillade only at the end of the film. Impotent killers indeed.

The lies about weapons of mass destruction are the subject of Paul Greengrass's *Green Zone* (2010), which features Matt Damon as a decent GI betrayed by those in the CIA and higher up in the administration who invented the story. *Rendition* (2007) tells the tale of the Bush administration's complicity in torture by allies through the fictionalized tale of one man mistaken for a militant who disappeared into the Bush administration's twilight zone. In a much more poignant, though downbeat, account of the costs of the Iraq War, *The Messenger* (2009), directed by Oren Moverman, focused on the work of the U.S. army's Casualty Notification Service – the men who brought home the news of a soldier's death on active duty.

The theme of decent soldiers locked in an indecent war recurs in Kathryn Bigelow's *The Hurt Locker* (2008). The film features a bomb disposal unit composed of men whose primary aim is to get home alive. Their sergeant, William James, played by Jeremy Renner, is a more puzzling man, someone who seizes danger by the throat. He appears to enjoy the Russian roulette of disarming booby-trapped bombs, and even when he makes it back home, he cannot reembrace civilian life.

At the end of the film, we see him returning for another tour of service in Iraq. Whether or not he was suicidal before the war, he certainly was during and after it. War as a home for suicidal men is hardly an advertisement for the military, and yet *The Hurt Locker* won the Oscar for both best director and best picture of the year.

The unending character of the "war on terror" was also the subject of Steven Spielberg's 2005 film *Munich*. Spielberg tells the story of the assassination squad that liquidated the men who masterminded the Munich massacre at the Olympics of 1972. After the killings have been avenged, the Israeli agent who is the central figure in the story tells his boss that he is through with assassination because it changes nothing of importance. He walks away from his mission against the backdrop of the World Trade Center. The script says nothing about the juxtaposition of words and scene; it doesn't have to. Silence does it better.

The advent of all-volunteer armed forces was not solely an American phenomenon. In Britain the last man conscripted on "national service" left the army in 1963. In the United States, the draft came to an end in 1973. In both countries, armies downsized. These developments reinforced the trend of focusing not on war but on individual soldiers in film. It is hardly surprising that when armies were reduced radically in size, films moved away from the spectacle of war to the predicament of the warrior and of those civilians trapped in war at this time. And yet this turn in narrative framework introduced a tension. The shift from heroic warfare to the troubled warrior individualized his moral dilemmas and personal risks that at times ran counter to the ethos of "the Corps" or other collective identifications with a service arm or a division. This tension mirrored a wider trend. War was individualized in film, at the very time that a kind of radical individualism dominated political debate in both Britain and the United States in the Thatcher and Reagan era. By the early 1980s, the collective experience of the Second World War was over; in its place came a new focus on individual liberties over collective rights and shared experiences.

In a way, the collective experience of war was still central to its filmic representation. The collective, though, was the platoon, or the unit, or the crew of a submarine. This was as true of Renoir's *Grand Illusion* as it was of *Saving Private Ryan*, and marks the plots and characterization of war films over the entire twentieth century.

Similar continuities exist in the filmic alignments of the warrior alongside other paladins, men of honor facing dishonor not only from

the enemy but frequently from within their own ranks. Cowboys and spies have performed similar functions in cinema, and millions of viewers still pay to see them in action. These loners are men apart, men who still retain vestiges of moral thinking in an immoral world, and thereby have to live outside "conventional" society. These filmic motifs were present before the 1970s, but grew rapidly thereafter. It makes sense, therefore, to see the development of the work of Clint Eastwood as a thematic continuum, moving from westerns to police films to war films (and back again to westerns) with a sure hand for the representation of scarred individuals facing a hostile and indifferent world. Steven Spielberg's *oeuvre* is more interested in innocence than in embittered experience, but he too is a cinematic student of betrayal, usually of the young by their elders.

The post-1970 phase of cinematic history resembled the early years of film in a number of additional ways. The authoritative historian of silent film, Kevin Brownlow, saw it as focusing on "The War, the West, and the Wilderness." The first two are easily identified settings for recent film. As in Spielberg's corpus, the "Wilderness" we imagine in the early twenty-first century is in the skies, in outer space, or in other futuristic landscapes.

The lone man in the "Wilderness" has been a pillar of the film industry from its early years in the form of the spy. Espionage films take us back to the beginning of the cinematic representation of war. The First World War spawned them, and so did the unstable international climate of the 1930s. Hitchcock's *The Man Who Knew Too Much* appeared in 1934. The next year, his *39 Steps* (1935) recycled a First World War story written by John Buchan. *Secret Agent* (1936) and *Notorious* (1946) explored the same genre. From the 1960s, some filmmakers portrayed the cold war as more of a moral wilderness than a crusade against the "Great Satan." Perhaps the most celebrated presentation of the nuclear stalemate was Stanley Kubrick's *Dr. Strangelove* (1964), mixing savage satire with the onset of Armageddon. Refueling aircraft open the film to a musical rendition of "Try a Little Tenderness." A year later, Martin Ritt's adaptation of John Le Carré's novel *The Spy Who Came in from the Cold* was the first of a number of spy films which offered a plague on both the houses of the Great Powers. Cartoon-strip cinema was available too: the highly profitable James Bond series of spy films also dated from the early 1960s, and they have gone on earning money for fifty years.

And yet in recent years, more cynical and critical portrayals of spies at work have appeared. British director John Madden's 2010 film, *The Debt*, showed the lies surrounding a botched operation by Israeli agents attempting to kidnap and transport to Israel for trial a man resembling Dr. Josef Mengele. A year later, *Tinker, Tailor, Soldier, Spy* (2011), directed by Tomas Alfredson, took up the same theme, and offered a sardonic antidote to the cult of spies as heroes. No doubt, both currents – the heroic and the antiheroic – will carry on in parallel in future years.

If espionage was a core element of the cold war, the use of private contractors to provide services for the American armed forces is an important departure in post-1989 military history. And yet there have been few films which focus on the effects of outsourcing war services to corporations. One is Stephen Gaghan's 2005 film *Syriana*, in which George Clooney and Matt Damon come to grief in a tale of corruption, greed, and betrayal. Rodrigo Cortés's *Buried* (2010) follows the travails of a civilian driver kidnapped and confined in Iraq; no rescue and no redemption follow.

Civil war is another subgenre of war films that spans all three periods of cinematic history. What the Irish call "the Troubles" has left a number of filmic accounts of their predicaments, all of which point to the moral ambiguity of the struggle for independence from Britain, first in the south and then in the north of Ireland. There is a long and distinguished tradition of filmmakers exploring Ireland's multiple civil wars. In the interwar years, Hitchcock entered this divided country with *The Shame of Mary Boyle* in 1930. The film was originally called *Juno and the Paycock*, the title Sean O'Casey gave to the play on which the film was based. John Ford followed with *The Informer* (1935), and a year later, with his adaptation of another O'Casey play *The Plough and the Stars*. In more recent years, Neil Jordan's 1996 portrait of *Michael Collins* (2001) described the treacherous world of betrayal in the second Irish civil war, between those who followed Collins into accepting the partition of Ireland, and those – including his killers – who did not. Ken Loach's *The Wind that Shakes the Barley* (2006) explores the same subject, with the same bleak view of the havoc civil war wrought.[22] A more unusual take on the subject of the IRA and Britain is Neil Jordan's *The Crying Game* (1992). This film is a subtle

[22] http://cain.ulst.ac.uk/images/cinema/nimovies.htm

portrayal of ambivalence and equivocation, both political and sexual, in men serving both in the IRA and the British army. The subject of civil war is prone to highlight the gray areas of conflict between neighbors and within families themselves. Recent films focusing on the Algerian war, on the civil war in Yugoslavia, or in Lebanon, among others, follow this darker, less stirring, agenda in showing the cruelties and uncertainties of societies torn apart by intercommunal violence. On balance, ambivalence is at the heart of many, though not all, cinematic forays into the terrain of civil war in recent decades.

The War between the States continues to attract cinematic treatment of varying kinds. Edward Zwick's *Glory* (1989) highlighted the story of black soldiers fighting for freedom in the Union army, and pointed back to the more comfortable moral terrain and noble sentiments (on the Southern side) of *Gone with the Wind* (1939) and many Second World War movies. More in line with the third phase of moral uncertainty about war and the mindless cruelty and senseless death it brought in its wake is Anthony Minghella's *Cold Mountain* (2003). This film tells of the struggle of a wounded deserter from the Confederate army to reach home. He does so, but is killed in the arms of his wife.

There are other evocations of a similarly downbeat kind in films concerning the civil war in Nicaragua (Roger Spottiswoode's *Under Fire*, 1983), in Somalia (Ridley Scott's *Black Hawk Down*, 2001), and in the former Yugoslavia (Danis Tanovic's *No Man's Land*, 2001). What they all have in common is recognition of the cruelty and moral ambiguity of all sides in civil wars.

Dignity without Voyeurism

In this all too brief survey of film and war, I have had to omit many facets of the cinematic history of military conflict – Eisenstein, Wajda, Tarkovsky, Kurosawa are integral to the subject of this chapter, but space limitations preclude discussing them here. I have omitted, too, the vexed question of filmmakers as ideologues, as representatives of certain powerful interests that want to "sell" war to the public. Consider as one example Gary Cooper's pacifist-turned-sniper in Howard Hawks's 1941 film *Sergeant York*. My aim is more modest. It is to point to certain trends in the way filmmakers have tried to portray war. I have

emphasized the choices filmmakers have to make, choices which are imbedded in the medium itself. Their business has been to choose the cast, to find ways to interchange silence and dialogue, to select a particular musical setting, to try to "recreate" a battlefield or base camp, to turn a rough cut into a final product. Some do better than others. But all, in my view, fall short of faithfully representing war.

Samuel Fuller, the director of *The Big Red One* (1980), was once asked what constituted a good war film. His answer was "one which cultivates dignity and does not pursue voyeurism." He saw service in Africa, Sicily, Normandy, Belgium, and Czechoslovakia, and was present at the liberation of the Falkenau concentration camp. He was one of the few directors with extensive combat experience.[23]

Dignity without voyeurism is indeed a good measure of the balance war films aim to achieve. And yet few succeed. The reason is that showing war without terror is a recipe for voyeurism, and spectacular war films rarely make terror come alive. Here is the central point about silence: it carries terror within it much more readily than the scariest movie score does. Stop the sound and terror is one of the elements of the story that rushes to the surface. The subject of terror is present in all war narratives, but it is differently configured in the age of asymmetrical wars. The terror of children, women, and the aged is etched into the history of the Shoah, and into the story of brutality from Biafra in 1968 to the Sudan, Somalia, Syria or Afghanistan today. Postnational warfare is therefore less about soldiers and more about victims. Terry George's *Hotel Rwanda* (2004) is a film about genocide, and the hotelier who saves hundreds of lives; he is a Schindler without the moral shadows. The friendship between two men is at the heart of the 1984 film *The Killing Fields*, and despite the monstrous evil he faces, Dith Pran's survival is what leaves us with hope, even now.

Surveying such films, we can see the force of Fuller's plea for dignity. Films can portray men and women at war, whose dignity, integrity, and existence are threatened, but who, if they are lucky, emerge from war as recognizable human beings nonetheless. We are left, therefore, with a modest conclusion: war defies simple representation, but men at war can be presented, with clichés or human qualities

[23] Norbert Multeau, "Quand la guerre est un spectacle," in Philippe d'Hugues and Hervé Coutau-Bégarie (eds.), *Le Cinéma et la guerre* (Paris: Economica, 2006), p. 148.

attached, depending on the actor, the director, and the audience the producers want to reach.

In a vast array of nondocumentary films, soldiers of many nationalities have been represented as frail, complex men as well as cartoon-strip figures. What differs is the framing of the wars in which these soldiers fight. Here, we can take note of an evolution, which I have presented in this chapter. Film in the silent age stood back from realism: it could hint, suggest, gesture, but without sound, it could not portray war. In the Second World War generation, a kind of spectacular realism took over, with mixed effects. Phony wars were presented as real wars, and given the moral clarity of the 1939 to 1945 conflict, in most cases, that was enough. But from the 1970s on, soldiering has been framed differently. It was darker, more tragic, more morally ambiguous, more focused on victims than on heroes. Heroic images of war were still on offer, but the colors of war grew somber, muted. Thus, the portrait of the soldier came to be more important than the story of the war in which he served.

In countries with a volunteer army, that was not a negative outcome; masculine virtues still matter, especially among the young. One television ad for enlistment in the U.S. offers not to make men strong, but to make them "Army strong." Yet once the broader public began to see war as morally precarious, as it did beginning in the 1970s, public support for the men who wage war became uncertain, too. Supporting the men but not the war is a hard act to pull off. It usually winds up in disillusionment and disengagement.

As for the legacy of one hundred years of war films, we ignore it at our peril. The search for a balance between the spectacular and the indirect in visual portrayals of war goes on, tilted towards the spectacular by the immense popularity of computer war games. Indirection or metaphor in that context is nonexistent, but the film industry is different. It does not speak with one voice. To take but one very recent box office success, Steven Spielberg's *War Horse* continues his immensely popular set of cinematic meditations on war and its cruelties. Speaking of war through the story of an animal and the young boy who searches for him, Spielberg tries to capture the futility of war in one of his many tales of the way innocent children are betrayed by their elders. The spectacular elements of the film are impressive enough: the horse confronted by three tanks is filmmaking at its best. The sheer sentimentality of the story, though, outweighs its moral message, much more

powerfully conveyed indirectly in the stage version of the story. A model of a horse, designed brilliantly by a South African company to approximate the uneven cadence of the animal, conveys the horror of war silently and in a way that puts the so-called "real" presentation to shame. My first response to seeing this film was to hope that someone would turn off the sound.

Filming war, like configuring war, and writing war, always works through mediation. The technical framework of cinema both limits what can be done and at times distorts war beyond recognition. That is true of painting, sculpture, and writing as well. But time and again exceptions appear which make us reaffirm a belief that the best defense we have against the ravages of war is the human imagination itself. At its best, cinema is today and has been from its birth a century ago an indispensable resource for those who are fascinated or puzzled or horrified by war. The flaws of those films which attempt to show what war "is really like" are evident, but in the hands of masters, film is today and is bound to remain an essential point of reference for those who try to understand what happens to soldiers in combat and for those who try time and again to imagine war, our brutal companion, past, present, and future.

4 WRITING WAR

Paths of Glory

What's in a word? In this chapter, I explore the lexicon of war through the semantic history of the word "glory," and do so in comparative perspective. The word "glory" has a history, and that history is different in different cultural contexts. The sense conveyed by the word is not the same over time and space; its connotations and denotations in English, French, and German are in no sense identical. My claim is that the usage of the word "glory" reflects different cultural and historical trajectories, with different inflections over time. In effect, "glory" carries history in it, and in particular the history of religious beliefs and revolutionary traditions. The word has weight and density.

So does the word "war," and all of the images and practices associated with it. I am particularly concerned with the language of glory in time of war, and the progressive separation of the two over time in some places but not in others. We all know that the institutions of war have mutated over time, but what is less evident are the many ways in which, over time, different words become attached to and at times detached from war. One such word is "glory." Again, I must delimit my claim. In some places, but not in others, war and glory have parted company and have gone their separate ways.

This story is not at all uniform; it is full of inflections and deflections, which are striking in comparative perspective. If I had

the linguistic competence, I would provide material concerning many languages, but given my own limitations, I leave this exercise to those who are able to do so.

Instead, let me start with the use of the word in a film which appeared in the United States in 1989. It was entitled *Glory*, directed by Edward Zwick and starring a host of African-American stars.[1] It is my claim that this film was so soaked in a particular facet of American history that it simply could not have been made or named in the same way anywhere else. The American term "glory" carries with it an avalanche of local meanings.

Who could miss the echoes of Martin Luther King's speech "I have a dream" in Washington on August 28, 1963? He used the word "glory" just once, but it was there throughout: "I have a dream that one day every valley shall be exalted, and every hill and mountain shall be made low, the rough places will be made plain, and the crooked places will be made straight"; "And the glory of the Lord shall be revealed, and all flesh shall see it together." Isaiah 40:5, trumpeted to mark the century since the abolition of slavery in the United States in the midst of the Civil War.

Such a film, with such a title, made sense in one semantic universe but not in others. The word "Glory" sounds right in a nation whose flag carries the same name, Old Glory, and where there hasn't been an invasion since the British burned down the White House in 1814. It sounds right in a country where the language of the Civil Rights Movement was soaked in the rhythms of the Baptist Church; of what we now term gospel music. But the word "glory" does not sound the same to other ears in other countries. Why? Because language frames memory. Words carry particular stories with them, and those stories vary from place to place and from language to language.

Whatever language we utter, we speak differently of war. I take English and French as my points of reference. Those learned in other languages can test this hypothesis easily enough. My claim is that languages of war, like those of peace, are neither interchangeable nor are they transparently equivalent. Each brings its history, its music, its memory of the past with it. We have many languages of war, and once we realize that, we can register the uncomfortable fact that the

[1] On this film, see Robert Burgoyne, *Film nation: Hollywood looks at U.S. history* (Minneapolis: University of Minnesota Press, 2010), pp. 17–37.

mountain of literature we have about war is one of the real towers of Babel of our time.

In order to persuade you that language frames memory, I address one question which highlights such linguistic and cultural differences. The question is this: Why does Britain have Great War "war poets" understood as a compound noun, while all other combatant nations have poets who wrote about war, individually and not collectively? The answer in part, I believe, lies in the different connotations and denotations of the word "glory" in different languages. That is the key to my argument.

The focus of this chapter is a single question: Why is it that a selection of British war poetry written during or about the 1914–18 conflict still serves, a century later, as a British cultural archive of popular images and phrases associated not only with that war, but with war as such? Archives are always selective, and this one is no exception. By no means all war poetry was written by trench soldiers, and by no means did all trench poetry enter the canon, but over time, a loosely defined set of such poems took on a metonymical function; the part stood for the whole. Why and how did this happen?

One reason that this small selection of soldiers' war poetry became iconic is that it struck then as now a popular chord. It captured a sense, widely, though not universally, shared after the Armistice, that the war was an exercise in futility, and that older languages of grandeur and glory had to be recast in the light of what soldiers saw and felt during that war. That recasting is in part the achievement of war poetry. In effect, what the British war poets did was clean up the English language, degraded by propaganda and civilian euphemism concerning events and cruelties most people at home could hardly imagine. War poetry brought the language of industrialized war down to earth, down to the muddy terrain of the Western Front, and thereby provided a specifically British poetic pathway beyond glory. In a moment, I will suggest that slow but measurable changes in the British language of glory – as opposed to the French or the Irish – provided the framework for their work and for its resonance, its lingering appeal.

Here I am following in the footsteps of Paul Fussell, who set in motion many arguments about the disappearance of what he terms "high diction" in the period of the Great War.[2] Fussell's work invites

[2] Paul Fussell, *The Great War and modern memory* (Oxford University Press, 1975).

comparison of the kind provided here related to the emergence, dissemination, institutionalization, and canonization of the very different vernacular about war provided by that group of soldiers who wrote what we call "war poetry."

In no other country did the vast array of poetry produced during the Great War yield such a discrete body of writing, constituting for Britain what Jan Assmann has termed a repository of "cultural memory." Here is his understanding of the term: "Cultural memory has its fixed point; its horizon does not change with the passing of time. These fixed points are fateful events of the past, whose memory is maintained through cultural formation (texts, rites, monuments) and institutional communication (recitation, practice, observance). We call these 'figures of memory.'"[3] In countless cities, villages, and towns in Britain and Northern Ireland, such "recitation, practice and observance" time and again have linked the words of the war poets with public remembrance of the Great War. It is in this sense that we can speak of a body of poetry written by soldiers of the Great War as having provided a kind of "cultural memory," a timeless register of terms and images through which later generations still frame their understanding of the 1914–18 war and its aftermath. My claim is that what Jan Assmann terms "cultural memory" operates differently in different languages.

It is partly in language, and partly in history, that we can find part of the answer to the question as to why there is voluminous poetry about the 1914–18 conflict throughout the world, but "war poetry," understood as a compound noun, a discrete corpus of writing, only in Britain. A journey across the Irish Sea may help in this quest.

In 1936, William Butler Yeats explained the omission of the poetry of Wilfred Owen from his *Oxford Book of Modern Verse* in these terms:

> I have a distaste for certain poems written in the midst of the great war; ... The writers of these poems were invariably officers of exceptional courage and capacity, one a man constantly selected for dangerous work, all, I think, had the Military Cross; their letters are vivid and humorous, they were not without joy – for all skill is joyful – but felt bound, in the words of the best known, to plead the suffering of their men. In poems that had for a time considerable fame, written in the first person, they made that suffering their own.

[3] Assmann and Czaplicka, "Collective memory and cultural identity," pp. 125–33.

> I have rejected these poems for the same reason that made Arnold
> withdraw his "Empedocles on Etna" from circulation; passive suf-
> fering is not a theme for poetry. In all the great tragedies, tragedy is
> a joy to the man who dies; in Greece the tragic chorus danced.[4]

When he learned that some were shocked at the exclusion, he elaborated
on his Olympian disdain for Owen, calling him "all blood, dirt &
sucked sugar stick" and judging him to be "unworthy of the poets'
corner of a country newspaper." He famously concluded: "There is
every excuse for him but none for those who like him."[5]

I want to suggest that the "excuse" for him and for those who
admired him in Britain was that Owen's work operated within
a linguistic grammar and register of emotion different from that of
Yeats and many other writers in Ireland and on the Continent. This is
not to say that there was only one voice in which either Yeats or other
Irish poets spoke on this subject; it is rather that the shadings of meaning
read into war differed in Ireland and in Britain, for the simple reason
that their histories and their language diverged in important ways.
The same, I believe, is true of French writers. The point here is to
highlight what was particularly British by stepping outside of its literary
and historical boundaries.[6] When we do so, we can see that the British
register of what came early on to be termed "war poetry" moved
"beyond glory," or in Yeats's language, beyond the "tragic joy" he
believed to be at the heart of poetry.[7] "Tragic joy" was not the register
of Owen or of much of British war poetry, because life in the trenches
had blown such a notion to pieces.

Yeats's choice paradoxically highlights the character of much
British poetry of the Great War and the reasons why a socially con-
structed corpus of work became central to the way later generations in
Britain have imagined the 1914–18 conflict. The war poets pointed to
a way beyond glory, at the very moment the word had lost its purchase
in describing the fate and fortune of the men who had fought in the

[4] W. B. Yeats, *The Oxford Book of Modern Verse* (Oxford University Press, 1936), p. xxxiv.

[5] *Letters on poetry from W. B. Yeats to Dorothy Wellesley* (Oxford University Press, 1940), p. 113.

[6] Thanks are due to Sarah Cole for her comments here and elsewhere.

[7] Roy Foster, *W. B. Yeats. A Life*, vol. II, *The Arch-poet* (Oxford University Press, 2003), pp. 555–58.

Great War. That was their achievement, and the reason their work has had such enduring resonance among generations of readers.

The significance of this poetic archive of the war is independent of the representative character of the writers or of their views. Much ink has been spilled unnecessarily in arguing that the war poets' words are misleading in constructing the way "ordinary soldiers" saw the war.[8] Skeptics argue that Owen and company did not share the working-class attitudes of the overwhelming mass of soldiers who served in the ranks. Such men, they hold, had lived difficult lives, and living in a ditch in Flanders was not fundamentally different from living in urban or rural poverty before 1914. They were proud of their war service, and did not shrink from boasting about it. Whether or not these claims are true is beside the point. What matters is that the words of the war poets reverberated; and millions of readers have been drawn to their work, still in print long after the Armistice. What the Germans term *Rezeptionsgeschichte* matters.[9] Cultural archives are selective by nature; inclusion and exclusion reflect very broad trends in the consumption as well as in the production of texts, independent of their authors. Unlike the "Auden generation"[10] or artistic circles like the Fauves or the Impressionists, many war poets died before they could have a say about being placed in a group of fellow soldier-writers. That the British war poets have entered the English-language cultural archive is indisputable. Why there and not elsewhere?

One answer is that the British war poets spoke a certain kind of English, a poetic language which was precisely that – English rather than French or German or Irish or American English. In this part of his work, Yeats, who after all wrote his own war poetry, had his own views about modernism which made him dislike Owen among others. Though Yeats spent a good deal of the war in London, he nonetheless inhabited a poetic and literary space closer to that found in France than to that found in Britain during and after the war.[11] It is ironic, a word Fussell loved, that the great modernist Yeats may have been less "modernist"

[8] Corelli Barnett, "A military historian's view of the Great War," in *Essays by divers hands. Transactions of the Royal Society of Literature*, n.s. 36 (1970), pp. 1–18.

[9] Gunter Grimm, *Rezeptionsgeschichte: Grundlegung einer Theorie: mit Analysen und Bibliographie* (Munich: W. Fink, 1977).

[10] Samuel Hynes, *The Auden generation: British writing in the 1930s* (Harmondsworth: Penguin, 1988).

[11] I am grateful to Nicholas Allen for his advice on this point. See his *Modernism, Ireland and civil war* (Cambridge University Press, 2009).

when writing about war than were what he saw as middle-brow poets like Owen and Sassoon. Perhaps too Yeats disclosed the ambivalence of many Irishmen beset by the difficult task of writing both about the war and the 1916 "Rising."

Many Irish and French writers still saw "glory" in war, in part because it was still possible to use that rhetoric and for two principal reasons. First, writers in both countries had at their disposal an older revolutionary rhetoric which they adapted to the issues of the day; and secondly, Roman Catholicism kept the notion of "glory" alive among communicants and freethinkers alike in both civil war Ireland and Republican France, but not in Britain in the same way or to the same degree.

When Yeats wrote of the men of the 1916 insurrection, he claimed that "a terrible beauty is born." In doing so, he was speaking out of a romantic tradition of nineteenth-century insurrections alive not only in Ireland but also in France. Here is Victor Hugo's paean to glory in his 1831 poem "Chants du crépuscule," honoring those who died in the revolution of the previous year:

> Ceux qui pieusement sont morts pour la patrie
> Ont droit qu'à leur cerceuil la foule vienne et prie.
> Entre les plus beaux noms leur nom est le plus beau.
> Toute gloire près d'eux passe et tombe éphémère;
> Et, comme ferait une mère,
> La voix d'un peuple entier les berce en leur tombeau.[12]

That revolutionary language had little resonance in Britain, and so did the Catholic romanticism of Patrick Pearse and his brethren. War poetry in England had the room to move beyond glory because British political, religious, military, and literary traditions created an entirely different cultural environment out of which a variety of poetic and prose reflections of the Great War emerged.

I want to suggest, therefore, that the French word "gloire" is not the same as the English word "glory," and that the difference may arise in part from history and from the distinction between Catholic and

[12] Victor Hugo, Œuvres complètes: Les Feuilles d'automne. Les Chants du crépuscule. Les Voix intérieures. Les Rayons et les Ombres (Paris: Ollendorf, 1909), vol. XVII, pp. 203–4.

Protestant usages and connotations. Here is a plaque from the village church at Auvers-sur-Oise, a church made immortal by Van Gogh's rendering of it. The plaque captures the voice of the village priest:

> Hommage d'affectueuse reconnaissance à mes chers enfants que j'ai élévés dans l'amour de Dieu et du Patrie, ils sont tombés glorieusement au champ d'honneur.
> Gloire à DIEU!
> Gloire à notre France immortelle!
> Gloire ici base et là Haut à ceux qui sont morts pour elle.
> Ceux qui pieusement sont morts pour la Patrie
> Ont droit qu'à leur tombeau la foule vienne et prie,
> Entre les plus beaux noms leur nom est le plus beau!
> Reposez en paix, mes chers enfants.
> Dormez dans la gloire!!!
> Votre vieux Curé bien fier de vous,
> Qui n'a jamais désespéré de la victoire.

I hesitate to translate this passage, since my intention is to compare and not to mock. It is evident that the Curé is drawing both on his faith and on Victor Hugo's poetry, in particular his "Chants du crépuscule" of July 1831, honoring those who died in the revolution of the previous year, and who were illuminated in the light of the glory of the revolutionary tradition.

The vicar of Auvers-sur-Oise used words found in hundreds of war memorials throughout France. Consider in contrast very different English words in the inscriptions parents chose for carving on the tombstones in the archipelago of Imperial (now Commonwealth) War Graves cemeteries. Here is one phrase chosen by the parents of one British soldier who died in the northern part of the Gallipoli peninsula during the landing at Suvla Bay in the summer of 1915. The parents of J. M. Browne, of the Derbyshire Regiment, who died there, declared his death was "not [for] glory, but [for] a purpose" (Illus. 4.1). The war poets captured this significant shift in ways vernacular English framed the carnage of the First World War.

Let me add some statistical evidence in support of my argument about British attitudes to and reference to "glory." Together with a consortium of universities, Google has created a unique statistical data base, composed of 6,000,000 books produced between 1800 and

2000, every page of which has been scanned in machine-readable form. We can search these 2 billion words easily, through Google n-grams, or graphs, where *n* means the number of occurrences in print of a particular word in a particular year. User-friendly software enables us to compare the frequency of use of different words over time in a very large corpus of published books.[13]

Let me first acknowledge an objection to this statistical approach. The appearance of words in printed books does not mean that they were read. We are measuring here the likelihood that certain words appear in print, but have no way of converting patterns of publishing certain words into patterns of reading them. My response to this valid response is to urge modesty. To know what a society prints in its native tongue in any one year is to know something about the archive from which readers take their vocabulary. The market of choice is still robust and unmeasurable at the level of single words. As we shall see in Chapter 5, where we again make use of Google n-grams, there are striking differences in the appearance of the word "martyr" over time in a number of languages. All we can say is that such differences convey the printed vocabulary of English, German, or Hebrew, but these spoken languages are still too elusive to be captured in statistical form. What we present here are limited claims about printed books, and the words that appear in them over time. The findings, I believe, while limited, are still significant in pointing toward differences over time and space in the printed vocabulary of societies at war.

Contrasts

I first present two comparisons (Figs. 4.1 and 4.2; at the end of this chapter): one for the word "glory" and "glorious" in British English over the period 1900–1930, and a second for "gloire" and "glorieux" in French over the same period. The upward inflection in the recourse to "gloire" contrasts strikingly with the slow decline in the use of the word "glory" in British English. In the second set of graphs (Figs. 4.3 and 4.4; at the end of this chapter), the contrasts show the same pattern, though

[13] Jean-Baptiste Michel et al., "Quantitative analysis of culture using millions of digitized ooks," *Science*, 331 (2011), pp. 176ff.

set against the years 1800–2000. The peak of "gloire" in French in the whole of the twentieth century is during the Great War; in contrast, "glory" in British English has declined in virtually a linear fashion from the Victorian years to the present. If we look to the *longue durée*, we can see other variations. Over the period 1800–2000, "glorious" is more robust than "glorieux," and the post-Napoleonic peak of "gloire" anticipates Victorian "glory" before both enter their long decline, interrupted in French by a rise in "gloire" during the Great War.

It is important not to overinterpret these findings. First, the difference between the French and English trends are slight, though palpable. Secondly, the nineteenth-century findings are more robust that the twentieth-century ones. I take these dates as useful for posing questions. The answers to these questions must be found in a variety of other sources.

To be sure, the presence of a word in a book does not establish its weight or its significance, but these data are consistent with my argument that language patterns vary over time and in different linguistic spaces, and so do the way different languages encode widely disseminated messages both about war in general and about the Great War in particular. In a nutshell, language frames memory.

Now let me add to this body of data some comparisons which further establish the parameters of a comparative semantic history of words associated with war and those who die in war. Let us first examine words that may have filled the space previously occupied by "glory." Figure 4.5 puts "glory" alongside "duty" and "honour" and charts the relative frequency of the appearance of each of these words over the years 1900–1950 in British English. We can see that as "glory" and "honour" decline, "duty" goes up before descending gently. Is it the case that "duty" fitted conscription and twentieth-century warfare whereas "glory" and "honour" were more suitable to naval warfare and a volunteer army? Perhaps. It is also possible that the increase in the use of the word "honour" coincided with the construction of thousands of war memorials and cemeteries of the Great War dead in the 1920s, though there are no doubt multiple sources. When we look at the long-term graph of these three terms in British English (Fig. 4.6), we see that the decline in "honour" during the First World War was striking during the war and even more precipitate than the decline in "glory." We can also see that the cumulative decline in the usage of the two terms accounts for the increase in "duty" at the same time.

Now let us compare this "family" of words associated with war and military service, this time in French (Fig. 4.7). I have made it a foursome this time, and the French graphs show no displacement effect of one word going up in frequency of usage, while others go down. All four words – "gloire," "honneur," "devoir," and "courage" – rise and fall together, noticeably during the First World War, and more modestly during the Second World War, as befits a country occupied and humiliated. Over the long term, "gloire," "honneur," and "devoir" cluster together, well above the usage of "courage," in the Napoleonic and Romantic period, and all decline slowly, with the exception of inflections in wartime, 1859, 1870, 1914–18, and 1940–44. Overall, "devoir" and "honneur" maintain their lead over both "gloire" and "courage," perhaps reflecting the increasingly secular character of Republican life. But when the call to arms occurs, all four words, as it were, rise to the occasion.

Now let us turn to the case of German, which presents different characteristics (Fig. 4.8). To be sure, there was censorship of published books in Britain, France, and Germany in both world wars, but the workings of the German state appear to be reflected particularly clearly in the Nazi period. We have seen that the set of words associated with martial virtues – "glory," "honor," "duty," "courage" – went up in French during the First World War. The German case shows something strikingly different: a modest inflection during the 1914–18 war, and a major inflection in the Nazi era and especially during the Second World War. My guess is that the Nazi state placed an iron fist around the necks of publishers, who either believed in the party line, or genuflected in its direction. That is why all four terms associated with martial valor move in the same direction, lock-step, like a Nazi parade. The alternative interpretation is that this graph suggests mass support of Nazi values, or probably distinct military values, in a war of survival.

What can we conclude from this brief exercise in the quantitative history of semantics? Not much; statistical findings suggest questions, not answers, which must be sought from other sources. So the question which emerges now is why was there a decline in the use of "glory" both over the long term and during the First World War in Britain, though not in France?

Again, we must be cautious here, and pose the question as to whether "glory" was an outlier, or an unusual case of vernacular atrophy. I have rejected this conclusion for a simple reason.

The decline in references to "glory" in British books is matched by a decline in the use of other similar signifiers: "empire" and "imperial" declined from the 1880s on; so after 1900, did "bravery" and "courage," along with "crown," "monarchy," "Royal and Royalty." This is not to say that Britain was any less an imperial monarchy in 1920 than it was in 1880; it is just that the language of imperial and monarchical grandeur appeared in published books in Britain less frequently in the early twentieth century than before, and that that decline continued throughout the century. Going beyond glory was in step with the times, at least as measured by the written and published word.

My argument, then, is that the war poets helped to disseminate a nonglorious lexicon about war. The ground had been prepared for them to do so. "Glory be to God for dappled things," wrote Gerard Manley Hopkins in 1883. The word "glory" frequently operated in a sacred register. The war poets took the language of the Bible and turned it to new uses in their meditations on war. They did not turn away from Scripture, or from romantic tropes, but refashioned them in order to frame an angry indictment of those who let the war go on.[14]

Nothing like the King James version of the Bible exists in France, where a divided nation shared two robust yet contradictory traditions – the Catholic and the French Revolutionary tradition. Each had its own rhetorical life in nineteenth-century France, and each had its own version of glory at its core. In contrast, by 1900, despite pride in the Empire, and the literature of the Raj, glory was becoming an outmoded, even an archaic, word in England, conjuring up martial images, to be sure, those of Crispin Crispian's day in *Henry V*, of Gloriana, the first Elizabeth, and the Glorious Revolution. All once glorious perhaps, but hardly the signature (outside of Protestant Ireland) of a trading nation without a standing army, and whose powerful navy had the great advantage of doing her work at sea and abroad. Perhaps the Crimean War had knocked the stuffing out of the word "glory," despite Tennyson's six hundred; the first war photographs and reports of shocking sanitary conditions of army encampments in *The Times* trampled on notions of "glory," as did many of Kipling's words about Tommy Atkins. There were many words one could use about the Boer War of 1899–1902, but "glory" or "glorious" is not one of them, except

[14] Jay Winter, *Sites of memory, sites of mourning: The Great War in European cultural history* (Cambridge University Press, 1995), ch. 8.

in the gentle mockery of Gilbert and Sullivan about who was or was not an Englishman. In the Edwardian period, conscription was the mad dream of a small group of Conservatives, and military service in no way constituted a pillar of citizenship, as it did in France. When Elgar and Benson wrote "Land of Hope and Glory" in 1902, they were trying to revive a set of images and impulses slowly but surely fading away.

The contrasting history of the two countries lay behind the fact that the French word "gloire" is not in any meaningful sense the equivalent of the English word "glory." In 1914, the two words carried different associations and had very different echoes. True, the royal anthem spoke of the king as "happy and glorious," but I suspect that that choice of words arose out of finding a suitable partner to "victorious"; the alternatives are appalling – vainglorious, uxorious, stentorious, and so on. In addition, church rhetoric was fading as political rhetoric in Britain. There was in late-Victorian and Edwardian Britain a movement away from church attendance which caused the Anglican Church no end of worry. There was a similar decline in the number of parishioners taking mass in France every Sunday, but in Britain, the language of politics was less and less about religious sentiment and more about social class.[15] The Dreyfus affair ensured that Catholicism and Republican values remained at war until 1914.

My claim, therefore, is that the war poets wrestled with the notion of "glory"; indeed, they wrestled it to the ground in ways that did not happen elsewhere. Glory has a history, and so do the attitudes which lay behind it. That history is different in Britain, France, and Ireland. And in a host of other countries too. My linguistic competence limits me to a small part of Western Europe, but my claim is broader and open to interrogation and comparison.[16] Changes in English usage, I claim, made the language of British war poetry ring true in Britain. It is hardly surprising, I believe, that it has taken a full century to get some British war poetry into French, and then only partially. French war poetry works differently, because the language of glory was and to a degree is still alive. Not so in Britain. It is in these subtle cultural differences that I seek an explanation for the fact that while there is a substantial corpus of poetic works written by French soldiers during and after the war,

[15] Gareth Stedman Jones, *Languages of class: Studies in English working-class history, 1832–1982* (Cambridge University Press, 1983).

[16] See Geert Buelens, *Everything to nothing: The poetry of the Great War, revolution and the transformation of Europe* (London: Verso, 2015).

there is no such thing as a group of "war poets." Different educational structures mattered, with different emphases on the teaching of poetry and the classics, and so did different approaches to citizenship and the army.

To be sure, a group of French "war poets" could indeed have emerged using a specific rhetoric of their own. The fact that no such group emerged in France tells us something about the strength of multiple lexicons concerning war in French discourse. The heroic and the "glorious" registers jostled for position with the pacifist and internationalist ones in France in different ways than they did in Britain. Political conflict in Third Republic France was much more ferocious than in interwar Britain.

The Second World War deepened these differences too. Britain was indeed fighting for her existence in 1939–40, just as was France, but in Britain the language of war was self-deprecating and decidedly civilian. Prose captured this language of national determination, either through the sonorous speeches of Churchill or the essays of Orwell and J. B. Priestley. In contrast, the French resistance earned the right to use the language of glory, though de Gaulle's exaggerated position that all of France resisted in one way or another could not stand the scrutiny of historians who engaged in myth-breaking work shortly after de Gaulle's death in 1970. What Henry Rousso calls the "Vichy syndrome" can be seen as a set of still smouldering debates about French glory or ignominy in the Second World War.[17] In short, British military victory in the two world wars enabled the term "glory" to depart the scene, quietly, as it were, in a very British manner. "Glory" survived in France in part for long-term historical reasons, and in part because the bloodbath of the Great War and the humiliation of defeat and occupation in the Second World War created an unstable rhetorical landscape which to a degree exists to this day.[18]

In the tradition of Reinhart Koselleck and *Begriffsgeschichte*, or the history of concepts,[19] I argue that "glory" and "gloire" operate in different semantic systems, carry different connotations, redolent with images and emotions arising out of different revolutionary and

[17] Henry Rousso, *The Vichy syndrome. History and memory in France since 1944*, trans. Arthur Goldhammer (Cambridge, Mass.: Harvard University Press, 1994).

[18] I owe much to John Horne for his insights on this and many other matters.

[19] Reinhart Koselleck (ed.), *Historische Semantik und Begriffsgeschichte* (Stuttgart: Klett-Cotta, 1979).

religious contexts. The literary and mental furniture many British soldiers brought with them to the front was not the same as that French or German (or other) soldiers carried with them. True enough, British soldiers had a reservoir of swashbuckling tales of imperial conflict from which to draw, and many could recite Kipling's verse "though I've belted you and flayed you, by the living God that made you, you're a better man than I am Gunga Din." But the Raj was a long way from the Somme and Passchendaele; "glory" was the stuff of other times, other places, other nations, with other histories and other sacred texts.

To be sure, British war poetry is not one thing; it emerged in stages, over time. It is important to note a slow and uneven evolution of war poetry, from that written during its first year to that reflecting the great offensives of 1916–18. The poetry of Rupert Brooke, Julian Grenfell and Patrick Shaw-Stewart antedated the failed attempts in the last two bloody years of the war to break through German lines in Picardy and in Flanders. Shaw-Stewart helped bury Brooke on Patmos, and wrote "Stand in the trench, Achilles," a phrase harder to swallow on the Western Front, which formed the setting for much of the work of the later war poets – Owen, Sassoon, Rosenberg, Gurney.

This development from early to later war poetry is not uniform; language does not march in step over time. And yet, with some notable exceptions, it is apparent that "glory" got a bad name during the war, and British war poetry was in part responsible for that. Yes, Brooke's "The Dead" is a counterexample. His verse is unambiguous: "He leaves a white / Unbroken glory, a gathered radiance." In contrast, Julian Grenfell does not use the word "glory" even once in "Into Battle," where we would expect such a word. He praises "courageous hearts," "nobler powers," the "joy of battle," but not glory. The word is absent in Hardy's "Men Who March Away."

Owen uses the word "glory" several times, perhaps most memorably in "Dulce et Decorum Est." We all know his appeal "To children ardent for some desperate glory," to turn away from the old lie and to stare at the ugliness of war. Less celebrated, but equally powerful, is his account in "Smile, smile, smile," of the reaction of "half-limbed men" reading a press report from Westminster, where, Owen imagines, they say: "We rulers sitting in this ancient spot / Would wrong our very selves if we forgot / The greatest glory will be theirs who fought." Reading this nonsense, disabled men "smiled at one another curiously / Like secret

men who know their secret safe." And yet, Owen also wrote in
"Apologia Pro Poemate Meo" of the faces of dying men. "War brought
more glory to their eyes than blood / And gave their laughs more glee
than shakes a child." But, Owen insists, theirs was a private language,
beyond the rest of us:

> except you share
> With them in hell the sorrowful dark of hell,
> Whose world is but a trembling of a flare
> And heaven but a highway for a shell,
> You shall not hear their mirth:
> You shall not come to think them well content
> By any jest of mine. These men are worth
> Your tears: You are not worth their merriment.

In a misogynistic vein, Sassoon wrote that women were not worth their
merriment either. In "The Glory of Women," he scoffed: "you believe /
That chivalry redeems the war's disgrace" and need to keep notions of
heroism alive, without the slightest inkling of what a dismembered
corpse smelled like. Glory was not embedded in war; it lived, if at all,
only in the fellowship of those who suffered together, and who shared
the horrors of combat.[20] War poetry was a language of bereavement
and of separation, from the dead and from an older, archaic language of
glory in the process of fading away.

This move beyond "glory" in war poetry marks a boundary
between British and Continental poetic responses not only to the Great
War but to other wars. In France twenty years later, there was
Resistance poetry, which to an extent had a collective character, in
part arising out of the strength of the Communist Party and the role it
played in the *Maquis*. But in 1914–18, even when the invasion of France
gave every reason for Frenchmen to view the war as a calamity inflicted
on them by Germany, there still was no outburst of soldiers' poetry
which turned into a collective body of work.

The language of glory is undercut by dissent. And dissent during
the war was much more muted in France than in Britain. With military
service as the price of citizenship from 1848 on, refusal to serve was
tantamount to betraying the sovereign people. Not so in Protestant

[20] Thanks are due to Santanu Das for his suggestions on this point.

Britain, where the strength of the call to arms in 1914 and 1915 was that it was voluntary. And when the need for men made conscription necessary, provision was made for those who could not in conscience bear arms and take the lives of other men. Here too we find a distinct contrast between British and French military practices and traditions. In France, the notion of conscientious objection was virtually unknown in 1914, and remained so throughout the century. In Britain, the dissenting tradition was robust, and in both world wars, objections on grounds of conscience were duly recognized in law, when they arose from undisputable transcendental or clear religious convictions.

The war poets were dissenters in another sense, one which arose out of moral considerations rather than religious ones. In a secularizing nation, the war poets reconfigured conscience outside of conventional faith. Their secular beliefs and their eyes led them to indict the war and the men who allowed it to go on for fifty bloody months.

The war poets were not pacifists; if they had been, they would not have been in uniform. Their active service gave them the moral authority to denounce that war and the suffering it caused. Their references to shell shock are part of their dissenting legacy. A war which, by its very industrialized nature, drove perfectly sane men mad was one which had redefined what bravery and honor meant. A new "anatomy of courage," in the words of Charles Moran, had to be described, and the war poets did so, bearing in mind the faces of "those whose minds the dead have ravaged," in Wilfred Owen's phrase. War poetry helped introduce the term "shell shock" into the lexicon of war, where it remains to this day. Not so elsewhere. Iconic language is language which finds a niche in the vernacular. What better instance of this is there than the British war poets' reference to the awkward, puzzling, frightening, and stigmatized category of psychological injury in war? Revealingly, there is no equivalent French poetic or other literary response to the recognized medical category of shell shock; *choc traumatique* simply does not carry the same connotations.

Owen, Sassoon, Gurney, Rosenberg did not write as a group, though in some instances they wrote together and were published in the same books. Furthermore, none of the war poets had the slightest idea they were writing canonical texts; that was not the way they were written, but it is the way they have been read, taught, mastered, set to music, and passed on to younger generations. Even in the twenty-first century, after every single soldier who fought in the war had died, the

war poets still are quintessentially English figures. They are indeed among Assmann's "figures of memory": the sentinels of the two minutes' silence of Armistice Day. They seem to stand guard over the nation's acknowledgment, or active knowledge, its re-cognition, its eternal return to and remembrance of the catastrophe of 1914–18.

Why did the Second World War not produce its company of British war poets? There were those who left poetry of great power and technical skill, but the collectivity "war poets" we have described emerging out of 1914–18 has no British analogue for the Second war. One explanation is that poetry is a form of commemoration, and British commemoration after 1939 suffered from a particular problem. First World War writing and commemorative sculpture were bathed in the language of never again; those who gave their lives did so in order that their children would not have to do so in their turn. And then Hitler made "never again" vanish into thin air. "Never" lasted twenty-one years, and thereafter war casualties were heavier among civilians in Britain than in the military, at least until D-Day in 1944.

This sense of a disappointed antiwar spirit may help us understand why Second World War commemoration, and English poetry within it, returned to the Great War poets. The war against Japan was a more complex subject, with racial and imperial overtones, but the victory over Hitler was both one which had to be won with gritted teeth and the consequences of which had to be endured. The language of that endurance was already there: the Great War poets had provided it.

And so it was perfectly natural that when Benjamin Britten, a pacifist composer, wrote his "War Requiem" for the reconsecration of Coventry Cathedral in 1962, he would turn to the poetry of Wilfred Owen to complement and renew sacred texts. In the midst of "Requiem aeternam," right at the start, we hear a tenor rendering "What passing bells for these who die as cattle? /Only the monstrous anger of the guns." Then in the "Dies irae," the baritone recites: "Bugles sang, saddening the evening air; / And bugles answered, sorrowful to hear." In the "Offertorium," we find Owen's Abraham, whose hand was not stayed by an angel, "but slew his son, and half the seed of Europe one by one." In the "Libera me," we hear Owen's "strange meeting" with "the man he killed." This braiding together of the Latin *Missa pro defunctis* with fragments of Owen's poetry was not only extraordinarily powerful, but it gave a new impulse to the afterlife of the "war poets," just in the run-

up to the fiftieth anniversary of the outbreak of war in 1914, a moment from which a new "memory boom" devoted to the Great War was about to take off.[21]

On Armistice Day 1985, a plaque was placed in Poet's Corner in Westminster Abbey to sixteen men who wrote war poetry about and during the Great War.[22] What better representation is there of the canonization of the war poets? School curricula have ensured that the younger generation has the chance to be exposed to this "cultural archive" of the nation's past. In 2012, one of the four awarding bodies responsible for the Advanced level course in English literature offered students "World War One literature" as one of four options from which they could choose for the examination.[23] Other awarding bodies offered similar options on war poetry for A-level pupils in English literature.[24] Websites of sixth-form colleges present syllabi and reading materials for those who make this choice.[25] Many similar instances can be cited. To be sure, a common education may be a body of learning we have all forgotten over time. But it is the music of the words, the cadences of the poems, which linger, at times subliminally, at times with direct effect, long after schooldays. And those sounds and gestures, half remembered, half forgotten, help us to see how deeply embedded the poetry of the Great War is in the ways substantial numbers of men and women think about their country's past.

The Afterlife of Glory

In conclusion, it may be useful to tie some of these threads together and to speculate yet again on the peculiarities of the English. One explanation for the English *Sonderweg* is the extent to which the classics and literature

[21] Jay Winter, *Remembering war: The Great War between history and memory* (New Haven, Conn.: Yale University Press, 2006).

[22] In alphabetical order: Richard Aldington, Laurence Binyon, Edmund Blunden, Rupert Brooke, Wilfrid Gibson, Robert Graves, Julian Grenfell, Ivor Gurney, David Jones, Robert Nichols, Wilfred Owen, Herbert Read, Isaac Rosenberg, Siegfried Sassoon, Charles Sorley, Edward Thomas.

[23] January 2012 1741/2741 English Literature A (AS and A2), www.aqa.org.uk/qualifi cations/a-level/english/english-literature-a.php

[24] Unit F661, www.wjec.co.uk/uploads/publications/8144.pdf

[25] Just one instance among many: www.tomlinscote.surrey.sch.uk/documents/ 6thFormCoursesBooklet-Sept2012.pdf

dominated elite education in the period prior to the Great War. Rhetoric, usually classical rhetoric, the historian of education Antoine Prost tells us, was more central to the curricula of the public schools of England than to the great *Lycées* of France or the *Gymnasia* of Germany. Partly, this was a function of educational reforms. In France, the Third Republic added geography and history as focal points of the school curricula, and thereby lessened the time and space left for the classics. In Germany, the sciences had a position in the school curricula and in university life that was superior to that in her competitors'.

These themes are worthy of further research, but they are too imprecise to be satisfactory. Knowledge of the classics led in many literary directions, and Thucydides or Tacitus, not to mention Homer, echo in the prose and poetry of war writers of many different nationalities and temperaments. Furthermore, it makes less sense to speak of the structure of elite education than to tease out what those who went through it took out of their schooling. The sources of what James Joll termed the "unspoken assumptions" of 1914 were diverse and certainly not limited to schooling.[26] Even among elites, tastes in poetry or prose were idiosyncratic and not programmed by formal schooling.

There is a more directly political matter which may have been more important in separating national traditions. The outcome of the war, and its staggering human costs, left deeper and more lingering doubts in Britain as to the meaning of victory. French men and women had little doubt as to the justice and necessity of expelling from their land an invading army which treated the captive population the way all invading armies had done before. The meaning of victory was less troubling too in parts of the Dominions. Soldiers who had fought for Australia and Canada by fighting for Britain retained their laurels as the founding fathers of their allied though more fully independent nations.

In addition, there was a fundamental divide in France that was not at all evident in interwar Britain. The veterans' movement represented perhaps half of the 8 million men who served in French forces; in Britain the figure is closer to one-tenth of the 6 million men who served. The French veterans' movement mattered politically, socially, and culturally, especially at the local level. Most of its members had little time for glory, but the rest of French society saw the war differently. They

[26] James Joll, *1914: The unspoken assumptions* (London School of Economics, 1968).

celebrated victory and the return of Alsace and Lorraine. And they recognized that they owed a debt to those who had fought, a debt which made it impossible for civilians to say to soldiers that they had fought for nothing. For civilians, the men in arms had suffered and died to liberate their country, invaded and occupied for four long years. True enough, some of the most widely read war novelists in France, like Henri Barbusse, were pacifists, but others were neither antiwar nor merchants of glory.[27] The absence of war poets in France may have been due to lack of a public prepared to denounce the war root and branch, for fear of not discharging their acknowledged debt to *ceux de '14*.

Among defeated countries, the meaning of the war was hardly ambiguous. Two million German soldiers had died for nothing; the same was true for 1 million men who died while serving the Austro-Hungarian monarchy. Italian nationalists were outraged at their treatment at Versailles, where, despite the loss of 600,000 men, their territorial ambitions were thwarted.

In other cases, defeat led to a heroic new lease on national life. In post-Ottoman Turkey, a proud national movement under Atatürk arose directly and heroically out of the ashes of defeat. And the acceptance of defeat at Brest-Litovsk gave the Bolshevik regime the space and time it needed to assure its existence by winning the civil war and establishing in its wake the USSR. Muscular militarism may have been the enduring legacy of the war and its postwar upheavals in Eastern Europe.

Only in Britain did the debate about what the war had achieved stimulate such ambivalent attitudes. To Ted Hughes, the war was a defeat around whose neck someone hung a victory medal. The shock of war losses was so severe that the notion of a pyrrhic victory made sense. No nation could survive another such episode of gallant sacrifice. And once the early economic troubles of the 1920s turned into the interwar depression, once the brotherhood of arms turned into the embitterment of the General Strike of 1926, then what possible benefit the British people had gained from their victory became a question without an answer. War poetry expressed this ambivalence. It was proud, elegiac, angry, dedicated to protecting from trivialization the memory of men pushed beyond the limits of human endurance in a war which placed metal against men and assured that the men would lose. It offered a semisacred epitaph to the Lost Generation, and offered it up

[27] I owe much to Antoine Prost and our extensive discussions on this point.

to the nation not only as a memorial but as a powerful if vague explanation of why Britain, once a great power, had become a country with a great future behind it. War poetry was pessimistic history, nostalgic history, elegiac history, written in a language which has endured. It is not the only register in which images of war have been passed on from generation to generation, but it is there, still. It has provided generations of schoolchildren with a language for family history, their family's history, a history of pride and of wounds, wounds which have never healed. It is to war poetry that we must turn to understand why commemorating the Great War in 2014, a century after the outbreak of the conflict, still has a taste as of ashes to it.[28]

In this chapter I have tried to show in one particular case that language matters, here as elsewhere, and language, while inflected by regional, ethnic, and social class distinctions, is a national resource through which groups of people tell stories about their past and other groups of people listen to them over time. My conclusion is that the phrases "glory" or "la gloire," *the Great War* alongside *la Grande Guerre*, are national speech acts, with very different connotations, and remain among those untranslatable terms which tell us who we are.

There has been an afterlife to the effort to go beyond glory in writing about war. In 1940, Churchill's language raised defiance into an art form. Grandeur may be the right word for his prose. And twenty-two years later, as I noted, in Coventry, Benjamin Britten's *War Requiem* urged us to go beyond glory, in the reconsecration of Coventry Cathedral. Pacifism meant something different after the two world wars, and to a degree it has become embedded in our contemporary human rights discourse.

The war poets still matter. From the 1960s on, and with some exceptional moments, there has been a slow but progressive delegitimation of war as national policy in a number of countries, leaving Blair in 2003 with no other choice than to lie about weapons of mass destruction because the vast majority of the British public would not follow him into war. None of this shift of public opinion was possible before the liquidation of empire, but from the mid 1970s, with reversals during the Falklands, in Serbia, after 9/11, and now in Syria, war has gotten

[28] As, at long last, it finally does in Ireland. See Sebastian Barry, *On Canaan's side* (Harmondsworth: Penguin, 2011); John Horne (ed.), *Our war* (Dublin: Royal Irish Academy, 2010).

something of a bad name. If the European project means anything, it is not, God knows, a stable currency, but a turning away from war, and the fading of a belief in the glory of war. British war poetry is part of that story, leading to the paradoxical conclusion that at least in one respect Britain and Europe may finally be coming together. And if so, then the English war poets deserve a plaque not only in Westminster but also in Strasbourg, in Rome, and maybe even in Berlin. Through the agency of the war poets among a host of others, at last, a century after the Great War, European attitudes to war have taken on some very English shadings, and Britain has a chance, in one respect and despite Brexit, of becoming the noblest European country of them all. Going beyond glory, after all, means going beyond war.

And yet even this conclusion must be qualified. There are still those in different parts of the world who believe in the glory of war. Their views have not vanished; rather, they have been sequestered, living on in jihadi fantasies, neo-Nazi delusions, in commercial ventures – in children's games, in star wars films, and on the dark side of the Internet. And given the ready availability of arms and of the chronic nature of political instability in many parts of the world, war without glory is with us still.

In addition, the word "glory" may have lost its resonance, but the word "sacrifice" still echoes in political discourse all over the world when soldiers are sent into battle zones. In the twenty-first century, "sacrifice" is a word describing the legitimacy of the deployment of armies vastly smaller than those mobilized in 1914–18. Individual sacrifice is still a matter to be honored, since it describes the courage of individual men and women who use force when their governments deploy them. But the word "sacrifice" applied to an entire generation of young men and women, no longer can be justified. As we shall see in Chapter 6, the deaths of 880,000 men in British forces in the Great War, each represented by a single ceramic poppy planted in the moat surrounding the Tower of London, is "sacrifice" on a scale no longer tolerable.[29] Of course, in all wars, armies suffer casualties, including fatal ones. But in the Great War, a difference in degree of loss of life in wartime turned into a difference in kind. The sacrifice of three-quarters of a million men in Britain alone was a defining moment, giving birth to the phrase "the lost generation." This metaphor captured the shock of

[29] I am grateful to John Horne for his insightful remarks on this point.

the Great War; such a bloodbath could not, indeed would not, happen again in Western Europe after 1918. Russia and Eastern Europe have another history, and another memory of the bloodbath of war. There, the term "sacrifice" retains other, sacred meanings, which we explore in the next chapter.

And yet how far we are from 1914. In many parts of the world, it is no longer natural for states to go to war; it is, in fact, unnatural, and unacceptable to a larger population scattered throughout the world than ever before. Many of these people, either consciously or unconsciously, carry the words of the English war poets with them. Honor those who serve in war, to be sure; but never honor the wars in which they serve. This message is still crystal-clear a century after the Armistice of 1918. Writing war has consequences, now and for the generations to come.

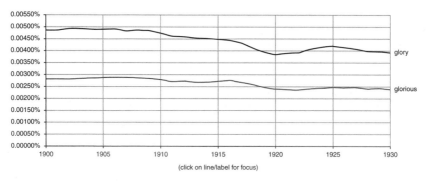

Figure 4.1 Google n-gram of Glory and Glorious in British English books, 1900–1930.

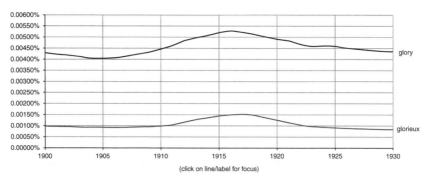

Figure 4.2 Google n-gram of Gloire and Glorieux in French books, 1900–1930.

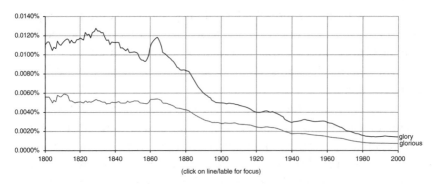

Figure 4.3 Google n-gram of Glory and Glorious in British English books, 1800–2000.

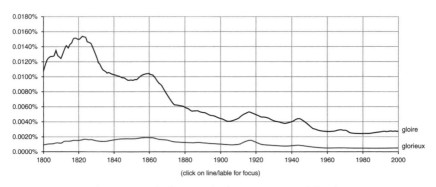

Figure 4.4 Google n-gram of Gloire and Glorieux in French books, 1800–2000.

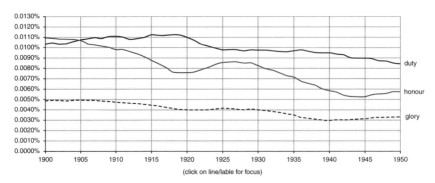

Figure 4.5 Google n-gram of Duty, Honour, Glory in British English books, 1900–1950.

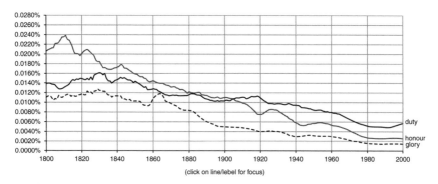

Figure 4.6 Google n-gram of Duty, Honour, Glory in British English books, 1800–2000.

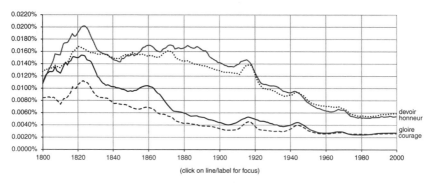

Figure 4.7 Google n-gram of Devoir, Honneur, Gloire, Courage in French books, 1800–2000.

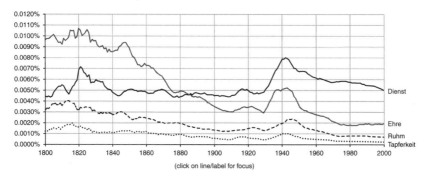

Figure 4.8 Google n-gram of Dienst, Ehre, Ruhm, Tapferkeit (Duty, Honour, Glory, Courage) in German books, 1800–2000.

PART II

FRAMEWORKS OF MEMORY

5 MEMORY AND THE SACRED: MARTYRDOM IN THE TWENTIETH CENTURY AND BEYOND

> Il n'y a que les martyrs pour être sans pitié ni crainte. Croyez moi, le jour du triomphe des martyrs, c'est l'incendie universel.
>
> JACQUES LACAN[1]

This chapter focuses on memory and the sacred. I want to ask you to think about a contrast between memory regimes currently operating in different parts of the world, in particular with respect to the Armenian genocide and the Shoah. The key difference is the continuing presence of images of martyrdom in discussions of the former, and the fading away or disappearance of the language of martyrdom in discussions of the latter.

I locate the source of this distinction in two areas. First, the ongoing Turkish denial of the Armenian genocide had no equivalent in the ways the post-1945 German state dealt with both the crime of genocide and the obligation the perpetrators owed to the victims. While both crimes were crimes against humanity, the Armenian genocide has never been recognized in its specificity, as a crime committed by those determined to Turkify their nation by destroying or expelling the Christian minorities within it.

Secondly, there has been a major change in the way in which Jewish theologians, writers, and survivors have come to understand the Shoah. At the very time mass murder was underway in the Warsaw

[1] Jacques Lacan, *Séminaire, Livre VII: L'éthique de la psychanalyse* (Paris: Éditions du Seuil, 1986), p. 311.

ghetto, a new turn of mind emerged which emphasized *al Kiddush Hachaim*, or the sanctification of life, departing from traditional Jewish martyrology and its stress on *Be Kiddush Hashem*, the sanctification of the name of the Lord in death. Rabbi Isaac Nissenbaum of Warsaw is credited with creating the new phrase, though others developed it.[2] The key problem was that traditionally, Jewish martyrs made a choice to sanctify the name of the Lord, even if death were the consequence. And yet, who could possibly say that over 1.5 million Jewish children made this choice in the Shoah? The same was true with respect to the nearly 2 million secular Jews who did not live observant lives before vanishing in the Shoah. Consequently, there emerged both during and after the genocide a different linguistic register in Jewish responses to the Shoah, one conspicuously free of the language of martyrology.

In conclusion, I consider the implications of this distinction for our understanding of genocide in comparative perspective and for our understanding of the politics of remembrance of both the Shoah and the Armenian genocide.

Memory Regimes

Memory regimes are ways groups of people frame their understanding of the past. These regimes are closely related to what Jan and Aleida Assmann term "cultural memory," in that they go beyond direct experience to privilege the symbolic representations of events whose origins lay outside the reach of contemporaries.[3] These ways of putting the past into the present do not rely on the voices of those who were there. Instead, they extend beyond the generations who sit around the dinner table, and who tell stories about how "I remember when." Even after they pass away, later generations share narratives about what happened in the increasingly distant past. This move is, in Jan and Aleida

[2] www.jewishvirtuallibrary.org/jsource/judaica/ejud_0002_0012_0_11108.html

[3] On the Assmanns' approach to communicative and collective memory, see Assmann andd Czaplicka, "Collective memory and cultural identity," pp. 125–33, and Aleida Assmann, *Cultural memory and western civilization: Functions, memory, archives*, trans. Aleida Assmann and David Henry Wilson (Cambridge University Press, 2011).

Assmann's terms, a shift from communicative memory, that of lived experience, to cultural memory, that of imagined experience.

In some cases, these narratives both suppose and disclose a sacred presence in history; they operate in what I term a sacred memory regime. They are based on a belief that the presence of God in both the world and in history is immanent. In other instances, there is no central agent operating in history: neither the benevolent hand of God nor the malevolent hand of a social or ethnic group is blamed for initiating the course of events, chaos or catastrophe being retold today. I term this set of beliefs the secular memory regime.[4]

What distinguishes the secular memory regime is that in it, God is either absent or distracted, unable or unwilling to shape history in the way His will commands. It is perfectly possible for adherents of a secular memory regime to believe in God; they may well hold that the sacred is present in their societies or in all societies.[5] What they do not do, though, is ascribe the course of history and its painful elements to part of a divine plan. Martyrology has no place in a secular memory regime.

The same distinction operates within what may be termed a demonic memory regime. Adherents to this way of ordering memories highlight salient groups – Jews, freemasons, gypsies, kulaks, and so on; these are targeted as intrinsically and powerfully evil, and responsible for the suffering of the ancestors of those telling the story. But while some of those believing in a demonic presence in the past do so as part of their religious outlook, others come to the conclusion that social groups are inherently evil and must be murdered, but they do not do so as part of their belief in God or in God's presence in history. Hitler killed Jews because he believed they stood in the way of his master plan for the German race.[6] God had nothing to do with it. Stalin was educated at

[4] The terms "sacred," "demonic," and "secular" are mine. On memory regimes more generally, see: Samuel Moyn, "Two regimes of memory," *American Historical Review*, 103, 4 (October 1998), pp. 1182–86; Eric Langenbacher, "Twenty-first century memory regimes in Germany and Poland: An analysis of elite discourses and public opinion," *German Politics and Society*, 89, 26(4) (Winter 2008), pp. 50–81; Astri Erll, "Locating family in cultural memory studies," *Journal of Comparative Family Studies*, 43, 3 (May–June 2011), pp. 303–18; and Richard Ned Lebow, "The future of memory," *Annals of the American Academy of Political and Social Science*, vol. 617, *The politics of history in comparative perspective* (May 2008), pp. 25–41.

[5] W. S. F. Pickering, "The eternality of the sacred: Durkheim's error?," *Archives de sciences sociales des religions*, 35e année, 69 (January–March 1990), pp. 91–108.

[6] Timothy Snyder, *Black earth: The Holocaust as history and warning* (New York: Penguin/Random House, 2015).

Tiflis Spiritual Seminary, but his attempt to exterminate the kulaks had nothing to do with their religion; he was an equal-opportunity murderer on the grand scale. He killed tens of thousands of devout Christians, whose memory regime was certainly sacred; his outlook was not.

These distinctions are highly schematized. In all societies, there are alloys of all three regimes, and occasions when one absorbs elements of the others. And yet, preserving such distinctions helps us see some important divergences in the ways different populations understand their collective past, and act in the present to recall it and even occasionally to go beyond it. I will use these terms for heuristic purposes and not because they are precise analytical categories.

With this rough framework in mind, I want to start by drawing attention to a global phenomenon. Today, strikingly different memory regimes are visible in different parts of the world. They are differentiated by their approach to martyrdom. The presence of the terms "martyr" and "martyrdom" and their correlates varies over time and space, increasing in frequency and significance the further east one goes. Perhaps it is best to speak of a spectrum of memory practices rather than a strict divide among them. Still, it is possible to show that in Western Europe, the term martyr (with some exceptions) has faded rapidly and irreversibly from use in the twentieth century; in Eastern Europe, it is still alive and well, informing a host of national and religious movements; and in the Middle East, and in adjacent areas including Turkey and Armenia, the term "martyr" is not only present but at times radioactive. Islamic radicalism is incomprehensible without it, and so are other political movements in Central Asia and the Far East.[7]

It is striking to see to what extent languages of martyrdom frame memory and history in different places and at different times. Memory regimes are both matters of practice and of language. Let me be as clear as possible about this. I believe that language frames memory, both in making it possible to understand the past, and in limiting the

[7] Guy Nicolas, "Victimes ou martyrs," *Cultures et conflits*, 11, *Interventions armées et causes humanitaires* (Autumn 1993), pp. 115–55; M. D. Litonjua, "Religious zealotry and political violence in Christianity and Islam," *International Review of Modern Sociology*, 35, 2, *Sociology in a post-American world* (Autumn 2009), pp. 307–31; Hassan Hanafi, "Voluntary martyrdom," *Oriente Moderno*, n.s. 25(86), 2 (2006), pp. 201–10; and Dominic Janes and Alex Housen (eds.), *Martyrdom and terrorism: Premodern to contemporary perspectives* (Oxford University Press, 2014).

ways we see it. Perpetuating the language of martyrdom, I contend, perpetuates the conflicts which led to the bloodletting in the first place.

Let us start with some reflections on the history of martyrdom itself. Martyrdom is both a trope and a practice framed by religious traditions and revolutionary movements. It is part of a grammar of sacrifice tending to elevate to the sacred level the act of dying for the state or for the church or for the two combined. It has also been a language of revolutionary sacrifice, vigorously deployed from Ireland to China.

This grammar of sacrifice, though, is not universal. It has a history, which differs according to national traditions and in response to national disasters. Figures 5.1, 5.2, 5.3, and 5.4, at the end of this chapter, show the secular decline in the frequency with which the terms "martyr" and "martyrdom" appeared in English, French, and German between 1800 and 2000, and in Hebrew between 1900 and 2000. In English books, there is a clear long-term decline from the 1870s, continuing during both world wars and, with some insignificant exceptions, in the interwar years and the 1950s. The same long-term decline occurs in French with respect to the usage of these two terms, except for their prominent reappearance during the two world wars. The German trend is similar to the French one, though in this case only the Second World War occasioned a radical return to the lexical frequency of martyrdom. With reference to Hebrew, it makes sense to start the series in 1900 due to the small number of books published in that language before that date. The trend there is strikingly different: there is a rise in the usage of terms relating to martyrdom until the end of the Second World War, and the end of the Shoah, followed by a sharp and almost linear decline thereafter. The significance of this finding will be addressed in a moment.

How should we interpret these graphs? In Britain, martyrdom was, alongside other key words, a term of the past from the mid nineteenth century on. Without a continuous revolutionary tradition, with a painful but palpable distance from Roman Catholicism dating from the Henrician Reformation itself, and – as we have seen in Chapter 4 – without an ongoing tradition of conscription for military service, the notion of sacrifice as "glory" and its attendant words and images constitute a lexicon which faded from the mid nineteenth century to the present. The language of "glory" was, as we have noted, on the wane when Elgar, at the suggestion of Edward VII, tried to raise it up again in

"Land of Hope and Glory," and while it made a temporary appearance in the two world wars, it was simply too shallow a vessel to carry the weight of suffering and loss of life in these massive conflicts. Thus, the cultural space for the war poets was created long before the Battle of the Somme, in contrast to Ireland and other countries in both Western and Eastern Europe for which glory and martyrdom were still robust, though frequently trivialized, signifiers.

After the Great War, the glory brigades dwindled further in much of Western Europe, though it took the fascist temptation and its destruction in 1945 to empty their ranks. A flourish of glorious martyrs to the Resistance took their place (sometimes justifiably so), but only for a brief time, yielding a memory regime in Western Europe which treated war not as a sacred moment or adventure but as an abomination. The German recovery of martyrdom during the Second World War was a self-serving myth.

Since, as the whole of this book contends, language frames memory, these significant linguistic shifts are part of the delegitimation of war and of military heroism in Western Europe over the last fifty years. The European project is incomprehensible without this cultural trajectory and symbolic movement away from war.

This cluster of developments has powerfully affected the current memory regime dominant in Western Europe. The separation of death in war in Western European cultural and political life from metaphors of martyrdom, glory, transcendence, beatification, canonization, sanctification, and so on, marks it off from Eastern European memory practices, and even more so from those found in Middle Eastern and East Asian cultures. There is a host of evidence that in Eastern Europe, the Middle East, and in East Asia, martyrology is a central and at times an essential part of the narrative of loss of life in wartime. As I will try to show later, this is also the case in Turkey and Armenia. But it is no longer true in Western Europe. The key divide is the Second World War and the Shoah. From then on, the Western European memory regime rested on a secularized story of suffering and death in wartime. It took time, but beginning in the 1970s, as the story of the murder of European Jewry entered centrally into the history of the Second World War, it was told without recourse to the notion of martyrdom in war.

The complicating factor in the history of European memory regimes was the entry into the European Union of most of the former

Warsaw Pact nations. They retained martyrdom as an essential feature of their memory regimes, producing an east–west split which precludes the emergence of any common approach to the history of the Second World War, and to the place of the Shoah within it. Thus Europe's political union rests on a fundamental cultural divide.

Divergences and Convergences

At the heart of the divergence in the pathways of remembrance in Europe in recent decades has been the question of how to commemorate the victims of the Second World War, and in particular, how to commemorate Jewish victims alongside other victims of the Nazis. In a nutshell, when martyrdom enters the equation, there is not enough symbolic space for both communities of victims to enter into national narratives of loss. The language of martyrdom creates a zero-sum game: only one set of martyrs can be commemorated at a time. To remember both is certainly not logically impossible; it is just politically impossible. On the head of the proverbial pin, there is room, apparently, for only one class of victims at a time.

A sculpture in the Dresden city cemetery gestures towards this point. It is near a series of memorial sites focusing on the fire-bombing of the city in February 1945 (Illus. 5.1). It is the work of Małgorzata Chodakowska, a Polish-born sculptress living and working in Dresden. The monument, entitled *Sea of Tears*, dedicated in 2010, presents a young girl whose arms gesture in completely opposite directions. At any single site, remembrance of war can move in many directions, but its center of gravity, its core, is grief, mourning, and bereavement, described as such in so much of Western art through an emphasis on the horizontal axis. The vertical is the language of hope; the horizontal the language of loss; we shall return to this point in Chapter 6.

Let me borrow from this image to suggest that the tradition of martyrdom symbolically points the trajectories of memory – that of the perpetrators and that of the victims – in two entirely different and irreconcilable directions. There can be no common narrative of suffering evoked by the sea of tears at the girl's foot; the truth to which this sculpture powerfully alludes is that the people who died

on February 13, 1945 in Dresden were not martyrs; they were victims of their own regime and of the brutal war that regime let loose on the world. Calling them martyrs, which some attending the ceremonies marking the day in 2015, when I visited the site, explicitly did, makes no sense, or less than sense. Some neo-Nazis termed them victims of the *Einsatzgruppen* in the air, meaning the American and British bombers which destroyed Dresden. Such claims are offensive, and intended to be so.

Using the language of martyrology is, I believe, a charged matter. It has consequences. This chapter is an attempt to measure the significance and consequences of uses of martyrology to register the signal disasters of the last century. It does not engage in the pointless discussion of comparative suffering, but rather examines language as an active force, taking a close look at the words we use to remember the victims of violence in the past.

Very shortly after the Second World War, there emerged an alternative language to that of martyrdom. It is the language of human rights. René Cassin, the primary author of the Universal Declaration of Human Rights of 1948, made no secret that this document was a monument to the victims of the Second World War. In its words, proclaimed at the Palais de Chaillot on December 10, 1948, he heard the cries of the murdered millions of the two world wars.[8]

Cassin lost twenty-six members of his family in the Shoah. He was not outside this history. The key point here is that he helped bring the Shoah into history not by using the language of martyrdom, which is always and necessarily particular – particular to a cause, a nation, a people, a religion – but by advancing the language of rights, which is universal. The Shoah, just like the Armenian genocide, was a crime against humanity; both subjected entire peoples to deportation and annihilation not for what they had done, but for who they were. These crimes threatened all those who heard Cassin's words in Paris in 1948; they still do now. The primary reason why all of us must insist on the universal recognition of the Armenian genocide is that it is a profound part of everybody's history, and lack of its recognition for whatever reason is everybody's shame.

[8] Archives Nationales de France, Pierrefitte-sur-Seine, Fonds Cassin, 382AP/128, dossier 3, "Discours de René Cassin, Délégué de la France à l'Assemblée Générale des Nations Unies à Paris," 9 décembre 1948.

Martyrdom after the Holocaust

In the remainder of this chapter, I point to two pairings: Jews and Poles facing the Shoah, and Armenians and Turks facing the genocide of 1915. I want to suggest that the language of martyrdom has vanished partially from the first pairing, but not from the second.

Why did this first change come about? The answer rests in part on German recognition of their collective responsibility for the Nazi murder of the Jews of Europe. But this development illuminates an astonishing and profound shift in Jewish thinking about martyrdom. Anyone visiting Poland today will still see the language of martyrdom in the iconic sites of memory associated both with Nazi and with Soviet crimes. I choose two here, but there are many more.[9]

One significant part of the Jewish commemorative landscape in Warsaw is the Umschlagplatz, or the railway station from which Jews living in the Warsaw ghetto were deported to be murdered in Treblinka, 80 kilometers away. The Umschlagplatz memorial, completed in 1988, is understated and marked by a presentation of the first names of those people who went from that point to their deaths (Illus. 5.2). It is one site of memory in Warsaw which is very close to the point of departure it marks. Other sites are difficult to locate today, since when Warsaw was rebuilt after the war, the streets of the Muranow district which housed the ghetto were laid out differently than they had been before the war.

In contrast, there is the very different monument to "the murdered and fallen in the East" (Illus. 5.3 and 5.4). The way of the Cross is manifest in a railway Via Dolorosa, indicating sites of Polish martyrdom on railway ties, leading to a Golgotha of dozens of crosses, pointing east – accusingly – to Russia. It is an impressive monument, located near and probably within the northern boundary of what was the ghetto. This monument to the Murdered and Fallen in the East is unmistakably an appropriated site, one turning a part of the ghetto, near its northeastern limits, a place of Jewish suffering, into a site of Christian martyrdom.

The monument was designed by Maksymilian Biskupski, and inaugurated in 1995, on the 56th anniversary of the Soviet invasion of Poland, on September 17, 1939. The monument commemorates not that date or event, but primarily the martyrdom of Poles following that

[9] See Jay Winter, "War and martyrdom in Poland," in E. Blacker (ed.), *The memory of the Second World War*, in press.

invasion. The railway tracks bear the names of the places that mark the deportation or execution of Poles, including Katyn, where thousands of Polish officers were executed on Stalin's orders.[10]

Consider for a moment the juxtaposition of these two memorials. In this contrast, we see symbolic representations of the way Jewish and Polish memory regimes move in opposite directions. The horizontality of Jewish names is entirely distinct from the verticality of the cross. Aside from the unique case of some of Marc Chagall's art, Christology has no place within it for Jewish acts of remembrance. The Polish Christological language of martyrdom, in particular when placed on an area within the former ghetto, makes it, if not inevitable, then very likely that Polish and Jewish memories of a common catastrophe remain distant, incompatible, indeed at odds with each other.

There is one additional and surprising reason why the language of martyrdom divides today more than ever. Let us go back to the graph of the usage of the term "martyrdom" in published books in Hebrew. The end of the Shoah is the beginning of the end of the term "martyrdom" as a referent for the victims of genocide.

Here is one of many indications of the extent to which martyrology has faded as a central element in Jewish memory regimes since the Shoah. In the past, the notion that Jews have memory but not history (elucidated in a classic work by Yosef Chaim Yerushalmi), depended on a belief that time was circular, that the mythical recurred year in and year out, and that, for instance, when the Jewish people celebrate Passover, they really do leave Egypt on the very evening they celebrate. In a more somber register, each Jewish catastrophe registers and echoes the destruction of the two Temples, marked by Tisha B'av, a fast day in the summer.[11]

But then came the massacres of the late nineteenth century, and these, followed by those of the Great War and then the Shoah, slowly but surely changed both the premise and the practice of Jewish memory. Historical time drove a wedge into the circularity of mythical time; there would be no celebration of Passover, no Exodus, no miracle in the vast spaces of Eastern Europe where Jewish life had been destroyed. In addition, the creation of the State of Israel was another historical rupture making it difficult, though not impossible, for Jews to continue

[10] I am grateful to Marzena Sokolowska-Paryz for her guidance on this and many other points.
[11] Yosef Chaim Yerushalmi, *Zachor. Jewish history and Jewish memory* (Seattle, Ill.: University of Washington Press, 1982).

to think that every year is like every other year, and that every enemy of the Jewish people resembles Haman from the Book of Esther.[12]

Such changes were evident during the war itself. Even during the years of destruction 1939–45, some remarkable Jewish scholars began to take a broader view of what martyrdom meant. Some even went so far as to redefine it entirely, not as dying in sanctification of the name, *be Kiddush Hashem*, but as living as sanctification of God, *al Kiddush Hachaim*. Others were not so open-minded, and saw the Shoah as yet another instance of the eternal return of the sufferings God metes out, for reasons only He knows, to the chosen people. For many, though not for all scholars, the Shoah complicated the discussion of martyrdom in radical ways.

The key issue, indeed the central problem, was the significance of intention or choice in the fate of those facing death as Jews in the Shoah. This matter was discussed by rabbis in Warsaw and elsewhere while the Shoah was under way. One of the most remarkable texts on this question was written by a Polish rabbi and polymath, Shimon Huberband, whose identification card survived the war, although he didn't. He was born in 1909 into a rabbinic family and took his *Smicha*, or ordination, with his grandfather. He was not only a rabbi but an historian, a writer, and a poet. He published widely on Talmudic and secular topics. He even was the author of a book on Jewish physicians in his home town of Piotrków in the Łódź district in the seventeenth century.

At the outbreak of the war, he and his family fled their home, but his wife and child were killed in the bombing of the nearby town of Sulejów. In a state of shock, Huberband traveled north to Warsaw, and began a new life working for the Jewish Social Self-Help Organization. He was director of the organization's religious section. Despite contracting typhus, he worked alongside Emanuel Ringelblum to document Jewish life in the Warsaw ghetto by placing these documents in milk cans buried for posterity. The project is now known as the Oneg Shabbat archive. The term in Hebrew means the joys of the Sabbath, a name showing the stark affirmation of Jewish belief *in extremis*.[13]

Huberband's astonishing work in Yiddish, later published in Hebrew and English under the title *Kiddush Hashem*, is a wide-ranging

[12] Jay Winter, "Jüdische Erinnerung und Erster Weltkrieg – Zwischen Geschichte und Gedächtnis," *Yearbook of the Simon Dubnow Institute*, 13 (2014), pp. 111–30.

[13] Samuel Kassow, *Who will write our history?: Emanuel Ringelblum and the Oyneg Shabes Archive* (Bloomington: Indiana University Press, 2007).

study not only of how Jews died, but of how Jews lived. He documents the daily rhythms of Polish Jewry, especially in Warsaw, in the midst of the Shoah. On August 18, 1942, Huberband and his second wife were deported from the Umschlagplatz in Warsaw to Treblinka, where they were murdered.

The fragments Huberband collected showed many different forms of the stubborn refusal of Jews to give up even the traces of their collective life. The teaching of Hebrew continued among different Jewish groups in the ghetto, Zionist and anti-Zionist alike. The non-observant shared other forms of defiance, rescuing Torah scrolls and sacred books, symbols of their collective life which meant more to them at the end of their lives than they ever had before. Huberband did not write a panegyric; he incorporated scenes of degradation and vulgarity among Jewish men and women too. His was a history of everyday life *in extremis*.

The topic of martyrdom was central to Huberband's work, and yet, perhaps not despite but because of the catastrophe he saw in front of his eyes, he took a very liberal and open-minded view of the subject of *Kiddush Hashem*. He starts with Maimonides' view that those who died in the mass murder of Jews were martyrs, even if the question of denying their faith was not posed. He termed these deaths as "passive *Kiddush Hashem.*" So far we are still within conventional thinking. Huberband departed from the way martyrdom was understood in traditional Jewish scholarship in 1942 by joining Nissenbaum in opening the door to another category, "active *Kiddush Hashem.*" Yes, Jews were being killed without having done a thing. That was passive martyrdom. In contrast, active sanctification of the Lord existed by living and preserving Jewish life and not only by dying.[14] The Ethics of the Fathers captured the dilemma: when there are no human beings around, be one.

There is a spectrum of possibilities in Huberband's discussion of martyrdom. The door was open to admit to the ranks of the martyrs virtually any Jew who died in the war. And yet there was considerable discussion about the significance of a willed act, of volition, rather than simply being Jewish and in the wrong place at the wrong time.

After the Shoah, the argument within Jewish thought on who was a martyr continued. While there were some dissenting

[14] Shimon Huberband, *Kiddush Hashem: Jewish religious and cultural life in Poland during the Shoah* (New York: Yeshiva University Press, 1987), pp. 247ff.

voices,[15] the consensus of rabbinic thinking was that *Kiddush Hashem* requires a decision to give up one's life rather than commit idolatry or murder or incest. Since the victims of the Nazis, in the overwhelming majority of cases, had no choice that would save their lives, and since many of them had no interest even in preserving a Jewish identity, the concept of martyrdom in its older forms was in need of review, and even of revision. As I have already noted, the claims that over 1 million Jewish children were martyrs are difficult to sustain. Innocent victims, to be sure, like all the others, but martyrs? Perhaps not.

We have seen that Huberband was open to the possibility that all victims were martyrs. He parted company therefore from earlier (and later) chroniclers who emphasized conscious choice. Perhaps one way to put Huberband's position is that Jews as Jews were forced to make not a religious but an existential choice – to go on living, whether or not they practiced Jewish law. The Nazis took that choice away from them, and rendered them martyrs despite themselves, as it were. What Huberband did was to make living as a Jew, preserving life whenever possible, and not dying as a Jew a focus of his affirmation of faith.

This is a revolutionary moment in Jewish thought and practice, and as the Google n-gram shows, the decline of reference to martyrdom in Jewish life which occurred while the Shoah was under way has continued uninterrupted to our own times. To be sure, the language of Jewish martyrdom did not disappear entirely. In 2015, the website Virtual Stetl had an entire section entitled "Sites of martyrdom." But the Shoah shifted the boundaries of martyrdom and opened the way to a new emphasis on the astonishing ways Jews preserved their way of life until the end. It is evident, therefore, that martyrdom is not a concept fixed in stone. It changes as history changes, and its fading away in the Hebrew language points to a pathway to reconciliation not available in the same way when older notions were still dominant.

On April 23, 2015, in Yerevan, the Armenian Apostolic Church held a service to canonize the victims of the Armenian genocide.[16]

[15] Emil L. Fackenheim, "Shoah," in *Contemporary Jewish religious thought: Original essays on concepts, movements and beliefs*, ed. Arthur A. Cohen and Par Mendes-Flohr (New York: Scribner, 1987), p. 406; and Samuel Shepkaru, *Jewish martyrs in the Pagan and Christian worlds* (Cambridge University Press, 2006).

[16] "Armenian church declares genocide victims saints in somber ceremony," *Los Angeles Times*, April 24, 2015, www.latimes.com/world/la-fg-armenia-sainthood-20150424-story.html; "Armenian Church makes saints of 1.5 million genocide victims," *Telegraph*, 24 April 24, 2015, www.telegraph.co.uk/news/worldnews/europe/

Thereby the Church "officially recognize[d] as saints of the church the countless souls who perished during the Genocide in witness of their Christian faith."[17] The canonization took place under the auspices of the Catholicos of All Armenians His Holiness Karekin II, and His Holiness Catholicos Aram I of the Great House of Cilicia. According to Rev. Fr. Daniel Findikyan, director of the Zohrab Information Center in New York, "They officially recognize[d] as saints of the church the countless souls who perished during the genocide for the sake of the name of Jesus Christ." This event is extraordinary within the history of the Armenian Apostolic Church, which had not canonized a single saint for centuries.

The project of canonization started long ago. In 1989, the year before the 75th anniversary of the genocide, and in the last phase of the communist era, Catholicoi Vasken I and Karekin II issued a joint communiqué, noting that "Since next year is the 75th anniversary of the Genocide, we propose that the preparatory activities continue for the canonization of our victims."[18] Twenty-five years later, that proposal, approved by the Armenian Bishops' Synod, has been realized.

Clearly, the key intervening event enabling this act to take place was the collapse of the Soviet empire and the subsequent creation of the Republic of Armenia. Prior to 1991, the Armenian Apostolic Church was subject to the same surveillance and restrictions on the part of the state as other churches had faced. Persecution, arrests, executions, expropriation were hallmarks of the Soviet years for the Armenian church, especially in the 1930s.

After Stalin, the life of the Church revived, and ties with the diaspora were strengthened. The Church's role in preserving the Armenian language and culture was even recognized by the state, and with Perestroika, the work of the church grew rapidly. Working within the system, Vazgan I helped control tensions which arose from the

armenia/11559613/Armenian-Church-makes-saints-of-1.5-million-genocide-vic tims.html

[17] "The canonization of the Armenian martyrs of 1915. What is Christian martyr-dom anyway?," Zohrab Information Center, New York, September 25, 2014, http://zohrabcenter.org/2014/09/25/the-canonization-of-the-armenian-martyrs-of-1915-what-is-christian-martyrdom-anyway/

[18] Hratch Tchilingirian, "Canonization of the genocide victims. Are we ready?," *Window View of the Armenian Church*, 1, 3 (January 1990), http://oxbridgepart ners.com/hratch/index.php/publications/articles/156-canonization-of-the-genocide-victims

Karabakh movement, and then moved to associate himself with the growing national movement. Vazgan swore in the first democratically elected leader of the new Republic of Armenia.

Some scholars saw the place of the church in the new political era as being more cultural than catechistic. That is, what drew people to the Church were not its religious teachings but its message of communal continuity. While 98 percent of Armenians profess to being Christians, only 8 percent attend services regularly. This is a trend well known in the West, but in Armenia the difference is that the Church represents the nation through its symbolic acts. One such is canonization.[19]

The collapse of the Soviet political framework generated a major movement for canonization in the Russian Orthodox Church as well. As Zuzanna Bogumil has shown, in the early 1990s, it canonized over a thousand martyrs. The KGB took mugshots of those they arrested. Among them were priests, nuns, and devout men and women who died for their faith. The Russian church was able to take these photographs and put gold foil around them, producing instant iconography out of the very records of the killers.[20]

Things took longer in Armenia. The Armenian Church, weakened by years of oppression, faced substantial obstacles. The Synod of Armenian bishops rarely met. The division between the Etchmiadzin and Antelias wings of the Church posed problems. There was no agreed procedure for canonization, none of the well-trodden steps along the path to sainthood favored by the Roman Catholic Church. There was little verifiable evidence on the deaths of many Armenians in the genocide of 1915, although there was substantial evidence about the collective catastrophe.[21]

And yet, the symbolic importance of canonization was evident, for one simple reason. It transformed victims into victors in Christ, as the Rev. Dr. Maxwell E. Johnson, Professor of Liturgical Studies at Notre Dame University, put it.[22] It performed justice, albeit of a transcendental kind, for the martyrs of the Armenian genocide at

[19] Hratch Tchilingirian, "In search of relevance: Church and religion in Armenia since independence," in Bayram Balci and Raoul Motika (eds.), *Religion et politique dans le Caucase post-soviétique* (Paris: Maisonneuve & Larose, 2007), pp. 277ff.

[20] Zuzanna Bogumil, "Do *milieux de mémoire* still exist in Eastern Europe?," Cambridge conference on The Memory Wars, May 13, 2013.

[21] Tchilingirian, "Canonization of the genocide victims."

[22] "Canonization of the Armenian martyrs of 1915."

a time when Turkish opposition remained firmly against recognizing that what happened to the Armenian people was indeed genocide. For these reasons, on behalf of the Armenian people, both in the republic and in the diaspora, the Armenian Church took this step to affirm not only that genocide occurred, but that those who died in it were martyrs.

Let us reflect on the consequences of this act and others like it. The first point to make is that adopting the framework of martyrology is by no means an innovation. The very names of many Armenian sites of memory show the ongoing tradition of locating the genocide of 1915 within this sacred tradition. The Armenian Apostolic Church of Holy Resurrection in Macquarie Park Cemetery, in Sydney, Australia, has a monument on its grounds which bears the following dedication: "This Altar-Memorial in sacred memory of the Armenian martyrs of the 1915 Holocaust was erected under the patronage of His Holiness Vazken I, Catholicos of all Armenians and blessed by Bishop Aghan Baliozian, Primate of the Australian Diocese, constructed by the Armenian Near East Society in conjunction with the Armenian Church in Sydney. April 1989."[23] The same message is conveyed by monuments erected over the years by the Armenian diaspora all over the world, in Providence, Rhode Island; in Montevideo, Uruguay; in Chelmsford, Massachusetts; in Montebello, California; in Nicosia, Cyprus; in Whittisville, Massachusetts; in Antelias, Lebanon; in Calcutta, India; and in Toronto, Canada. Wherever the Armenian diaspora has settled, sites and acts of remembrance can be seen today, frequently though not always framed by the language of martyrdom.

In 2015, the Armenian ecclesiastical authorities extended this tradition by affirming that the victims of the Armenian genocide had met the conditions of sainthood, namely: "martyrdom for the faith and the fatherland, pious life – pious behavior of an individual or a collective, existence of miracles alive or dead, and preaching the faith, spreading the belief."[24] Here are precisely the points on which Jewish opinion paused in extending the title of "martyr" to the victims of the Shoah. The Armenian Church, in contrast, reaffirmed earlier practices of the sacralization of memory to embrace the victims of genocide.

[23] www.armenian-genocide.org/Memorial.36/current_category.53/memorials_detail.html

[24] "Holy recognition: Church to canonize genocide victims," ArmeniaNowcom, www .armenianow.com/genocide/60305/armenian_apostolic_church_genocide_holy_ see_echmiadzin

Genocide remembrance day, or Armenian Christian Martyrs' Day, is April 24. Turkish Martyrs' Day is March 18, marking the successful defense of the country one hundred years ago, when Ottoman Turkish forces defeated a British and French naval attack to force the Straits at the Dardanelles, and to knock Turkey out of the war. On December 23, 2014, thousands of Turks went on a "Martyrs' Walk" in commemoration of those soldiers who died in the Battle of Sarikamiş, a Turkish defeat in the first year of the war. Greeting them, the Turkish chief of general staff Necdet Ozel praised the valor and loyalty of Sarikamiş martyrs, as part of a broader commemorative moment in honor of "thousands of soldiers tragically martyred in 1914–1915" in Turkey's north. On January 4, 2015, thousands of Turks followed the same trajectory to mark the deaths of what they termed the martyrs of Sarikamiş. The speaker of the Turkish parliament, Cemil Çiçek, said that through such acts of "unity and solidarity," "Maybe . . . our martyrs will rest in peace."[25]

In the Turkish-Armenian world, there are martyrs everywhere. And yet, the lexicon of martyrdom undermines the possibility of creating an act or gesture of remembrance for all victims of the Ottoman theater of the Great War, civilian and military alike. This is not to say that all victims are equal; some were infinitely more innocent than others. And yet martyrs occupy a world in which the sons of light are arrayed against the sons of darkness. Martyrs are not dispatched by other martyrs; the killers do the work of the devil, and hence can never be sanctified. As long as the language of martyrdom frames the narratives that both sides fashion about the period of the Great War, then a mutual understanding of what Atatürk himself once termed the "shameful act" of the murder of the Armenian people will remain unattainable.

Who can miss the unfortunate fact that we still live in an age of martyrs? There are martyrs' days in the following countries: Afghanistan, Azerbaijan, Bangladesh, Burma, India, Lebanon, Libya, Malawi, Pakistan, Panama, Syria, Togo, Tunisia, Vietnam, and Uganda. Most, though not all, have large Muslim populations. Others use this term to mark struggles for independence, such as Vietnam and India. Similar to Vietnam's "Memorial day for war martyrs" in her serial wars of decolonization is Turkey's martyr's day, mentioned

[25] "Turkey commemorates Sarikamis martyrs," *World Bulletin*, January 4, 2015, www .worldbulletin.net/haber/152222/turkey-commemorates-sarikamis-martyrs

above. And yet the Ottoman Turkish victory at the Dardanelles was not the end of the campaign. Seven weeks later, on 24–25 April, the Allies launched an amphibious landing on the southern and western coast of Gallipoli. They established various beachheads, but never reached the heights above. Mustafa Kemal was one of those who led the successful Turkish resistance, and his legendary rise to become the father of his people began then and there. Note the date: the landings at Gallipoli and Kemal's defeat of the Allied invasion began on the night of 24 April, the same date as when the first phase of the Armenian genocide began; 24/25 April is when Armenians today commemorate the beginning of the genocide.

And there's the rub. Over a century, one side's martyrs have occluded the other's. To repeat: making this statement in no sense equalizes the two populations of victims. Those who died at Gallipoli suffered to be sure, but not in the way the Armenians did in Anatolia, in Mesopotamia, in Syria and beyond. Bloodshed and terrible conditions marked the lives of soldiers on Gallipoli, but never, like the avalanche of rape, murder, spoliation, and the torture of hundreds of thousands of women and children uprooted from their homes and forced to march to their deaths. Turkey's Martyrs' Day marks twentieth-century warfare in an older heroic language. Similarly, Armenian Martyrs' Day marks twentieth-century warfare in the much earlier language of the history of Armenian martyrdom within the history of the Armenian Church and people.

Is there a way to mark the depredations and monstrous crimes of twentieth-century warfare outside of the language of martyrdom? I believe there is. It is by appealing not to a tradition of religious values alone, or centrally, but by appealing to a tradition of human rights values, established in part because of the Armenian genocide and the Shoah which followed in its wake. The Universal Declaration of Human Rights is a normative, and not a judicial, document. That is both its strength and its weakness. It describes what rights individuals have as against the states in which they live; the darkest end of the denial of these rights is genocide. To be sure, there is a gamut of violations which falls short of genocide, but which also appall the conscience of the world. Violating that conscience is a moral and not a legal crime. That is the price we pay for maintaining our system of nation-states, including Armenia and Turkey.

Could it not be that the language of human rights and not that of martyrdom is the appropriate register in which to frame both

remembering the Armenian genocide and maintaining pressure on attaining its universal recognition? I will leave it to those wise and learned enough to comment thoughtfully on the differences between Christian martyrdom and Islamic martyrdom, and between the different forms of martyrdom we have seen in recent years. My aim is more modest, limited to the case of Armenians and Turks looking back on the catastrophe of the First World War. From this perspective, I reaffirm my belief that language matters. As long as martyrs face off, each in majestic isolation on their separate and sacred peaks, even the act of imagining the end of conflict recedes progressively from our view.

My conclusion is a mixed one. The language and imagery of martyrdom, still present in many commemorative forms outside of Europe, has slowly vanished from Western European commemorative practices and art.[26] The conceptual gap between those remembering war and those who die in war through sacred language, and those who use secular language to do so is deep and likely to deepen further. This divide is unavoidable, and has grown in significance and intensity over time, as the Shoah entered centrally into Western narratives of the Second World War.

We have seen in Western Europe that when narratives of martyrdom fade away, narratives of war also lose their sacred aura and their potentially redemptive force. This is the key to the postredemptive character of Western European memory regimes. Martyrs redeem; dispense with martyrs and the sacred may cease to be the only or the central narrative framework for war and for remembering the victims of war.

The language of martyrdom is not the only choice to frame our understanding of genocide. As we have seen, a number of remarkable individuals, living in the Warsaw ghetto while the Shoah was under way, reconfigured the Shoah not only as an example of the sacredness of death but also and perhaps more importantly as an example of the sacredness of life. The people who fashioned the Oneg Shabbat archive in the shadow of their own extermination, and others who have followed, have rendered explicit much of what was implicit in earlier Jewish thinking about the victims of violence. Their example is in their lives and the courage they manifested in preserving them.

[26] Sigrid Weigel and Georgina Paul, "The martyr and the sovereign: Scenes from a contemporary tragic drama, read through Walter Benjamin and Carl Schmitt," *New Centennial Review*, 4, 3, *Theory of the partisan* (Winter 2004), pp. 109–23.

The language of the sacred and the demonic is entirely under-standable in the practice of Armenian genocide commemoration. It links the national tragedy with the earliest days of the Armenian Church, and with those who have died in the faith and for the faith thereafter. And yet, for some Jews, the long march of Jewish martyrology came to an end in the Shoah. That contrast sets out a choice. It is entirely consistent with an unshakable commitment to remember the Armenian genocide to complement older tropes with a newer, more universal framework of remembrance, that of human rights.

I am by no means the first to see the force of this argument. In the 1980s, a group of Armenians decided to erect a monument in Arlington National Cemetery. It takes the form of a tree, and salutes those Armenians who fought both on the Western Front and in the Middle East for Allied victory in the Great War, the war which triggered the Armenian genocide. The plaque in front of the tree states they fought "in defense of freedom and human rights" (Illus. 5.5). Is it possible that, perhaps only after decades go by, this framework points to a way out of the endless circling around each other of the Turkish Martyr of the Great War and the Armenian Martyr of the very same conflict. It was war which ended their lives, and those of more than 10 million others, a war which obliterated the distinction between military and civilian targets. That is what made genocide possible.

The international human rights movement is a frail instrument, to be sure, and it will not take away the bitter taste of denial – until Turkey recognizes the Armenian genocide for what it was. And yet there are those in Turkey willing to find another way. A minority to be sure, but we know that they are there. At the moment, the Turkish defense of the honor of its martyrs (alongside more material considerations) blocks that way forward. But is it too much to hope that when the language of martyrdom recedes and the language of human rights moves to the foreground of discussions of 1915, we then can begin even to imagine breaking out of the vortex of hatred and suspicion? What better way to honor the victims of the Armenian genocide than to see to it that their great-grandchildren learn, as René Cassin and so many other Jews learned after the Shoah, that a commitment to human rights is the best (perhaps the only) defense we have against the killers in our midst. Now that Daesh and other movements have driven home to us all the aware-ness that the language of martyrdom can be turned easily into the language of barbarism, perhaps Turks too can begin to look outside of

older slogans and pathways. Perhaps they will begin to see the suffering of the 1914–18 war as a human catastrophe, one transcending even the story of the birth of their nation. That may be impossible today, but only cynics and fools are sure about what tomorrow brings.

Jacques Lacan went a bit too far, as he was wont to do, when he wrote that "Only martyrs have neither pity nor fear. The day of their victory will be the day of universal destruction."[27] But taking the victims of genocide outside of the sacred circle of martyrdom may enable us to do something equally difficult: to honor them without perpetuating or exacerbating the conflicts which brought about the genocide in the first place. Transcendence is an alternative both to forgetting and to conflict without end.

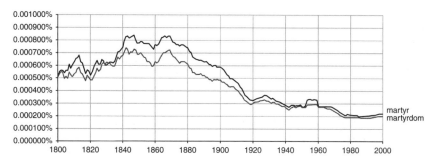

Figure 5.1 Google n-gram of Martyr and Martyrdom in British English books, 1800–2000.

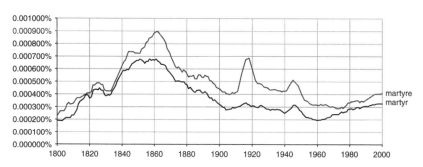

Figure 5.2 Google n-gram of Martyr and Martyre in French books, 1800–2000.

[27] Lacan, *Séminaire, Livre VII*, p. 311.

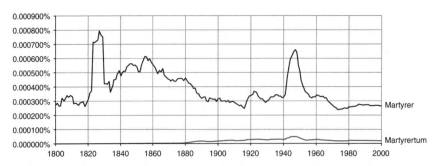

Figure 5.3 Google n-gram of Martyrer and Martyrtum in German books,
1800–2000.

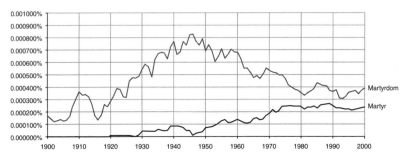

Figure 5.4 Google n-gram of Martyr (מְעוּנֶה קָדוֹשׁ) and Martyrdom (הַקְדוֹשׁ'ם מָוֶת) in
Hebrew books, 1900–2000.

6 THE GEOMETRY OF MEMORY: HORIZONTALITY AND WAR MEMORIALS IN THE TWENTIETH CENTURY AND AFTER

Samuel Johnson, it is said, remarked that every time he slowly climbed up the steep incline of a moral problem, he saw Plato coming down the other side. I am by no means the only scholar who feels like Dr. Johnson when exploring the way artists, designers, architects, and others have configured war memorials in the twentieth century and after. Someone has been here before.

And in part that is why I keep coming back to Käthe Kollwitz. In fifty years of research on the First World War, I have returned time and again to her art, and in particular to the war memorial she sculpted in memory of her son Peter, who died in combat in October 1914. In its original location it consisted of two granite sculptures of Karl and Käthe Kollwitz on their knees in front of the lines of crosses in the German war cemetery in Roggevelde near Dixmuide in Flemish Belgium. The Kollwitzes came there in July 1932, to unveil the statues eighteen years after Peter's death (Illus. 6.1). At that time, the fields of the cemetery were bare, and the graves of roughly 4,000 men were marked by rough wooden crosses. The sculptures were placed at the back of the cemetery, well apart from each other (Illus. 6.2). In 1955, German war cemeteries in Flanders were consolidated, in a larger cemetery, containing the remains of roughly 25,000 men unearthed from different cemeteries and reinterred at nearby Vladlso. The original crosses at Roggevelde were replaced by stone slabs listing the names and dates of death of a number of men reburied there (Illus. 6.3). There are several Gothic crosses at irregular intervals, and large trees, common to many German cemeteries of the period. At the back of the cemetery, Käthe Kollwitz's two granite sculptures stand, much closer

to each other than at Roggevelde, not far from the slab of stone marking the names of men whose remains are there, including Peter Kollwitz (Illus. 6.4).

In this chapter, I dwell not on Käthe Kollwitz's long journey to the completion of this memorial, on which I and others have written before,[1] but on what this work of art tells us about what I term the geometry of remembrance, or the spatial logic of war memorials. The argument I want to develop is this. From 1914 on, the gravity of mass violence and mass death in war in effect pulled commemorative forms away from the vertical. Both during and after the Great War, many artists and architects, Kollwitz included, engaged in a long meditation on horizontality. By no means all used or use the horizontal axis as the guiding line of their work. Still, many have engaged with it time and again, in an open dialogue with verticality, that language of uplifting sacrifice, of upright bravery, mostly masculine and in uniform, and of redemptive hope. Since 1914, many artists and architects have shown that there is both a logic and a force of gravity in the preference for the horizontal, an almost irresistible force which tends to bring us down to earth with a thud.

A significant number of commemorative artists and designers in the twentieth century and after have invited us to look down when we view their work. This posture of contemplation was not invented in 1914, and I shall turn to earlier artistic configurations of horizontality as well. In the twentieth century and after, abstract artists, architects, museum designers, and others shared with those using figuration the tendency to urge us to turn our gaze downward. In doing so, they have created a kind of spatial dialogue, as it were, between earlier and contemporary commemorative forms.

To be sure, much commemorative art, particularly in the Soviet Union after the Second World War, retained its heroic verticality.[2] But in

[1] Regina Schulte, "Käthe Kollwitz's sacrifice," trans. Pamela Selwyn, *History Workshop Journal*, 41 1996), pp. 193–221; Winter, *Sites of memory, sites of mourning*; Angela Moorjani, "Käthe Kollwitz on sacrifice, mourning, and reparation: An essay in psychoaesthetics," *MLN*, 101, 5, *Comparative Literature* (December 1986), pp. 1110–34; Annette Becker, *Voir la Grande Guerre: Un autre récit* (Paris: Armand Colin, 2014); Claudia Siebrecht, *The aesthetics of loss: German women's art of the First World War* (Oxford University Press, 2013); Leona Catherine Sargent, "Visions of World War I through the eyes of Käthe Kollwitz and Otto Dix," MA thesis, Wright State University, 2012.

[2] Michael Ignatieff, "Soviet war memorials," *History Workshop Journal*, 17 (1984), pp. 157–63; Catherine Merridale, "War, death and remembrance in Soviet Russia," in

many parts of the world the geometry of memory was and remains dialogic, confronting and mixing the vertical, the language of hope and pride, with the horizontal, the language of mourning and loss. To use the horizontal is not a conclusion so much as an interrogation of earlier redemptive forms of commemorating those who die in war. Some, like Kollwitz, gave up any notion that loss of life in war had a meaning, in the sense of yielding some good through sacrifice. Not everyone, but many shared her outlook when confronting later the calamities of war and genocide, and organized the space of their commemorative work through horizontal configuration. The vertical did not disappear; witness the tower of the Ossuary at Douaumont, which dominates the vast cemeteries of Verdun.[3] It was inaugurated by French president Albert Lebrun in 1932, the same year that Kollwitz's statues were installed in Roggevelde. But Douaumont was set increasingly over time against another way of looking at the world of war and how to represent it. I want to examine a number of these dialogic sites of memory, places where we can see this search for an appropriate posture of commemorative design in the century of total war.

Gazing Downward: From Mantegna to Kollwitz

Käthe Kollwitz's sculptures offer us a point of departure for understanding the mix of verticality and horizontality in the commemorative art of the First World War. Consider the work for Peter at Vladslo as a triad, visually linking mother, father, and son. Each appears separate from the others, and in the original placement of the statues in Roggevelde in 1932, that separation was striking, reduced in 1955, ten years after Kollwitz's death, to a kind of proximity, where father and mother are still apart but almost alongside each other. Peter's cross stands in Roggevelde, but it has been replaced by a slab on which his name appears along with nineteen others. The statue of Karl Kollwitz is rigidly vertical, almost hieratic, but the sculpture captures his immense effort to contain his emotion and to remain upright. Käthe Kollwitz's portrait of herself is bowed, as if in resignation or prayer, overflowing with sorrow. Her head and shoulders

Jay Winter and Emmanuel Sivan (eds.), *War and remembrance in the twentieth century* (Cambridge University Press, 1999), pp. 61–83.

[3] On Verdun, see Antoine Prost, *Republican identities in war and peace: Representations of France in the nineteenth and twentieth centuries* (London: Bloomsbury, 2010), ch. 1.

are at roughly a 45-degree angle of inclination. And the third member of this family, Peter Kollwitz, is now represented just by his name, like his remains, in an entirely horizontal space. Here is the new dialogue of commemorative art: the vertical is not abandoned, but it is pulled downward, from paternal determination to hold himself together, on his knees and literally with his arms pressed to his body, to maternal resignation, to the inescapable reality of their son's death. Through these sculptures, Käthe Kollwitz has created a prototype of the spatial choices available to commemorative artists in the century that followed the installation of her work in Flanders in 1932.

Käthe Kollwitz lost her son Peter in 1914. Her grandson, also named Peter, died in combat in Russia in the Second World War. In 2014, her two granite sculptures of her husband and herself on their knees were recast and brought to Rshew, northwest of Moscow, where they now stand in the German war cemetery in which her grandson is buried.[4]

In a second way, Kollwitz captured a significant feature in the twentieth-century geometry of remembrance. In January 1919, the Sparticist leaders Rosa Luxemburg and Karl Leibknecht were murdered by paramilitary police after the failure of the revolutionary uprising in Berlin. Leibknecht's family asked Käthe Kollwitz to design something in his memory. She created a lithograph entitled "The Survivors of the Dead. In Memoriam, January 15, 1919" (Illus. 6.5). The title is ambiguous, but may refer to older traditions in the German labor movement to remember its losses through a rededication to the cause. The etching shows workers in various positions around the dead body of Leibknecht, whose head is surrounded by a kind of white aura. A number of mourners are bending down, to pay their last respects. Among them is a mother and child. It is this downward gaze to which I would like to draw your attention. Not everyone in the design adopts it, but there is an inescapable pull of the horizontal body of the dead revolutionary which turns their faces (and our eyes) downward. It is not only the horizontality of the lithograph, but also the downward gaze of the mourners which is striking here.

In both these representational choices – the horizontal organization of space, and the configuration of the downward gaze of the living – Käthe Kollwitz captured an approach to commemoration of signal importance in the twentieth century and beyond. Later in this

[4] Maurice Bonkat et al., "Band des Erinnerns. Kollwitz-Skulptur reist von Vladslo nach Rshew," *Frieden. Zeitschrift des Volkesbundes Deutsche Kriegsgräberfürsorge e. V* (October 2014), pp. 22–27.

chapter, I shall discuss that abundant legacy in detail. One reason her work has had such a powerful echo is that she drew on older artistic traditions dating from both before and after the Great War.

As the granddaughter of a Protestant pastor living in Königsberg, Kant's city, Kollwitz was well aware of the Protestant artistic tradition.[5] In particular, the work of Hans Holbein guided a number of her important lithographic designs. In 1520, Holbein painted a revolutionary work, perfectly suited to the Protestant Reformation launched just three years before by Luther. That work is entitled The Body of the Dead Christ in the Tomb, now in the Kunstmuseum in Basel (Illus. 6.6). It is a hyperrealistic painting, with meticulous detail, showing the dead Christ with the marks of the Crucifixion apparent, as well as the resultant dislocation of his middle finger caused by it. This man is so palpably dead, and so clearly encased in his tomb, that it is hard to imagine that hours later, he would rise from the dead. And that is precisely the point. To believe that this emphatically dead Christ will rise can only be the outcome of faith and faith alone. The Reformation is embodied in this painting, a work of terrifying originality.[6]

What makes it so striking is how it departs from traditional Christian iconography. There are no angels, no signs of the Passion, and above all, no mourners to soften the vision. There is nothing but the horizontality of death.

Holbein's masterpiece is also at the heart of Dostoyesvsky's The Idiot, what some see as his darkest novel.[7] Prince Mishkin thinks about that painting: "'At that painting!' the prince suddenly cried out, under the impression of an unexpected thought. 'At that painting! A man could even lose his faith from that painting!' 'Lose it he does,' Rogozhin agreed unexpectedly."[8]

Compare the Holbein painting to another masterpiece, painted forty years earlier by Andrea Mantegna, The Dead Christ and Three Mourners, now in the Pinacoteca di Brera in Milan.[9] The title shows

[5] On Käthe Kollwitz's religious convictions, see Klemens von Klemperer, The passion of a German artist: Käthe Kollwitz (Bloomington, Ind.: Exlibris Corp., 2011), pp. 20–21.

[6] Pál Ács, "Holbein's 'Dead Christ' in Basel and the radical Reformation," Hungarian Historical Review, 2, 1 (2013), pp. 68–84.

[7] I owe this judgment (and much else) to Sasha Etkind.

[8] Dostoyevsky, The idiot, trans. David McDuff (Harmondsworth: Penguin, 2004), ch. 4.

[9] On Mantagna's Lamentation, see Colin Eisler, "Mantegna's meditation on the sacrifice of Christ: His synoptic savior," Artibus et Historiae, 27, 53 (2006), pp. 9–22.

that this work has a secondary focus, that on the mourners on the left side of the painting (Illus. 6.7). This additional human element is precisely what is missing in the Holbein work, and what makes that later masterpiece so stunning. Mantegna presents Christ not fully horizontally, but foreshortened and with the marks of the Crucifixion visible on his feet and hands. Both paintings are path-breaking in their departure from earlier renderings of the dead Christ. Both were reworked by Kollwitz in her lithographic art.

Holbein's use of horizontality is not at all unique in the sixteenth century and after. The Venetian painter Vittore Carpaccio presented the dead Christ horizontally, on a bench awaiting his placement in the tomb in *The Dead Christ* (c. 1520), now in the Gemäldegalerie in Berlin (Illus. 6.8). Like Mantegna, he added figures of the Virgin and others in mourning, along with Job leaning against a tree. And like Holbein, he suspends the dead Christ in the foreground, separate from the multiple signs of death and desolation around him. His horizontality is highlighted strikingly by the verticality of St. John on the right, near the Virgin and Mary Magdalene.

The decision to force the viewers' gaze downward in paintings of sacred death has clear precedents too. Consider Caravaggio's *The Death of the Virgin* (1601–6), now in the Louvre (Illus. 6.9).[10] The painting caused a scandal, in part because of the posture of the Virgin, horizontally rendered and with splayed feet. But notice the rendering of the mourners, come to Ephesus to see the Virgin in her last earthly moments. Some appear to be reflective, others converse, but the three central figures highlighted by shafts of light have the same downward gaze as we have seen in the mourners in Kollwitz's lithograph for Karl Leibknecht. Her borrowing from Caravaggio's masterpiece seems evident.

The Dead Toreador (1864) by Edouard Manet, now in the National Gallery in Washington, carries traces of the same tradition in the rendering of heroism reduced to horizontality. Manet's debt to Velasquez is evident here.[11] The painting was originally part of a larger work, but Manet cut it in half, thereby highlighting the reality of violent and sudden death, separated from the bullfight which caused

[10] Philip Sohm, "Caravaggio's deaths," *Art Bulletin*, 84, 3 (September 2002), pp. 449–68.

[11] Gary Tinterow and Geneviève Lacambre, with contributions by Juliet Wilson-Bareau and Deborah L. Roldán, *Manet/Velázquez: The French taste for Spanish painting* (New Haven, Conn.: Yale University Press, 2003).

it (Illus. 6.10). The other half of the painting, entitled *The Bullfight*, is in the Frick Museum in New York. I cite Manet's work here not because Kollwitz saw it or used it, but because it shows that secular artists also experimented with the horizontal axis.

These configurations of death formed a visual archive from which Käthe Kollwitz drew time and again. In 1900, she produced one of her rare allegoric lithographs, entitled "From many wounds you bleed, O people!" (Illus. 6.11). This work has both the horizontality of Holbein in the rendering of the dead Christ/worker, flanked by two crucified women, representing poverty and prostitution, and the downward thrust of Caravaggio, in the sword and hand of the figure pointing to Christ's wound. Preferring realism to allegory thereafter, Kollwitz rendered the dead woman in "The Widow" (1922) in the same angular way Mantegna presented his Christ, though hers draws attention to the woman's head, and her dead baby on her chest, with her feet pointing away from the viewer (Illus. 6.12).

To understand fully these elements of Kollwitz's commemorative art, we need to attend to a more general reconfiguration of the geometry of remembrance in the twentieth century and beyond. Hers is a tradition not solely wedded to the horizontal, but one in which there is very little verticality on which to hang thoughts of hope and redemption. As in so many other facets of the cultural history of the Great War, Kollwitz's work shows how older forms were reconfigured to provide a visual language of mourning appropriate to the age of total war and to the indisputable facts of mass death in war. It is as if she was urging us to question the usefulness of verticality, the language of hope, in the fashioning of commemorative art. After 1914, war descended to the earth and below, and so did the vision of many artists like Käthe Kollwitz who lived through the war and who tried to do justice to the misery and loss it produced.

One such artist was Wilhelm Lehmbruck, the son of a miner born in Düsseldorf in 1881, and trained as an artist there. By 1914 he had known a degree of recognition, including a solo exhibition in Paris. During the war he served as a medic, and like Max Beckmann, he was unable to stand the suffering he saw. In 1915–16, he produced the sculpture *The Fallen Man*, the horizontality of which is deployed in an expressionist manner (Illus. 6.13). At the end of 1916, suffering from severe depression, he fled to Switzerland, where he joined antiwar artistic circles. After the end of the war, he returned to Berlin, and was elected, alongside Käthe

Kollwitz, to the Prussian Academy of Arts. None of this enabled him to survive his depression, and he took his own life in March 1919.

Lehmbruck's *Fallen Man* is open to many interpretations. It is about the artist, about the men he treated in hospital, and also about the entire war generation. Horizontality here is the language of depression, which took Lehmbruck's life barely four months after the end of the conflict.[12]

Horizontality and the Unknown Soldiers of the Great War

In the immediate aftermath of the war, the victors acknowledged the staggering loss of life they suffered by erecting cenotaphs, empty tombs to represent all the dead of the war. In Paris on July 14, 1919 and five days later in London, the victorious armies marched past two cenotaphs to symbolize all those who had died in the war. These were empty coffins placed on a high plinth, thus mixing the verticality of victory with the horizontality of mourning. The French cenotaph was demolished, in part because the French premier Georges Clemenceau thought it was too "Germanic." No such objections were made to the British cenotaph, designed by Sir Edwin Lutyens as a pre-Christian form, appropriate to the war fought by the British empire, whose armies were composed of men of every religion and none.[13]

A year later, the interment of an individual "known but to God" in the language of the Imperial War Graves Commission, was also a collective act, in that the individual could have been the son or father or brother or lover of any one of the millions of men and women who grieved for missing men. Having no identity, the Unknown Soldier, or warrior, as he was termed in Britain to do justice to the navy and the new air force, could not be adequately represented in a figurative manner. Consequently, either classical tombs, as in Washington, or slabs and eternal flames, as in London and Paris, had to suffice. All of them depart from the vertical, and invite the viewers' gaze downward to read the official tribute: "Ici repose un soldat français mort pour la patrie," under the Arc de Triomphe, and a much longer encomium at the entry

[12] Siegfried Salzmann, *Hommage à Lehmbruck: Lehmbruck in seiner Zeit* (Duisburg, Germany: Wilhelm-Lehmbruck-Museum der Stadt Duisburg, 1981).

[13] Jay Winter and Jean-Louis Robert (eds.), *Capital cities at war: Paris, London, Berlin, 1914–1919* (Cambridge University Press, 2007), vol. II, ch. 1.

to Westminster Abbey, which incorporated religious rhetoric: "They buried him among the kings because he had done good toward God and toward his house." At the base of the monument is inscribed the phrase from 1 Corinthians 22: "In Christ shall all be made alive." As ecumenical as the Cenotaph was, so the tomb of the Unknown Warrior in London bore the hopeful and unmistakably Christian message of the Resurrection. By 1930, twelve other countries had followed this practice of burying an unknown soldier who had died in the war. And in these cases of post-1918 commemoration, horizontality was – unavoidably – the dominant note.[14]

Figurative art decorated only one tomb of the Unknown Soldier, and then it was in the case of a sculpture covering an empty tomb, which only informally took on the popular title of Australia's "unknown soldier" after its unveiling in 1927. The Australian artist George W. Lambert, who was named an official war artist in 1917, received a commission eleven years later from the Roman Catholic Sailors and Soldiers Society for "one bronze recumbent figure of Soldier [sic] life size." The figure was unveiled in St. Mary's Cathedral in Sydney in 1931, after Lambert's death. It shows a soldier, in full kit, worn by combat, killed by a single bullet to the heart, lying intact and peaceful (Illus. 6.14).[15] We can see the sanitized idealization of noble sacrifice in war, made even more palatable by the beauty of the face, said to be of a type familiar to anyone visiting Bondi Beach in Sydney. Here horizontality did not foreclose the artist's choice of an heroic representation of loss of life in war. Innocence rises from the sculpture, like dew on a summer morning.

A final example of horizontality in First World War commemoration brings us to our own time. It is what is now termed installation art, and it lasted through the centennial year 2014, and then vanished from London but was recreated in 2016 at Lincoln Castle: it will be "on tour" elsewhere in the UK in 2018. Its title is *Blood Swept Lands and Seas of Red*, and it was realized by a partnership between Paul Cummins, a British ceramic artist from Derby, and Tom Piper, a

[14] K. S. Inglis, "Entombing unknown soldiers: From London and Paris to Baghdad," *History and Memory*, 5, 2 (Fall–Winter 1993), pp. 7–31. See also François Cochet and Jean-Noël Grandhomme, *Les soldats inconnus de la grande guerre. La mort, le deuil, la mémoire* (Saint-Cloud: Éditions Soteca, 2012).

[15] George W. Lambert, *Recumbent Figure* (1927), www.artgallery.nsw.gov.au/collection/works/8002/

London stage set designer.[16] Cummins had found in the Chesterfield Record Office the last letter of an unknown soldier who had died in Flanders. In the letter was a couplet: "The blood-swept lands and seas of red. / Where angels fear to tread." Dyslexic, Cummins sees words as colors, and had a vision of producing a red field made up of ceramic poppies, one for every soldier who had died in British forces during the war. In 2013 Deborah Shaw, head of a company called Historic Royal Palaces, brought Cummins together with Piper, and the two came up with the idea of producing "The Weeping Window" (Illus. 6.15), in the Tower of London, a design in which a cascade of ceramic red poppies, each roughly 12 inches high, would emerge from the Tower and one at a time, be planted and eventually surround every inch of the moat around the Tower.

This was marketing at its most brilliant, in that for the privilege of planting a ceramic poppy, individuals paid £25 to benefit charities aiding British soldiers and their families. Starting on August 5, 2014, and continuing until the end of the year, 888,246 ceramic poppies were planted. This public installation artwork was an unparalleled success, and showed the power not of the state but of civil society to do the work of commemoration.

There were many critical voices which spoke of the project's sanitization of loss of life in war, of its turning of suffering on an unparalleled scale into public art or kitsch, quickly seized by the British army as a way of filling its charitable coffers. And yet there are two points which resist all such criticism and which are relevant to the argument of this chapter. The first is that the project was immensely popular, and from newspaper surveys and blogs, the sentiments attached to the event were nearly universally somber. The simplicity of the design of the project strikingly captured the sea of blood, shed in the war (Illus. 6.16). And what gave it its elegiac and sad power was the very horizontality of the vast tapestry of red which seemed to emerge from the heart of British history, at the Tower of London, and engulf

[16] Natasha Geiling, "For WWI anniversary, the Tower of London has become sur-rounded by a sea of poppies," *Smithsonian Magazine* (August 2014), www.smithso nianmag.com/travel/wwi-anniversary-tower-london-bleeding-poppies-180952236/ #lzxj7hObcjgzHyhX.99; and Mark Brown, "Blood-swept lands: The story behind the Tower of London poppies tribute," *Guardian*, December 28, 2014, www.theguar dian.com/world/2014/dec/28/blood-swept-lands-story-behind-tower-of-london-pop pies-first-world-war-memorial

symbolically the nation, which has never recovered fully from the shock of that war. In one way or another, on television, in the press, or in person, everyone in England came to the Tower and looked down, and what they saw was no advertisement for war or the military; they saw a visualization of the poetry of Wilfred Owen and Siegfried Sassoon and many others, still taught in schools and colleges throughout the country; they saw a sea of blood, and perhaps learned something of the long afterlife of war in the hardships faced by disabled veterans and their families. At the end of the year, the red carpet of suffering was rolled up, one poppy at a time, and taken away. But Cummins and Piper had made their point horizontally. By forcing us to look down, they showed visually that the one facet of the Great War that remains at the heart of the nation's memory of it is the Lost Generation.

The Second World War and Civilian Deaths

More civilians than soldiers died in the Second World War. This transformation in the way war was waged changed the nature of commemorative practices and forms. Yet initially, older forms of vertical heroic architecture proliferated. In the Soviet Union, massive verticality marked the staggering price paid in lives for victory. And yet we can see a slight shift in the optics of commemoration when civilian victims came to the fore.

Starving to death in Leningrad was hardly heroic, but it was the fate of hundreds of thousands of ordinary people. The approximately 1 million residents who died during the siege of the city, and the soldiers who died in its defense, are honored both by a vertical column at Victory Square (Illus. 6.17) and by the horizontality of 486 mass graves in the city's Piskarevskoye Memorial Cemetery. Preceding this seemingly endless plain of slightly raised mounds, at which visitors place flowers, is a vertical statue of the Motherland, placed at the head of the Avenue of the Unvanquished (Illus. 6.18).

The victory at Stalingrad is marked similarly at the site by a huge sculpture of the Motherland, 52 meters high, built between 1958 and 1967, (Illus. 6.19).[17] It is iconic in the same way as Franco's gigantic

[17] Scott W. Palmer, "How memory was made: The construction of the Memorial to the Heroes of the Battle of Stalingrad," *Russian Review*, 68, 3 (July 2009), pp. 373–407.

cross, 150 meters high, which marked his victory in the Spanish Civil War, in the Valley of the Fallen, between Madrid and El Escorial (Illus. 6.20).[18] This ensemble was built by workers and Republican prisoners between 1940 and 1958, to honor Franco and the men who died in overthrowing the Spanish Republic from 1936 to 1939.

Monumentality was a choice which began to fade when the history of the Second World War became braided together with the history of the Holocaust. Initially, the victims of the Holocaust were occluded by those who suffered in the Resistance, but by the 1970s, European political and economic recovery was sufficiently stable to enable the dark history of genocide to emerge from the shadows. And when that happened, new approaches to the commemoration of the victims of war emerged. Among them was the choice of horizontality as the geometry of remembrance.

Initially, the heroic last stand of the Warsaw ghetto uprising received the same Soviet-style treatment in Nathan Rapoport's "Ghetto Heroes Monument," unveiled in 1948 (Illus. 6.21).[19] But over time, it became more and more difficult to represent the Holocaust through singling out Jewish resistance groups. What about the others? Were they less "heroic"? One way in which artists have tried to represent the fate of the murdered Jews of Europe is by exploring their absence and that of the entire world of Eastern European Jewry, destroyed between 1933 and 1945. And in that exploration, horizontality appeared more and more as a strategy of artistic expression.

There are many instances I could point to in support of this interpretation, but I choose only four. The monument of Jochen Gerz and Esther Shalev-Gerz in Harburg, Hamburg (1986), the empty library of Micha Ullman in Berlin (1995); the monument to Walter Benjamin entitled *Passages* by Dani Karavan in Portbou, Catalonia (1994), and Peter Eisenman's Monument to the Murdered Jews of Europe in Berlin (2005).

The first is a monument dedicated to deal not only with the Holocaust, but also with fascism tout court. At the invitation of the municipal council of Harburg, Hamburg, Jochen Gerz and Esther

[18] Walther L. Bernecker and Sören Brinkmann, *Kampf der Erinnerungen. Der spanische Bürgerkrieg in Politik und Gesellschaft 1936–2006* (Nettersheim: Graswurzelrevolution, 2006).

[19] James E. Young, "The biography of a memorial icon: Nathan Rapoport's Warsaw Ghetto Monument," *Representations*, 26, *Special issue: Memory and counter-memory* (Spring 1989), pp. 69–106.

Shalev-Gerz created a 12-meter-high lead-coated column, on which residents were asked to sign their names as opponents of fascism. It was erected at Harburger Ring at the corner of Hölertwiete/Sand (Illus. 6.22–6.23). Between 1986 and 1993, the monument was lowered eight times, until it disappeared. What was left was this inscription on the ground:

> We invite the citizens of Harburg, and visitors to the town, to add their names here next to ours. In doing so we commit ourselves to remain vigilant. As more and more names cover this 12-metre tall lead column, it will gradually be lowered into the ground. One day it will have disappeared completely, and the site of the Harburg Monument against Fascism will be empty. In the end it is only we ourselves who can stand up against injustice.[20]

Jochen Gerz and Esther Shalev-Gerz found a powerful way to assert that remembering the horrors of the Third Reich should not be restricted to erecting or visiting stone memorials. The citizens who signed their names on the column were not discharging thereby their debt to the victims of fascism. More powerful than a vigil was vigilance, a form of active citizenship needed to stop even the tiniest shoots of fascism from reemerging. With justice, James Young refers to this work as an antimonument, against the grain of monuments in front of which the living engage in a kind of empty genuflection toward the dead which stops then and there.

But consider the form of this monument and its progressive disappearance. Who could miss the symbolism of creating a disappearing monument in a city which had a Jewish population of 185,000 in 1939 and a few hundred in 1946? By starting with verticality, and by progressively making a vertical structure disappear, they reenacted the murders that wiped out, in J. A. S. Grenville's phrase, an entire civilization.[21] What we are left with today at the site is horizontality *pur et dur*.

A second site uses a horizontal portal to represent both a famous moment in Nazi history and where it led. At precisely the place on Unter den Linden near the Berlin Opera where on May 10,

[20] See www.gerz.fr; also Jochen Gerz and Esther Shalev-Gerz, *Mahnmal gegen Faschismus, Monument against Fascism* (Stuttgart: Hatje/Cantz, 1994) (German and English).

[21] J. A. S. Grenville, *The Jews and Germans of Hamburg: The destruction of a civilization 1790–1945* (New York: Routledge, 2012), p. 298.

1933 Nazis burned thousands of books, Israeli artist Mischa Ullman constructed an underground library, consisting of entirely empty shelves (Illus. 6.24). This empty space is made even stranger by the placement of upward-facing lights within the "library," which, in the evening and night, give the site a subterranean glow. Adjacent is a citation from Heine's play *Almansor*: "That was only a prelude; where they burn books, they will in the end also burn people." Ullman created a commemorative site accessible only by looking downward.[22]

Ullman's *Library* opened in 1995. A year before, another Israeli artist, Dani Karavan, invited us to look down to understand the fate of one of those who died trying to flee Nazi persecution. His *Passages*, financed jointly by the government of Catalonia and by the Federal Republic of Germany, was created in memory of the German critical theorist Walter Benjamin, who committed suicide at Portbou on the Franco-Spanish (Catalonian) border on September 8, 1940. He had been turned away by Spanish border police, and feared arrest and return to either French collaborators or to the Gestapo. In fact, the border reopened the day after his death, but for Benjamin, no stranger to depression, the prospect of being handed over to the Nazis was unbearable.

The title *Passages* refers not only to Benjamin's failed attempt to flee France, but to the German title of what is now known as the "Arcades project," a sprawling literary and philosophical exploration of the streets and byways of Paris, the city he termed the capital of the nineteenth century. Karavan placed his monument high up on the cliffs surrounding the railway station of Portbou.[23] The wild and beautiful landscape frames what looks like the entry to an air-raid shelter, or perhaps a simplified Parisian Metro station. Within it, there is a series of steps leading to the sea, and freedom (Illus. 6.25). Two-thirds of the way down is a transparent pane of glass, blocking the way forward. On it is written in five languages one of Benjamin's reflections *On the concept of history*: "It is more arduous to honour the memory of the nameless than that of the renowned. Historical construction is devoted to the memory of the nameless."[24]

[22] On antimonuments in general and on Ullman in particular, see James Young, "Memory, counter-memory and the end of the monument," in Shelley Hornstein and Florence Jacobowitz (eds.), *Image and remembrance: Representation and the Holocaust* (Bloomington: Indiana University Press, 2006), pp. 59–78.

[23] John Payne, "'An expensive death': Walter Benjamin at Portbou," *European Judaism: A Journal for the New Europe*, 40, 2 (Autumn 2007), pp. 102–5.

[24] Esther Leslie, *Walter Benjamin* (London: Reaktion Books, 2007), p. 225.

Karavan's is not the only monument to Benjamin in Portbou. Hannah Arendt visited the site shortly after Benjamin's death, and though he was probably buried in a mass grave, she helped prepare a stone memorial in the town cemetery, inscribed with the seventh of his *Theses on the Philosophy of History*: "There is no document of civilization, which is not at the same time a monument to barbarism." What Karavan added was a downward passage to the freedom Benjamin never found.

A fourth instance of the use of the horizontal perspective in the commemorative art of the Holocaust is Peter Eisenman's Monument to the Murdered Jews of Europe, near the Brandenburg Gate in Berlin. The monument is an ensemble of 2,700 concrete rectangular shapes of varying heights, many above human height, others below (Illus. 6.26). The result, not entirely anticipated by the architect, was to create a space of disappearance. Here is Eisenman's own sense of the effect of his design, from an interview on May 9, 2005:

> Just yesterday, I watched people walk into it for the first time and it is amazing how these heads disappear – like going under water. Primo Levi talks about a similar idea in his book about Auschwitz. He writes that the prisoners were no longer alive but they weren't dead either. Rather, they seemed to descend into a personal hell. I was suddenly reminded of that passage while watching these heads disappear into the monument. You don't often see people disappear into something that appears to be flat. That was amazing, seeing them disappear.[25]

Like a concrete maze, Eisenman's monument suggests a nightmare, in which tombstones change size, and some grow to become huge rectangular blocks, imprisoning those who wander among them. From above, the field of stone looks like waves in a sea (Illus. 6.27). Another way of capturing the effect his design produces is that it likens entry into the time and space of the Holocaust to a black hole, which absorbs all light or energy in its orbit. Here too we are deep into the language of loss, descent, entrapment, and horror. A "personal hell" to which one could affix Dante's admonition in *The Inferno*, "Abandon hope all you who enter here."

[25] "SPIEGEL interview with Holocaust monument architect Peter Eisenman: 'How long does one feel guilty?'," *Spiegel Online International*, May 9, 2005, www.spiegel.de/international/spiegel-interview-with-holocaust-monument-architect-peter-eisenman-how-long-does-one-feel-guilty-a-355252.html

The way this monument is shaped creates a landscape of disorientation, discomfort, and at times, panic. But not everyone who has been there feels these negative emotions. The monument has no border, and thus children skateboard over and through this space. Its abstract title says little about which murdered Jews it commemorates and who were the murderers.[26] True, there is a visitors' center in one corner, but that underground space is not part of the monument visitors see. And yet, the one term hard to avoid in assessing Eisenman's achievement is that it captures the uncanny character of the crime. It tells us that the Holocaust happened, and that Berlin is the place to remember it, since here was where the orders went out to kill every Jew in Europe. And yet that matter-of-factness is just the beginning of a story which still seems strange, unnatural, otherworldly.

An architectural environment of a descent into hell, Eisenman's design followed Karavan's downward path to death not as it happened to one person, but as it happened to the 6 million as a whole. The Memorial to the Murdered Jews of Europe does not invite our gaze downward, but asks us to feel that descent into genocide.

Once again, the material presented here highlights but one visual strategy of remembrance, only one geometry of memory, in which the vertical is either muted or disappears. There are many other Holocaust memorials which employ different optics and use vertical space. Just one is the New England Holocaust Memorial in Boston (Illus. 6.28). Located on the Freedom trail, this monument contains six 54-feet-high transparent columns. At their base are statements describing the experience of those trapped in the Holocaust. I believe that such monuments use verticality to describe a trajectory of hope, of a belief in survival manifest in the lives of those who commissioned this project. What horizontality offers is a different perspective, one perhaps with muted hope at best, and with a puzzlement as to whether we can truly comprehend the nature and significance of this moment of darkness. Horizontality in Holocaust commemoration is an interrogation, a question mark, an expression of doubt as to whether we can grasp in any meaningful sense the disappearance of Eastern European Jewry, the one irreversible victory the Nazis registered during the Second World War. Preserving such uncertainty may be its most enduring effect.

[26] For just one critique, see Richard Brody, "The inadequacy of Berlin's 'Memorial to the Murdered Jews of Europe,'" *New Yorker*, July 12, 2012.

Maya Lin and the Vietnam Veterans Memorial

The Holocaust monuments discussed above were commissioned and realized from the mid 1980s to 2005. One very different project preceded them: Maya Lin's design and realization of the Vietnam Veterans Memorial on the Mall in Washington.[27] I discuss her work separately in part because her approach to horizontality drew on other sources and other meanings than did those who designed Second World War commemorative sites, either with respect to military losses or with respect to the Holocaust. The best way to understand her achievement is to see it as parallel to though independent of the efforts of the architects working on problems of configuring sites directly dealing with the deaths of the Jewish civilian population of Europe.

Maya Lin's work does not deal with civilian deaths in war. Her design was an entry to the competition to build a monument to the 60,000 American men in uniform who had died in the Vietnam War. She completed her submission while an undergraduate student in architecture at Yale University. Among her teachers was Vincent Scully, who famously lectured on the power of Sir Edwin Lutyens's monument to the missing of the Battle of the Somme at Thiepval in France. It was her creative engagement with First World War commemorative forms which enabled her to create the design which won the national competition.

The links between the two wars was evident. Vietnam was a war whose meaning for Americans came to lay predominantly in the blood of the American soldiers who lost their lives in the conflict. For the Viet Cong and the North Vietnamese, the war was an anticolonial conflict which extended from 1945 until 1975. In the first phase, lasting from 1946 to 1954, the French were defeated; in the second phase, lasting until 1975, the Americans were defeated. The cost in Vietnamese lives is unknown; a very rough approximation is that over 1 million Vietnamese died in the war. The divide in American opinion over the justice of the war in Vietnam was profound; ultimately, the nation lost the will to continue the struggle, and wound up experiencing a sense of futility disturbingly similar to that expressed by the war poets of the First World War.

[27] Daniel Abramson, "Maya Lin and the 1960s: Monuments, time lines, and minimalism," *Critical Inquiry*, 22, 4 (Summer 1996), pp. 679–709.

Both after 1918 in Britain, and after 1972 in the United States, an essential question arising from war was how to honor those soldiers who died in war without honoring war itself. Maya Lin found a way to do so by focusing solely on the names of those Americans who had perished on active duty. And here again, war memorials of the First World War offered her an archive, since names were all that remained for fully 50 percent of all those who died in the conflict. Artillery had turned industrialized war from being solely a killing machine to being a vanishing act. That is why, at the poet Rudyard Kipling's behest, the Imperial (now Commonwealth) War Graves Commission adopted the phrase from Ecclesiasticus to mark a stone of sacrifice in every war cemetery: Their name liveth forever more.

Lutyens had gone one step further at Thiepval. There, the 73,000 names of missing soldiers who died in the Battle of the Somme between July 1 and November 10, 1916 are listed by regiment and by rank on massive stone spaces on the lower facade of the monument. The monument is approached by a slight grassy incline, and while initially visitors see only the stone facade, there comes a vanishing point at which the names suddenly become visible and legible.

In 1982, Maya Lin displayed the names of the 60,000 dead American servicemen horizontally, by date of death, starting from the join of two long stone walls. One wall pointed directly to the Washington Monument on the Mall; the other, to the Lincoln Memorial.

She broke new ground in two respects. First, she used highly polished black stone surfaces on which to etch the names; this presented visitors with their own faces looking at and into the monument. Secondly, unlike Lutyens, she designed a downward pathway into the monument meaning that visitors disappear from sight. They effectively move into the earth to move into history (Illus. 6.29). And when they did so, they not only saw their own reflection, but they also one at a time symbolically brought the dead of the Vietnam War back home, to the heart of the nation they served. The cause has faded away, but not the men who had died in it.

Initially more than a few servicemen objected to the design, and some objected to the fact that an Asian-American woman was its creator. In later years, a Texas millionaire financed a vertical and figurative monument adjacent to Maya Lin's wall, to offer visitors a different face of war and of warriors. But over time, the power of her horizontal design has achieved iconic status. By changing the geometry of remembrance

from the vertical to the horizontal, and by making each individual visitor confront her own image in the surface of the monument, she found a way to bypass the political dimension of commemoration and to locate the project in the realm of individual and family loss. This army of names was not an army; it was a vast array of individuals who died before their time. To touch the name of any one soldier on the wall became both a way of reaching that man or woman, and of reaching that part of ourselves that we lost with their deaths (Illus. 6.30).[28]

The genius of Maya Lin's design was this: Her use of the horizontal axis as the organizing principle of her design enabled her to create a narrative of war that went beyond glory. No other monument has ever done so in a nation whose flag is still named "Old Glory." By inviting us to descend below the surface of the Mall, Maya Lin changed the geometry of American remembrance.

Maya Lin's memorial has one additional feature shared in a number of other twentieth-century commemorative sites. Its gentle decline into the ground and its highly polished stone invite the laying of wreaths, the insertion of flowers at particular names, and the placement of objects as gift exchanges with the dead. The meaning of the gesture is clear. They gave everything; this wreath or this toy or this other intimate object is the least we, the living, can give. The practice started in the Victory Parade past the Cenotaph on July 19, 1919; thousands of flowers and other objects had to be carted away, gifts from a public numbering over a million. Who knows how many people left objects for Lady Diana after her sudden death in 1997. The same practice has created an archive of objects left at the Vietnam Veterans Memorial, thereby adding an element of pilgrimage to the practice of visiting the site. As suggested in Chapter 5, these gestures show that the sacred is alive and well, even in countries which have secular memory regimes.

Horizontality and European Pacifism

Horizontality is an expression of pacifist tendencies in the public representation of the First World War in Europe. At the heart of the design of two sites of memory, both in northern France, the horizontal

[28] Maya Lin, "Making the memorial," *New York Review of Books*, November 2, 2000, www.nybooks.com/articles/archives/2000/nov/02/making-the-memorial/

represented the language of mourning, in preference to the vertical, the language of hope. In contrast to museums and monuments of the Second World War, though not of the Holocaust, these projects show a rejection of representations of war centered on the upright soldier, with weapons pointing onward and upward. Instead, the new designs returned to the ground in which the men who fought and died in the First World War remain.

In a sense, this is in line with the meaning of European integration as a turn away from war. Since the Treaty of Rome in 1960, Western Europe has been reconstructed as a loose confederation in which states trade off a degree of sovereignty for a flawed, though palpable guarantee of security. Internal borders no longer control European population movements. The fact that it is possible to drive from France to Germany just as if one were driving from Connecticut to Massachusetts is an example of this change. Yes, the American security umbrella and NATO made this possible, especially before the collapse of the Soviet Union, but the vital fact is that since 1960 domestic opinion within Europe changed about the legitimacy of war as an expression of political purpose. After the expansion of the European Union to incorporate most of the old Warsaw Pact nations, however, there arose a divide between West and East on issues of war and peace, reflected in different levels of support in the two parts of Europe – what the American secretary of defense Donald Rumsfeld famously called "Old Europe" and "New Europe" – for the American-led wars in Iraq and Afghanistan.

Furthermore, the First World War did not have the iconic status in Eastern Europe it had in the West, and hence the public representation of the history of the 1914–18 war did not reflect current political trends in Warsaw, Bucharest, or Budapest as it did in Paris, London, and Berlin.

Museums and monuments of the First World War have expressed this sea change in Western European opinion against war in a number of places and in a number of ways. We focus on two here, both of which strikingly employ horizontality as the organizing principle of their spatial design. The first is the Historial de la grande guerre, at Péronne, Somme, France, a museum of the First World War located at the site of German headquarters of the Battle of the Somme;[29] the

[29] For part of the story, see Jay Winter, "Public history and the 'Historial' project 1986–1998," in Sarah Blowen, Marion Demossier, and Jeanne Picard (eds.), *Recollections of France: Memories, identities and heritage in contemporary France* (Oxford, Berghahn, 2000), pp. 52–67.

second is *The Ring of Remembrance*, a monument in northern France to the men who died further north in Artois and Flanders during the Great War.

In 1985, local politicians in the Département de la Somme in France were encouraged by a retired minister of the armed forces, Max Lejeune, to fund the construction of a new museum of the Battle of the Somme there, where it happened, and where his father had fought, in a department which had no other tourist sites within many kilometers. The battle was the most massive encounter of the British army in the war, and it engaged millions of German and French soldiers for six full months of futile combat, yielding little gain for the Allies, but over 1 million casualties. It was a battle without precedent, the place where the German writer Ernst Jünger said the twentieth century was born.[30] With a British, a French, and a German dimension, the Battle of the Somme had to be represented in a multinational museum of the battle, a rarity at the time. This was particularly important in France, where French participation and casualties – over 200,000 – were occluded by a singular focus on the Battle of Verdun, fought from February to November 1916, which has a special status in French history and memory.

The support of one man was essential to the success of the project. Max Lejeune was a long-serving president of the Conseil général of the department. He had the gravitas and influence to ensure that the project would be completed. He and his colleagues actively sought out the advice of historians as to how the project could be realized. He accepted the idea that the museum should be more ambitious and aim to represent the Great War as a whole. He heard sympathetically my plea, as one of the three senior historians guiding the project in its early days, that the department should set up a research center to help design the museum, as well as to continue to support this center subsequently, in order to bring the fruits of historical research into its life and work thereafter. We historians were not advisors alone, but active partners in the work of creating the museum.

The support of local authorities created a unique moment, one that married the money of local government with the enthusiasm of a generation of historians of the First World War prepared to engage in public history, the engagement with the millions of people outside the

[30] Winter, *Remembering war*, p. 223.

academy passionately interested in history in general and the history of
the First World War in particular. As was the case for many of them,
Max Lejeune's own family memories of the war and its aftermath were
still very much alive. His father, long dead, had fought in the war, and
creating this museum was a way for Max Lejeune to honor him.

Between 1989, when the research center was launched, and
1992, when the museum was inaugurated, in the presence of Ernst
Jünger, guest of honor, who had fought in Péronne seventy-six years
before, we[31] in the research center worked alongside the architect Henri
Ciriani, the museographer Adeline Rispal, the collector Jean-Pierre
Thierry, and Hugues Hairy and his colleagues in the Department of
the Somme. This was truly a collective entreprise, with individual con-
tributions mixed chaotically and creatively.

This was also a transnational project from the start. There were
two innovations in design. The first was the placement in the showcases
of artefacts purchased in the vast antiquarian market selling First World
War memorabilia, on parallel shelves, in French alphabetical order, first
German (*Allemagne*) at the top shelf, then French in the middle, then
British (*Grande Bretagne*), Dominions and Empire below. This spatial
proximity and parallelism of objects showed how similar were the
artefacts, cultural as well as military, produced during the war across
national boundaries. Already, this was daring, since, for example, the
display suggested that French and German propaganda was very simi-
lar, thereby stripping each of the label "good" and "evil" so universally
accepted during the war itself. To be sure, those designations depend to
a degree on the viewer's nationality.

What came to be termed "war cultures," signifying practices
enabling men and women to make sense of and to endure the cruelties
and hardships of war, were prominently displayed on the wall show-
cases dedicated to the home fronts at war. Let me add that placing
German objects above French objects and showing the striking simila-
rities in the way civilians on both sides understood the war in an entirely
French-funded museum were innovations at the time. Older forms of
representation, focusing solely on "our side" during the war and separ-
ating almost hermetically the front and the home front, were common at
the time.

[31] The five original contributors were Jean-Jacques Becker, Gerd Krumeich, Stephane
 Audoin-Rouzeau, Annette Becker, and me.

The second original transnational aspect of the design of the Historial is its use of horizontality in the organization of space. Instead of using only the wall space to present objects in glass cases, we designed a dozen rectangular shallow dugouts, perhaps 8 inches in depth, and 15 feet by 8 feet in length and width, in which to place the objects soldiers used during the Battle of the Somme and throughout the period of trench warfare extending from 1914 to 1918. These dugouts, or *fosses* in French, were placed in the two large rooms in which we developed our visual narrative of the war from 1914 to 1916, before the Battle of the Somme, and from 1917 to 1918, after it.

These *fosses* clearly distinguished the approach adopted in the Historial from that of other museums of the First World War. First, the objects placed in the *fosses*, authentic period items, were arrayed in a highly stylized and nonrealistic pattern. This decision enabled us to make three points. The first was that the misery of French soldiers in the trenches was no different from that suffered by their British allies or their German enemies. Trench warfare was a transnational experience, involving millions of soldiers from all over the world, using the same lice powder and playing the same kind of instruments, fashioned by artisans and used by millions to keep their spirits up.

Secondly, the design enabled us to make a visit to the museum an interrogation rather than a simple didactic exercise. In effect, we asked viewers "*Can you* imagine what war was like?" We did not make the statement "We know what war was like, and now you do too." Many museums pretend to provide viewers with answers, through "total immersion" in "the trench experience," through displays laden with plastic rats and other recreations of the detritus of war, or through sound, either a soundtrack telling visitors what to feel or through films made today in which actors speak historical accounts of battle or of the treatment of the wounded. No pseudo-realism here; instead, we challenged the visitor to imagine war, rather than to be told precisely what it felt like to be a soldier in it. This is the reason why there was initially no display of the topography or stages of the Battle of the Somme in the museum; it is up to the visitor to make the leap herself as to what that immense battle "was like."

Thirdly, looking down on these *fosses* suggested that those visiting the museum had come to a vast cemetery. The Somme is dotted with war cemeteries, French, German, and Imperial, now Commonwealth, and visitors were bound to see some of them on

leaving the museum. This emphasis on death and bereavement is spatial, and scattered poems and prose in the base of the showcases reinforced the point. The fact of mass death in wartime is everywhere in the Historial, and the use of horizontality in its design emphatically brings that home to the visitor.

Fosses dominate the two central rooms of the museum (Illus. 6.31 and 6.32). In the entrance to the third room, covering 1916–18, there was a visual syllogism: three *fosses*, one showing fire power, a second showing the frail defensive cover soldiers had, and a third showing the outcome – surgery and medical repair. In this third *fosse* are the surgical kit of the French surgeon and writer Georges Duhamel, and the flute which kept him sane between long bouts of surgery.

What gives the use of *fosses* a further depth of meaning is the placement alongside them of video screens at eye level which present visitors with wartime cinematic images of the objects in the *fosses* or in the showcases along the walls in use. To see contemporary film footage of a prosthetic arm in use or shell-shocked soldiers under care makes the *fosses* repository not of objects alone, but of experience.

In other parts of the museum, the horizontal was used in dialogue with the vertical. The architect, Henri Ciriani, designed a central "Hall of Portraits" in which floor-to-ceiling poles of images of ordinary life before the war stand in front of a presentation of the 53-part lithographic masterpiece of Otto Dix, *Der Krieg*, discussed in Chapter 2. Dix fought at Péronne, and in 1924, created a vision of the horrors of war which has a force similar to that of Goya's work. Behind the verticality of peace, the design suggests, is the horizontality of wartime cruelty and suffering. In the first room of the museum, dealing with the prewar world, the space was divided into two parts: one on the right of horizontal and enlarged maps of points of conflict before 1914 – Alsace-Lorraine, the arms race, empire, the Balkans – and the other on the left of objects representing the commercial, educational, and social ties that bound the European powers together before the war. The organization of space suggested that war was a choice, not a necessity nor an inevitable conflict, in 1914.

Colleagues in the Imperial War Museum in London and elsewhere felt that this horizontal design would never work. They pointed out the danger that children would jump into the *fosses* and ruin objects. But in the twenty-five years that have followed the opening of the museum, not a single person (to my knowledge) has

entered the space of the *fosses*, protected too by electronic surveillance. I suspect this is because the design forces people to look downward, producing a kind of aura around the *fosses* associated with visits to cemeteries or archeological digs. There is a kind of semisacred atmosphere produced by these *fosses*, one which helps reinforce the overall sense of our visual narrative that the Great War was a catastrophic bloodbath, the outcome of which prepared the ground for worse to come.

This unstated but palpable interpretation reinforces the view that the museum is pacifist in character. It is a space for the comparative European military and cultural history of societies torn apart by war between 1914 and 1918. The men who died in it served with courage and conviction, and died by the million. In the fourth room, on the postwar years, the displays focus on war memorials, and on the failed peace.

Silent, beautiful, complex, demanding: the Historial de la grande guerre uses the horizontal axis to force visitors, young and old, to look at the war anew, and to recognize that the scale of the catastrophe was so great that postwar Europe was made less of victors and vanquished than of survivors. The museum's success is that it found in a new kind of geometry of memory an original space enabling us to honor the men who died in war without honoring war itself.

In 2014, twenty-two years after the inauguration of the Historial de la grande guerre, a second project was completed in northern France. It was a monument rather than a museum, though it bears striking similarities in one important respect to the Historial. It is resolutely horizontal in form and both transnational and pacifist in character.

The Ring of Remembrance is a huge elliptical structure set alongside one of the largest military cemeteries in France at Notre Dame de Lorette, near the city of Arras and the Canadian memorial at Vimy. The monument is a 328-meter cast concrete ring, bearing 500 copper-toned panels (Illus. 6.33). On each plaque are written in specially designed calligraphy the names of approximately 1,000 soldiers who died in Artois and Flanders in the First World War. These names are arranged alphabetically without reference to nationality (Illus. 6.34).

Philippe Prost, the architect, had two years to complete the project. As in the case of the construction of the Historial, Prost enjoyed the full support of regional and local politicians in the Department of the

Nord and of the Pas-de-Calais. Yves Le Maner, Director of the Office of History, Memory and Commemorations of the Regional Council, played an important role in this effort, comparable to that of Hugues Hairy, who fulfilled a similar function in guiding the Historial project for the Department of the Somme. The *Ring of Remembrance* was inaugurated on November 11, 2014 by President François Hollande, whose family fled this region in 1914, and whose grandfather served in the war.[32]

This part of France has been devastated over the last fifty years by the decline of textiles and mining. Local politicians and administrators look to tourism and commemorative projects to create what they see as a third industrial revolution, one based on information rather than on extractive or manufacturing industry.[33] Financial support for commemoration is part of the effort regional authorities are making to redefine their profile and to present their "heritage" to tourists and schoolchildren alike.

The war is etched in the landscape of this part of France, which was devastated by fighting both before and after the great battles of 1916 on the Somme, further south, or at Verdun, further east. Here was the site of global war, drawing in military units and munitions from all over the world.[34] One of the great war novels, *Under Fire* by Henri Barbusse, which won the Prix Goncourt in 1917, describes the savage fighting and misery of soldiers in this sector. In addition, this part of the Western Front extended into Flanders, passing through the city of Ypres, virtually destroyed during the war. The Flemish government, autonomous on questions of culture under Belgium's divided political structure, has been a very active player in commemorative politics with an emphatic pacifist tone to their interventions. Both north and south of the border between Belgium and France, there was a consensus that the war had to be commemorated at the centennial of its outbreak as a human disaster. The new monument at Notre Dame de Lorette powerfully reflects this point of view.

[32] "14–18: en inaugurant 'l'anneau de la Mémoire,' Hollande se confie sur son grandpère," MY TF1 News, November 11, 2014, http://lci.tf1.fr/france/societe/centenaire-de-14-18-hollande-veut-faire-passer-un-message-d-espoir-8517229.html?xtmc=notre%20dame%20de%20lorette%20l%27anneau%20de%20memoire&xtcr=2

[33] I am grateful to Philippe Prost for talking with me about the project. Interview, Paris, August 31, 2015.

[34] Philippe Prost, *Mémorial international de Notre-Dame-de-Lorette* (Paris: Les Édifiantes Éditions, 2015).

A secondary element in the public profile of the project was its entirely transnational character. To list names without nationalities describes its European and humanist character in a crystalline way, highlighted by the development of an original typeface and process for engraving 580,000 names on the 580 large rectangular plates placed in the ellipse. Of these names, roughly half served in British forces.[35]

Given the fact that many of the names are those of non-Europeans who served in European armies, honoring all those who died in precisely the same understated way is a political statement at a time of rising xenophobia and tension over immigration, in particular Muslim immigration, to France and Belgium, as well as to the rest of Europe. Treating the names of German men as indistinguishable from the names of all the others follows the same Europeanization of the history of the war, understood as a common catastrophe, that we saw in the Historial. By 2014, at the time of the centennial of the outbreak of the conflict, Ernst Jünger's robust fascination with war no longer captured the public mood. More somber views about war now predominate, and Philippe Prost and his team reflected them. The funerary character of the project was reinforced by the fact that during its construction, nine bodies were unearthed, two of which were identified as French soldiers killed in the French offensives of May 1915.[36]

Prost acknowledges that the horizontal axis was the organizing principle of the project from the start. Adjacent to a vertical Catholic basilica, and a vertical stone lantern and beacon to the "glory of the dead," Prost's ring unfolds in an entirely different spatial universe (Illus. 6.35). His elliptical structure was placed so as to be below the line of the horizon. The rhythm of the 500 copper-toned sheets of names recalls, he stated, the elegant rhythms of the Campo Santo cemetery in Pisa.

In this project, the names and only the names are what matters. The sheer number of the dead precludes a downward gaze in viewing them. On entering the monument, we need to look up to start searching for individuals. We can find Wilfred Owen's name here, as well as Isaac Rosenberg's name. But they are no different from the others'.[37] Here Prost's work echoes the precedent set by the Imperial (now Commonwealth) War Graves Commission, but diverges in using a metal rather than a

[35] "14–18: en inaugurant 'l'anneau de la Mémoire.'" [36] Prost, *Mémorial.*
[37] Kate Williamson, "New French WWI memorial focuses on individuals, not nations," BBC News, November 11, 2014, www.bbc.com/news/blogs-eu-29991019

concrete surface on which to etch the names of the dead. In a sense, Prost's monument is half way between the Commonwealth cemeteries scattered throughout northern France and Maya Lin's Vietnam Veterans Memorial. Prost did not create a polished reflecting surface, capturing the visitors in the optic of the memorial, but the simplicity of his structure and the names it bears, as well as its horizontality, suggest a line running from the First World War to Vietnam to today.

Like one of the rings of Saturn, Prost's *Ring of Remembrance* is perched on a slope, with a section unanchored to the ground. His purpose, he said, was in part to suggest the fragility of memory and of peace. The monument has none of the massive stability of Lutyens's monument at Thiepval, nor the imbeddedness in the ground of Maya Lin's Vietnam Veterans Memorial, firmly dug in to the soil of the Washington Mall. What gives *The Ring of Remembrance* its solidity is the overwhelming number of names, one name for one man, in the army of the dead of the Great War.

A twenty-first century addition to the practice of using the horizontal as the defining spatial element in commemorative projects, Philippe Prost's *Ring of Remembrance* both continues what is now a clear line in the practice of remembrance, and breaks new ground in its silent, spatial dialogue with older, vertical monuments and religious buildings near it.[38] Like Maya Lin, Prost has engaged in a dialogue between using the horizontal and the vertical. In the landscape, the horizontal is dominant; but when you enter the space of commemoration, in both cases you look up at a field of names. The vertical is there, but it is drawn downward, by the weight of numbers, of the thousands and thousands of names of the dead. In Notre Dame de Lorette as in Washington, we see powerful instances of the turn away from the vertical language of hope and redemption in public meditations on war and its meaning.

Consider finally how the need to look down defines the National September 11 Memorial and Museum in Lower Manhattan. *Time* magazine captured the design and the power of the site's geometry in these words:

> A few months after the attack on the World Trade Center, Rudolph
> Giuliani, then the outgoing mayor of New York City, called for a

[38] See the interesting discussion in Sabina Tanović, "Memory in architecture. Contemporary memorial projects and their predecessors," PhD thesis, Delft University of Technology, 2015.

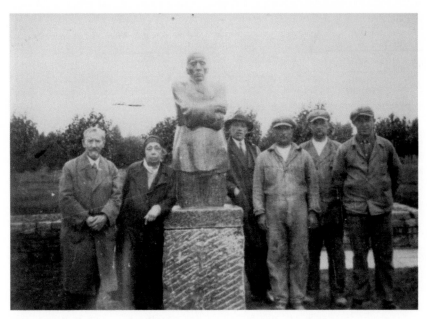

Illustration 6.1 Karl and Käthe Kollwitz with workers installing her statues, German military cemetery, Roggevelde, Belgium (1932). Photo courtesy of the In Flanders Fields Museum, Ypres.

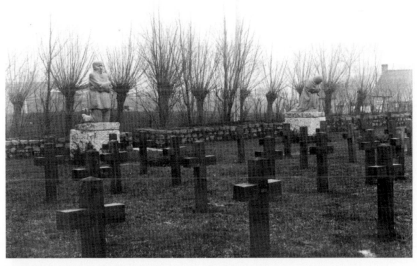

Illustration 6.2 German military cemetery, Roggevelde, Belgium (1932). Copyright: De Klaproos Editions.

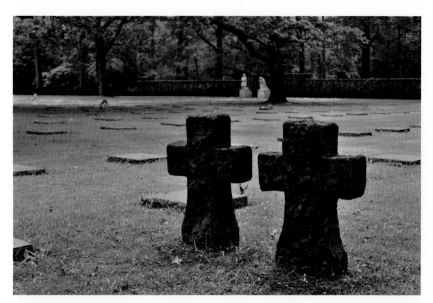

Illustration 6.3 Stone crosses and WWI tombstones at German First World War One military cemetery in the Praatbosforest, Vladslo, Belgium, with Kollwitz statues in the rear. Arterra Picture Library / Alamy Stock Photo.

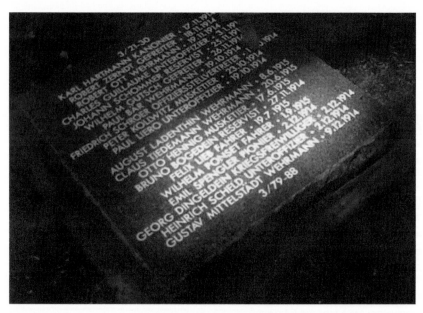

Illustration 6.4 Slab bearing the name of Peter Kollwitz, German military cemetery, Vladslo, Belgium (2014). Photograph: the author.

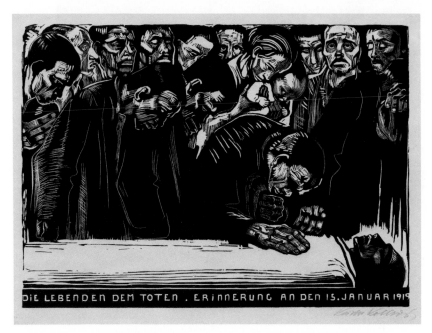

Illustration 6.5 Käthe Kollwitz, "The Survivors of the Dead. In Memoriam, January 15, 1919." Sterling and Francine Clark Art Institute, Williamstown, Massachusetts, USA/Bridgeman Images.

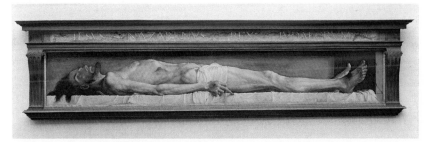

Illustration 6.6 Hans Holbein the Younger, *The Body of the Dead Christ in the Tomb* (1520–22). Kunstmuseum, Basel, Switzerland/Bridgeman Images.

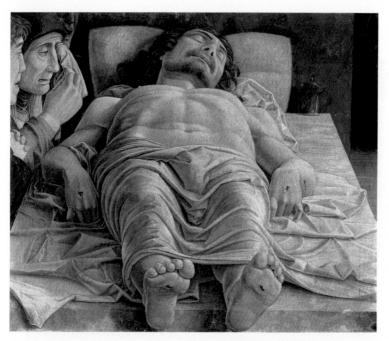

Illustration 6.7 Andrea Mantegna, *The Dead Christ and the Three Mourners* (1480). Pinacoteca di Brera, Milan, Italy / Bridgeman Images..

Illustration 6.8 Vittore Carpaccio, *The Dead Christ* ca. 1520. Artexplorer / Alamy Stock Photo.

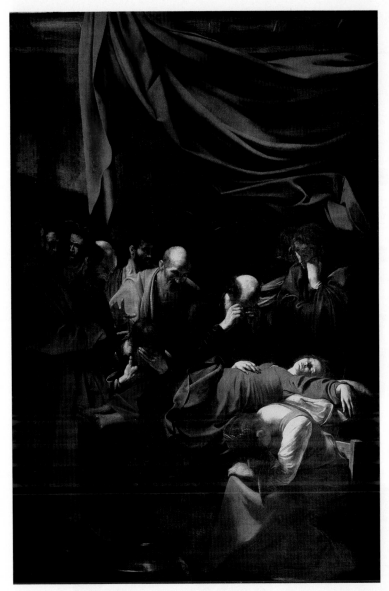

Illustration 6.9 Caravaggio, *The Death of the Virgin* (1601–6). Louvre, Paris, France / Bridgeman Images.

Illustration 6.10 Edouard Manet, *The Dead Toreador* (1864). National Gallery of Art, Washington.

Illustration 6.11 Käthe Kollwitz, "From many wounds, you bleed, O People!" between 1893 and 1897, etching (c) Käthe Kollwitz Museum Köln.

Illustration 6.12 Käthe Kollwitz, "The Widow" (1922). © The Museum of Modern Art/Scala, Florence.

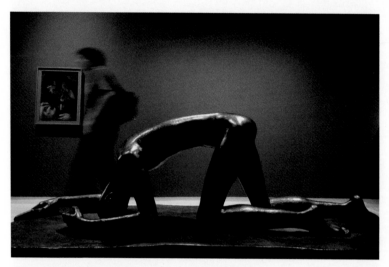

Illustration 6.13 Wilhelm Lehmbruck, *The Fallen Man* (Der Gesturzte), (1915–16). Photo: AFP / Stringer.

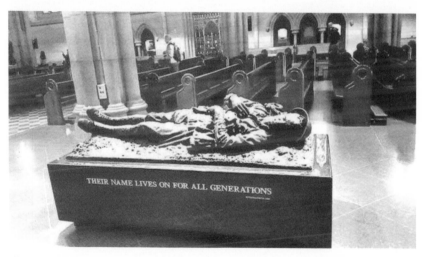

Illustration 6.14 George W. Lambert, *Recumbent Figure of a Soldier* (*Unknown Soldier*), St. Mary's Cathedral, Sydney (1927). Photograph: the author.

Illustration 6.15 The Weeping Window at the Tower of London on Remembrance Day 11 November 2014, to remember those who lost their lives during the First World War. Photo: Andrew J. Smith / Getty Images.

Illustration 6.16 The Poppies on display at the Tower of London commemorating the anniversary of the First World War. Photo: Jamie Garbutt / Getty Images.

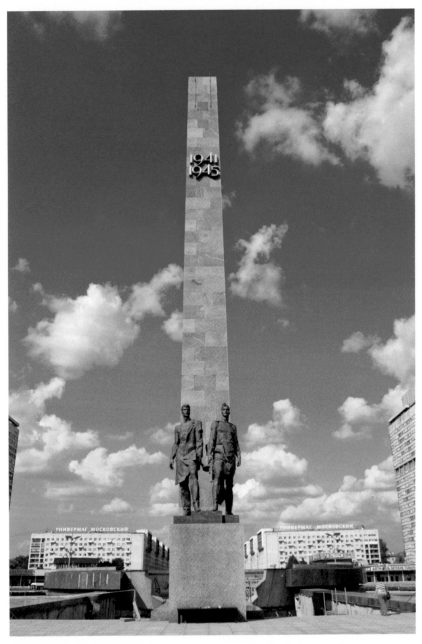

Illustration 6.17 Monument to the Heroic Defenders of Leningrad (1970), Ploshchad Popedy, Victory square, Moskovsky district, St. Petersburg, Russia. Peter Forsberg / Europe / Alamy.

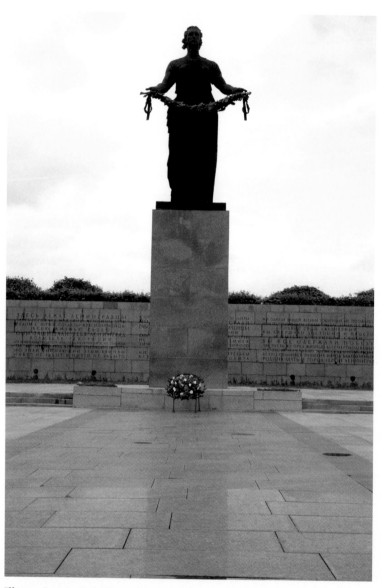

Illustration 6.18 St. Petersburg, Further Afield, Piskarevskoye cemetery. Dorling Kindersley Ltd / Alamy Stock Photo.

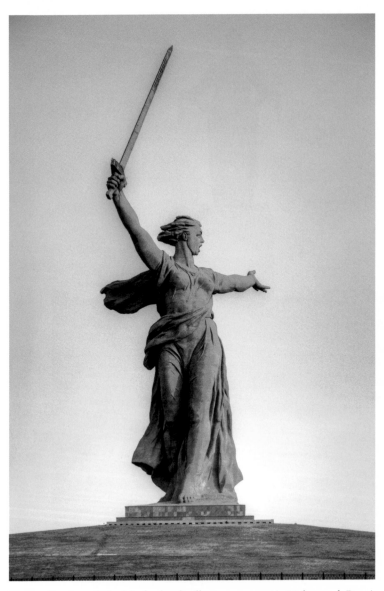

Illustration 6.19 "The Motherland calls!" monument in Volgograd, Russia. Andriy Kravchenko / Alamy.

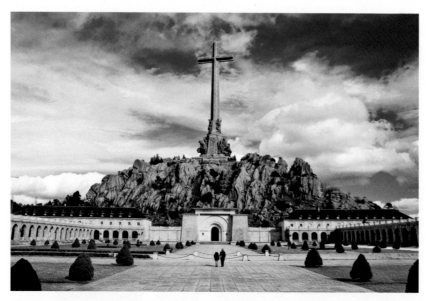

Illustration 6.20 Valle de los Caídos (Valley of the Fallen), Spain. YAY Media AS / Alamy Stock Photo.

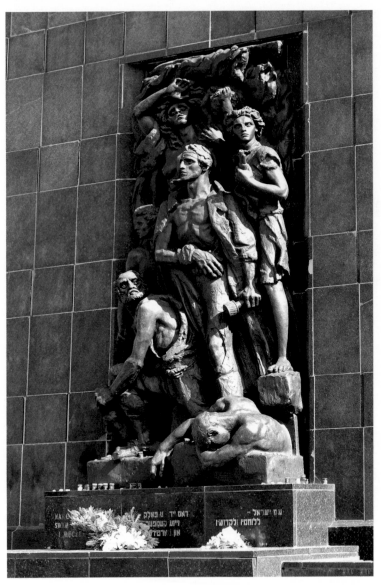

Illustration 6.21 Nathan Rapoport, Monument to the Heroes of the Warsaw
Ghetto Uprising. Zoonar GmbH / Alamy.

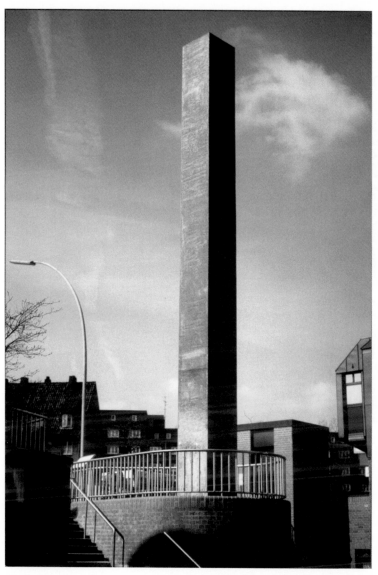

Illustration 6.22 Jochen Gerz and Esther Shalev-Gerz, *Monument Against Fascism*, Harburg, Hamburg (1986–93) – 1. DACS / Jochen Gerz, VG Bild-Kunst, Bonn 2016.

Illustration 6.23 Jochen Gerz and Esther Shalev-Gerz, *Monument Against Fascism*, Harburg, Hamburg (1986–93) – 2. DACS / Jochen Gerz, VG Bild-Kunst, Bonn 2016.

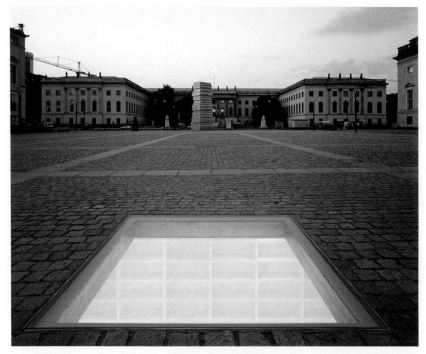

Illustration 6.24 Micha Ullman, *Versunkene Bibliothek* (Sunken Library), Bebelplatz (formerly known colloquially as Opernplatz), Berlin. Lothar Steiner / Alamy Stock Photo.

Illustration 6.25 Dani Karavan, *Passages*, Portbou, Catalonia (1994).

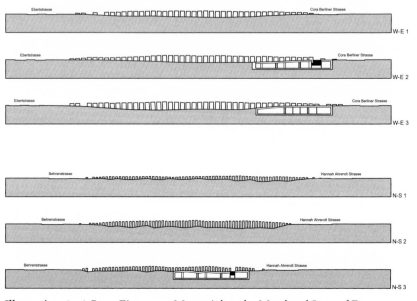

Illustration 6.26 Peter Eisenman, Memorial to the Murdered Jews of Europe, Berlin, ground-level design (1995). Courtesy Eisenman Architects.

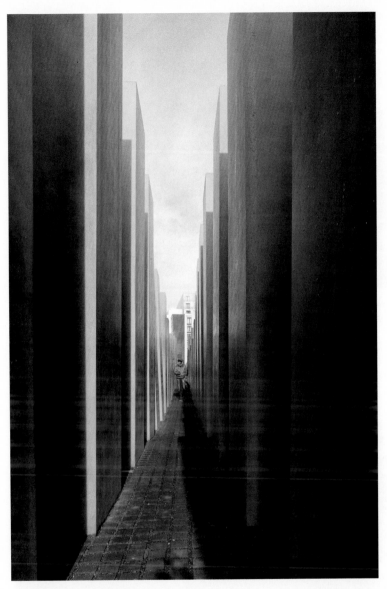

Illustration 6.27 Memorial to the Murdered Jews of Europe, Berlin, Germany.
Julie G. Woodhouse / Alamy.

Illustration 6.28 Boston, Mass. New England Holocaust Memorial (1999), Geoffrey Taunton / Alamy.

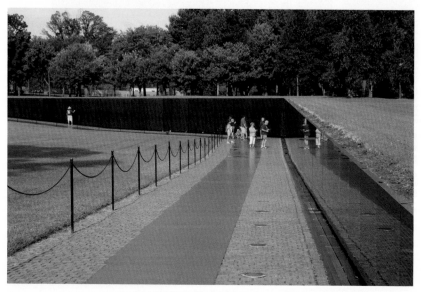

Illustration 6.29 The Vietnam Veterans' Memorial, with the names of those who died in this war carved in a black, granitewall, in Washington DC (2015). Monica Wells / Alamy Stock Photo.

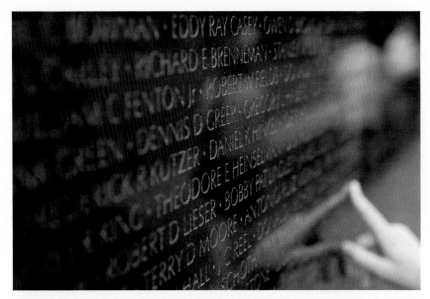

Illustration 6.30 Close-up of Vietnam Veterans Memorial, Washington, D.C., USA (2007). Design Pics Inc / Alamy Stock Photo.

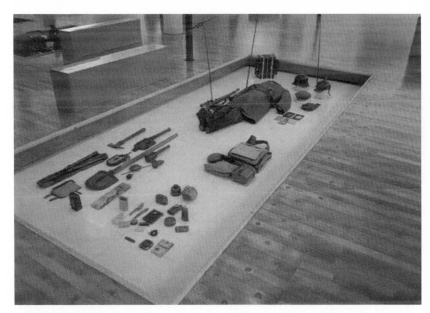

Illustration 6.31 Historial de la grande guerre, Péronne, Somme, *fosse*, Room 2 (1992). Photograph: the author.

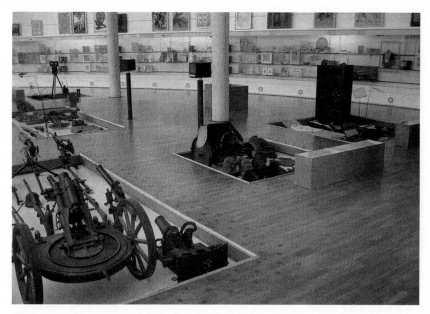

Illustration 6.32 Historial de la grande guerre, Péronne, Somme, *fosse*, Room 3 (1992). Photograph: the author.

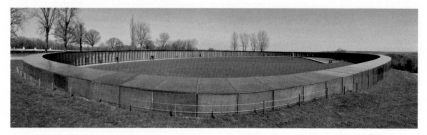

Illustration 6.33 France, Pas de Calais, Ablain Saint Nazaire, necropolis of Notre Dame de Lorette, "L'Anneau de la memoire" (Ring of Remembrance), overview of the Ring (2015). Hemis / Alamy Stock Photo.

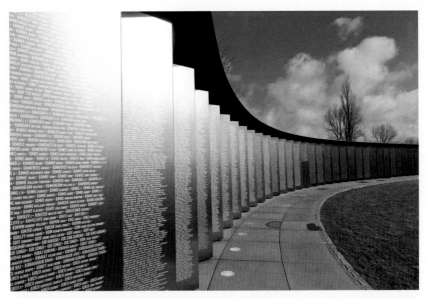

Illustration 6.34 France, Pas de Calais, Ablain Saint Nazaire, (2015) "L'Anneau de la mémoire" (Ring of Remembrance). Hemis / Alamy.

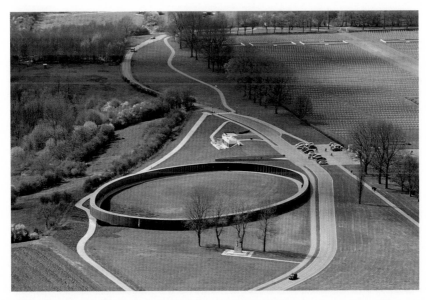

Illustration 6.35 "L'Anneau de la mémoire" (Ring of Remembrance) at Ablain Saint-Nazaire French Military Cemetery, aerial view (2015).

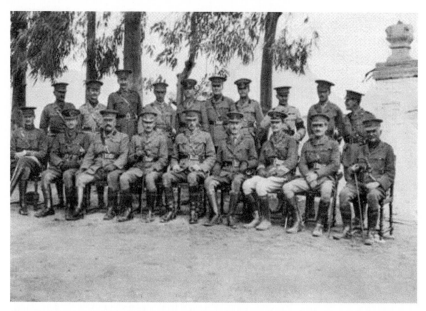

Illustration 7.1 Lt. Col. W. G. Patterson, third from left, front row, group portrait, 1st Australian Division, Egypt (1914). Bruce Scates, *World War One: A history in 100 stories* (Melbourne: Penguin, 2015).

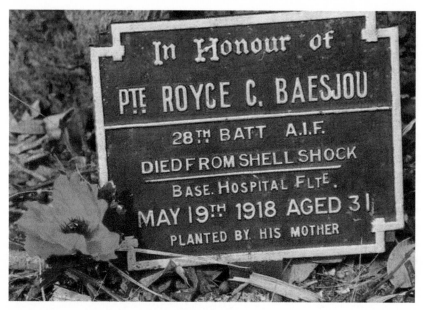

Illustration 7.2 Perth War Memorial, plaque for Royce Beasjou, "Died of shell shock." Bruce Scates, *World War One: A history in 100 stories* (Melbourne: Penguin, 2015).

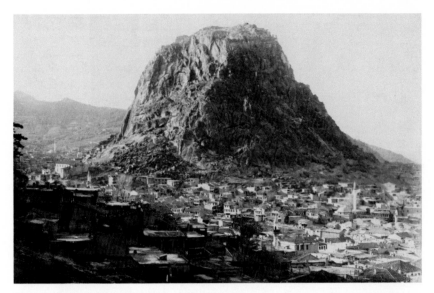

Illustration 7.3 Afyon Karahissar, Turkish prisoner-of-war settlement (1918).
Chronicle / Alamy Stock Photo.

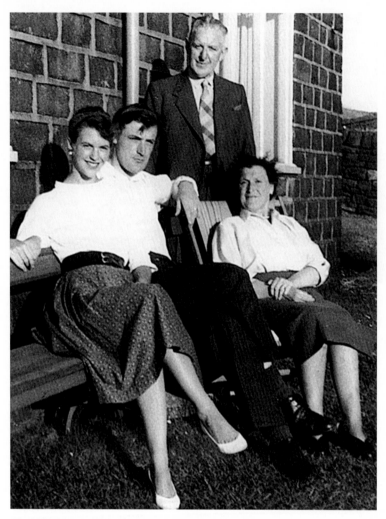

Illustration 7.4 Sylvia Plath, Ted Hughes, William Hughes and Edith Hughes (1956).

"soaring" memorial to the people who died on 9/11. But ten years later, the newly completed memorial carries us in the opposite direction. Two massive square voids sited within the footprints of the towers, it digs down – almost as if the collapse of the towers had pounded out a space to deposit feelings about the whole wretched day.[39]

That is what horizontal sites of memory do: they provide space for reflections on loss.

There are still many places in which older forms of remembrance predominate, but in some parts of Western Europe and elsewhere, the gravity of mass death in war has indeed made it difficult for us to look up when we think about the history of armed conflict. In commemorative art, as in much of European politics, a turn away from the vertical means many things. Among them is a turn away from war.

[39] Richard Lecayo, "Gravity's rainbow: The 9/11 Memorial manages a delicate balance between grief and consolation," *Time*, September 7, 2011, as cited in http://content.time.com/time/arts/article/0,8599,2092287,00.html

7 WAR BEYOND WORDS: SHELL SHOCK, SILENCE, AND MEMORIES OF WAR

Frameworks of Silence

So far, we have entered into very varied domains in which those who lived through war tried to communicate what it meant to them. Painters, sculptors, photographers, filmmakers, poets, writers, men of faith, architects, and countless others have left us an extraordinary array of reflections of and on war. Most of them resemble what physicists find through the use of a cloud chamber – traces of a collision rather than elements of the collision itself.

In effect, representing war is a Sisyphean task, unavoidable, but (in a profound sense) unachievable. Many of those who fought never spoke about what they knew. There were many reasons they placed their memories of war beyond words. Some felt that civilians could not comprehend and did not want to hear what they had to say. Some wanted to leave their nightmares in the dark, where they belonged, and to go on living ordinary lives. Others went further and concluded that the horror of war was beyond speech, beyond images, beyond monuments. What war did was to place itself beyond utterance.

I am grateful for the comments of the following people on this chapter: Robert Dare, Joan Beaumont, Ken Inglis, Petra Ernst, Al Thomson, Harvey Mendelsohn, Antoine Prost, Paul Lancaster, and Alexander Macfarlane.

From this perspective, all of the creative work in art and architecture as well as in poetry, photography, painting surveyed in this book, were bound to hit a brick wall – the massive boundary separating what war does to human beings and what we can say about it. Any account of the cultural repercussions of war must admit the truth of this statement.

And yet it is an incomplete truth. One reason why this is so is that the silence men and women brought back from war had many different meanings. These survivors time and again brought us what I term performative nonspeech acts. By that term, I follow J. L. Austin, who posited that there are speech acts which are constitutive rather than descriptive; they establish the condition of which they speak rather than describe it. I go one step further and suggest that there are performative nonspeech acts through which some people tell us about war beyond words.[1]

Some such nonspeech acts are relatively well known. The two-minute silence on Armistice Day or Remembrance Sunday is one of them. Liturgical approaches to mourning those who die in war are full of silences, since such losses profoundly challenge our sense of meaning or order or justice. Other silences are political in character; for instance, the Museum of Memory in Santiago de Chile is eloquent about the victims of the Pinochet regime but totally silent on the perpetrators, many of whom are still alive and very unlikely to answer for their crimes. There is still an embargo in Spain on calling to account those guilty of war crimes committed during and after the Spanish Civil War. These cruelties are beyond words (and deeds) because people chose to put them there.

Still other silences are essentialist, in that they are based on a claim that only those who have been there could talk about war. This accounts for the tendency of some veterans to open up only to other veterans, as if they had imbibed war with their rations, and could only speak with others just like them. Finally, there are family silences which are kept by fathers and mothers, sisters and brothers, to enable ordinary life to go on after difficult events. In some ways, all families are defined by the silences they keep.

[1] For a full elaboration of this position, see Winter, "Social construction of silence," pp. 1–29.

Shell Shock

Many such families lived with a particular silence in the aftermath of war. That silence is the subject of this chapter. Silence is, among other things, what everyone knows and no one says. There has been a silence, I believe, lasting a century surrounding the extent to which the soldiers of the Great War suffered psychological injury. In part, this silence arose out of the stigma then and still now attached to mental illness in general, and to mental illness among soldiers in particular. Another contributory factor to this silence was the relatively underdeveloped diagnostic skills doctors and administrators had available to them when confronted with a mixture of somatic and emotional disorders that many tended to treat as malingering. In addition, there was a financial matter to deal with in the inclement weather of the interwar years. How could doctors be sure that the best use of state money was to give it to those who were still bearing the hidden wounds of a war which had ended long before? Surely, some believed, the physically disabled took precedence, and even then, their pensions and entitlements remained meager. These are questions to which we have no clear response in our everyday dealings with mental illness today; should we be surprised that the people in charge got it wrong in the years after the Great War?

How large is this underestimate? Only God knows. I will make a few educated guesses (some would say stabs in the dark) on this point, but the critical matter is to acknowledge that it is large, though no one will ever be able to be precise about it. This chapter is, therefore, about countless individual and collective silences, willful turnings away from men damaged in their minds in wartime, and unable in several respects to stand on their own two feet or to achieve emotional balance thereafter. The burial of this facet of the experience of war I term a categorical silence. That is, "shell shock" was a phenomenon systematically occluded by those who treated the injured or administered pensions sought by men with war-related psychological or neurological disabilities.

There was one occasion in 1918 when we can see British high command attempting to block medical officers from using the diagnosis "shell shock" as a category of combat casualties. The War Diary of General Headquarters, First Echelon, shows staff officers trying to maintain troop levels at the height of the German spring offensive of 1918. On April 13, with German troops still moving forward on many

points on the Western Front, GHQ made the "recommendation" to the War Office "that cases of shell shock should not in future be classified as battle casualties."[2] There were numerous conversations that preceded this finding. Ration strength in many British infantry units was falling rapidly under German pressure; conversely, casualty levels were rising rapidly. Getting more disabled men back to the front was an urgent matter, and so too was making the British War Cabinet and (in time) the public feel that the army had enough "backs to the wall," as General Haig put it, to stem the German tide. That is indeed what happened, but achieving it was a near thing.[3] One way High Command thought would help was putting the lid on "shell shock."

It is difficult to know how this "recommendation" was implemented. In the chaos of the last major military crisis of the war, it may have sunk without trace. It is possible, though, that those who compiled statistics simply took matters into their own hands, and wiped the slate clean when there was any mention of shell shock in casualty reports. In any event, we can see this directive as one of a number of measures ensuring that the proportion of all battle casualties attributable to psychological or neurological injury would be underestimated. In effect, British High Command created a statistical silence, or a categorical silence, about shell shock in 1918 which has resounded to this day.

There is another important facet of silence we need to explore. It is the silence of soldiers themselves. I term this phenomenon communicative silence. On this point there is a wealth of indirect evidence. In how many cases have friends and colleagues turned to me and others and said I wish I had asked my grandfather about his war service? Or they say "my father or husband or uncle or lover never said a word about it," but no one asked for their views either.

Some soldiers did not want to go over the ground again. Harry Patch, the very last Tommy, who died in 2009, at the age of 111, said that he never wanted to talk about the war. He kept his peace for eighty years, and then opened up at age 100 only when he was pestered by journalists who asked him about his centenarian's thoughts on the war of which he was the last survivor. It was a miserable, pointless part of his

[2] National Archives, Kew, War Office, WO/95/26/3. I am grateful to William Spencer, Principal Military Specialist at the National Archives, for drawing my attention to this document.

[3] David Stevenson, *With our backs to the wall: Victory and defeat in 1918* (London: Penguin–Allen Lane, 2011).

life, he said. His mates had died for nothing.[4] He never watched war films or television documentaries, although he agreed to meet a German veteran on one such program in 2004 and appeared in another on his visit to Ypres in 2008. When he was drawn out in his last years, he spoke laconically and reluctantly. He did not commemorate the war; he commemorated the three men of his unit who died in the Ypres salient. "That day, the day I lost my pals, 22 September 1917 – that is my Remembrance Day, not Armistice Day." He added, "I am always very, very quiet on that day and I don't want anybody talking to me, really."[5] In Richard van Emden's collection of interviews with Patch, published as his "life," Patch's resistance to remembering aloud the horrors of war and to leaving his words behind is palpable.

I am touching here on one of the things we historians do or are supposed to do. We speak for these men, not primarily (and certainly not solely) in our own words, but in theirs and through theirs. What do we do with their silences? We can try to understand them, and break the taboos surrounding them; we can talk about the frightening or the hideous without shrinking from them or fearing contamination. Above all, we have to make it plain to everyone that the silence of soldiers was not indifference, callousness, or just plain forgetting. Silence is a language of remembrance; it connotes meaning. It informs a special category of remembrance all of its own.

A word or two may be in order about the different dimensions of silence which have contributed to the radical underestimate of psychological injury in the Great War. Some doctors had faith in the category, that it described something that indeed had happened to men at war. One such physician was John William Springthorpe, a tireless medical advocate of humane treatment for shell-shocked men in Australia.[6] But they also knew that some pension officials were less open-minded. When some physicians saw a soldier who had had either a psychological injury alone, or a physical injury alongside a psychological one, then reporting the physical ailment alone would

[4] www.bbc.co.uk/news/local/somerset/hi/people_and_places/newsid_8186000/8186376.stm

[5] Harry Patch with Richard van Emden, *The last fighting Tommy: The life of Harry Patch, last veteran of the trenches, 1898–2009* (London: Bloomsbury, 2010), p. 203.

[6] Anne Sanders, "Springthorpe, John William," in Christopher Chapman (ed.), *Inner worlds: Portraits and psychology* (Canberra: National Portrait Gallery, 2011), pp. 200–2.

ensure that the man had a good shot at getting a pension and keeping it. For the well-being of their own patients, some doctors misreported their full condition.

And then there is the case of the psychological damage of mutilating injuries. Can anyone honestly believe that someone who had had part of his face removed by shrapnel or his genitals shot off did not also face psychological conditions of multiple kinds?

Other doctors didn't believe in the category of shell shock at all, and preferred the term "malingering" to describe those who may have sought cover or comfort under its protective shield. Underreporting in this field arose from varying medical opinions and strategies, which had only one thing in common: they tended to understate the proportion of the wounded who suffered from psychological or neurological injury, preferring to believe that soldiers were manipulating the system to save their necks or line their pockets. And some soldiers did do precisely that.[7]

In short, for a cluster of reasons, the medical profession created a silent protective box, a categorical silence, around shell shock, since while war was supposed to produce physical injuries, how did it lead to invisible psychological or neurological injuries? These were another matter. Who were these purists protecting? The army, the taxpayers, the army medical services, those men who had the courage to go back up the line even when haunted by nightmares and worse, sometimes even those shell-shocked men who faced destitution unless their army physicians did some creative adaptation of their condition to the rules and regulations of the pension system.

Creative thinking operated on so many levels. There was one more level of denial too. There were soldiers who had been buried alive or who had suffered some other traumatic event and yet who felt deeply the stigma of reporting their condition. Some even denied that they had had any psychological injury at all. Self-denial (or underreporting) is a well-known category. It comes under different names – a stiff upper lip; male stoicism or other gendered poses supposedly representing the martial spirit; or just plain shame.

Consider the following case as indicating a whole world of silenced psychological injury that emerged from soldiers' own accounts

[7] For further discussion and references, see Jay Winter, "Shell shock," in Winter, *Cambridge history of the First World War*, vol. III, pp. 310–33. On the French case, see Didier Fassin and Richard Rechtman, *The empire of trauma: An inquiry into the condition of victimhood* (Princeton University Press, 2009).

of their war. In the course of researching the narratives of heroism imbedded in Canadian regimental histories of the First World War, Janet Cavell of Carleton University came across an annotated copy of the regimental history of the 4th Canadian Mounted Rifles. Banal stuff, but what made it special were the marginalia one working-class soldier, Dick McQuade, added to the book. By comparing his marginal comments with his military service record, Cavell showed that he had totally hidden the true story of his being buried alive and shell-shocked, and built over it an entirely invented story of steady participation in the bloody combat his unit, mixed with others, had endured, and which he conspicuously had missed.[8] Here we can see that one soldier covered up shell shock through creating a fantasy tale, with which he could live.

True enough, McQuade had been buried alive on April 20, 1916, and left the line for follow-up treatment in London. Months later he was diagnosed at long last as having "neurasthenia," one of the many terms for shell shock. He could not have been at Sanctuary Wood, or Hill 62 near Ypres, on June 2, 1916, when Canadian troops (including his unit) took devastating casualties: a total of 626 officers and men serving out of 702 had been killed, wounded, or taken prisoner. In the margins of the regimental history, McQuade added his comments as to how he had returned from England, where he was recovering from an unspecified ailment, "right into the Somme battle," in July 1916. He then, he said, went through Vimy ridge, Passchendaele and the last hundred days. After the Armistice he and his surviving comrades had a "Good dinner and lots of fun" and "a big time at Mons."

All of this is fiction. McQuade left the line for unspecified headaches, and never told his doctors he had been buried alive. Instead, he prolonged his stay in hospital until after the bloody destruction of much of his unit, and then returned to France, where he amassed an undistinguished record, including a long list of days gone AWOL and other forms of indiscipline which he also chose to forget about later. His annotations are remarkable in that they clearly indicate the way the regimental history, with all its noble words, provided him with the war story he wished he had had, and through his mendacious marginalia, he himself had provided his family with his (*soi-disant*) real war story,

[8] Janice Cavell, "In the margins: Regimental history and a veteran's narrative of the First World War," *Book History*, 11 (2008), pp. 199–219. The regimental history with McQuade's marginal notes is in the MacOdrum Library, Carleton University, Ottawa, Canada.

which is to say, the one he wished he had had. Next to illustrations, he wrote fabulously "1st time we seen a tank," "I used Bayonet to good advantage here," and most striking of all, next to a photograph of Canadians somewhere near Passchendaele in October 1917, "This is me."

If only it had been he. Then his inventions might not have been necessary. There remains a doubt as to whether McQuade believed his own lies, but no doubt that fabricating enabled him to preserve a life-long silence about his true military history. There is a Swiss case of a similar kind, where a prize-winning novelist, Binjamin Wilkomirski, on seeing a photograph of a child Holocaust survivor, decided "This is me."[9] Wilkomirski could not be shaken from his firm belief that he indeed was the child in the photo. We will never know, but my guess is that McQuade's story is simpler but almost as ingenious. A man deeply shamed by shell shock and its after-effects made up an entirely different war story to account for himself not only to his family, but also to himself. An invented heroic tale was infinitely better than the truth, and the truth was that he had been shell-shocked and remained so terrified about returning to the scene of that horror that he never saw combat in the great battles of 1916–18. And then for decades, he never admitted the truth to his family or possibly even to himself. The taboo surrounding shell shock remained; perhaps all soldiers' war stories have fictional elements in them.[10] This one has more than most, and they served a purpose – to draw a veil of silence over his own breakdown.

There is another matter related to timing relevant here. Jim McPhee was a stretcher-bearer both at Gallipoli and on the Western Front. He kept his demons at bay, until old age caught up with him. The resistance we all have embedded in mid-life, in work, in the rhythms of family life, in raising children, all work for a time, and then there is retirement, more time, more space for reflection, and for the shadows to return. This is how he put it: "We thought we managed alright, kept the awful things out of our minds, but now I'm an old man and they come out from where I hid them. Every night."[11]

[9] Blake Eskin, A Life in pieces: The making and unmaking of Binjamin Wilkomirski (New York: W. W. Norton, 2002).

[10] Hynes, Soldiers' tale; see also Tim O'Brien, "How to tell a true war story" (1990), at www.ndsu.edu/pubweb/~cinichol/CreativeWriting/323/OBrienWarStory.pdf

[11] http://web.archive.org/web/20130411192803/ http://australia.gov.au/about-australia/australian-story/australians-on-the-western-front

It is absurd to argue that all shell-shocked men couldn't admit what had happened to them. Rather, in the First World War, and even in the Second World War and after, to tell the truth about psychological injury in combat, and about its prevalence in the casualty lists of war, was something only some of the people did some of the time. And no one has yet explored the implications of this open secret for the history of the First World War.

The great filmmaker John Huston made the film *Let There Be Light* in 1946 for the U.S. army. It is a documentary film about the way psychologically injured men were brought back to health and a functional life. What got him into trouble was the narrator's statement right at the beginning of the film that 20 percent of all American combat casualties in the Second World War were psychological or neurological in character. This the U.S. army could not swallow, since, they believed, it would have compromised army recruitment. They thus banned the film. It was silenced, and only came out of the box of the unsayable in 1981, when it was screened in the Cannes film festival,[12] just one year after the American Psychiatric Association published its DSM III, or third edition of *Diagnostic and Statistical Manual of Mental Disorders*, certifying that "Posttraumatic stress disorder" was a legitimate medical syndrome, with causes, treatments, and cures.[13]

Here is a story about silence, and the silencing of the story of shell shock (or whatever term we choose) as a central part of the experience of modern war. Many soldiers themselves hardly knew what had happened to them when they suffered particular symptoms. They looked to doctors to tell them what they had and then to cure them of whatever it was called. But what did they do if doctors didn't believe that shell shock (however termed) was a real condition, or if doctors (following General Patton) doubted the manliness of those who suffered from it? Who knows how many simply dropped "shell shock" like a pair of shoes which didn't fit, and put on another pair, another story which better fitted their own narrative about who they were and who they had been during the war. The distance between illness and health is by no means only located in narratives, but without a rigorous examination of

[12] Michael Kernan, "War casualty, John Huston's 1945 film now public," *Washington Post*, February 12, 1981.
[13] N. C. Andreasen, "Posttraumatic stress disorder: A history and a critique," *Annales of the New York Academy of Sciences*, 1208 (October 2010), pp. 67–71.

the full extent of psychological and neurological damage to men in uniform, the only alternative is another century of silence.

One argument more than any other has persuaded me that shell-shock casualty statistics in the First World War are in need of major revision. It is that we cannot ignore the disconnect between the level of psychological casualties reported for the First World War and those reported for later conflicts. No one would doubt that what happened on the Somme or at Verdun or at Gallipoli at times was matched in ferocity by later battles, in Normandy, Monte Cassino or during the Battle of the Bulge. And yet casualty statistics for the Second World War and for later conflicts register psychological casualties at levels between five, ten, and even twenty times higher than those in the First World War.

It is evident that we First World War historians can benefit from the greater sophistication of military medicine in general and military psychiatry in particular in the Second World War and in later conflicts. We can compare the incidence of psychological or neurological casualties as a proportion of all casualties in these later campaigns or battles and ask, is there any compelling reason why the levels reported for later wars are so much higher than those reported for the First World War? Of course there will be differences in nomenclature and taxonomies. But the gap between the estimates of the incidence of shell shock as a proportion of all casualties in the First World War and those for later wars is so vast that we must confront the possibility that something has gone wrong in the accounting of First World War losses. Radical underestimates are a form of medical and administrative silence.

In the British army, the statistics reported shortly after the final capture of Monte Cassino, in August 1944, indicated that 40–50 percent of all casualties suffered in the battle were psychological or neurological in character. Many of these men were wounded in other ways too. In the Yom Kippur war of 1973, a nasty shock if ever there was one, we know that 50 percent of all casualties were found to be psychological in character. As Jones and Wessely state, "Today there is a consensus that a constant relationship exists between the incidence of the total killed and wounded and the number of psychiatric casualties."[14] That is, the bloodier and more intense the battle, the higher the psychiatric casualties will be. The measure we are trying to refine – proportion of all

[14] Edgar Jones and Simon Wessely, "Psychiatric battle casualties: An intra- and interwar comparison," *British Journal of Psychiatry*, 178 (2001), pp. 242–47.

losses which are neurological or psychological in character – is thus a function of the intensity and deadliness of firepower. The best practice medical history today requires us to bring up to date existing and radically flawed underestimates of the incidence of shell shock in the First World War.

There is a second variable which increases the proportion of psychological casualties within all casualties: the improvement in medical and surgical care, which kept many men alive from 1939 on who would have died in 1914–18. The fear of death, a cause of profound anxiety in any war, might have been higher in the Great War, when survival rates were lower than those in the wounded in the 1940s, since those injured in the Second World War had a higher chance of surviving their injuries. And yet for many, survival meant another period of combat, and the stress and fear of death and dismemberment that went with it. Let us be cautious, then, and conclude that the terrifying firepower of the two world wars and of later conflicts yielded roughly comparable levels of psychiatric battle casualties. It is likely that more soldiers survived to be diagnosed with various infirmities, including psychological ones, after 1939, though this difference will only modestly affect our estimates.

To start this reconsideration of the incidence of shell shock during the Great War, I take a limited case. Tables 7.1 and 7.2 provide data on casualty figures for Allied combatants in just one theater of operations: the Gallipoli campaign of 1915–16. As we can see in Table 7.1, the Allies suffered 46,000 killed and about 86,000 men wounded in the campaign. There are scattered figures that refer only to British forces of 3,100 cases of shell shock or mental illness. Once again, adopting the 1922 estimate in official British publications, the incidence of shell shock, however defined, was between 2 and 4 percent of all casualties.[15] This figure calculates as between 1,700 and 3,500 cases. The mid-point is 2,550.

[15] *Statistics of the Military Effort of the British Empire in the War* (London: HMSO, 1922), p. 237. The Ministry of Pensions treated 63,296 "neurological cases." Total wounded in British forces was 1,662,625; thus 3.7 percent of all British casualties were deemed neurological by the Ministry of Pensions. Joanna Bourke notes that the British army dealt with 80,000 cases of shell shock during the war. That would present an estimate of 4.8 percent of all casualties, a bit above the boundary of other estimates of between 2 and 4 percent. "Shell shock during World War One," BBC Radio, October 3, 2011, www.bbc.co.uk/history/worldwars/wwone/shell shock_01.shtml

Table 7.1. *Allied casualties at Gallipoli, 1915–16**

British**	26,054 killed	44,721 wounded	total 70,775
French	8,000 killed	15,000 wounded	total 23,000
Australia	7,825 killed	17,900 wounded	total 25,725
New Zealand	2,445 killed	4,752 wounded	total 7,197
India	1,682 killed	3,796 wounded	total 5,478
Totals	46,006 killed	86,169 wounded	Overall total 132,175

* Thanks are due to Robin Prior for providing me with these figures. Needless to say, there are many other estimates of varying degrees of reliability.
** In addition the *Statistics of the Military effort of the British empire* lists about 2,000 non-battle deaths and 142,000 sick, but these figures are for British troops only.

Table 7.2. *Estimates of the incidence of shell shock, under different assumptions, at Gallipoli, 1915–16, and throughout the 1914–18 war*

	wounded	2% shell shocked	10%	20%	40%
British*	44,721	894	4,472	8,944	1,788
French	15,000	300	1,500	3,000	6,000
Australia	17,900	358	1,790	3,580	7,160
New Zealand	4,752	95	475	950	1,900
India	3,796	76	380	760	1,520
Totals	86,169	1,723	8,617	17,234	34,468
Total for all Armies, 1914–18[1]	21,219,152	424,384	2,122,000	4,244,000	8,488,000

[1] Jay Winter, *The Great War and the British People* (2nd ed.; London: Macmillan, 2000), p. 183.
* There were much lower estimates as well, especially among those produced by the Ministry of Pensions; consequently, the assumption in the postwar years was that between 2 and 4 percent of all British casualties were psychological, psychiatric, or neurological in character. See Peter Leese, "Problems returning home: The British psychological casualties of the Great War," *Historical Journal*, 40, 4 (December 1997), pp. 1055–67. See Lord Southborough, "Shell-shock," *The Times*, September 2, 1922, p. 5, for a discussion of the Southborough report's estimates and dismissal of the term "shell shock." For a new discussion, see Carol Alexander, "The shock of war," *Smithsonian Magazine* (Summer 2010), www.smithsonianmag.com/history/the-shock-of-war-55376701/?no-ist=&c=y&page=3

If the high levels of psychological casualties as a proportion of all casualties applied, say that of Monte Cassino or the 1973 Arab-Israeli War on the Israeli side, then there were more than ten times that number, or nearly 35,000 men, who suffered from injuries of a psychological or neurological kind in the Gallipoli campaign. It is evident that we are dealing with nontrivial errors. A diagnostic error of 35 percent in accurately attributing causes of disability would raise eyebrows or hackles in medical and administrative circles today. Though we can understand how these underestimates arose, why should we tolerate them today?

My conclusion is simple: shell shock was not a marginal, but rather a common, at times a central, part of the experience of the wounded at Gallipoli, as it was at similarly lethal theaters of military operations in the two world wars and after. While we cannot offer a precise estimate, we can say that the problem of underrepresentation of shell shock in the official record of the toll the war took on Australian and all other soldiers is serious and substantial.

In C. E. W. Bean's volume on the Gallipoli campaign in the official history of the Australian Imperial Force, there is but one reference to shell shock among soldiers in the 7th and 8th Battalions near Steele's Post in mid July 1915.[16] One reason for this silence is the division within the medical profession about shell shock, and how it had to be treated. This was true in all medical services among all combatant countries.

Medical opinion in both Britain and Australia was divided over what to do about shell shock. Virtually everyone, including the man who first coined the phrase, C. S. Myers, disliked the term, since it grouped together conditions of wildly different origins. But "shell shock" was such a brilliant metaphor for the terror of industrialized warfare that it could not be suppressed.[17]

There were differences, too, in approaches to treatment. One of the most thoughtful reflections on these problems was authored by Grafton Elliot Smith, an Australian physician, distinguished anatomist, and anthropologist, then dean of the faculty of medicine of the

[16] C. E. W., *Official history of Australia in the war of 1914–1918*, vol. II, *The Story of ANZAC from 4 May, 1915 to the evacuation of the Gallipoli Peninsula* (11th edn.; St. Lucia: University of Queensland Press, 1941), pp. 342–43.

[17] J. M. Winter, "Shell shock and the cultural history of the Great War," *Journal of Contemporary History*, 35, 1 (2000), pp. 7–11.

University of Manchester and a member of the General Medical Council in England. In 1916, he published an article on "Shock and the Soldier" in the *Lancet*, which showed deep sensitivity to the complexity of the subject and its implications for maintaining "the efficiency of the combatant forces." He was not immune, though, to the prejudices of his times. While physically unfit people were being rejected by the thousands by the army, no effort had been made to exclude what Elliot Smith called the "mental weakling," who broke down in combat to the detriment of his entire unit. Such men were troublesome in mixed wards, and rarely got the specialist treatment they deserved. Consequently, Elliot Smith and his assistant T. H. Pear sat down in late 1915 to survey the French and German literature and then to make recommendations for the treatment of this class of disabled men.[18] He found that the initial interview with the patient frequently got nowhere; instead, Elliot Smith noted, a scrutiny of the patient's dreams frequently got to the heart of the matter, which was the terror associated by the patient with various forms of combat or the anticipation of combat. Indeed, both Elliot Smith and Pear were open to the notion that soldiers who remembered a disturbing event actually relived or reinstated the emotion associated with it. However painful, it was better for doctor and patient to uncover these troubling emotions together than to bury them; no silence here. His view was that these men were not insane, and many had shown their courage time and again. They had just reached their limit. Some conspicuously brave men survived combat and returned to the line, only to break down after they were relieved. It was their fear of collapse the next time which had overwhelmed them. Those who doubted that shell shock existed at all should consider these men. They showed that for many men, "the real trauma is psychical, not physical."[19]

Elliot Smith went further and rejected a strategy of isolating these patients. In contrast, Alfred Walter Campbell, who served in the 2nd Australian General Hospital in Cairo, later worked at the Military

[18] http://adb.anu.edu.au/biography/smith-sir-grafton-elliot-8470. My thanks are due to Paul Lancaster, for drawing my attention to facets of Australian medical history during the Great War. See also Grafton Elliot Smith and T. H. Pear, *Shell shock and its lessons* (Manchester University Press, 1917). On Elliot Smith and Pear, see Edgar Jones, "Shell shock at Magull and the Maudsley: Models of psychological medicine in the UK," *Journal of the History of Medicine and Allied Sciences*, 65, 3 (2010), pp. 368–95.

[19] A. W. Campbell, "Remarks on some neuroses and psychoses in war," *Medical Journal of Australia*, 1 (1916), pp. 319–23.

Hospital, Randwick, and advised the Department of Repatriation,[20] took precisely the opposite view.[21] The official historian of Australian medical services during the war, A. G. Butler, sided with Campbell. In his volume on Australian medical care at Gallipoli,[22] he cited Campbell's view published in the *Medical Journal of Australia* in April 1916 that doctors must try to avoid "psychic contagion." Those suffering from mental disorders must be isolated from each other and receive "no sympathy" leading them, in his view, to turn a temporary disability into a permanent or long-term one. Such men, Dr. Campbell observed, had to be "guarded with the utmost tact and circumspection against themselves and their friends and a grateful country."[23] Otherwise, they might not recover.

In a later chapter of his medical history, Butler made it clear that he understood the plight of these men. He refers to the relaxation of Australian insanity laws, permitting shell-shocked men after the war to avoid the stigma associated with "lunacy." And yet he recognized that "no special treatment" was made for such men who suffered from conditions grouped "under the unfortunate generic designation of 'shell shock', a term which had given to the Great War its most characteristic mental feature."[24]

Butler recognized too that conditions on Gallipoli itself insured that there would be a substantial number of men suffering from shell shock. Being pinned down on the beaches and first two ridges facing Anzac Cove, or at Cape Helles, or later at Suvla Bay, meant that most men had no respite from the strain of sniping, shellfire, and combat. The Western Front was deep enough to permit evacuation; men in Allied forces on Gallipoli were without this option by land, and evacuation by sea was limited mainly to those physically injured. Medical officers on the ground had to make decisions about how to handle individual cases without clear diagnostic categories to use. Did self-inflicted wounds mean that a man was a coward or that he had simply been pushed too far? Any full understanding of the acute effects of extended exposure to combat was unavailable at the time. Neither was the study of epidemiology in a state which could be of help in 1915.

[20] http://adb.anu.edu.au/biography/campbell-alfred-walter-5481.

[21] Campbell, "Remarks on some neuroses and psychoses in war."

[22] Arthur Graham Butler, *Official history of the Australian Army Medical Services, 1914–1918*, vol. I, *Gallipoli, Palestine and New Guinea* (2nd edn.; St. Lucia: University of Queensland Press, 1938), part 1, p. 417.

[23] Ibid., citing Campbell, "Remarks on some neuroses and psychoses in war," pp. 319ff.

[24] Ibid., part 1, p. 541.

The same is true, some have noted, a century later, further complicating or limiting effective postcombat care. Finally, the notion of delayed onset – the sense that combat stress could have effects which appear only years later – was beyond the medical paradigm of the early twentieth century. In effect, the underestimation of psychological casualties on Gallipoli (as elsewhere) was overdetermined.[25]

In sum, medical opinion disliked the term "shell shock," since it was much too imprecise,[26] but recognized that there was a cluster of disabilities of a psychological or neurological kind which had appeared during the war. How to treat these disabled men remained a matter of dispute, both during and after the war. Given this wide divergence of medical opinion, it was inevitable that many men were neither diagnosed nor treated for these disabilities at the time or in later years.

So far, my focus has been on published statistics which radically underestimate the incidence of shell shock in the First World War. These faulty calculations arose from many sources. Among them was a calculated silence, or a decision, taken silently, to look away from this form of war-related disability and accept what are almost certainly useless official statistics about its incidence. Now let us consider how our understanding of the war and of its aftermath is affected by the systematic occlusion of the condition known as shell shock. Here we confront both short-term and long-term suffering, which may actually have festered or worsened since no one wanted to talk about it. The silence surrounding what had happened to these men and their families, and the silence into which many of them retreated, added immeasurably to their fate.

Case Studies

Here we turn from aggregates to individuals. What do we know not about the amplitude or the incidence of shell shock, but about what it did to those who suffered from it? In what follows, I restrict my discussion to one campaign, simply to suggest where research in future needs

[25] Alexander McFarlane of the Center for Traumatic Stress Studies, in Adelaide, has done considerable work in this field. I am very grateful for his advice on this chapter. See Alexander McFarlane, "One hundred years of lessons about the impact of war on mental health," *Australian Psychiatry* (2015), pp. 1–4; and Alexander McFarlane and David Forbes, "The journey from moral inferiority to post-traumatic stress disorder," *Medical Journal of Australia*, 202, 7 (2015), pp. 1–3.

[26] Butler, *Official History*, part 1, p. 417, n. 28.

to go. I will describe a number of instances in which men broke down, and then died of their condition. I then turn to men damaged during their service at Gallipoli who either spoke only indirectly about their condition, or withdrew from the spoken word. Some used physical language, including the language of violence, to express something about their fate; others, walled up, used no language at all. And still others, by virtue of their impenetrable silences, left traces which their children spoke for them. I shall analyze this last case through the poetry of the British poet laureate Ted Hughes.

Lieutenant Colonel W. G. Patterson was Assistant Adjutant and Quartermaster General of the 1st Australian Division. In a photo taken by Charles Bean in Egypt, he is third from the left in the front row, in a formal portrait of the staff officers of the division (Illus. 7.1).[27] A member of Melbourne's elite Athenaeum Club, he had served in the army for twenty-six years. On the day of the landings in Gallipoli, Patterson had control over the giant chessboard of supplies and transport in the landing areas. He went mad at the worst possible time. Col. John Gellibrand, Deputy Adjutant, and Col. E. William Smith, Assistant Provost Marshal, were so troubled by his bizarre behavior that they placed him under guard. He had been seen wandering around looking for General Bridges, whom he was intent on killing. What preceded this breakdown we do not know. He was evacuated to Alexandria, and told a medical board that he suffered from tremors and an inability to speak. He said he had had "a sudden nervous breakdown on 25th–26th 1915, from which he says that he recovered." The doctors did not agree with his self-prognosis. He was diagnosed as still suffering from "neurasthenia" and was invalided back to Australia on July 3, 1915, and died a year later, on May 19, 1916, aged 53.[28] The cause of death was neurasthenia. Whether he had any other neurological or medical problems during his last months, is not disclosed in the records.

In Albany, Western Australia, there is an Avenue of Honor of trees planted in 1921 in honor of the men who died in the war. One of

[27] www.awm.gov.au/collection/G01606/, photo taken by Charles Bean. See also www.awm.gov.au/collection/A00712A/?image=1#display-image, for another image of Patterson, fourth from the left in the front row. Bean is the hatless man on the left in the back row.

[28] http://vic.ww1anzac.com/pa.html, WWI Pictorial Honour Roll of Victorians, p. 6. I am grateful to Bruce Scates for providing me with a copy of his Medical Board of June 19, 1915.

them was Royce Baesjou. [29] He had joined the 28th Battalion and had fought at Gallipoli. He was invalided out after heavy bombardment on Russell's Top. The diagnosis was "shell shock" (Illus. 7.2).

Baesjou had the bad fortune to be hit by a bombardment a second time, after recovery and redeployment in France. This time while manning a machine gun, he got a direct hit which blew him yards away from his gun emplacement. It also left him senseless. A report of this incident in the *Albany Advertiser* of August 12, 1916 cited him as saying "My nerves are shaky and my eyes not too good," but he was sure rest would bring him back to battle readiness.

Baesjou never recovered from his wounds. He died of a cerebral hemorrhage at the 8th Australian General Hospital in Fremantle on May 19, 1918. Here is an incident where the initial understandings of shell shock seemed to have been confirmed. From the time the term was invented in 1915, doctors took shell shock to mean a serious concussion, one which followed a direct hit by artillery or similar explosion hurling the soldier's body in the air. This diagnosis pointed to a physical insult or injury which had neurological or psychological consequences. Doctors had little trouble with this sequence of events, since unseen damage in the inner ear or the brain was physiological in character nonetheless. It is also possible that his psychological condition could have led to hypertension, which in turn led to his stroke. We will never know. [30]

It was not surprising, therefore, that Baesjou's condition was treated like all other physical injuries. Nor is it surprising that his family put on the memorial tree planted in his memory, and similarly on his tombstone in the Fremantle cemetery the following epitaph:

Died from Shell Shock
Base Hospital Fremantle
May 19 1918

Thomas Dowell was among the first contingent of Anzac troops who landed at Gallipoli. He fought through the first months of the

[29] A brief (digital) narrative of Baesjou's story can be found on the 100 Stories website, http://future.arts.monash.edu/onehundredstories/. The full text appears in Bruce Scates, Rebecca Wheatley, and Laura James, *A history of the First World War in 100 Stories* (Melbourne: Penguin, 2015), p. 82. I am grateful for the authors' permission to use these stories, which they have unearthed from a wide variety of sources.

[30] I am grateful to Dr. Alexander McFarlane, for his suggestion on this point.

campaign, and took part in the night attack in August towards the summit of Sari Bair. His unit got lost, and subsequently was exposed to flanking fire. Dowell was almost killed, but was pushed to safety during a Turkish attack. His fall had broken his leg, leaving him unable to move for hours. The following day, he was captured, and put on a boat to Constantinople. His wound had developed an abscess. On board, there was little medication and morphine was a rarity. Thirty years later, this is how he described his operation:

> Four Turks put me on the table and held me while the Doctor used his knife; after each cut he would ask "Good, Australia" then go on some more and do the same again ... I was again held down while the doctor opened the abscess and cut it out then the bone was scrubbed with a wire brush.[31]

As with many other men, the traumatic incidents were not over when incarceration began. Dowell was transferred to a prison camp at Afion Karahissar (Illus. 7.3). Hunger was constant, alleviated occasionally by Red Cross parcels. Discipline was hard, backed up by the images of hanged criminals on display in the camp. Fear festered, along with loneliness and boredom.

Dowell was freed when the war came to an end. He returned to Australia in December 1918. One decisive step he took was not to apply for a pension. He wanted to live on his own. And yet his war service had left its marks on him. Here is a significant silence in Dowell's life, one with consequences. Later he wrote that "I feel like a spring wound up, and I can't unwind." Nightmares recurred, along with nerves and even hallucinations. Twenty years later he claimed: "Even at this distant time, I can mentally see the whole scene as clearly as possible."[32] He spoke of his fears of disaster of an unspecified nature.

His wife had no doubt that his mental state was due to his incarceration in Turkey. He was, she said,

> Subject to extreme mental aggravation by the Turks; and strain of being surrounded by wounded and dead; cut off from all his own ...

[31] Appellant's statement, September 16, 1935. Thomas Dowell repatriation file, National Archives of Australia, B73, M41646, as cited in Scates et al., *100 stories*, p. 123.

[32] Letter dated March 12, 1935, Dowell to Repatriation Department, NAA, B73, M41646.

unable to understand speech or custom without difficulty, nor they
him, his increased suffering from neglect and unskillful [sic] treat-
ment of the war wounds . . . His body . . . was covered with scurf and
large sores, jaundice . . . to accompany the nervous trouble.

By "nervous trouble," she meant violent moods, leading to threatening
behavior to farm animals and even to his family. He built explosives to
"bomb the place." Dowell's wife never left the children alone with him.
The nervous state he had suffered in Turkish prisons was still with him.

As in many other cases, the difficulty was to identify what was
war-related in this sad state of affairs. The Repatriation Department
saw his case for assistance as "doubtful," and his need for medical care
"transient."[33] Nevertheless, twenty years after Gallipoli, the
Reparations Department granted him a partial pension. Can we read
between the lines that the partial pension referred to recognition of his
physical injury at Gallipoli, and not the psychological troubles which
plagued him and his family for decades?

By the time this grudging recognition of his war-related difficulties
came, he was a physical and nervous wreck. His leg never healed, and for
days on end he would lapse into silence. Can we separate that silence from
his sense of the injustice of his treatment, both during and after the war?
To be sure, both Dowell and his wife spoke time and again of his plight,
and railed against the bureaucratic obstacles he faced. What rendered his
family speechless was official doubt about the long-term psychological
consequences to a soldier of his having faced combat, having been injured,
having been incarcerated in an Ottoman Turkish prisoner-of-war camp
when the Turks were running out of food, and then, on his return to
Australia, finding it virtually impossible to live a "normal" life, whatever
that might have been. Yes, other soldiers faced the same or worse, and went
back intact to the world they had left behind. They were the lucky ones.
The question is, why is there not more place in the narrative of Gallipoli for
both sides of this story, the ones which unfolded successfully over the long
term, and the ones which didn't?[34]

Dowell's case raises another facet of the long road medical
science had to travel before gaining an understanding of the psycholo-
gical effects of incarceration in prisoner-of-war camps. To be sure,

[33] Dr. Godfrey to Repatriation Department, November 26, 1934, NAA, B73, M41646.
[34] See Scates et al., 100 stories, for further details; for the online course related to the 100
stories, see http://future.arts.monash.edu/onehundredstories/

Dowell's injury was traumatic, and his imprisonment brutal. But there is now an extensive literature on the long-term effects of military incarceration on the mental health of former prisoners-of-war which offers a different reading to parts of Thomas Dowell's enduring history of "nervous trouble." No one used the term "posttraumatic stress disorder" (PTSD) at the time; in considering the story of Thomas Dowell and many others, perhaps it is time to do so now.

The difference between shell shock, as understood in the period of the Great War, and PTSD, is that between those manifesting symptoms of psychological injury immediately or shortly after combat, injury, or incarceration, and those whose conditions develop years, and sometimes decades, after an apparently successful return to civilian life after war. We shall have more to say about this latter set of conditions below, but it is now clear that a loss of language capacity, or an inability to put into words the stresses veterans faced, is a feature of the late-onset illness not recognized at the time of Thomas Dowell's troubled life. For him, angry, frustrated silences may not have been a choice, but rather a symptom of his condition.[35]

So far I have discussed three instances of shell shock. Two had immediate and fatal consequences. The third case was more representative, reflecting the story of a man whose wartime troubles, physical and psychological, left traces which lasted a lifetime. Due to underreporting, we do not have reliable statistics about how many men recovered from shell shock. And yet the scattered evidence available suggests that most did not die of the condition, and many recovered rapidly. Others, though, were like living time-bombs, and exploded in later years, with devastating consequences for themselves and for their families.

Instead of further cataloging these sad life histories, I want to probe more deeply the long-term legacies both of shell shock and of silences surrounding it. I want to turn to the well-documented case of a soldier devastated by his time at Gallipoli and at Ypres, a man whose son has left us much evidence as to the silence of the survivors and the transmission of that silence to the generation born after the war.

Here it is important to distinguish between two kinds of silence. The official, medical, and administrative underrecognition of shell

[35] Edgar Jones and Simon Wessely, "British prisoners-of-war: From resilience to psychological vulnerability: Reality or perception," *Twentieth-century British History*, 21, 2 (2010), pp. 164–83.

shock constitutes what I term a "categorical silence," a willful blindness to including in the number of men disabled by war those who suffered from psychological or neurological conditions. A second kind of silence was communicative. That is, those suffering from the condition and its sequelae either were unable or unwilling to speak about it. Their silence was heavy with meaning. One way in which we can hear the reverberations of these silences is to examine the writing of one soldier's son, the British poet Ted Hughes.

Ted Hughes was born on August 17, 1930, in West Yorkshire. His father William served in the Lancashire Fusiliers on Gallipoli, and was one of the few local men who came back alive and intact. When the 1st Battalion of the 5th Lancashire Fusiliers transferred to HMS *Eurylus* at 6 p.m. on 24 April 24, 1915 at Tenedos to prepare to land at Gallipoli, their strength was 25 officers and 913 other ranks. At 6 p.m. on April 26 it was 15 officers and 411 other ranks. Over 500 men, or half the battalion, had been killed or wounded in one day. And that was just the beginning of the wastage. It is difficult to be sure if the figure William Hughes gave of 17 survivors of his unit who came back from Gallipoli is accurate, but there is no doubt that the Battalion that landed at Gallipoli was torn to pieces, and remained a hollow shell, filled with new drafts from anywhere and everywhere, by the time they evacuated the peninsula in January 1916. Without this watering down of the regional composition of infantry regiments, they would have simply vanished. Instead, they lived on, thereby upholding local traditions hardly any of the new men in them shared.

William Hughes and his unit next went to the Ypres salient, where once again he was in the midst of heavy fighting. He lived through some of the worst combat conditions in the war, and was awarded the Distinguished Conduct Medal for helping evacuate wounded to casualty clearing stations. He even claimed to have had a "lucky war." One tale which dated from that period was about a ration book kept in his breast pocket, which apparently saved his life. It stopped a piece of shrapnel, which hit him, but did no further damage. The ration book had pride of place on the mantelpiece for decades thereafter.[36] This kind of story was common in the war. Mustafa Kemal Atatürk told the same story, though the lucky object which stopped a piece of shrapnel was his pocket watch.

[36] See Jeffrey Meyers, "Ted Hughes: War poet," *Antioch Review*, 71, 1 (Winter 2013), pp. 30–39.

As he was growing up, young Ted Hughes found out soon enough that the price of his father's survival was high. Ted heard about his father's war from others. While some local men might regale their families with tales of the war, William Hughes said nothing about it at all. In "For the duration," written in the 1980s, ten years after his father's death, his son recaptured the puzzlement of a child faced with the immovable face of a silent father, damaged in the war. War talk like artillery shells approached William, threatening to bring back the horrors, details of which his young son Ted had heard from others, but never from his father. He knew that a shell burst had lifted his father heavenward, and then had deposited him back on the earth, shaken, injured, but alive. But what was worse was his father's silence. He never uttered a word to his son about his ordeal.[37]

Perhaps his father did not want to terrify his son, but his silence did precisely that. His son felt too ashamed to ask, of what, he never knew, though peering at his father's suffering could easily have accounted for it. His father's silence made the child pose the question why his father's war was unspeakable, beyond the ordinary language of an ordinary family. No, the child looked at his father's still face, and his cigarette, and remained rooted to the spot. Numbness made deeper when this paternal silence was broken later, at night, not by words but by shouts emerging from his father's dreams, in which the war went on and on as if his father could not find a way to protect his family, transported in dream-time to the trenches.[38]

Survivor's guilt with a vengeance: that was part of William Hughes's burden. But his son too had his nightmares; among them was his sense of clinging to his shell-shocked and wordless father. As his son saw it in his poetry, trapped in no-man's-land, still searching for his damaged son, William Hughes staggered on clasping him silently to his body for the rest of their lives. This is a dark motif evident

[37] Ted Hughes, "For the duration," in *Collected poems*, ed. Paul Keegan (London: Faber & Faber, 2003), pp. 760–61. Having applied for, but not received, permission from Faber & Faber to cite Ted Hughes' poetry, I have described the poems, but urge readers to return to the original texts. This problem adds another level of meaning to the title of this book; War Beyond Words.

[38] Ibid., p. 761.

throughout Ted Hughes's long life as a poet, from Yorkshire outsider to Poet Laureate.

At times the references to his father's internalized war, raging silently within him for decades after 1918, were direct, at times transformed into verse about the sea and the coast at Holderness on May Day. There stretched the North Sea, leading to the Western Front and beyond to Gallipoli. Beneath the sea lay the shouts of those torn to pieces in battle.[39]

In "Ghost Crabs," he follows the creatures coming ashore, uncannily resembling the helmets of Tommies in the trenches, murderously climbing all over each other. These crabs return to England like ghosts, who dominate our lives just as we never escape their deaths. They are, Hughes concludes, like Lear, playthings to God.[40] Here are the words of a son living his father's near death and sharing his not complete survival. This poetic merging of the violence of crabs and birds and other living things with the violence of men in war is one of Ted Hughes's most striking themes.

Think back for a moment to the fictional identification Dick McQuade sought with Canadian soldiers at Passchendaele he never knew at a battle he never fought, and now consider the force of Ted Hughes's evocation of one of his father's photos in his poem of the lost generation of the Great War, "Six Young Men." Six months after the photo was taken, all were dead, in Ted Hughes's words, holding the worst, their own deaths beyond all their hopes. This is the diametrical opposite of McQuade's prevarication, since the silence of the photo and the silencing of these young voices were essential parts of the story Ted fashioned out of his father's silences on the Great War. In "Six Young Men," Ted Hughes is speaking both of them and for them; he did the same when meditating about his father's refusal to talk about the war.

The eerie presence of his father's silence in Ted Hughes's poems is part of what gives them their power. In the first part of his poem "Out," entitled "Dream Time," Hughes tells of seeing his father rendered speechless, just sitting in his home, recovering from a war which was, for him, beyond words. While his bodily wounds healed, he continued hearing the voices of the past, and remained, in a profound sense, chained to the dead, while his son Ted looked on, puzzled and troubled by it all.

[39] Ibid.　[40] Ibid., pp. 149–50.

William Hughes's silence about the horrors he lived through was the opposite of forgetting; silence was a kind of brooding acknowledgment of unbearable memories and deeply hidden injuries. Seeing them without hearing his father uttering a word is what made his son "his luckless double," doomed to return to the scene of the crime in perpetuity.

In the second, untitled, part of the poem, Hughes meditates on a dead soldier put back together somehow returning to life hesitantly, walking in fits and starts like a baby with the face of a very tired man. Could this be a reference to the mingling of father and son, the binding together of babe and clerk, the reassembly of a half-alive father, tied to the son who tried to understand his silences?

In "Remembrance Day," the third part of the poem, Hughes develops his identification with his father. No easy commemoration rituals for either of them. The poet damns the poppy, the symbol of so much sufffering, and of so many unshakable memories from which no one escaped. Then he brought his mother into this silent landscape of remembrance. These ghosts, the poet saw too, also haunted his mother. There was no room for poppies in a home where survival was mocked by dreadful, unspoken and yet terribly ubiquitous memories of war.[41]

Growing up in the presence of a man shell-shocked at Gallipoli, then again nearly killed at Ypres, Ted Hughes was one of an unnumbered population of men and women who came of age in the shadow both of the Great War and of the silent generation of veterans it left behind.[42] William Hughes was never diagnosed as shell-shocked. He is one of the millions of men throughout the world whose disabilities were hidden and unacknowledged officially. Their families dealt with their injuries as best as they could. And his son was exceptional in finding a way to break the silence, to register the suffering in words his father never uttered.

This personal and silent identification of father and son has recently been challenged by Ted's sister Olwyn. Theirs was a tempestuous relationship, and her acting as literary executor for Sylvia Plath raised another level of family secrets and family silences to public view. Olwyn claimed that her father did indeed tell Ted and her of his war experiences, but that Ted had no memory of these

[41] Ibid., pp. 166–67. [42] See Meyers, "Ted Hughes," pp. 30–39.

conversations. As in many family histories, both versions may be true or shadings of the truth. What matters for our purposes is that Ted heard his father's silences and turned them into poetry. Instead of choosing between siblings, the best way to handle such delicate differences in remembrance is to let Ted Hughes speak for himself (Illus. 7.4).[43]

Ted Hughes's poetry moves us to ponder two unanswerable questions. The first is, how many other men were like his father, trapped in a terror of the trenches all of their own, unrecognized psychological casualties of the Great War? The second is, how many families, how many wives and children, were marked indelibly by these silences, these inner scars of combat? Michael Roper has begun a study of the transmission of war narratives, and the emotions attached to them, among families of First World War soldiers. The results of this research should throw considerable light on the darker corners of family life in the aftermath of the Great War.[44]

Geoffrey Moorhouse's close study of Bury, a military garrison town, and the shadows cast over it by Gallipoli,[45] reinforces the view that the underestimation of British casualties of all kinds, including psychological ones, was a general phenomenon. The 1st Battalion of the Royal Lancashire Fusiliers, based in Bury, won six Victoria Crosses on the first day of the landing at W beach at Cape Helles on April 25, 1915. They were withdrawn from Gallipoli and served alongside the 2nd Batallion on the Western Front. They fought over the difficult terrain of Beaumont Hamel on the Somme. One of their number was the author J. R. R. Tolkien.

The unit's war service was heroic by any measure. Postwar commemoration in the town has kept that story alive for a century. And yet, as Moorhouse shows, this narrative occluded another much darker story, one of suicides and criminal acts committed by damaged men, whose misery had no place in the collective memory of the town or the regiment. Indeed, the reluctance of young men from Bury to enlist in

[43] Jonathan Bate, *Ted Hughes: An unauthorized biography* (London: HarperCollins, 2015), pp. 33, 41. Olwyn Hughes withdrew the family's "authorization" of this biography. The quarrels besetting this unfortunate family are best left outside any account of Ted Hughes and his father.

[44] For information on Roper's project, "The Generation Between: Growing up in the aftermath of war, Britain 1918–1939," see www.essex.ac.uk/sociology/staff/profile.aspx?ID=138

[45] Geoffrey Moorhouse, *Hell's foundations: A town, its myths and Gallipoli* (London: Hodder & Stoughton, 1962).

the Lancashire Fusiliers in the Second World War points to stories and silences exchanged in pubs or homes about just how bad was the after-math of the Great War in this one town.[46]

These additional references to widespread trauma among sol-diers reinforce my plea that we stop underestimating both the number and the significance of the hidden story of shell shock in the Great War. Unacknowledged by doctors, bureaucrats, friends, even perhaps at times by themselves, an unspecified, but a very large number of men never overcame fully the psychological or neurological damage they sustained in the war. The women who cared for them on their return knew the truth; it is time we listened to them too.[47] In the interwar years and after, these women knew all too well how some men retreated into the defensive redoubt of silence, never to emerge again. When the talk turned to war, they turned to the wall. Now, a century later, it is surely the right time to make audible and legible what these veterans did not say. Let us not ignore their silences, since through silence they spoke deeply and movingly about the consequences of a war we still barely know today.

William Hughes died in 1981. His son Ted died in 1998, having served as Poet Laureate for fourteen years. By then many, though by no means all, of the silences surrounding shell shock and about the men who endured it during and after the Great War had been broken. In part this was a function of a sea change in many countries leading to public recognition of the psychological damage suffered by both civilians and soldiers in wartime, especially during the Second World War and in the Holocaust.

In addition, medical opinion itself shifted over time in many different countries. In the immediate aftermath of the Vietnam War, the American Psychiatric Association, in its *Diagnostic and Statistical Manual of Mental Disorders* of 1980 (DSM III), recognized "Posttraumatic stress disorder" as a legitimate medical syndrome, with causes, characteristics, and regimes of care.[48] Central participants in the five-year period preparation of DSM III recount how difficult it

[46] I am grateful to Adrian Gregory for bringing this reference to my attention.

[47] Scates et al., *100 stories*; Marina Larrsen, *Shattered Anzacs: Living with the scars of war* (Sydney: University of New South Wales Press, 2009).

[48] Robert L. Spitzer, Janet B. Williams, and Andrew E. Skodol, "DSM-III: The major achievements and an overview," *American Journal of Psychiatry*, 137(2) (February 1980), pp. 151–64.

was for them to persuade colleagues in the late 1970s that mental disorders were medical. Through a series of over a hundred field trials, the authors made revisions to their protocols reflecting actual medical treatment of mentally ill men. Finally, the category Post Traumatic Stress Disorder was specified. It was defined in this way:

> In this disorder, sometimes referred to as Traumatic Neurosis,
> symptoms of re-experiencing stressful events, numbness toward
> and reduced involvement with the external world, and other affec-
> tive, physiological and cognitive symptoms develop after
> a psychologically traumatic event that is outside the range of usual
> human experience.[49]

The positive acceptance of DSM-III in the United States and elsewhere, made it easier for mentally ill men to get treatment and file for pensions in the same way as their physically injured comrades. In the aftermath of the 1973 war, Israel adopted the same criteria as the United States in the aftermath of the Vietnam War.[50]

In many countries from the 1980s on, what I have termed a categorical silence, meaning an administrative reluctance or refusal to accept as legitimate some war-related mental disabilities, had diminished, and yet the social stigma attached to mental illness among soldiers endured. Older notions of masculinity, courage, and stoicism were difficult to square with a recognition that all soldiers had their breaking points, psychologically as much as physically.

Over time, though, the cumulative effect of publicly reported cases of soldiers' breakdowns, all too frequently with attendant violence to themselves or to their families, was to reduce the silence surrounding the need to help those suffering from PTSD.[51] In the period of professional rather than mass armies, the numbers in uniform declined, and so did the cost of treating those who needed care for mental illness. Better psychological screening on entry into the service helped reduce the number of such vulnerable men in the armed services. By the last decades of the twentieth century, there was a consensus that however positively motivated, however brave, men in combat will break down,

[49] Ibid., p. 159. [50] I am grateful to Emmanuel Sivan for his advice on this point.
[51] For a first-person "biography of PTSD," see David J. Morris, *The evil hours. A biography of post-traumatic stress disorder* (Boston: Houghton Mifflin Harcourt, 2015). Note that the title comes from the memoirs of Siegfried Sassoon.

either immediately or over time. This was no reflection on them; the risk of mental injury was simply built into war.

This normative change was significant, though, like other similar shifts in opinion, it was incomplete. Many people refused to be guided by the new tolerance of mental illness in the military. Still, by the time of the wars in Iraq and Afghanistan, the taboo against even mentioning this subject was gone. The volume of publications, fictional and nonfictional alike, on the topic became an avalanche. Film and television dramatized (and overdramatized) PTSD among soldiers, and among other civilians who suffered the after-effects of extreme violence.

The terrifying silences of Ted Hughes's childhood still recurred within some soldiers' families, but now there were many groups within civil society willing and able to help. There are organizations like the British PTSD Resolution which from 2010 offered what they term a "resolution network" to help veterans recover from symptoms.[52] In the United States, a veterans' support organization, DAV, claimed in 2015 that they were there to help the estimated nearly 50 percent of returning American soldiers diagnosed with PTSD.[53] "Soldier's best friend" even provides American veterans with service or therapeutic companion dogs to help the men rebuild their sense of trust.[54] A parallel group working in Australia is entitled Picking up the Peaces.[55] There are dozens of such associations around the world which operate on the assumption that combat puts men's minds as well as their bodies at risk.

Yet, there is work still to be done to persuade ex-soldiers to seek psychiatric help when they need it. One British organization working with veterans, the Mental Health Foundation, reported that "only half of those ex-soldiers suffering from mental health problems sought help from the NHS [National Health Service], and those that did were rarely referred to specialist mental health services."[56] What I have termed "communicative silence," the silence of soldiers carrying the weight of war with them, dies hard. All too many men and women who have

[52] www.ptsdresolution.org/index.php

[53] https://secure3.convio.net/dav/site/Donation2;jsessionid=00000000.app315a?
df_id=10800&10800.donation=form1&NONCE_TOKEN=0F94C0F38CBD5FAD
25D09E9392BCC55A&gclid=CKnJu6imycgCFVUTHwoduywL3g

[54] http://soldiersbestfriend.org/?gclid=CMOd99ilycgCFdcZgQod7NMKbQ

[55] www.pickingupthepeaces.org.au/

[56] Mental Health Foundation, www.mentalhealth.org.uk/help-information/mental-
health-a-z/a/armed-forces/

served still refuse to talk about their depression or alcohol and drug abuse as symptoms of a war-related illness. Many of their children follow in the footsteps of Ted Hughes, and carry their fathers' or mothers' injuries with them. They have more help today than the Hughes family had in the 1930s, but the heavy shadow of war still falls on children growing up in soldiers' families.[57]

Silence and Remembrance

This chapter is about certain kinds of silence and about certain kinds of silence-breaking. Some of this story unfolds in wartime. Much of it happens in families, long after the termination of armed conflict.

One conclusion seems unavoidable. During the Great War, there was a general unwillingness to recognize that psychological injury in wartime was a very common occurrence, much more prevalent than official statistics suggested.

A second conclusion is that this silence about shell shock was an enduring one. Indeed, there is a school of thought that the delayed onset of mental illness related to military service – now termed PTSD – entails a loss of language capacity. Alexander McFarlane terms it a kind of "speechless terror."[58]

It is impossible to say if Ted Hughes's father suffered this fate. But what is clear is that the poetry of Ted Hughes captured the reverberations of war and injury in war long after the end of the conflict. Many commentators on war have discussed variations on what he saw in his father's face. I have termed this gaze, one rich in "communicative silence," a socially reinforced ban on words, a blockage of conversation, even (or especially) in intimate family circles, about the long-term psychological injuries veterans bear. We can still hear such silences today, and we still need silence-breakers to enable us to communicate from generation to generation what we see and what we know about the ravages of war. If William Hughes thought that by not speaking of his war, he was sparing his son or wife from confronting some its horrors, he was profoundly mistaken. Silence can be full of meaning. It has

[57] For one such organization addressing this problem, Mental Health America, see: www.mentalhealthamerica.net/military-mental-health

[58] Once more my thanks are due to Dr. McFarlane for his valuable advice on this point.

weight. When we unpack the meanings of silence, we turn its powerful emotive force into something else, something spoken, something preserved in what we call auditory memory.[59]

I have claimed above that silence operates in different domains: the liturgical, the political, the essentialist, and the familial. In each case, performative nonspeech acts proliferate, about theological questions without answers, about unglorious episodes in a nation's or group's history, or about shameful or divisive acts of family members.[60]

When we turn to shell shock and the silences it engenders, we can add two additional forms of performative nonspeech acts to the discussion. The first is diagnostic silence, a way of bypassing the taking of official, financial, or public account of a condition most doctors and many patients do not want to acknowledge. The vast underestimates we have uncovered in the official statistics of shell shock arise from many sources; diagnostic silence is one of them.

Secondly, I have followed Jan and Aleida Assmann's pioneering work on communicative memory by positing an additional category of performative nonspeech acts, which may be termed communicative silence. Just as family stories told around the dinner table establish narratives of a shared past, so in subtle ways do silences around the dinner table. They transmit messages about distressing or suppressed incidents about which everyone knows but nobody speaks.

For students of war and remembrance, perhaps the most important implication of this chapter is the way it helps us to see that silence is a language, a constitutive part of the way we imagine war. As in so many other domains, silence is not an empty space but, under certain circumstances, a powerful mode of conveying meaning. It is a great mistake to equate silence with forgetting; on the contrary, silence remains an essential part of our landscape of memory. All we need are eyes and ears to see and hear it.

[59] I owe this point, and much else, to Robert Dare.

[60] For another formulation of this position, see Jay Winter, "Silence as a language of memory," in Esther Captain and Trudy Mooren (eds.), *Familie, generaties en oorlog. Historische, psychologische en artistieke inzichten* (Amsterdam: National Committee for May 4–5, 2014), pp. 26–59.

CONCLUSION

This book is a meditation on war and remembrance. Both words describe social practices which have been transformed since 1914. Many of these developments have arisen from technological change. The institutions and practices of war were revolutionized by the second industrial revolution. Nineteenth-century advances in mass production, in the chemical industry and metallurgy, and in transportation and communication increased exponentially the means of destruction states could deploy in armed conflict. Consequently the social relations of destruction, rules governing war, and the organization of society to conduct war on a scale the world had never seen before, changed in turn. What we term total war – in geometric terms, more an asymptote than a limit describing the absorption into the war machine of all productive capacity – happened after and as a direct result of the industrialization of all the major powers.

The outcome – the Great War – was the greatest bloodbath in history to date. It was followed by the first memory boom of the twentieth century. This side of the story was also technologically driven. While both photography and film were nineteenth-century innovations, technical advances increased exponentially the exposure of mass populations to fixed and moving visual images of war. At the same time, the need to commemorate the army of the dead – 10 million strong – produced a demand for commemorative works of many kinds. We can still see those monuments in stone built in the 1920s and 1930s as war memorials on battlefields, and in villages and towns all over Europe and in areas of white settlement elsewhere. Some repeated earlier heroic

tropes; many more adopted a more somber rhetoric, with horizontal axes undermining the vertical language of aesthetic redemption.[1] Much more numerous were the books and ephemeral publications, the works of art, popular and professional, the photographs, and the films on war created in the interwar years. Among scientists as well as avant-garde writers and artists – for Freud, as much as for Proust and Virginia Woolf – memory became a fascination, indeed an obsession, greater than ever before. In the more popular markets, the thirst for war stories and illustrated books seemed to be limitless before the outbreak of the Second World War created additional markets for them all over the world.

The second memory boom of the twentieth century – starting in the 1980s – was also technologically driven. The means of recording, preserving, retrieving, and disseminating war stories were altered radically in the second half of the twentieth century. Audio recorders, video recorders, and then the Internet made it possible to capture and circulate images of war and the voices and faces of the victims of war as never before. Memory archives and museums proliferated in the 1980s and after.[2]

By that time, many people throughout the world had come to the delayed recognition that the Shoah was not only a monstrous deformation of the practices of war, but that it was also at the heart of the history of the Second World War. The civilian victims of the Shoah and the myriad other atrocities of post-1945 wars could not be commemorated in the same way as the soldiers of the Great War.

Remembering them, and other victims of war, including soldiers, became a matter touching on a new category of memory – traumatic memory – in which the psychological damage of war could go underground, explode long after the events which triggered it, and last a lifetime. Other victims of violence – of sexual abuse in particular, but also of civilian victims of police states – joined the ranks of those deemed to be suffering from traumatic memories, now formally recognized by the medical profession as pathological in character.[3]

[1] See Chapter 6.

[2] See Jay Winter, "The Generation of memory: Reflections on the 'memory boom' in contemporary historical studies," *Bulletin of the German Historical Institute*, 27 (Fall 2000), pp. 69–92.

[3] See Winter, *Remembering war*, ch. 1 and 2.

The exponential growth of the Internet and social media disseminating images of war precipitated the third memory boom of the early twenty-first century. As we have noted in Chapter 2, only in the age of miniaturization and globalization, of cellphones and instant video and photographic recall, could there have been the Abu Ghraib scandal, in which American soldiers in an Iraqi prison engaged both in recording and in promiscuously "sharing" violent pornographic images of the tortures they inflicted on their charges and the pleasure they got in inflicting them. When these images went "viral," meaning uncontainable and therefore undeniable, remembering war and its cruelties entered a new phase. Viral circulation is the hallmark of the third memory boom.[4]

In each of these three memory booms, we can see that *how* we remember affected deeply *what* we remember. That is at the core of the premise with which this book began, that language frames memory. War is not the only driving force behind today's memory boom, but it is an important element in the story. And the transformation of war from being a conflict on battlefields populated primarily by soldiers to conflicts populated overwhelmingly by civilians ensured that a certain kind of heroic imagery and literature of men at arms would be compromised. The Shoah was the iconic war of soldiers against civilians; other disasters have followed in its wake and have helped change how we imagine war.

To be sure, older images of men in uniform as noble warriors did not vanish; they persist in some parts of the world. A second array of visual and verbal images of war as an unjustifiable abomination has grown alongside what Edmund Wilson once termed "patriotic gore,"[5] and has also been disseminated easily and globally to become part of the digital memory boom. This set of images has created a widespread visceral revulsion at the inevitable sights accompanying armed conflict today: images of the homeless, the torn bodies of children and other broken inhabitants of war zones. In parts of Western Europe and North America, these images have tended to undermine the political legitimacy

[4] Andrew Hoskins, "Media, memory, metaphor: Remembering and the connective turn," *Parallax*, 17, 4 (2011), pp. 19–31; and Andrew Hoskins, "7/7 and connective memory: Interactional trajectories of remembering in post-scarcity culture," *Memory Studies*, 4, 3 (2011), pp. 269–80.

[5] Edmund Wilson, *Patriotic gore* (New York: Alfred A Knopf, 1960).

of war; in other places, they have fueled mobilization for punitive military action.

It is too early to tell whether the bad (visual) press that war has gotten in recent years will make it more difficult to "sell" war to populations whose support is needed to launch and sustain it. Suffice it to say that the array of social practices and media surrounding war and the victims of war today bears very little resemblance to those languages of memory which operated in 1914. That radical transformation of images of war, the key subject of this book, is still in motion.

Twenty years have passed since the publication of *Sites of Memory, Sites of Mourning: The Great War in European Cultural History*. Do the findings of the present book confirm its central argument that the real break in twentieth-century cultural history is 1945 and not 1918? The answer is a qualified yes; the general conclusions of *Sites of Memory* still stand. There is overwhelming evidence that remembering the Great War in Europe entailed a return to traditional practices of mourning, embedded in classical, romantic, and religious images and languages. That was not the case after 1945, but the radical distinction between the two postwar periods I drew in 1995 is probably too sharp, and in need of qualification.

In the first chapter of the present book, I show that the words ennobling war as a site of glory faded away after 1918 in English, though not to the same degree in other languages. Where Roman Catholic or other religious traditions predominated, or where revolutionary memories were at the heart of state commemorative practices, "glory" outlived the horrors of the Great War; not so in parts of the Anglo-Saxon world. Similarly, in Chapter 5, we saw that the Shoah undermined the language of martyrdom as a means of ennobling or sanctifying the victims of war. Again, qualifications are necessary. In Eastern Europe, the Middle East, and in large parts of Asia, the language of martyrdom still framed the remembrance of war and its victims in the early twenty-first century. Cultural history is a messy business, registering trends moving in different directions over time.

In other ways, this book provides support for the view that the Great War was a decisive moment in the history of how we see war. Despite the Armenian genocide and the massive refugee flows of the Great War and its sequelae, that conflict was commemorated and

imagined primarily as a soldiers' war. Ten million men died in that war, and half of them have no known graves. They just disappeared. At the same time, advances in the technology of photography and film multiplied by millions images of the soldiers who were no longer there. On mantelpieces and in family albums all over the world, the faces of the dead were all that remained of them. As Roland Barthes argued, there is an aura of mortality in all photography; snapshots record yesterday what is absent today.[6] For families all over the globe, photos highlighted as nothing else did the void in which they had to live in the aftermath of the Great War.

Soldiers' photographs went further still. By the mass distribution of cheap cameras, soldiers broke through codes of decorum and censorship to photograph and to preserve images of the ugliness of industrial war. It was not at Bergen Belsen or Buchenwald that soldiers first saw bodies lined up like matchsticks; it was in the killing fields of northern France in 1915. The imagery of state-legitimated industrial killing was born not in Hitler's war, but in 1914–18. Without this visual precedent, I believe, the Shoah was not even imaginable.

The progressive disappearance of the human face in representations of war in the visual arts shows the cumulative effects of the two world wars. And yet the massive commemorative wave of the 1920s and 1930s was based on a belief, false though totally understandable, that the horrors of the Great War could not happen again. Building a war memorial was an attempt to resist what Julia Kristeva termed "symbolic collapse,"[7] and to give meaning to the massive loss of life in the First World War. In many places, this effort could not be repeated in the same way after the Second World War and the Shoah. Consequently, the disappearance of the human face, for example in the installation art of Anselm Kiefer, shows the distance he and other children of the Second World War had traveled from the symbolic language used by Paul Klee and others after the 1914–18 war. The angel of history had indeed lost her face.

Chapters 6 and 7 move in different directions. As the images of Franco's Valley of the Fallen and the Motherland monument at Stalingrad show, the principal of verticality in monumental art survived

[6] Roland Barthes, *Camera lucida: Reflections on photography* (New York: Hill & Wang, 1981).

[7] Julia Kristeva, *Black sun: Depression and melancholia*, trans. Leon S. Roudiez (New York: Columbia University Press, 1989), p. 81.

the First World War in different parts of the world. And yet the weight of mass death pulled, as it were, against the verticality of hope, yielding both after 1918 and after 1945 monuments and war memorials of striking originality. Here the link between Käthe Kollwitz and Maya Lin shows that it was the Great War which provided the initial impulse behind revolutionary and enduring trends in commemorative art.

In the last chapter, I argued that silence is a language of memory. In this domain, continuities predominate. Silence about the psychological damage suffered by soldiers was as much a property of the Second as it was of the First World War. There was both a diagnostic silence, lying behind major underestimates of the incidence of shell shock in particular in the First World War, and a communicative silence, invading veterans' homes and the lives of their families thereafter. But in the later twentieth century, there was an erosion of the silence surrounding shell shock, both among physicians and among soldiers themselves. The real break in the history of social constructions of war-related mental disabilities happened in the 1980s. The official recognition of posttraumatic stress disorder as a medical syndrome, with causes, treatments, and pension rights associated with it, was a major step in breaking the silence about the suffering of soldiers not only in wartime but long after the end of armed conflict.

In sum, all the languages of memory bear traces of the different ways the wars of the twentieth century have changed our lives. Today we face the same difficulties in making sense of armed conflict, brutally written on the walls of Parisian cafes and on the bodies of those who died in them, as did the men and women who endured war a century ago. Imagining war is the curse of our violent world; we have no choice but to face that task with as much intelligence, compassion, and courage as we can.

BIBLIOGRAPHY

Abramson, Daniel, "Maya Lin and the 1960s: Monuments, time lines, and minimalism," *Critical Inquiry*, 22, 4 (Summer 1996), pp. 679–709.

Ács, Pál, "Holbein's 'Dead Christ' in Basel and the radical Reformation," *Hungarian Historical Review*, 2, 1 (2013), pp. 68–84.

Agamben, Giorgio, *Homo sacer: Sovereign power and bare life*, trans. Daniel Heller-Roazen (Stanford University Press, 1998).

Allen, Nicholas, *Modernism, Ireland and civil war* (Cambridge University Press, 2009).

Alexander, Carol, "The shock of war," *Smithsonian.com Magazine* (Summer 2010).

Amad, Paula, *Counter-archive: Film, the everyday, and Albert Kahn's Archives de la Planète* (New York: Columbia University Press, 2010).

Amichai, Yehuda, "And who will remember the rememberers?", in *Open closed open*, trans. Chana Block (New York: Mariner Books, 2006).

Andreasen, N. C., "Posttraumatic stress disorder: A history and a critique," *Annales of the New York Academy of Sciences*, 1208 (October 2010).

Apel, Dora, "Cultural battlegrounds: Weimar photographic narratives of war," *New German critique*, 76 (1999), pp. 49–84.

Assmann, Aleida, *Cultural memory and Western Civilization: Functions, memory, archives*, trans. Aleida Assmann and David Henry Wilson (Cambridge University Press, 2011).

Erinnerungsräume. Formen und Wandlungen des kulturellen Gedächtnisses, 4th edn.(Munich: C. H. Beck, 2009).

Geschichte im Gedächtnis. Von der individuellen Erfahrung zur öffentlichen Inszenierung (Munich: C. H. Beck, 2007).

Lange Schatten der Vergangenheit. Erinnerungskultur und Geschichtspolitik (Munich: C. H. Beck, 2006).

Assmann, Aleida and Sebastian Conrad (eds.), *Memory in a global age. Discourses, practices, and trajectories* (Basingstoke: Palgrave Macmillan, 2010).

Assmann, Aleida and Linda Short (eds.), *Memory and political change* (Basingstoke: Palgrave Macmillan, 2012).

Assmann, Jan, *Cultural memory and early civilization: writing, remembrance, and political imagination* (Cambridge University Press, 2011).

Das kulturelle Gedächtnis. Schrift, Erinnerung und politische Identität in frühen Hochkulturen (Munich: C. H. Beck, 1992).

Moses the Egyptian. The memory of Egypt in western monotheism (Cambridge, Mass.: Harvard University Press, 1998).

Religion and cultural memory: Ten studies, trans. Rodney Livingstone (Stanford University Press, 2006).

"Communicative and cultural memory," in *Cultural memory studies: An international and interdisciplinary handbook*, ed. A. Erll and A. Niinning, in collaboration with S. B. Young (Berlin: de Gruyter, 2008), pp. 109–18.

Assmann, Jan and John Czaplicka, "Collective memory and cultural identity," *New German Critique*, 65 (Spring–Summer 1995), pp. 125–33.

Assmann, Jan and Dietrich Harth (eds.), *Kultur und Konflikt* (Frankfurt-on-Main: Suhrkamp, 1990).

Athanassoglou-Kallmyer, Nina, "Géricault's severed heads and limbs: The politics and aesthetics of the scaffold," *Art Bulletin*, 74, 4 (December 1992), pp. 599–618.

Austin, J. L., *How to do things with words* (Oxford University Press, 1962).

Azoulay, Ariella, *The Social contract of photography* (New York: Zone Books, 2008).

Baird, Kingsley, "Patterns of ambivalence: The space between memory and form," in *Rhetoric, remembrance and visual form: Sighting memory*, ed. Anne Teresa Demo and Bradford Vivian (New York: Routledge, 2012), pp. 113–27.

Barnett, Corelli, "A military historian's view of the Great War," *Essays by divers hands. Transactions of the Royal Society of Literature*, n.s. 36 (1970), pp. 1–18.

Barry, Sebastian, *On Canaan's side* (Harmondsworth: Penguin, 2011).

Barthes, Roland, *Camera lucida: Reflections on photography*, trans. Richard Howard (New York: Hill & Wang, 1981).

Batchen, Geoffrey (ed.), *Photography degree zero: Reflections on Roland Barthes' Camera Lucida* (Cambridge, Mass.: MIT Press, 2009).

"Seeing and saying: A response to 'incongruous images,'" *History and Theory*, 48, *Theme issue* (December 2009), pp. 26–33.

Bate, Jonathan, *Ted Hughes: The unauthorized life* (London: HarperCollins, 2015).

Bean, C. E. W., *Official history of Australia in the war of 1914–1918*, vol. II, *The story of ANZAC from 4 May 1915 to the evacuation of the Gallipoli Peninsula*, 11th edn. (St. Lucia: University of Queensland Press, 1941).

Becker, Annette, *Voir la Grande Guerre: Un autre récit* (Paris: Armand Colin, 2014).

Bernecker, Walther L. and Sören Brinkmann, *Kampf der Erinnerungen. Der spanische Bürgerkrieg in Politik und Gesellschaft 1936–2006* (Nettersheim: Graswurzelrevolution, 2006).

Beurier, Joëlle, *14–18 Insolite: Albums-photos des soldats au repos* (Paris: Nouveau Monde Éditions et Ministère de la Défense, 2014).

Photographier la Grande Guerre. France–Allemagne. L'héroïsme et la violence dans les magazines (Presses Universitaires de Rennes, 2016).

"Mapping visual violence in Germany, France, and Britain, 1914–1918," in *Liberal democracies at war: Conflict and representation*, ed. Andrew Knapp and Hilary Footitt (London: Bloomsbury Academic, 2013), pp. 15–38.

Beuys, Joseph, *Joseph Beuys: In memoriam. Joseph Beuys, obituaries, essays, speeches*, trans. Timothy Nevill (Bonn: Inter Nationes, 1986).

Bodnar, John, *The "Good War" in American memory* (Baltimore, Md.: Johns Hopkins University Press, 2010).

Boggs, Carl and Tom Pollard, *The Hollywood war machine: U.S. militarism and popular culture* (London: Paradigm, 2007).

Bonkat, Maurice, et al., "Band des Erinnerns. Kollwitz-Skulptur reist von Vladslo nach Rshew," *Frieden. Zeitschrift des Volkesbundes Deutsche Kriegsgräberfürsorge e. V* (October 2014), pp. 22–27.

Borchardt-Hume, Achim, "'Dreh dich nicht um': Don't turn around. Richter's paintings of the late 1980s," in *Gerhard Richter. Panorama*, ed. Mark Godfrey and Nicholas Serota, with Dorothée Brill and Camille Morineau (London: Tate Publishing, 2011), pp. 163–200.

Bouhours, Jean-Michel (ed.), *Anselm Kiefer* (Paris: Éditions du Centre Pompidou, 2015).

"Les alchimistes montent au ciel," in Bouhours, *Anselm Kiefer*, p. 170.

Brandon, Laura, "Words and pictures: Writing atrocity into Canada's First World War official photographs," *Journal of Canadian Art History/ Annales d'histoire de l'art Canadien*, 31, 2 (2010), pp. 110–26.

Brody, Richard, "The inadequacy of Berlin's 'Memorial to the Murdered Jews of Europe,'" *New Yorker*, July 12, 2012.

Brownlow, Kevin, *The War, the West, and the wilderness* (New York: Alfred A. Knopf, 1979).

Brothers, Caroline, *War and photography: A cultural history* (London: Routledge, 1997).

Buchloh, Benjamin H. D., "Divided memory and post-traditional identity: Gerhard Richter's work of mourning," *October*, 75 (Winter 1996), pp. 60–82.

"A note on Gerhard Richter's 'October 18, 1977,'" *October*, 48 (Spring 1989), pp. 88–109.

Buelens, Geert, *Everything to nothing: The poetry of the Great War, revolution and the transformation of Europe* (London: Verso, 2015).

Buettner, Angi, *Holocaust images and picturing catastrophe: The cultural politics of seeing* (Farnham: Ashgate, 2011).

Burgoyne, Robert, *Film nation: Hollywood looks at U.S. history* (Minneapolis: University of Minnesota Press, 2010).

Butler, Arthur Graham, *Official history of the Australian Army Medical Services, 1914–1918*, vol. I, *Gallipoli, Palestine and New Guinea*, 2nd edn. (St. Lucia: University of Queensland Press, 1938).

Butler, Judith, *Frames of war: When is life grievable?* (London: Verso, 2016).

Campbell, A. W., "Remarks on some neuroses and psychoses in war," *Medical Journal of Australia*, 1 (1916), pp. 319–23.

Carmichael, Jane, *First World War photographers* (London: Routledge, 1989).

Cavell, Janice, "In the margins: Regimental history and a veteran's narrative of the First World War," *Book History*, 11 (2008), pp. 199–219.

Chapman, Christopher (ed.), *Inner worlds: Portraits and psychology* (Canberra: National Portrait Gallery, 2011).

Chapman, James, *War and film* (London: Reaktion Books, 2008).

Chignola, Sandro and João Feres Júnior, "In honor of Reinhart Koselleck," *Contributions to the History of Concepts*, 2, 1 (March 2006), pp. 3–6.

Clendinnen, Inga, *Reading the Holocaust* (Cambridge University Press, 1998).

Cochet, François and Jean-Noël Grandhomme, *Les soldats inconnus de la grande guerre. La mort, le deuil, la mémoire* (Saint-Cloud: Éditions Soteca, 2012).

Danchev, Alex, "The artist and the terrorist, or the paintable and the unpaintable: Gerhard Richter and the Baader-Meinhof group," *Alternatives: Global, Local, Political*, 35, 2 (April–June 2010), pp. 93–112.

Daniel Libeskind and the Jewish Museum of Berlin/Remarks by W. Michael Blumenthal (New York: Leo Baeck Institute, 2000).

Dostoyevsky, Fyodor, *The idiot*, trans. David McDuff (Harmondsworth: Penguin, 2004).

Downey, Anthony, "Zones of indistinction: Giorgio Agamben's 'Bare Life' and the politics of aesthetics," *Third text*, 23, 2 (March 2009), pp. 109–25.

Eckel, Jan and Samuel Moyn (eds.), *Breakthrough: Human rights in the 1970s* (Philadelphia: University of Pennsylvania Press, 2014).

Eisler, Colin, "Mantegna's meditation on the sacrifice of Christ: His synoptic savior," *Artibus et Historiae*, 27, 53 (2006), pp. 9–22.

Elliot Smith, Grafton and T. H. Pear, *Shell shock and its lessons* (Manchester University Press, 1917).

Erll, Astrid, *Memory in culture* (Basingstoke: Palgrave Macmillan, 2011).

"Locating the family within cultural memory studies," *Journal of Comparative Family Studies*, 42, 3 (May–June 2011), pp. 303–18.

"Media and the dynamics of memory: From cultural paradigms to transcultural premediation," in *Oxford handbook of cultural memory*, ed. Brady Wagoner (Oxford University Press, 2017).

Eskin, Blake, *A life in pieces: The making and unmaking of Binjamin Wilkomirski* (New York: W. W. Norton, 2002).

Etkind, Alexander, *Warped mourning: Stories of the undead in the land of the unburied* (Stanford University Press, 2013).

Etkind, Alexander, Uilleam Blacker, and Julie Fedor (eds.), *Memory and theory in Eastern Europe* (Basingstoke: Palgrave Macmillan, 2013).

Fackenheim, Emil L., "Holocaust," in *Contemporary Jewish religious thought: Original essays on concepts, movements and beliefs*, ed. Arthur A. Cohen and Par Mendes-Flohr (New York: Scribner, 1987), p. 406.

Fassin, Didier and Richard Rechtman, *The empire of trauma: An inquiry into the condition of victimhood*, trans. Rachel Gomme (Princeton University Press, 2009).

Faust, Drew Gilpin, *This republic of suffering: Death and the American Civil War* (New York: Alfred A. Knopf, 2008).

Felman, Shoshana, "Theaters of justice: Arendt in Jerusalem, the Eichmann trial, and the redefinition of legal meaning in the wake of the Holocaust," *Critical Inquiry*, 27, 2 (Winter 2001), pp. 201–38.

Foster, Roy, *W. B. Yeats: A life*, vol. II, *The arch-poet* (Oxford University Press, 2003).

Friedrich, Ernst, *War against war!*, with an introduction by Bruce Kellner (Seattle, Ill.: Real Comet Press, 1987).

Fussell, Paul, *The Great War and modern memory* (Oxford University Press, 1975).

Gatrell, Peter, "Refugees," in Winter, *Cambridge history of the First World War*, vol. III, chapter 10.

Gershenson, Olga, *The phantom of the Holocaust. Soviet cinema and Jewish catastrophe* (New Brunswick, NJ: Rutgers University Press, 2013).

Gerz, Jochen and Esther Shalev-Gerz, *Mahnmal gegen Faschismus/Monument against Fascism* (Stuttgart: Hatje/Cantz, 1994).

Godfrey, Mark and Nicholas Serota, with Dorothée Brill and Camille Morineau (eds.), *Gerhard Richter. Panorama* (London: Tate Publishing, 2011).

Graham, Helen, *A short introduction to the Spanish Civil War* (Oxford University Press, 2006).

Grayzel, Susan, *At home and under fire: Air raids and culture in Britain from the Great War to the Blitz* (Cambridge University Press, 2012).

Green, Anna, "Individual remembering and 'collective memory': Theoretical presuppositions and contemporary debates," *Oral History*, 32, 2 (2004), pp. 35–44.

Grimm, Gunter, *Rezeptionsgeschichte: Grundlegung einer Theorie: mit Analysen und Bibliographie* (Munich: W. Finkj, 1977).

Gruner, Wolf, "'Peregrinations into the void?': German Jews and their knowledge about the Armenian genocide during the Third Reich," *Central European History*, 45 (2012), pp. 1–26.

Gust, Wolfgang, "Armin T. Wegners Vortrag: 'Die Austreibung des armenischen Volkes in die Wüste,'" in Armin T. Wegner, *Die Austreibung des armenischen Volkes in die Wüste*, ed. Andreas Meier, with an essay by Wolfgang Gust (Göttingen: Wallstein Verlag, 2011), pp. 193–210.

Hall, John R., Blake Stimson, and Lisa Tamiris Becker (eds.), *Visual worlds* (London: Routledge, 2005).

Hanafi, Hassan, "Voluntary martyrdom," *Oriente Moderno*, n.s. 25(86), 2 (2006), pp. 201–10.

Harding, Colin, "The Vest Pocket Kodak was the soldier's camera," National Media Museum blog, http://blog.nationalmediamuseum.org.uk/the-vest-pocket-kodak-was-the-soldiers-camera (2014).

Hayes, Patricia, "Vision and violence: Photographies of war in southern Angola and northern Namibia," *Kronos*, 27, *Visual History* (November 2001), pp. 133–57.

Hirsch, Marianne, *Family frames: Photography, narrative, and postmemory* (Cambridge, Mass.: Harvard University Press, 1997).

Hofmann, Tessa and Koutcharian, Gerayer, "'Images that horrify and indict': Pictorial documents on the persecution and extermination of the Armenians from 1877 to 1922," *Armenian Review*, 45, 1–2 (1992), pp. 53–184.

Holmes, Oliver Wendell, "The stereoscope and the stereograph," *The Atlantic*, June 1, 1859.

Horne, John (ed.), *Our war* (Dublin: Royal Irish Academy, 2010).

"Atrocities and war crimes," in Winter, *Cambridge history of the First World War*, vol. I, pp. 561–84.

Horne, John and Alan Kramer, *German atrocities, 1914: A history of denial* (New Haven, Conn.: Yale University Press, 2001).

Hornstein, Shelley and Florence Jacobowitz (eds.), *Image and remembrance: Representation and the Holocaust* (Bloomington: Indiana University Press, 2006), pp. 59–78.

Hoskins, Andrew, "Media, memory, metaphor: Remembering and the connective turn," *Parallax*, 17, 4 (2011), pp. 19–31.

"7/7 and connective memory: Interactional trajectories of remembering in post-scarcity culture," *Memory Studies*, 4, 3 (2011), pp. 269–80.

Huberband, Shimon, *Kiddush Hashem: Jewish religious and cultural life in Poland during the Holocaust* (New York: Yeshiva University Press, 1987).

Hughes, Ted, *Collected poems*, ed. Paul Keegan (London: Faber & Faber, 2003).

Hugo, Victor, *Œuvres complètes: Les Feuilles d'automne. Les Chants du crépuscule. Les Voix intérieures. Les Rayons et les Ombres* (Paris: Ollendorf, 1909), vol. XVII.

Hull, Isabel V., *A scrap of paper. Breaking and making of international law during the Great War* (Ithaca, NY: Cornell University Press, 2014).

Huyssen, Andreas, "Anselm Kiefer: The terror of history, the temptation of myth," *October*, 48 (Spring 1989), pp. 25–45.

Hynes, Samuel, *The Auden generation: British writing in the 1930s* (Harmondsworth: Penguin, 1988).

The soldiers' tale. Bearing witness to modern war (New York: Allen Lane, 1997).

A war imagined: The First World War in English culture (London: Bodley Head, 1990).

Ignatieff, Michael, "Soviet war memorials," *History Workshop*, 17 (Spring 1984), pp. 157–63.

Isenberg, Michael T., *War on film: The American cinema and World War I, 1914–1941* (Rutherford, NJ: Fairleigh Dickinson University Press, 1981).

Iversen, Margaret, "What is a photograph?," *Art History*, 17 (1994), pp. 450–63.

Janes, Dominic and Alex Housen, *Martyrdom and terrorism: Pre-modern to contemporary perspectives* (Oxford University Press, 2014).

Jay, Martin, *Songs of experience. Modern American and European variations on a universal theme* (Berkeley: University of California Press, 2005).

"Photography and the event," in Olga Shevchenko (ed.), *Double exposure: Memory and photography* (New Brunswick, NJ: Transaction Books, 2014).

Jones, Edgar, "Shell shock at Magull and the Maudsley: Models of psychological medicine in the UK," *Journal of the History of Medicine and Allied Sciences*, 65, 3 (2010), pp. 368–95.

Jones, Edgar and Simon Wessely, *Shell shock to PTSD. Military psychiatry from 1900 to the Gulf War* (New York: Psychology Press, 2005).

"British prisoners-of-war: From resilience to psychological vulnerability: Reality or perception," *Twentieth-century British History*, 21, 2 (2010), pp. 164–83.

"Psychiatric battle casualties: An intra- and interwar comparison," *British Journal of Psychiatry*, 178 (2001), pp. 242–47.

Jones, Gareth Stedman, *Languages of class: Studies in English working-class history, 1832–1982* (Cambridge University Press, 1983).

Kahn, Leora (ed.), *Child soldiers* (New York: Power House Books, 2008).

Kaldor, Mary, *New and old wars: Organized violence in a global era* (Cambridge: Polity Press, 1999).

Karcher, Eva, *Otto Dix* (New York: Crown Publishers, 1987).

Kassow, Samuel, *Who will write our history?: Emanuel Ringelblum and the Oyneg Shabes Archive* (Bloomington: Indiana University Press, 2007).

Keenan, Thomas and Eyal Weizman, *Mengele's skull: The advent of forensic aesthetics* (Berlin: Sternberg Press, 2012).

Kelsey, Robin, *Photography and the art of chance* (Cambridge, Mass.: Harvard University Press, 2015).

Kennedy, Liam, "Soldier photography: Visualising the war in Iraq," *Review of International Studies*, 35, 4 (October 2009), pp. 817–33.

Kernan, Michael, "War casualty, John Huston's 1945 film now public," *Washington Post*, February 12, 1981.

Kiefer, Anselm, *L'art surivra à ses ruines* (Paris: Collège de France–Fayard, 2011).

Kieser, Hans-Lucas and Donald Bloxham, "Genocide," in Winter, *Cambridge History of the First World War*, vol. I, pp. 585–614.

Knapp, Andrew and Hilary Footitt (eds.), *Liberal democracies at war: Conflict and representation* (London: Bloomsbury Academic, 2013), pp. 15–38.

Knapp, Thura E., "Gerhard Richter and the ambiguous aesthetics of morality," *Colloquia Germanica*, 45, 1 (2012), pp. 95–112.

Koch, Gertrud, "The Richter-scale of blur," *October*, 62 (Autumn 1992), pp. 133–42.

Koselleck, Reinhart, *Begriffsgeschichten: Studien zur Semantik und Pragmatik der politischen und sozialen Sprache / mit zwei Beiträgen von Ulrike Spree und Willibald Steinmetz sowie einem Nachwort zu Einleitungsfragmenten Reinhart Kosellecks von Carsten* (Frankfurt-on-Main: Suhrkamp, 2006).

The practice of conceptual history: Timing history, spacing concepts; trans. Todd Samuel Presner, with others (Stanford University Press, 2002).

Koselleck, Reinhart (ed.), *Historische Semantik und Begriffsgeschichte* (Stuttgart: Klett-Cotta, 1979).

Koselleck, Reinhart, Otto Bruner, and Werner Conze (eds.), *Geschichtliche Grundbegriffe: historisches Lexikon zur politisch-sozialen Sprache in Deutschland*, 9 vols. (Stuttgart: E. Klett, 1972–92).

Koselleck, Reinhart, Otto Bruner, Werner Conze, Javiér Fernández Sebastián, and Juan Francisco Fuentes, "Conceptual history, memory, and identity:

An interview with Reinhart Koselleck," *Contributions to the History of Concepts*, 2, 1 (March 2006), pp. 99–127.

Kristeva, Julia, *Black sun: Depression and melancholia*, trans. Leon S. Roudiez (New York: Columbia University Press, 1989).

Kwon, Hoenik, *The other cold war* (New York: Columbia University Press, 2010).

Lacan, Jacques, *Séminaire, Livre VII: L'éthique de la psychanalyse* (Paris: Éditions du Seuil, 1986).

Lake, Marilyn et al., *What's wrong with Anzac? The militarization of Australian history* (Melbourne University Press, 2008).

Lagrou, Pieter, *The legacy of Nazi occupation: Patriotic memory and national recovery in Western Europe, 1945–1965* (Cambridge University Press, 1999).

Langenbacher, Eric, "Twenty-first century memory regimes in Germany and Poland: An analysis of elite discourses and public opinion," *German Politics and Society*, 89, 26(4) (Winter 2008), pp. 50–58.

Lansberg, Alison, *Prosthetic memory: The transformation of American remembrance in the age of mass culture* (New York: Columbia University Press, 2004).

Larrsen, Marina, *Shattered Anzacs: Living with the scars of war* (Sydney: University of New South Wales Press, 2009).

Laqueur, Thomas W., *The work of the dead: A cultural history of mortal remains* (Princeton University Press, 2015).

Lebow, Richard Ned, "The future of memory," *Annals of the American Academy of Political and Social Science,* vol. 617, *The Politics of History in Comparative Perspective* (May 2008), pp. 25–41.

Leese, Peter, "Problems returning home: The British psychological casualties of the Great War," *Historical Journal*, 40, 4 (December 1997), pp. 1055–67.

Leidinger, Hannes et al., *Habsburgs schmutziger Krieg – Ermittlungen zur österreichisch-ungarischen Kriegsführung 1914–1918* (St. Pölten/Salzburg/Vienna: Residenz Verlag, 2014).

Levi, Primo, *Survival in Auschwitz: The Nazi assault on humanity*, trans. Stuart Woolf (New York: Simon & Schuster, 1996).

Levinas, Emmanuel, *Totalité et infini* (Paris: Martinus Nijhoff, 1961).

Liebman, Stuart (ed.), *Claude Lanzmann's Shoah: Key essays* (Oxford University Press, 2007).

Lindeperg, Sylvie, *Les écrans de l'ombre: La Seconde Guerre mondiale dans le cinéma français (1944–1969)* (Paris: CNRS, 1997).

"Nuit et brouillard," un film dans l'histoire (Paris: Odile Jacob, 2007).

Linfield, Susie, *The cruel radiance. Photography and political violence* (University of Chicago Press, 2010).

Litonjua, M. D., "Religious zealotry and political violence in Christianity and Islam," *International Review of Modern Sociology*, 35, 2, *Sociology in a post-American world* (Autumn 2009), pp. 307–31.

Lohr, Eric, "The Russian Army and the Jews: Mass deportation, hostages and violence during World War I," *Russian Review* (July 2001), pp. 404–19.

McFarlane, Alexander, "One hundred years of lessons about the impact of war on mental health," *Australian Psychiatry* (2015), pp. 1–4.

McFarlane, Alexander and David Forbes, "The journey from moral inferiority to post-traumatic stress disorder," *Medical Journal of Australia*, 202, 7 (2015), pp. 1–3.

Maier, Charles, "Consigning the twentieth century to history: Alternative narratives for the modern era," Forum Essay, *American Historical Review*, 105, 3 (June 2000), pp. 807–31.

Marien, Mary Warner, *Photography: A cultural history*, 2nd edn. (Upper Saddle River, NJ: Pearson/Prentice Hall, 2006).

Meier, Andreas, "Nachwort: Armin T. Wegners Armenienprojekt," in Wegner, *Austreibung des armenischen Volkes in die Wüste*, pp. 153–92.

Merridale, Catherine, "War, death and remembrance in Soviet Russia," in Winter and Sivan, *War and remembrance in the twentieth century*, pp. 61–83.

Merz, Jörg Martin, "Otto Dix' Kriegsbilder. Motivationen – Intentionen – Rezeptionen," *Marburger Jahrbuch für Kunstwissenschaft*, 26 (1999), pp. 189–226.

Mesch, Claudia and Viola Michely (eds.), *Joseph Beuys: The reader*, with a foreword by Arthur C. Danto; additional translation by Nickolas Decarlo, Kayvan Rouhani, and Heidi Zimmerman (London: I. B. Tauris, 2007).

Meyers, Jeffrey, "Ted Hughes: War poet," *Antioch Review*, 71, 1 (Winter 2013), pp. 30–39.

Michel, Jean-Baptiste et al., "Quantitative analysis of culture using millions of digitized ooks," *Science*, 331 (2011), pp. 176–85.

Milton, Sybil, "Photography as evidence of the Holocaust," *History of Photography*, 23, 4 (1999), pp. 303–12.

Minnseux-Chamonar, Marie (ed.), *Anselm Kiefer. L'Alchimie de livre* (Paris: BNF–Éditions du Regard, 2015).

Mitchell, William J., *The Reconfigured eye: Visual truth in the post-photographic era* (Cambridge, Mass.: MIT Press, 1992).

Moorhouse, Geoffrey, *Hell's foundations: A town, its myths and Gallipoli* (London: Hodder & Stoughton, 1962).

Moorjani, Angela, "Käthe Kollwitz on sacrifice, mourning, and reparation: An essay in psychoaesthetics," *MLN*, 101, 5, *Comparative Literature* (December 1986), pp. 1110–34.

Morris, David J., *The evil hours. A biography of post-traumatic stress disorder* (Boston, Mass.: Houghton Mifflin Harcourt, 2015).

Morris, Errol, *Believing is seeing: Observations on the mysteries of photography* (New York: Penguin, 2011).

Moyn, Samuel, "Two regimes of memory," *American Historical Review*, 103, 4 (October 1998), pp. 1182–86.

Multeau, Norbert, "Quand la guerre est un spectacle," in *Le cinéma et la guerre*, ed. Philippe d'Hugues and Hervé Coutau-Bégarie (Paris: Economica, 2006), pp. 101–18.

Murav, Harriet, *Music from a speeding train: Jewish literature in post-revolution Russia* (Stanford University Press, 2011).

Murphy, Robert, *British cinema and the Second World War* (London: Continuum, 2000).

Nicolas, Guy, "Victimes ou martyrs," *Cultures et Conflits*, 11, *Interventions armées et causes humanitaires* (Autumn 1993), pp. 115–55.

Norris, A., "Sovereignty, exception, and norm," *Journal of Law and Society*, 24, 1 (2007), pp. 31–45.

O'Brian, John (ed.), *Clement Greenberg: The collected essays and criticism*, 5 vols. (University of Chicago Press, 1986–93).

Olick, Jeffrey K., "Between chaos and diversity: Is social memory studies a field?," *International Journal of Politics, Culture, and Society*, 22, 2 (2009), pp. 249–52.

Olick, Jeffrey K. and Joyce Robbins, "Social memory studies: From 'collective memory' to the historical sociology of mnemonic practices," *Annual Review of Sociology*, 24 (1998), pp. 105–40.

Palmer, Scott W., "How memory was made: The construction of the memorial to the heroes of the Battle of Stalingrad," *Russian Review*, 68, 3 (July 2009), pp. 373–407.

Palonen, Kari, "The politics of conceptual history," *Contributions to the History of Concepts*, 1, 1 (March 2005), pp. 37–50.

Patch, Harry with Richard van Emden, *The last fighting Tommy: The life of Harry Patch, last veteran of the trenches, 1898–2009* (London: Bloomsbury, 2010).

Payne, John, "'An expensive death': Walter Benjamin at Portbou," *European Judaism: A Journal for the New Europe*, 40, 2 (Autumn 2007), pp. 102–05.

Penny, Nicholas, "English sculpture and the First World War," *Oxford Art Journal*, 4, 2 (1981), pp. 36–42.

Pickering, W. S. F., "The eternality of the sacred: Durkheim's error?," *Archives de sciences sociales des religions*, 35e année, 69 (January–March 1990), pp. 91–108.

Pike, David Wingeate, "Les photographes de Mauthausen: Aspects nouveaux d'une affaire célèbre," *Guerres mondiales et conflits contemporains*, 218 (April 2005), pp. 85–99.

Prost, Antoine, *Republican identities in war and peace: Representations of France in the nineteenth and twentieth centuries* (London: Bloomsbury, 2010).

"Verdun," in *Republican identities in war and peace*, chapter 1.

Prost, Philippe, *Mémorial international de Notre-Dame-de-Lorette* (Paris: Les Édifiantes éditions, 2015).

Quaknin, Marc-Alain, "La Kabbale et l'art de la bicyclette," in Bouhours, *Anselm Kiefer*, pp. 28–43.

Rancière, Jacques, *The future of the image*, trans. Geoffrey Elliott (London: Verso, 2007).

Roberts, Adam, "Lives and statistics: Are 90% of war victims civilians?," *Survival*, 52, 3 (June–July 2010), pp. 115–36.

Rousset, David, *L'Univers concentrationnaire* (Paris: Éditions de Pavois, 1946).

Rousso, Henry, *The Vichy syndrome. History and memory in France since 1944*, trans. Arthur Goldhammer (Cambridge, Mass.: Harvard University Press, 1994).

Salzmann, Siegfried, *Hommage à Lehmbruck: Lehmbruck in seiner Zeit* (Duisburg, Germany: Wilhelm-Lehmbruck-Museum der Stadt Duisburg, 1981).

Saltzman, Lisa, *Anselm Kiefer and art after Auschwitz* (Cambridge University Press, 1999).

"L'année prochaine à Jérusalem, cette année à Paris: À propos d'Anselm Kiefer, der impératifs iconographiques et des juifs," in Bouhours, *Anselm Kiefer*, pp. 50–59.

"Gerhard Richter's Stations of the Cross: On martyrdom and memory in postwar German art," *Oxford Art Journal*, 28, 1 (2005), pp. 27–44.

Sanders, Anne, "Springthorpe, John William," in *Inner worlds: Portraits and psychology*, ed. Christopher Chapman (Canberra: National Portrait Gallery, 2011), pp. 200–2.

Sargent, Leona Catherine, "Visions of World War I through the eyes of Käthe Kollwitz and Otto Dix," MA thesis, Wright State University, 2012.

Sarkonak, Ralph, "Roland Barthes and the spectre of photography," *L'esprit créateur*, 22 (1982), pp. 56–57.

Scates, Bruce, Rebecca Wheatley, and Laura James, *World War I: A history in 100 stories* (Melbourne: Penguin, 2015).

Schindler, Pesach, "The Holocaust and Kiddush Hashem in Hassidic thought," *Tradition: A Journal of Orthodox Jewish Thought*, 13, 1 (1973), pp. 88–104.

Schmitt, Carl, *The concept of the political* (University of Chicago Press, 1927).
Political theology. Four chapters on the concept of sovereignty (1922), trans.
G. Schwab (University of Chicago Press, 2005).

Schneede, Uwe M. (ed.), *1914. Die Avantgarden im Kampf* (Cologne: Snoeck, 2013).

Schulte, Regina, "Käthe Kollwitz's sacrifice," trans. Pamela Selwyn, *History Workshop Journal*, 41 (1996), pp. 193–221.

Schwake, Norbert, "The Great War in Palestine: Dr. Tawfiq Canaan's photographic album," *Jerusalem Quarterly*, 56–7 (Winter 2013–Spring 2014), issue on Palestine in World War One, pp. 140–56.

Schwarzbard, André, *The last of the just* (New York: Alfred A. Knopf, 1963).

Sheehan, James, *Where have all the soldiers gone? The transformation of Europe* (New York: Alfred A. Knopf, 2008).

Shepkaru, Samuel, *Jewish martyrs in the pagan and Christian worlds* (Cambridge University Press, 2006).

Shevchenko, Olga (ed.), *Double exposure: Memory and photography* (New Brunswick, NJ: Transaction Books, 2014).

Siebrecht, Claudia, *The aesthetics of loss: German women's art of the First World War* (Oxford University Press, 2013).

Silver, Kenneth, *Esprit de corps: The art of the Parisian avant-garde and the First World War, 1914–25* (Princeton University Press, 1989).

Sivard, Ruth Leger, *World military and social expenditures 1991* (Washington DC: World Priorities, 1991).

Smither, Roger, "'A wonderful idea of the fighting': The question of fakes in *The Battle of the Somme*," *Historical Journal of Film, Radio and Television*, 13, 2 (1993), pp. 149–68.

Snyder, Joel and Neil Walsh Allen, in "Photography, vision, and representation," *Critical Inquiry*, 2 (1975), pp. 143–69.

Snyder, Timothy, *Black earth: The Holocaust as history and warning* (New York: Penguin/Random House, 2015).

Sohm, Philip, "Caravaggio's deaths," *Art Bulletin*, 84, 3 (September 2002), pp. 449–68.

Sontag, Susan, *On photography* (New York: Farrar, Straus & Giroux, 1977).
Regarding the pain of others (New York: Picador, 2003).

Spitzer, Robert L., Janet B. Williams, and Andrew E. Skodol, "DSM-III: The major achievements and an overview," *American Journal of Psychiatry*, 137, 2 (February 1980), pp. 151–64.

Statistics of the military effort of the British Empire in the war (London: HMSO, 1922).

Stevenson, David, *With our backs to the wall: Victory and defeat in 1918* (London: Penguin–Allen Lane, 2011).

Storr, Robert, "October 18, 1977," *MoMA*, 4 (January 2001), pp. 31–33.

Taft, Robert, *Photography and the American scene: A social history 1839–1889* (New York: Macmillan, 1942).

Tamcke, Martin, *Armin T. Wegner und die Armenier. Anspruch und Wirklichkeit eines Augenzeugen* (Hamburg: Lit, 1996).

Tanović, Sabina, "Memory in architecture. Contemporary memorial projects and their predecessors," PhD dissertation, Delft University of Technology, 2015.

Tavernise, Sabrina and Andrew W. Lehren, "A grim portrait of civilian deaths in Iraq," *New York Times*, October 22, 2010.

Tchilingirian, Hratch, "In search of relevance: Church and religion in Armenia since independence," in *Religion et politique dans le Caucase post-soviétique*, ed. Bayram Balci and Raoul Motika (Paris: Maisonneuve & Larose, 2007), pp. 277–90.

Tinterow, Gary and Geneviève Lacambre, with contributions by Juliet Wilson-Bareau and Deborah L. Roldán, *Manet/Velázquez: The French taste for Spanish painting* (New Haven, Conn.: Yale University Press, 2003).

von Klemperer, Klemens, *The passion of a German artist: Käthe Kollwitz* (Bloomington, Ind.: Exlibris Corp., 2011).

Wagoner, Brady (ed.), *Oxford handbook of cultural memory* (Oxford University Press, 2017).

Wagner-Pacifici, Robin, "Witness to surrender," in *Visual worlds*, ed. John R. Hall, Blake Stimson, and Lisa Tamiris Becker (London: Routledge, 2005).

Wegner, Armin T., *Die Austreibung des armenischen Volkes in die Wüste*, ed. Andreas Meier, with an essay by Wolfgang Gust (Göttingen: Wallstein Verlag, 2011).

Der Weg ohne Heimkehr. Ein Martyrium in Briefen, 2nd edn. (Dresden: Sibyllen-Verlag, 1920).

"Armenien … Offener Brief an den Präsidenten der Vereinigten Staaten von Amerika, Herrn Woodrow Wilson, über die Austreibung des armenischen Volkes in die Wüste," *Berliner Tageblatt und Handels-Zeitung, Morgen-Ausgabe*, 85, February 23, 1919, p. 4; translated by Silvia Samuelli, and published as "An open letter to the President of the United States of America, Woodrow Wilson, on the mass deportation of the Armenians into the Mesopotamian desert," *Journal of Genocide Research* 2, 1 (2000), pp. 127–32.

Weigel, Sigrid and Georgina Paul, "The martyr and the sovereign: Scenes from a contemporary tragic drama, read through Walter Benjamin and Carl Schmitt," *New Centennial Review*, 4, 3, *Theory of the partisan* (Winter 2004), pp. 109–23.

Weinrich, Arndt, "Visual essay," in Winter, *Cambridge history of the First World War*, vol. II, pp. 663–71.

Welzer, H., *Das kommunikative Gediichtnis: Eine Theorie der Erinnerung* (Munich: C. H. Beck, 2002).

Welzer, H. (ed.), *Das soziale Gedichtnis: Geschichte, Erinnerung, Tradierung* (Hamburg: Hamburger Edition, 2010).

Whitman, Walt, "Drum-taps," The Walt Whitman archive, Published works, www.whitmanarchive.org/published/LG/1867/poems/159

Wieviorka, Annette, *L'ère des témoins* (Paris: Plon, 1998).

Winter, Jay, *Dreams of peace and freedom: Utopian moments in the twentieth century* (New Haven, Conn.: Yale University Press, 2006).

The experience of World War I (London: Macmillan, 1988).

The Great War and the British people, 2nd edn. (London: Macmillan, 2000).

Remembering war: The Great War between history and memory (New Haven, Conn.: Yale University Press, 2006).

Sites of memory, sites of mourning: The Great War in European cultural history (Cambridge University Press, 1995).

"The generation of memory: Reflections on the 'memory boom' in contemporary historical studies," *Bulletin of the German Historical Institute*, 27 (Fall 2000), pp. 69–92.

"The Great War and Jewish memory," in *European Jewish literatures and World War One. Yearbook for European Jewish Literature Studies no. 1*, ed. Petra Ernst (Berlin: de Gruyter, 2014), pp. 13–40.

"Jüdische Erinnerung und Erster Weltkrieg – Zwischen Geschichte und Gedächtnis," *Yearbook of the Simon Dubnow Institute*, 13 (2014), pp. 111–30.

"Public history and the 'Historial' project 1986–1998," in *Recollections of France: Memories, identities and heritage in contemporary France*, ed. Sarah Blowen, Marion Demossier, and Jeanne Picard (Oxford: Berghahn, 2000), pp. 52–67.

"Shell shock," in Winter, *Cambridge History of the First World War*, vol. III, pp. 310–33.

"Shell shock and the cultural history of the Great War," *Journal of Contemporary History*, 35, 1 (2000), pp. 7–11.

"Thinking about silence," in *Shadows of war: The social construction of Silence*, ed. Efrat Ben-Ze'ev, Ruth Ginio, and Jay Winter (Cambridge University Press, 2010), pp. 1–30.

"Under cover of war: The Armenian genocide in the context of total war," in *The specter of genocide: Mass murder in historical perspective*, ed. Robert Gellately and Ben Kiernan (Cambridge University Press, 2003), pp. 189–214.

"Vermisste Söhne. Der Krieg als Akt des Auschlöschung," in *1914. Die Avantgarden im Kampf*, ed. Uwe M. Schneede (Cologne: Snoeck, 2013), pp. 326–31.

"War and martyrdom in the twentieth century and after," *Journal of soviet and post-soviet society*, 2 (2015), pp. 217–55.

Winter, Jay (ed.), *The Cambridge history of the First World War*, 3 vols. (Cambridge University Press, 2014).

Winter, Jay and Emmanuel Sivan (eds.), *War and remembrance in the twentieth century* (Cambridge University Press, 1999).

Wolin, Richard, "Carl Schmitt: The conservative revolutionary habitus and the aesthetics of horror," *Political Theory*, 20, 3 (August 1992), pp. 410–35.

Yeats, W. B., *Letters on poetry from W. B. Yeats to Dorothy Wellesley* (Oxford University Press, 1940).

Yeats, W. B. (ed.), *The Oxford book of Modern Verse* (Oxford University Press, 1936).

Yerushalmi, Yosef Chaim, *Zachor. Jewish history and Jewish memory* (Seattle, Ill.: University of Washington Press, 1982).

Young, James, *The texture of memory* (New Haven, Conn.: Yale University Press, 2000).

"The biography of a memorial icon: Nathan Rapoport's Warsaw Ghetto monument," *Representations*, 26, *Special issue: Memory and counter-memory* (Spring 1989), pp. 69–106.

"Memory, counter-memory and the end of the monument," in *Image and remembrance: Representation and the Holocaust*, ed. Shelley Hornstein and Florence Jacobowitz (Bloomington: Indiana University Press, 2006), pp. 59–78.

Index